The Education of the Filmmaker in Africa, the Middle East, and the Americas

GLOBAL CINEMA

Edited by Katarzyna Marciniak, Anikó Imre, and Áine O'Healy

The **Global Cinema** series publishes innovative scholarship on the transnational themes, industries, economies, and aesthetic elements that increasingly connect cinemas around the world. It promotes theoretically transformative and politically challenging projects that rethink film studies from cross-cultural, comparative perspectives, bringing into focus forms of cinematic production that resist nationalist or hegemonic frameworks. Rather than aiming at comprehensive geographical coverage, it foregrounds transnational interconnections in the production, distribution, exhibition, study, and teaching of film. Dedicated to global aspects of cinema, this pioneering series combines original perspectives and new methodological paths with accessibility and coverage. Both "global" and "cinema" remain open to a range of approaches and interpretations, new and traditional. Books published in the series sustain a specific concern with the medium of cinema but do not defensively protect the boundaries of film studies, recognizing that film exists in a converging media environment. The series emphasizes a historically expanded rather than an exclusively presentist notion of globalization; it is mindful of repositioning "the global" away from a US-centric/Eurocentric grid, and remains critical of celebratory notions of "globalizing film studies."

Katarzyna Marciniak is a professor of Transnational Studies in the English Department at Ohio University.

Anikó Imre is an associate professor of Critical Studies in the School of Cinematic Arts at the University of Southern California.

Áine O'Healy is a professor of Modern Languages and Literatures at Loyola Marymount University.

Published by Palgrave Macmillan:

Prismatic Media, Transnational Circuits: Feminism in a Globalized Present
By Krista Geneviève Lynes

Transnational Stardom: International Celebrity in Film and Popular Culture
Edited by Russell Meeuf and Raphael Raphael

Silencing Cinema: Film Censorship around the World
Edited by Daniel Biltereyst and Roel Vande Winkel

The Education of the Filmmaker in Europe, Australia, and Asia
Edited by Mette Hjort

The Education of the Filmmaker in Africa, the Middle East, and the Americas
Edited by Mette Hjort

The Education of the Filmmaker in Africa, the Middle East, and the Americas

Edited by Mette Hjort

THE EDUCATION OF THE FILMMAKER IN AFRICA, THE MIDDLE EAST, AND THE AMERICAS
Copyright © Mette Hjort, 2013.

All rights reserved.

First published in 2013 by
PALGRAVE MACMILLAN®
in the United States—a division of St. Martin's Press LLC,
175 Fifth Avenue, New York, NY 10010.

Where this book is distributed in the UK, Europe and the rest of the world,
this is by Palgrave Macmillan, a division of Macmillan Publishers Limited,
registered in England, company number 785998, of Houndmills,
Basingstoke, Hampshire RG21 6XS.

Palgrave Macmillan is the global academic imprint of the above companies
and has companies and representatives throughout the world.

Palgrave® and Macmillan® are registered trademarks in the United States,
the United Kingdom, Europe and other countries.

ISBN: 978–1–137–03268–3

Library of Congress Cataloging-in-Publication Data

The education of the filmmaker in Africa, the Middle East, and the
Americas / edited by Mette Hjort.
 pages cm.—(Global cinema)
 ISBN 978–1–137–03268–3 (alk. paper)
 1. Motion pictures—Production and direction—Study and teaching—
Africa. 2. Motion pictures—Production and direction—Study and
teaching—Middle East. 3. Motion pictures—Production and direction—
Study and teaching—Americas. I. Hjort, Mette, editor of compilation.

PN1993.8.A35E38 2013
791.4302'3071—dc23 2013002358

A catalogue record of the book is available from the British Library.

Design by Newgen Imaging Systems (P) Ltd., Chennai, India.

First edition: August 2013

10 9 8 7 6 5 4 3 2 1

For Gaston Kaboré

Contents

List of Figures ix

List of Tables xi

Acknowledgments xiii

Introduction: More than Film School—Why the Full Spectrum of
 Practice-Based Film Education Warrants Attention 1
 Mette Hjort

Part I: Africa

 1 Audience Response in Film Education 25
 Anton Basson, Keyan Tomaselli, and Gerda Dullaart

 2 Bridging the Gap: Answering the Questions of Crime, Youth
 Unemployment, and Poverty through Film Training
 in Benin, Nigeria 39
 Osakue Stevenson Omoera

 3 Global Interchange: The Same, but Different 59
 Rod Stoneman

Part II: The Middle East

 4 Branch-Campus Initiatives to Train Media-Makers and
 Journalists: Northwestern University's Branch Campus
 in Doha, Qatar 81
 Hamid Naficy

 5 Film Education in Palestine Post-Oslo: The Experience of Shashat 99
 Alia Arasoughly

 6 Art and Networks: The National Film School of Denmark's
 "Middle East Project" 125
 Mette Hjort

Part III: The Americas

 7 Goodbye to Film School: Please Close the Door on Your Way Out 153
 Toby Miller

 8 "An Arrow, Not a Target": Film Process and Processing at the
 Independent Imaging Retreat 169
 Scott MacKenzie

 9 The School for Every World: Internationalism and Residual
 Socialism at EICTV 185
 Nicholas Balaisis

10 Building Film Culture in the Anglophone Caribbean: Film
 Education at the University of the West Indies 203
 Christopher Meir

11 Practice-Based Film Education for Children: Teaching and Learning
 for Creativity, Citizenship, and Participation 221
 Armida de la Garza

12 Audiovisual Educational Practices in Latin America's Peripheries 239
 George Yúdice

Notes on Contributors 261

Bibliography 267

Index 287

List of Figures

1.1 Courtesy of AFDA, Scaffolded learning: AFDA students supporting each other 30

1.2 Courtesy of AFDA, Learning by doing: AFDA students collaborating on a film project 34

2.1 Courtesy of Osakue Stevenson Omoera, Map of Nigeria showing Edo State 43

2.2 Courtesy of Osakue Stevenson Omoera, Map of Edo State showing the study area 44

3.1 *Cross Cultural Television*, Hank Bull and Antoni Muntadas/Western Front Video Production, 1987 61

3.2 *The Wild Field* 66

3.3 *Zan Boko* 69

3.4 *Tinpis Run* 73

4.1 Framegrab from Ethar Hassaan's film *What I Saw* 96

4.2 Framegrab from *What I Saw* 96

5.1 Courtesy of Shashat, 8th Festival, Ramallah Billboard 103

5.2 Courtesy of Shashat, *My Lucky 13* by Dara Khader 117

5.3 Courtesy of Shashat, *If They Take It!* by Liali Kilan 118

5.4 Courtesy of Shashat, Young women filmmakers, 2009 119

6.1 *Equal Men*, a documentary by Anthony Chidiac (Lebanon) 146

9.1 Photograph by Nicholas Balaisis, Comments left on the walls at EICTV 188

9.2 Photograph by Nicholas Balaisis, EICTV brochure, 2011 193

10.1 Courtesy of UWI, St. Augustine Film Programme, Partnering with the Trinidad and Tobago Film Festival. Jamaican director Storm Saulter (left) meets with UWI, St. Augustine film students 211

10.2 Proving that Caribbean cinema exists. A still from Yao Ramesar's *Sistagod* 214

11.1–

11.2 Puppets and scenery made by children at *La Matatena A.C.* 230

11.3 International Children's Film Festival, 2011 234

11.4 Films made by children by school 235

12.1 Screenshot of *Troca de Olhares/Exchange of Views*, from YouTube 253

List of Tables

11.1 Table Comparing Training Workshops 234
12.1 Salient post-NLAC filmmakers of the 2000s 241
12.2 Schroeder Rodríguez's periodization of NLAC and post-NLAC 247

Acknowledgments

Lingnan University established a Centre for Cinema Studies (CCS) in 2011 and generously offered to bring the scholars involved in the two-book "The Education of the Filmmaker" project to Hong Kong for discussions of their ongoing research. The opportunity to have contributors share their early findings at what became the CCS's inaugural conference helped to bring central issues into clear focus and to create a strong sense of shared purpose, all of which is reflected, I believe, in the chapters. I am deeply grateful to Lingnan president Yuk-Shee Chan and Vice President Jesús Seade for their generous support for Cinema Studies more generally, and for research on practice-based film education specifically. Wendy Lai from the Human Resources Office dealt effectively with unexpected visa requirements. CCS colleagues Meaghan Morris, Mary Wong, John Erni, and Red Chan helped to make the discussions in Hong Kong fruitful. New media artist Zoie So brought talent to various design issues, while Hong Kong artist Chow Chun-fai kindly allowed images of his paintings based on scenes from well-known Hong Kong films to be featured on the CCS website, as well as on the poster and banner for "The Education of the Filmmaker" conference. Felix Tsang Chun Wing, senior research assistant to the CCS, provided consistently gracious and efficient help at all stages of the project. Student volunteers from across the Faculty of Arts—Kara Chan, Felicity Chau, Emily Choi, Terence Choi, Amis Kwok, Lilian Ngan, Law Kwun Kit, and Sally Lau—deserve thanks for their help and for being utterly dependable, and so genuinely committed to the project.

CCS Advisory Board member Stephen Teo (Head of the Broadcast and Cinema Studies Division at Nanyang Technological University in Singapore) made being at the inaugural conference a priority, for which I am truly grateful. Carving out time from punishing Hong Kong schedules, critics, researchers, filmmakers, and festival organizers from across Hong Kong moderated sessions and contributed to a concluding round table discussion. These figures are: Xavier Tam (Vice Chairperson [hearing], The Second Hong Kong Deaf Film Festival), Law Kar (Hong Kong Film Archive), Tammy Cheung (filmmaker and Founding Director, Chinese Documentary Film Festival), Teresa Kwong (Director of ifva—Incubator for Film and Visual Media in Asia), Wong Ain-ling (film critic and researcher), Jessica Yeung Wai Yee (actress, translator and scholar at Hong Kong Baptist University), Esther M. K. Cheung (Chairperson, Comparative Literature, Hong Kong University), Camille Desprez (Academy of Film, Hong Kong Baptist University), and Emilie Yeh (Director, Centre for Media and Communication Research, Hong Kong Baptist University). The support of CCS members Cheung Tit-leung, Mike Ingham, Li Bo, and Paisley Livingston is also gratefully acknowledged.

I am grateful to Kasia Marciniak, Anikó Imre, and Áine O'Healy, editors for Palgrave's Global Cinema series, for having thought of approaching me, and for having immediately taken a keen interest in what I had to propose. Robyn Curtis, Samantha Hasey, and Desiree Browne, all at Palgrave Macmillan, have been supportive throughout. Their willingness to accommodate a two-book project made it possible to solicit more in-depth case studies and from a much wider range of contexts. The contributors to *The Education of the Filmmaker in Europe, Australia, and Asia* and *The Education of the Filmmaker in Africa, the Middle East, and the Americas* deserve special thanks for having been a delight to work with, and for having written so compellingly on the models and values driving practice-based film education around the world.

The Education of the Filmmaker in Africa, the Middle East, and the Americas is dedicated to Burkinabé filmmaker and founder of the alternative film school Imagine in Ouagadougou, Gaston Kaboré.

Introduction: More than Film School—Why the Full Spectrum of Practice-Based Film Education Warrants Attention

Mette Hjort

Adapting Simone de Beauvoir's well-known phrase, one is not born a filmmaker but becomes one.[1] To ask about the nature of practice-based film education as it has emerged around the globe and exists today, is to begin to understand how filmmakers become filmmakers. Inquiry along these lines sheds light on the process not only of becoming a filmmaker, but also a particular *kind* of filmmaker, where "kind" encompasses skills, as well as narrative and aesthetic priorities, preferred modes of practice, and understandings of what the ideal roles and *contributions* of film would be.

A few suggestive anecdotes from the field of film practice help to set the stage for a more scholarly account of the questions, commitments, and aspirations that are behind *The Education of the Filmmaker in Europe, Australia, and Asia* (vol. 1) and *The Education of the Filmmaker in Africa, the Middle East, and the Americas* (vol. 2). Evoking both a desire to make meaningful, authentic choices, and questions having to do with what counts as a genuine justification for the costs of filmmaking (in terms of money, effort, and time), Danish director Lone Scherfig reflects as follows on the process of selecting her next script from among an array of possible choices: "I'm quite marked by an experience that I've had twice, uncannily. My father died while I was shooting *Italian for Beginners* and my mother died while I was shooting *An Education*. When I watch these films I can't help but ask myself whether they were worth it. When you start to look at the whole filmmaking process with those eyes, there are really a lot of scripts that life is simply too short for."[2]

In an exchange about *The Video Diary of Ricardo Lopez* (2000), documentary filmmaker Sami Saif—who, like Scherfig, is a graduate of the National Film School of Denmark—foregrounds his commitment to taking his responsibilities as a filmmaker seriously. Saif's film is based on Lopez's webcam recordings, which had been sensationalized by the media, inasmuch as they captured his suicide shortly after having mailed a bomb to Icelandic singer Björk with whom

he was obsessed. In response to a question as to why *The Video Diary of Ricardo Lopez* remains difficult to get hold of, and why the filmmaker prefers to be present when audiences watch the film, Saif says: "I have a lot at stake in being able to stand by what I've done with the material. I want to be able to explain why I edited it the way I did, why I saw it as important to make the film, and how I understand Ricardo Lopez. My desire to engage very directly with the audiences who see the film also has to do with the fact that Ricardo Lopez is dead....I want to be there when people see the film, because there are all sorts of things about Ricardo Lopez on the internet. I like to be able to talk to people about what it is they've actually seen."[3]

One last anecdote, this one referring to developments in Hong Kong, on the Chinese mainland, and in South Korea, suffices to draw attention to filmmakers as agents of moral deliberation with significant choices to make that extend well beyond the punctual craft-based decisions required by any given filmmaking project. The year 2012 saw well-known sixth-generation Chinese filmmaker Jia Zhangke "installed as the dean of the Busan International Film Festival's Asian Film Academy (AFA)." Called on to describe the experience of working with 23 young filmmakers in workshops and seminars spanning 18 days, Jia spoke of his commitment to "mak[ing] honest films and films that will make people think." Jia sees his values as reflected not only in his films, but also in his efforts to mentor young filmmakers through his company Xstream Pictures. His ongoing efforts to establish a funding program called The Renaissance Foundation in Hong Kong, in collaboration with "fellow filmmaker Pang Ho-cheung, author Han Han, and musician Anthony Wong Yiu-ming," are similarly an expression of an understanding of the film practitioner as an agent of moral choice. As Jia puts it, "It is all about giving young artists the freedom to create. Through that comes honesty—and artists should be honest."[4]

Over time, what emerges through filmmakers' professionally relevant and publicly available actions—by no means limited to the actual making of films—are patterns of choice that are indicative of certain values and thus amenable to assessment in broadly ethical terms. That is, filmmakers have decisions to make, not only about whether a given story (if the film is a narrative one) is really worth telling and warrants the time, cost, and effort needed to articulate it in moving images, but also about how to treat the actors and other practitioners with whom they work, about the environmental costs of their filmmaking practices, the possible ideological implications of their work, and the terms in which they choose to discourse about it. Examples of filmmakers having made poor choices are not at all difficult to find. Titles that come to mind include Danny Boyle's *The Beach* (2000), James Cameron's *Titanic* (1997), and fifth-generation Chinese filmmaker Chen Kaige's *The Promise* (2005), all three of them for reasons having to do with a failure to take the environmental duties of filmmakers seriously. Duties, after all, may be moral in nature rather than strictly legal, requiring considered action even in the absence of (enforcement of) rigorous laws preventing the remodeling of beaches in the Phi Phi Islands National Park in Thailand (*The Beach*), the chlorination of sea water in Baja California (*Titanic*), or the killing of trees in the gardens of Yuanmingyuan, China (*The Promise*).[5]

Filmmaking is usually an intensely collaborative process, making it difficult to draw firm inferences about a specific practitioner's values, and equally so to assign responsibility for decisions made and for the consequences arising from them. Furthermore, every instance of filmmaking takes place within a series of larger, interconnected contexts, in environments, for example, shaped by the ethos of a studio as it interacts with the constraints and opportunities of a larger (economic) system. Thus Richard Maxwell and Toby Miller see "the wider background to the ecologically destructive filmmaking" evoked above as being "the message of economic structural adjustment peddled by the World Bank, the International Monetary Fund, the World Trade Organisation, and the sovereign states that dominate them."[6] Yet, acknowledging the interconnected ways of decision making in the world of film, and the constraints, tendencies, and enticements of larger forces, by no means obviates the need to ask questions about the values of filmmakers—as individuals, but also, just as pertinently, as members of communities where common knowledge and shared practices reflect ways of being in the world through filmmaking.

Burkinabé filmmaker Gaston Kaboré, whose alternative film school IMAGINE in Ouagadougou provides film training for aspiring filmmakers from across francophone Africa, is clearly motivated by a conception of what film is all about that is quite different from that of, say, James Cameron. As Burkinabé actor Serge Yanogo puts it in *IMAGINE FESPACO Newsreel 3*, a 15-minute documentary produced through a training initiative involving filmmaker Rod Stoneman, director of the Huston School of Film & Digital Media in Galway, Ireland and Kaboré's alternative film school, "most films in Africa involve learning."[7] Yanogo, who had a leading role in Kaboré's award-winning *Wend Kuuni* (1983) was responding to a question put to him by a filmmaking student in the context of an outdoor, nighttime screening of the film, which the organization Cinémobile had mounted in a village distant from Ouagadougou and its many well-frequented cinemas. Yanogo's point is borne out by a film such as Ousmane Sembène's *Moolaadé* (2004), which takes a moving and critical look at female genital mutilation. In Samba Gadjigo's documentary entitled *The Making of Moolaadé* (2006), Sembène identifies a desire to have *Moolaadé* function as a vehicle of enlightenment and emancipation in remote villages throughout Senegal and elsewhere in Africa.

A conception of both fiction and nonfiction filmmaking as contributing to authentic cultural memory and to the causes of justice and fairness was like a clear red thread running through conference, exhibition, and screening activities taking place at Kaboré's alternative school during the 2011 edition of FESPACO. One evening, for example, the newly whitewashed wall in the school's courtyard became the screen for animated shorts produced by young Burkinabé children (in the context of training workshops conducted by Golda Sellam from Cinélink and Jean-Luc Slock from the Liège-based Caméra-etc). A feature common to all of the films, which were being screened with the children and their families present, was that they drew on indigenous traditions of artistry—the topic of a fascinating poster exhibition at Kaboré's IMAGINE, which was also hosting a related conference focusing on ancestral myths—and highlighted social issues from

everyday life. *Leila*, a five-minute film produced by eight Burkinabé children, drew attention to the problem of child labor through the figure of a "cut-out" girl who becomes a donkey when the new family in which she finds herself exploits her. The central and clearly educational question asked by the film is: "What has to happen for the donkey to become a girl again?"

But are the values and commitments of a Kaboré or a Sembène, as these find articulation in cinematic narratives or training initiatives aimed at capacity building on the African continent, as the case may be, really connected, in any nontrivial sense, to the paths through which these filmmakers became film practitioners? Do they reflect a specific kind of practical induction into the world of film? Kaboré was trained at the École supérieure d'études cinématographiques (ESEC) in Paris, and graduated with a degree in film production in 1976. Sembène, who was largely self-taught as a filmmaker, spent one year at the Gyorki Film Studio in Moscow, having failed to get into filmmaking programs in France and elsewhere:

> I learned how to make films in the Soviet Union. I didn't have a choice. To get training, I initially turned to people in France, notably Jean Rouch. I had written to America, Canada, etc. and was rejected everywhere without being given a chance. Then I got in touch with Georg Sadoul and Louis Daquin. They suggested the Soviet Union. I spent a year there (1961–1962). It must be said, before I went there I had my ideas and my ideology. I'd been a unionist since 1950. I was very happy that it was eventually the Soviet Union that offered me a scholarship.[8]

So, at one level the paths were very different, in terms of the geography of the training, its institutional environment, and its wider political contexts and social systems. What these filmmakers do share, however, is the experience, among other things, of having had to leave Africa, whether for western or for eastern Europe, in order to achieve the training they saw as necessary. Further common ground is to be found in the experience of making films in sub-Saharan Africa without adequate indigenous personnel to draw on, and in a shared understanding of film as a medium well suited to fostering change in societies where oral traditions, as compared with the written word, are strong.

There can be no one-to-one correspondence between the profile of a given film school on the one hand, and the priorities and values of its graduates on the other. After all, film schools are subject to the full range of complexities that characterize institutional life. Among other things, they are in constant evolution, be it as a result of changes in leadership, incorporation into educational parameters such as the Bologna Accord (Anna Stenport, vol. 1) or the sorts of major historical changes that have affected key institutions in a once divided Germany (Barton Byg and Evan Torner, vol. 1). And then, of course, there is the not-so-small matter of human psychology, which, thankfully enough, can be counted on to generate differences that are anything but trivial. If being a filmmaker is the outcome of a process of becoming, factors shaping that process are not merely to be sought in the institutional landscape of film schools and practice-based training programs. Also, filmmakers may choose, temporarily or over the longer run, to *resist* the training they receive,

including the values that are ultimately driving it. It would be wrong to suggest that Eva Novrup's interview with Phie Ambo in *The Danish Directors 3: Dialogues on the New Danish Documentary Cinema* shows that this award-winning documentary filmmaker has rejected the training she received through the National Film School of Denmark's well-known documentary program (discussed by Hjort with reference to initiatives in the Middle East and North Africa, this volume). At the same time, it is fair to note that Ambo understands herself as having asserted her strong desire at a certain point to counter aspects of her training:

> After film school, I had a real need to undertake a process of "de-film-schoolification." I wanted to do something that involved shooting from the hip.... I had a strong desire to put aside all that learning I'd acquired, all those sophisticated ways of articulating things, so that I could just follow my instincts and go for what seemed like fun. When I look at the film now, I can easily identify all the things I'd learnt and that I'd started to do almost automatically, without even being aware of it, the things that had become second nature. But [making] *Gambler* [about filmmaker Nicolas Winding Refn, 2006] was about a desire to get film to flow through me again, instead of having constantly to stop the creative elevator for a bunch of obligatory consultations with consultant A, B, and C.[9]

That the question of *values* is important in the context of a consideration of film schools and, arguably by extension, the fuller field of practice-based film education, is clearly suggested by the topic chosen for a recent conference organized by the International Association of Film and TV Schools (CILECT). The organization meets biannually for an "Extraordinary General Assembly," and in 2011 the theme for the conference, which was hosted by the Film and TV Academy of the Performing Arts (FAMU) in Prague, was "Exploring the Future of Film and Media Education." Subthemes providing further foci for discussion were: "the fundamental *values* [emphasis added] of film education"; "benchmarking and evaluation"; and "the impact of internationalization."[10] CILECT "was founded in Cannes in 1955 with the intention of stimulating a dialogue among film schools in the deeply divided world of those times. Its membership was drawn from eight countries: Czechoslovakia (presently the Czech Republic), France, Great Britain, Italy, Poland, Spain, the USA, and the USSR (presently Russia). By the year 2012, CILECT had grown to include 159 institutions from 60 countries on five continents. A significant number of the world's leading film and television makers are graduates of member schools." CILECT sees itself as "deeply committed to raising and maintaining the standards of teaching and learning in its member schools, and to exploring the potentials of new technologies for education, information and entertainment." What is more, the organization envisages "a new level of international cooperation" made possible by "the relaxation of international tensions among the great powers, the diminishing of national frontiers and the emergence of new technologies."[11] Membership in CILECT involves meeting strict criteria, as verified in a vetting process. Unsurprisingly, membership is a coveted badge of honor in a world where education is increasingly globalized, with student recruitment often a matter of intense competition

on national, regional, and global levels. What membership potentially means is clearly suggested in a press release featured on the University of Auckland's website, which makes reference to "elite CILECT membership" having been secured by the Department of Film, Television, and Media Studies' Screen Production Program, following an "exhaustive audit" and a vote among existing members.[12]

There are of course many reasons for studying film schools, some of them having little or nothing to do with the *values* that are constitutive of what I have called "practitioner's agency."[13] At this stage in the argument, the issue is not one of determining what the full range of research questions looks like once practice-based film education is seen as warranting careful scrutiny through various lenses, including historical, political, ethical, industrial, and institutional ones. Rather, what must first be settled is the question of institutional scope. What kinds of institutions merit attention? Of the relevant kinds, which specific instantiations of the more general types are particularly worthy of study? What sorts of principles might legitimately be invoked to inform decisions regarding inclusions and exclusions when answering both these questions? Let it be clear: it is my firm belief that the questions being asked here have many possible legitimate answers. The answers to which I am committed, and that are reflected in the design of *The Education of the Filmmaker in Europe, Australia, and Asia* and *The Education of the Filmmaker in Africa, the Middle East, and the Americas*, are shaped by a range of factors, including, most importantly, a dogged interest in small nations and their film cultures (including minor cinemas and their various politics of recognition),[14] and in the ways in which systemic constraints are transformed, through practitioners' agency, into creative opportunities and the conditions needed for an entire milieu to thrive. Another factor, relevant in terms of the global reach of this two-volume project published in the "Global Cinema" series, is my own personal and institutional history, which has offered affiliations, networks, and solidarities linked to practitioners, researchers, institutions, and sites of training in Africa, Canada, Denmark, and HK China (where I have lived as a non-local academic for well over a decade).

We have the possibility as film scholars, or as practitioner-scholars (which many of the contributors to the "Education of the Filmmaker" project are) to affirm certain kinds of initiatives, institutions, and organizations, and to bring awareness of valuable and effective practices to a wider audience, including researchers in the first instance, but also filmmakers, policy makers, and practitioners working in sites of training located at a considerable cultural and geographical remove from those under discussion. We have the opportunity to learn from practices that are innovative, hopeful, and in some cases at least partially transferable. Even the discovery of challenges may be promising, for if these turn out to be a matter of shared problems, then they provide a potential basis for new alliances and partnerships.

But what should the focus be, and is it enough to focus on film schools? My response to the second part of this question is emphatically negative, and this, in turn, helps to define the scope of the research efforts contributing to the present project.

Practice-Based Film Education: Sites, Types, and Systems

Anyone interested in investigating (among other things) the impact that practice-based film education has on the values and practices of filmmakers, and thus on the communities and industries in which they work, is faced with a vast array of stand-alone conservatoire style or industry-oriented film schools, as well as professional programs delivered within the context of universities, from which to choose. A US-based Academy of Television Arts & Sciences Foundation publication entitled *Television, Film and Digital Media Programs*, which presents itself as a guide for anyone "hoping for a life in the competitive world of TV, film, and the fast-growing field of digital media,"[15] describes "*556 Outstanding Programs at Top Colleges and Universities Across the Nation*," as the book's subtitle indicates. And then there are the 159 CILECT members, drawn from 60 countries, which further expands the potential field, although paradoxically enough, by no means sufficiently. Indeed, it is the premise of the current project that crucial practice-based initiatives are being run through institutional arrangements that have little of the institutional robustness that is a feature of the CILECT schools, and thus the scope of analysis extends well beyond this network.

With reference to the first, US-based context of analysis suggested by the above guide, the point to be made here is that the amount of space given to institutions serving as direct feeders of the US film industry has been deliberately limited, in keeping with the aims of the "Global Cinema" series, among others. *The Education of the Filmmaker in Africa, the Middle East, and the Americas* includes a section on "The Americas," but this has but one chapter devoted to schools in the USA (Toby Miller). Discussion of US schools is, however, also pursued in another section, devoted to the Middle East, where Hamid Naficy (this volume) draws out the ambivalences, values, challenges, and opportunities arising from American branch campus initiatives in such places as Qatar. Like many of the contributors to the "Education of the Filmmaker" project, Naficy is able to speak from first-hand experience of the institutional arrangement about which he writes, having been a key player in Northwestern University's development of programs to be delivered through a branch campus located in Education City (alongside other American, British, and French branch campuses) in Doha, Qatar.

Included in "The Americas" section are the results of research focusing on a range of initiatives that are neither US-based nor (likely ever to be) captured by the reach of CILECT's network: George Yúdice's chapter focusing on community-based initiatives aimed at promoting audiovisual literacy in Brazil (Central Única das Favelas / Central Union of Slums and The Escola Livre de Cinema / Free Cinema School) and Uruguay (Usinas Culturales / Cultural Factories); Scott MacKenzie's account of the process-oriented Independent Imaging Retreat or Film Farm school established by Canadian filmmaker Philip Hoffman (who is also on the faculty of York University in Toronto); Christopher Meir's discussion of the energies and aspirations driving efforts to build practice-based film cultures in the anglophone Caribbean; and Armida de la Garza's analysis of the contributions made by the Mexico-based civil association known as La Matatena

to the area of practice-based film education for young children, and through this, to society more generally.

As for the second possible context of analysis—that provided by the CILECT network—it should be noted that some of the case studies presented in the two-volume "Education of the Filmmaker" project provide in-depth analysis of institutions linked to CILECT. Toby Miller's contribution, entitled "Goodbye to Film School: Please Close the Door on Your Way Out" (this volume), takes a critical look at well-established American film schools that are part of the CILECT network. The School of Motion Picture Medium and Live Performance in Cape Town, South Africa (AFDA) figures centrally in the chapter entitled "Audience Response in Film Education," by Anton Basson, Keyan Tomaselli, and Gerda Dullaart (this volume). In Ben Goldsmith and Tom O'Regan's chapter (vol. 1), the histories, profiles, and current roles of Australian members of CILECT (Victorian College of the Arts in Melbourne, the Australian Film, Television and Radio School in Sydney, and the Griffith Film School in Brisbane) are discussed, as part of a more wide-ranging analysis of the ecology of practice-based film education in Australia. In Nicolas Balaisis's chapter entitled "The School for Every World: Internationalism and Residual Socialism at EICTV," the transnational and ethical commitments of the Cuban CILECT member, Escuela Internacional de Cine y TV, are considered in light of changing historical circumstances (this volume). My own chapter, also in this volume, looks at the one Danish member of CILECT, the National Film School of Denmark, and, more specifically at its efforts, through partnerships with NGOs in the Middle East and North Africa and institution building in Jordan and Lebanon, to make transnational networking an integral part of the school's documentary programs.

References to the work of Yúdice, MacKenzie, Meir, and de la Garza help to evoke what is at stake in expanding the context of discussion beyond the institutional models figuring centrally in the CILECT network. It is not just a matter of trying to be comprehensive by bringing a fuller spectrum of *models* of film education into play, but of trying to ensure that models that are clearly fueled by values having to do with inclusion, fairness, sustainability, and authentic expression are given the attention they deserve. Inasmuch as many of these models are prompted by a clear sense of social, creative, or political needs, they may rely on what Renata Šukaitytė (vol. 1), referring to the specific context of Lithuania within the Baltic region and as a former Republic of the Soviet Union, calls tactical reasoning. One of the defining features of the relevant type of rationality is the awareness of challenges, and of the need for constant adjustment and flexibility, and this in connection with terrain that is anything but stable or secure. Making references to a host of serious social problems in Nigeria, Osakue Omoera makes the case for investing in film training programs, as a means of creating alternative paths for youths otherwise easily absorbed into lives of crime (this volume). Charlie Cauchi (vol. 1) takes up issues arising from the absence of a well-developed system of practice-based film education in Malta, and in the course of her discussion the significance of various forms of self-teaching and of amateur societies becomes clear. Yoshi Tezuka's chapter (vol. 1) looks closely at the role that informal communities of filmmakers in Japan have played in developing

filmmakers' skills, and thus in keeping Japanese filmmaking alive, following the collapse of the studio system in the 1970s. Moinak Biswas (vol. 1) discusses the Media Lab that was established at Jadavpur University in Calcutta, as part of a Digital Humanities initiative that aimed to make space for critical and alternative forms of image production in a landscape almost entirely dominated by industry norms and industrial conceptions of skill. Interestingly, the broader historical perspective that Biswas provides is one that links current developments at the Media Lab to the type of education that Satyajit Ray received in India in the pre-film-school days of the 1940s.

In addition to the issue of geography or location (and what these mean within the larger scheme of things), and that of models, there are *systemic dynamics* to consider. Goldsmith and O'Regan's chapter (vol. 1) is helpful in drawing attention to the benefits of situating the different models of practice-based film education existing within a given national context in relation to each other. The premise, clearly, is that while it is important to achieve clarity about the various types on offer—about their modes of operation, for example—it is equally important to grasp their respective roles within a larger *system*. Is the dynamic governing interaction among the different models one that agents contributing to their operation find productive or are there tensions or outright conflicts within the system, some of them the product of competing values? This is the sort of question that is clearly well worth asking, and not only in the context of Australia.

If we return to Gaston Kaboré, for example, we may note that there are two main sources of film training in Burkina Faso, both of them with a regional role to play in sub-Saharan, francophone Africa: IMAGINE and ISIS (Institut Supérieur de l'Image et du Son). There is a clear division of labor between these two schools, with IMAGINE providing short courses within the context of an alternative and often somewhat precarious set up that contrasts with the model of a well-developed stand-alone school with a full range of programs, all of them accredited and funded. ISIS, which is funded by the European Union, Africalia, and Stockholms Dramatiska Högskola (Stockholm Academy of Dramatic Arts), is the one Burkinabé member of CILECT. IMAGINE has been dependent on short-term sources of funding, but also on Kaboré's own film earnings and support provided by his wife Edith Ouedraogo, who is a pharmacist. Sources of external funding include the "Danfaso Culture and Development Programme for Burkina Faso" and a grant from the Center for Kultur og Udvikling / CKU (Danish Center for Culture and Development / DCCD).[16] The international networks into which ISIS and IMAGINE tap, as instantiations of two quite different models of practice-based film education, are to some extent shared, with Madeleine Bergh from Stockholm Academy of Dramatic Arts participating in collaborative initiatives with ISIS during FESPACO 2011, and also eager to be involved in the seminar that Rod Stoneman, Kaboré, and Hjort mounted at IMAGINE, entitled "L'Enseignment et la formation professionnelle au cinéma en Afrique" ("Film Training and Education in Africa: Challenges and Opportunities"). Motandi Ouoba, who has played a central role at IMAGINE, also offered film training courses at ISIS, before going on to mount an independent training initiative focused on children. Teaching at ISIS provided a source of income for Ouoba, but

also made him an important human link between two quite different sites, and indeed models, of training, both of which contribute to crucial capacity building in West Africa. Rod Stoneman has played a significant role in the context of African filmmaking, initially as a commissioning editor for Channel 4 and, over the last ten years or so, through his involvement in workshops at IMAGINE. Drawing on his own experiences with capacity building through short courses at IMAGINE, and also in the Maghreb, Vietnam, and the Middle East, Stoneman's chapter (this volume) provides insight into the workings of a model of film training that has strong elements of the transnational and the peripatetic.

Alia Arasoughly's chapter (this volume), focusing on Palestinian Shashat (which she founded), but also on the features of various university-based programs in Palestine that partly provide the rationale for this NGO's existence, helps to drive home the point that if the full significance of a given practice-based institution, university program, or NGO-driven framework is to be grasped, it must to some extent be understood in relation to the larger system in which it operates. Arasoughly's account of Shashat's pioneering work in Palestine strongly suggests that the success of practice-based film education often depends on the energies and vision of a practitioner whose milieu-building efforts are decisive. It also shows that while peripatetic training initiatives may be valuable in many respects, they can hardly be seen as problem-free.

Entitled "Film Schools in the PRC: Professionalization and its Discontents," Yomi Braester's chapter (vol. 1) is finely attuned to the dynamics between different kinds of practice-based film education in the People's Republic of China (PRC). Braester provides a contrastive explication of the models underwriting the conservatoire-style Beijing Film Academy (BFA) on the one hand, and Wu Wenguang's Caochangdi Station and the Li Xianting Film School, both "unaccredited institutions [that] have repeatedly incurred the authorities' disapproval," on the other. Braester's point, which can be adapted and extended to the larger collective project to which his chapter contributes, is this: "The juxtaposition of these extremes is not intended to condemn one or to show the weaknesses of the other, but rather to foreground the unique set of constraints within which each operates."

Entitled "'We Train *Auteurs*': Education, De-centralization, Regional Funding and Niche Marketing in the New Swedish Cinema," Anna Stenport's analysis (vol. 1) of recent developments in the greater Gothenburg region of western Gotland in Sweden draws attention to the question of how a well-functioning system of film education, consisting of mutually supporting elements, actually evolves. Clearly the answer given to any question concerning the evolution of an entire ecology of film education will vary from case to case, just as it seems unlikely that any one set of causes and causal relations could be identified as the preferred and somehow normative one. The Swedish example discussed by Stenport is especially interesting, however, because of the apparently emergentist nature of its processes, with agents coordinating and calibrating their activities without reference to any overarching blueprint or set of directives. Duncan Petrie's account (vol. 1) of initiatives taken toward the establishment of a Scottish film school, and of the collaboration between Napier University and Edinburgh College of Art, which

has yielded a well-functioning Scottish Screen Academy, sheds further light on the conditions and actions through which a larger system of film education evolves. Entitled "Sites of Initiation: Film Training Programs at Film Festivals," Marijke de Valck's chapter (vol. 1) adds another dimension to the discussion of the causal factors driving change and innovation within a larger system. With access to various interlinked film industries becoming ever more competitive, film festivals, de Valck argues, have emerged as sites where networking and training combine in ways that are critical to the success of aspiring filmmakers, including those who have graduated from well-established film schools.

The ecology of practice-based film education may be balanced or imbalanced, finely differentiated, or dominated by a single model, among other possibilities. In some cases the idea of a system of film training consisting of well-differentiated and mutually supportive constitutive elements is mostly an aspirational one. Indeed, there are contexts where the lacks are so substantial that the nation or subnational entity in question becomes dependent, among other things, on the efforts of mutually supportive amateurs, on the transnational reach of robustly developed institutions situated elsewhere, and on the sorts of boundary-crossing partnerships and solidarities that make collaborative projects possible, and through them, some kind of development of a milieu.

Small Nations and Transnational Affinities

The design of *The Education of the Filmmaker in Europe, Australia, and Asia* and *The Education of the Filmmaker in Africa, the Middle East, and the Americas* is necessarily a reflection of the editor's interests and even research trajectory. As a film scholar, my research has been intensely focused on small nations, especially Denmark. The study of small nations, including debates about what counts as a small nation, is an entire field of its own. Suffice it to say that there are several measures of small nationhood, including, as Miroslav Hroch has argued convincingly, rule by non-conationals over a significant period of time.[17] Other measures include a country's GDP, its population size, the reach of its national tongue, and so on.[18]

The aim in earlier projects has been to understand the specificity of the challenges that small nations face in their pursuit of filmmaking, and to identify the conditions that have allowed some small-nation contexts, most notably the Danish one, to thrive in a range of different ways. Motivating these pursuits was a desire to see whether partnerships built on affinities derived from small nationhood might help to trouble a world order that often placed large nations at the center of things, and small nations on the peripheries or margins. This same desire is evident in both of the "Education of the Filmmaker" volumes. In *The Education of the Filmmaker in Europe, Australia, and Asia*, for example, Europe is evoked through the lenses that realities in Lithuania, Scotland, Sweden, Malta, Germany, and the European Union provide. And in the case of Germany, the only national or subnational context that does not match crucial criteria associated with small nationhood, much of the discussion concerns key institutions

in the former German Democratic Republic, which clearly did (having involved rule by non-conationals over a significant period of time). The discussion of China in the first of the two volumes brings official and alternative practices in the People's Republic of China into clear focus (Yomi Braester, vol. 1), and thereby the efficacy of various "minor" practices, to use Gilles Deleuze and Félix Guattari's term. The complexity of practice-based film education in a Chinese context is further explored in a second chapter devoted to China in the post-Handover era. Evoking the contributions of Hong Kong Television Broadcasts Limited (HKTVB) up until the late 1980s, and the lacuna that its retreat from the field of training created, Stephen Chan (vol. 1) discusses the promise of such recent initiatives as the Hong Kong International Film Festival Society's Jockey Club Cine Academy. As a player in a "One Country, Two Systems" arrangement, and as a former British colony, Hong Kong, quite clearly, counts as a small nation following some of the most crucial measures of size.

Interest in practice-based film education is, quite simply, an inevitability given the concerns relating to small nations evoked above, as even the most cursory reference to various texts makes clear. The access to filmmakers that film scholars enjoy in small-nation contexts made possible the production, over a period of 15 years, of three interview books with directors: *The Danish Directors: Dialogues on a Contemporary National Cinema* (with Ib Bondebjerg); *The Danish Directors 2: Dialogues on the New Danish Fiction Cinema* (with Eva Jørholt and Eva Novrup Redvall); and *The Danish Directors 3: Dialogues on the New Danish Documentary Cinema* (with Bondebjerg and Redvall).[19] Together these books comprise 55 film directors' responses to research-oriented questions, including ones having to do with the sites of education and training through which the relevant practitioners entered the world of professional filmmaking. Whereas *The Danish Directors*, featuring dialogues with mostly an older generation of filmmakers, underscores the significance of "learning by doing," of mentoring within various production companies, and of training afforded by such "foreign" institutions as FAMU, *The Danish Directors 2* and *The Danish Directors 3* draw attention to the nature of the training offered at the National Film School of Denmark, an institution that must be central to any attempt to explain the various forms of success that Danish cinema has enjoyed for about two decades. Yet, what also emerges from these conversations is the significance of the Video Workshop in Haderslev, the Film Workshop in Copenhagen, the European Film College in Ebeltoft, and the Copenhagen Film and Photo School Rampen—in short, the workings of a rich and diversified landscape of practice-based film education. A section entitled "Learning to become a filmmaker in Denmark: The National Film School of Denmark, Super 16 and the Film Workshop in Copenhagen," in *The Danish Directors 2*, provides a summary account of this landscape, as does the chapter "Denmark," in *The Cinema of Small Nations* (co-edited with Duncan Petrie).[20] In "Denmark" the National Film School of Denmark's emphasis on teamwork, interdisciplinarity, and creativity under constraint are seen as having worked in synergy with effective cultural policy and exceptional artistic leadership in one of the milieus of actual film production to produce unusual conditions of viability for the cinema of a small Nordic nation.

The idea of small nations coming together in solidarity based on affinities having to do with shared culture, values, problems, or aspirations, was explored through analysis of the so-called Advance Party Project. A rule-governed project, which built on the efficacies of the Dogma 95 initiative, Advance Party was initially a three-film effort involving a partnership between filmmaker Lars von Trier and his Copenhagen-based Zentropa Film Town on the one hand, and Gillian Berrie and her production company Sigma Films, based in Govan Town Hall, Glasgow on the other. The point of the rules, and, indeed of the partnership, as expressly stated by Berrie in an interview, was to deliver capacity building and mentoring that was seen as sorely lacking on the Scottish scene. "Affinitive and Milieu-Building Transnationalism: The Advance Party Project" explores the implications of an initiative that was designed to link novices to established filmmakers, for mentorship purposes.[21] Attention, more specifically, is called to the role that innovative film projects have to play, as a vehicle for the articulation of policy-related ideas, in contexts where institutional development pertaining to film training falls short of the aspirations of practitioners.

In 2009, Duncan Petrie hosted "The University of York Film Schools Seminar," which became an opportunity to continue collaboration initiated through *The Cinema of Small Nations*. The seminar included three sessions, one focusing on the historical significance of film schools, a second on film schools today (and especially the international dimension of film education), and a third on education and training. As one of the three partners in this event, Hjort chaired the third session and contributed a paper entitled "Official and Unofficial Film Schools" to the second session. This paper explored the differences and relation between the well-established National Film School of Denmark and the alternative film school Super 16 that was created by a number of applicants who had sought, but failed to gain admission to the official, national school. The point was to expand the discussion beyond a certain institutional model, and to draw attention to what can be achieved in the area of practice-based film education through what I call "gift culture," the gifts—in the case of Super 16—being a matter, among other things, of professionals teaching more or less for free and facilities being lent to the unofficial (but not unstructured) school by the production company Nordisk.

Designed by Petrie and Rod Stoneman, the program for the Film Schools Seminar brought key figures such as Ben Gibson (director of the London Film School) and Igor Korsic (CILECT) into the conversation about film schools, as efforts were made to identify the crucial areas for research.[22] The Film Schools Seminar led to Hjort joining Stoneman at Gaston Kaboré's alternative film school, IMAGINE, in February 2011. Stoneman was conducting a ten-day, practice-based workshop for students at IMAGINE (some of them from Burkina Faso, others from other West African countries). The workshop produced three "Newsreels" focusing on FESPACO, all of which were shown on TV in Burkina Faso and in the cinemas ahead of the FESPACO features. Serving as the team's translator and subtitler, Hjort worked alongside the student editors in the IMAGINE film studio. Stoneman, Kaboré, and Hjort also organized the seminar referred to above, "Film Training and Education in Africa: Challenges

and Opportunities," with speakers including Dorothee Wenner (director of the Berlinale Talent Campus), Golda Sellam (Cinélink), Daphne Ouoba (Cinomade), Motandi Ouoba (IMAGINE), Don Boyd (filmmaker, producer, and governor of the London Film School), and June Givanni (programmer and jury coordinator, Africa International Film Festival), among others.

What has emerged through these various interactions, friendships, and collaborations is a loosely connected series of research projects that will work together, we hope, to develop practice-based film education as a vital and innovative field of research. Petrie's interest in the history of conservatoire-style film schools has yielded key articles, namely: "Theory, Practice and the Significance of Film Schools," "Theory/Practice and the British Film Conservatoire," and "Creative Industries and Skills: Film Education and Training in the Era of New Labour."[23] Petrie and Stoneman are co-authoring a book on the past, present, and future of film schools; Petrie and Stoneman have both contributed chapters to the "Education of the Filmmaker Project" (EOFP); and in 2013, Hjort once again joined Stoneman at IMAGINE, this time for a workshop focusing on film and human rights, organized in tandem with the short-film training program that supports students in their production of Newsreels documenting Africa's largest and most important festival, FESPACO. Projects that take the issue of film education into other networks are designed to provide further density to the research. An example of such a project is *The Blackwell's Companion to Nordic Cinema*, edited by Hjort and Ursula Lindqvist, which includes a section on film education to which the following Nordic scholars are contributing: Heidi Philipsen (University of Southern Denmark), Astrid Söderberg Widding (Stockholm University), Mats Jönsson (Lund University), and Hjort.

The Larger Context: Different Kinds of Writing on Practice-Based Film Education

Linked to the Society of Film Teachers and later the Society for Education in Film & Television, the influential journal *Screen* has been an important space for discussions of film education, especially within schools. The same can be said of the journal *Screen Education*, which was also established in the 1960s. The work published in these two journals provides an historical context for the kind of research that is being pursued through the EOFP. For the most part, however, writing on practice-oriented film education and its institutions has been very limited. Also, the most salient work on the topic can be characterized as narrow in focus. The tendency has been: (1) to focus on the West, especially the US and the UK; (2) to write in a popular, non-research-oriented vein; (3) to focus on well-established film schools and university-based programs where industry needs are served; (4) to neglect the diversity of models of practice-oriented film education; (5) to fail to articulate the core values that are constitutive of various models of practice-oriented film education; (6) to overlook the diverse purposes that practice-oriented film education can serve; (7) to neglect the collaborative educational initiatives that various globalizing processes have

made possible; (8) to focus on practice-oriented film education aimed at relatively mature individuals who aspire to become professional filmmakers; (9) to neglect practice-oriented film education aimed at children and young people; (10) to neglect community-oriented film training initiatives; (11) to neglect practice-oriented film education that aims to provide solutions to specific social and political problems; and (12) to ignore the interest of fostering a transferability of models with significant social contributions to make.

Film School Confidential: Get In. Make It Out Alive by Tom Edgar and Karin Kelly is a good example of popular writing on film schools.[24] Focusing on 29 film schools, this book provides a descriptive account of the curricula and costs associated with specific film training programs in the United States as well as advice to the aspiring filmmaker on how to select a film school, gain admission to it, and make the transition from film school to the filmmaking industry. A more scholarly relevant category of writing on practice-based film education and its institutions draws heavily on two genres: the practitioner's interview and the memoir. The most research-relevant, book-length publications on film schools belong in this category. *Projections 12: Film-makers on Film Schools*, edited by John Boorman, Fraser MacDonald, and Walter Donahue, provides a series of interviews with staff members and former students from such schools as the National Film and Television School in London, the London Film School and film programs at NYU, Columbia, USC, and UCLA.[25] Ni Zhen's *Memoirs from the Beijing Film Academy: The Genesis of China's Fifth Generation* is a moving instance of life writing that clearly suggests the extent to which the visual and narrative tendencies that scholars and critics discern on the world's screens are traceable, in many instances, to the institutional culture and priorities of specific sites of practice-oriented film education.[26] The existence of such research-relevant books as *Projections 12* and *Memoirs from the Beijing Film Academy* suggests just how significant a role the institutions of film education play, yet these works cannot fill what is a clear lacuna in the scholarly landscape of film.

With the growing interest in "practitioner's agency," film scholars have begun to see the value of studying practice-oriented film education in a systematic way. Some of the most promising scholarly work on practice-oriented film education, not surprisingly, is being produced by scholars who are located within the kinds of small-nation contexts that facilitate empirical, case-based research that is informed by ongoing exchanges over a significant period of time with policy makers, institution builders, and a whole range of film practitioners, including those who dedicate themselves to the training of others. Working independently of each other, and making good use of the scholarly access to film practitioners that small-nation contexts provide, scholars such as Eva Novrup Redvall, Heidi Philipsen, and Chris Mathieu have published pioneering work that convincingly shows that the priorities and philosophies of institutions devoted to practice-oriented film education have a decisive impact on filmmakers' creative outlook, working practices, and networks, shaping not only the stylistic (visual and narrative) regularities that define distinctive bodies of cinematic work, but also the dynamics of a given film industry. Redvall's "Teaching Screenwriting to the Storytelling Blind—The Meeting of the Auteur and the Screenwriting Tradition

at The National Film School of Denmark,"[27] clearly demonstrates that at the institution under discussion, auteurist traditions have been consciously replaced in recent times with a model of collaborative authorship, to positive effect. Heidi Philipsen's dissertation entitled "Dansk films nye bølge" ("Danish Film's New Wave"), shows that Denmark owes much of its success with film over the past two decades to the values, methods, and principles that figures such as Jørgen Leth, Mogens Rukov, and Henning Camre brought to the National Film School of Denmark, and made an integral part of its institutional culture.[28]

The Institutional Turn in Film Studies

Research on practice-based film education is necessarily oriented toward institutional culture and processes of institutionalization, since the film schools and universities, where much of what counts as film training takes place, are, quite simply, institutions. Yet, it is imperative that research energies also be channeled toward goals, values, practices, and arrangements that are not necessarily well served by the *standard* forms of what I want to call "robust institutionalization." Practice-based film education, it is clear, admits of many models, some of them having a far stronger tendency toward institutional visibility, stability, and persistence than others. Thus, for example, Moinak Biswas (vol. 1) is interested in understanding "humanist [practice-based film] education in its indeterminate relationship with institutions," just as Renata Šukaitytė (vol. 1) evokes the remarkable achievements of "anti-institutionalist" activists such as Lithuanian filmmakers Jonas Mekas and Šarūnas Bartas. At the same time, it is important to recognize that institutions and institution building are phenomena that can themselves be rethought in innovative and creative ways. In some cases, the very process of articulating an alternative model of practice-based film education provides rich opportunities to rethink the ways and means of institution building, and its more standard manifestations. Philosopher Cornelius Castoriadis's ground-breaking work on social imaginaries, creativity, and the work of instituting and world making can be usefully evoked here. As he puts it in *The Imaginary Institution of Society*, "What is essential to creation is not 'discovery' but constituting the new: art does not discover, it constitutes; and the relation between what it constitutes and the 'real,' an exceedingly complex relation to be sure, is not a relation of verification. And on the social plane, which is our main interest here, the emergence of new institutions and of new ways of living is not a 'discovery' either but an active constitution."[29]

It is, I believe, uncontroversial to assert that in-depth, sustained analysis of the practice-oriented educational initiatives that are upstream of actual film production and constitutive of film's institutional dimensions has much to contribute to what might be called the "institutional turn" being encouraged by developments in film studies. On the one hand, there is growing interest in practitioner's agency, understood not in terms of abstract philosophical reflections on the nature of authorship, but in terms of *actual* agents' reasoning about their practices in relation to preferred self-understandings, artistic norms, and the

constraints and opportunities that specific institutions and policies bring to the world in which these practitioners live their personal and professional lives as filmmakers. On the other hand, film scholars have long understood that film policy is an area warranting careful attention if film's institutional underpinnings are to be properly understood. Important work on relevant issues has been done, *Cultural Policy*, co-authored by Toby Miller and George Yúdice, being a case in point.[30] More recently, remarkable efforts by researchers with an understanding of the need for team- and network-based research in film studies have helped to bring the roles and workings of film festivals into sharp relief. I am thinking here of Dina Iordanova and her "Dynamics of World Cinema" team, and of Marijke de Valck and the Film Festival Research Network (FFRN) that she and Skadi Loist established together.[31] Among other things, the findings that emerge from such work depict the institutions and the processes of change where much of the creative work of instituting occurs. Practice-oriented film education deserves the same kind of rigorous scholarly attention that phenomena such as film policy and film festivals have received. Establishing practice-oriented film education as a legitimate and worthwhile area of inquiry is no doubt a task that can be achieved on older models of research that have long dominated the arts and humanities: stand-alone articles and monographs written by scholars working largely on their own. The second task, which has to do with achieving the kind of density of findings that would count as significant progress in the research area in question, will, however, require a commitment to precisely the sorts of principles and practices that are characteristic of the film festival field as a research area: mutually supportive partnerships between researchers and practitioners, team-based research, and loose, yet meaningful synergies among research projects being pursued on a more individual basis.

The Aims of the "Education of the Filmmaker" Project (EOFP)

The EOFP is driven by a number of goals that can only be partly realized through the two volumes published in Kasia Marciniak, Anikó Imre, and Áine O'Healy's Global Cinema series. The hope is that these goals will be further pursued, and indeed, revised as necessary, as new scholars, institution builders, and film practitioners join the conversation about the hows, whys, and wherefores of practice-based film education. Some of the goals informing the design of the EOFP can be described as follows:

1. To establish practice-based film education as a central area of scholarly research;
2. To shed light on the aspiration to establish film schools in contexts where these do not yet exist;
3. To identify the "pre-institutional" modes of practice-based film education that often prepare the ground for full-blown efforts at institution building;

4. To identify the full spectrum of types of practice-based film education and their specificities, including constitutive values, recurring challenges, and characteristic contributions;
5. To chart the impact of historical forces and political change on well-established film schools;
6. To analyze the impact of different kinds of globalization on practice-based film education, as well as the challenges and advantages arising from transnational and network-based initiatives;
7. To examine the motivations for, and significance of, practice-based film education aimed at children and young people;
8. To clarify the implications of new technologies for practice-based film education;
9. To explore the role that practice-based film education plays in the building of sustainable communities;
10. To assess the use of practice-based film education in contexts focused on health, well-being, and social inclusion;
11. To profile practice-based initiatives that have proven themselves to be especially valuable and, through this, to facilitate various forms of knowledge transfer;
12. To draw attention to the agents—the people—who have developed such valuable initiatives;
13. Through all this, to constitute networks and bodies of knowledge that can be mobilized in conversation with policy makers and government representatives, among others.

As books, *The Education of the Filmmaker in Europe, Australia, and Asia* and *The Education of the Filmmaker in Africa, the Middle East, and the Americas* have a somewhat unusual history, for whereas conferences often lead to publications, in this case a team-based book project involving an advance contract for a single edited volume became the impetus for a conference and then grew into a two-volume project. Prompting the organization of "The Education of the Filmmaker—Views from around the World" conference was the creation of a new research center—The Centre for Cinema Studies (CCS)—at Lingnan University in Hong Kong. The contributions presented at this conference, which was held at Lingnan in the spring of 2012, were seen as breaking new ground in genuinely substantial ways, and thus as meriting the kind of scope for development that only the addition of a second edited volume would provide. That the series editors and acquisitions editors at Palgrave Macmillan agreed to a request along these lines is a reason for considerable gratitude, as is the decision (made by Lingnan's senior management team, especially President Yuk-Shee Chan and Vice President Jesús Seade) to make Cinema Studies a priority area for the University. The latter decision is an unlikely but welcome one in today's academic world, inasmuch as it is never "resource-neutral." Resources—in the form of conference funding, a full-time senior research assistant, and precious space dedicated to the CCS—have helped to bring unexpected momentum to the EOFP. Intense interaction among the contributors to the two volumes, with members of the CCS's advisory board,

and with scholars and practitioners from the wider Hong Kong community, did much to clarify the central issues and effectively transformed a series of coordinated, but ultimately individually pursued parallel projects, into a genuine team effort. That the EOFP was enthusiastically adopted, not only by Lingnan's president and vice president, but by all members of the CCS, says a lot about the synergies between the project's goals and the aims of the Centre, which are: "To create a dynamic research environment for emerging and established researchers; to contribute to policy-related discussions in Hong Kong; to stimulate public interest in film culture; and through various forms of community engagement, to support filmmakers' efforts to develop independent filmmaking in Hong Kong and on the Chinese mainland."[32]

Interest in film education, it must be acknowledged, is not new at Lingnan, for in May 2010, noted poet and film scholar Ping-kwan Leung partnered with Shu Kei, a filmmaker and dean at the Academy for Performing Arts in Hong Kong (APA), to organize a two-day workshop entitled "Film in Education." Held at both Lingnan University and at the APA's "Bethanie Landmark Heritage Campus," and with the participation of filmmakers such as Ann Hui and Johnny To, the workshop was designed to explore how synergies could be created between the academic and theoretical study of film on the one hand, and practice-based approaches to film on the other. The focus for the workshop was film education in Asia, especially in China. Among other things, my own contribution to the workshop was an attempt to test the relevance, as perceived by scholars and practitioners based in Hong Kong and China, of an envisaged research proposal focusing on practice-based film education (which has since been developed and funded by the Hong Kong government's Research Grants Committee). Entitled "Practice-oriented Film Education and its Institutions: Values, Methods, Transferable Models," this research project is funded for a three-year period and aims, among other things, to shed light on the Nordic countries' growing involvement in training partnerships in West Africa, East Africa, the Middle East, and China.

The EOFP Team

Readers of *The Education of the Filmmaker in Europe, Australia, and Asia* and *The Education of the Filmmaker in Africa, the Middle East, and the Americas* will find chapters written by emerging and established scholars, by authors working in their mother tongue, and by authors for whom English is but one of several languages spoken. An important feature of the volumes is that many of the contributions come from practitioner-scholars, that is, from people who have been actively involved in making films, in delivering practice-based film education, and in helping to develop the milieus in which all this happens. Key figures in this regard are Yoshiharu Tezuka, Moinak Biswas, Ben Goldsmith, Rod Stoneman, Keyan Tomaselli, Anton Basson, Gerda Dullaart, Hamid Naficy, and, finally, Alia Arasoughly who, working against all odds, has managed to carve out a vital, enabling space for practice-based film training in Palestine through Shashat.

While some of the film scholars in the two contents tables cannot claim to be makers of films, all are committed to ensuring that their research on practice-based film education is informed by the self-understandings of relevant practitioners, through practitioner interviews and practices of participant observation where possible. Several of the scholars in question have collaborated with filmmakers or spent time at film schools, or in various training contexts, in connection with their research. The research that has been carried out for the project can legitimately be seen as having a strong empirical dimension, with concepts being introduced on an "as-needed" basis and in constant conversation with specific examples and concrete cases. All of the contributors write as authors with something genuinely at stake in the cases on which they have chosen to focus. In this sense, *The Education of the Filmmaker in Europe, Australia, and Asia* and *The Education of the Filmmaker in Africa, the Middle East, and the Americas* combine elements of advocacy, critique, celebration, and problem solving. As we discussed the issues together in Hong Kong, we found this to be a fruitful mix, capable of encouraging new alliances and of suggesting new lines of research engagement. The hope is that the conversation will continue, and that new voices, some of them belonging to readers of these two books of ours, will become part of it.

Notes

1. Simone de Beauvoir's famous phrase is "One is not born a woman, but becomes one." See *The Second Sex*, trans. Constance Borde and Sheila Malovany-Chevalier (New York: Vintage Books, 2011).
2. *The Danish Directors 2: Dialogues on the New Danish Fiction Cinema*, ed. Mette Hjort, Eva Jørholt, and Eva Novrup Redvall (Bristol: Intellect Press, 2010), 231.
3. *The Danish Directors 3: Dialogues on the New Danish Documentary Cinema*, ed. Mette Hjort, Ib Bondebjerg, and Eva Novrup Redvall (Bristol: Intellect Press, 2013).
4. Mathew Scott, "The View Finder," *South China Morning Post*, November 4, 2012, The Review section.
5. See Richard Maxwell and Toby Miller, "Film and the Environment: Risk Off-screen," in *Film and Risk*, ed. Mette Hjort (Detroit: Wayne State University Press, 2012), 272. See also, Mette Hjort, "The Film Phenomenon and How Risk Pervades It," in *Film and Risk*, ed. Mette Hjort (Detroit: Wayne State University Press, 2012), 20–22.
6. Maxwell and Miller, "Film and the Environment," 272.
7. IMAGINE FESPACO Newsreel 3 (2011), http://www.youtube.com/watch?v =CUwUlJIdtqM (accessed November 5, 2012).
8. "African Cinema is Not a Cinema of Folklore," in conversation with Siradiou Diallo, in *Ousmane Sembene: Interviews*, ed. Annette Busch and Max Annas (Jackson, MS: University of Mississippi Press, 2008), 58.
9. *The Danish Directors 3.*
10. http://cilect.org/posts/view/114 (accessed November 7, 2012).
11. http://cilect.org/ (accessed November 7, 2012).
12. http://www.auckland.ac.nz/uoa/home/about/perspectives/videos-and-perfor mances/CILECT (accessed November 7, 2012).
13. I develop the concept of "practitioner's agency" in *Lone Scherfig's "Italian for Beginners"* (Washington, Seattle, and Copenhagen: University of Washington Press &

Museum Tusculanum, 2010) and in *The Danish Directors 2*. Research based on investigations of "practitioner's agency" has been encouraged through the Nordic Film Classics series, for which I am founding co-editor, with Peter Schepelern. As I see it, being committed to understanding practitioner's agency involves giving explanatory priority to the self-understandings and subjective rationality of those who are, in some capacity, involved in the filmmaking process

14. Mette Hjort, "Danish Cinema and the Politics of Recognition," in *Post-Theory*, ed. Noël Carroll and David Bordwell (Madison: University of Wisconsin Press, 1996).

15. Staff of The Academy of Television Arts and Sciences Foundation and the Staff of The Princeton Review, *Television, Film, and Digital Media Programs: 556 Outstanding Programs at Top Colleges and Universities across the Nation* (New York: Random House, 2007).

16. Danish Center for Culture and Development (DCCD), "Danfaso Culture and Development Programme for Burkina Faso, 2011–2013," http://www.cku.dk /wp-content/uploads/DANFASO-Culture-and-Development-Programme-for-Burkina-Faso.pdf (accessed November 8, 2012).

17. Miroslav Hroch, *The Social Preconditions of National Revival in Europe: A Comparative Analysis of the Social Composition of Patriotic Groups among the Smaller European Nations* (Cambridge: Cambridge University Press, 1985); see also Mark Bray and Steve Packer, *Education in Small States: Concepts, Challenges, and Strategies* (Oxford, England, and New York: Pergamon Press, 1993).

18. See Mette Hjort, *Small Nation, Global Cinema* (Minneapolis: University of Minnesota Press, 2005), and Mette Hjort and Duncan Petrie, "Introduction," in *The Cinema of Small Nations*, ed. Mette Hjort and Duncan Petrie (Indianapolis and Edinburgh: University of Indiana Press and Edinburgh University Press, 2007).

19. *The Danish Directors: Dialogues on a Contemporary National Cinema*, ed. Mette Hjort and Ib Bondebjerg (Bristol: Intellect Press, 2001); *The Danish Directors 2*; *The Danish Directors 3*.

20. Mette Hjort, Eva Jørholt, and Eva Novrup Redvall, "Learning to become a filmmaker in Denmark: The National Film School of Denmark, Super 16 and the Film Workshop in Copenhagen," in *The Danish Directors 2*: 22–26; Mette Hjort, "Denmark," in *The Cinema of Small Nations*.

21. Mette Hjort, "Affinitive and Milieu-Building Transnationalism: The Advance Party Project," in *Cinema at the Periphery*, ed. Dina Iordanova, David Martin-Jones, and Belén Vidal (Detroit: Wayne State University Press, 2010). See also, Mette Hjort, "On the Plurality of Cinematic Transnationalism," in *World Cinemas, Transnational Perspectives*, ed. Nataša Durovicová and Kathleen Newman (London and New York: Routledge, 2010).

22. See Duncan Petrie's "Film Schools Symposium Report for TFTV Research Committee" (2009), www.york.ac.uk/.../FILM%20SCHOOL%20SYM...(accessed November 5, 2012).

23. Duncan Petrie, "Theory, Practice and the Significance of Film Schools," *Scandia* 76 (2010); "Theory/Practice and the British Film Conservatoire," *Journal of Media Practice* 12 (2011); "Creative Industries and Skills: Film Education and Training in the Era of New Labour," *Journal of British Cinema and Television* 9 (2012).

24. Tom Edgar and Karin Kelly, *Film School Confidential: Get In. Make It Out Alive* (New York: Perigee, 1997).

25. *Projections 12: Film-makers on Film Schools*, ed. John Boorman, Fraser MacDonald, and Walter Donahue (London: Faber & Faber, 2002).

26. Ni Zhen, *Memoirs from the Beijing Film Academy: The Genesis of China's Fifth Generation* (Durham: Duke University Press, 2001).

27. Eva Novrup Redvall, "Teaching screenwriting to the storytelling blind – The meeting of the auteur and the screenwriting tradition at The National Film School of Denmark," *Journal of Screenwriting* 1 (2010).

28. Heidi Philipsen, "Dansk films nye bølge" ("Danish Film's New Wave") (PhD diss., University of Southern Denmark, 2005).

29. Cornelius Castoriadis, *The Imaginary Institution of Society* (Cambridge: Polity Press, 1987), cited by Meaghan Morris and Mette Hjort in "Introduction: Instituting Cultural Studies," in *Creativity and Academic Activism: Instituting Cultural Studies*, ed. Meaghan Morris and Mette Hjort (Hong Kong and Durham: Hong Kong University Press and Duke University Press, 2012).

30. Toby Miller and George Yúdice, *Cultural Policy* (London: Sage Publication Ltd., 2002).

31. For Dina Iordanova and the Dynamics of World Cinema project, see http://www.st-andrews.ac.uk/worldcinema/; for Marijke de Valck and The Film Festival Research Network, see http://www.filmfestivalresearch.org/.

32. Centre for Cinema Studies at Lingnan University, http://www.ln.edu.hk/ccs/ (accessed June 9, 2012).

Part I

Africa

1

Audience Response in Film Education

Anton Basson, Keyan Tomaselli, and Gerda Dullaart

In this chapter we discuss a contemporary private initiative, so as to illustrate industry-oriented and audience-oriented film education. The South African School of Motion Picture Medium and Live Performance, trading as AFDA, was established in 1994, the first year of democracy in South Africa. We focus on how AFDA places entertainment value at the center of its curriculum, and how this value is theorized, applied, and achieved, within the context of South Africa's film industry and history.

The film industry in South Africa offers little secure salaried employment.[1] Skilled filmmakers provide a service industry for international movies and commercials shot on South African soil. They also work in the production of South African feature films, TV, music videos, and commercials. Graduates thus enter a seasonal and freelance industry where entrepreneurship and responsiveness to change are coping strategies for a nation and industry in transition. Therefore this chapter also looks at AFDA values and at how attitudinal and networking skills are taught alongside creative and craft skills to enable graduates to navigate the changing industry and the transition from film school to work. As globalizing processes have made collaboration possible, the chapter touches on relevant curricular responses.

Film Education: Early History

Although film technology came to South Africa as early as 1895 and feature films were produced in the 1910s, film and TV education was a latecomer to South Africa, just as TV broadcast was introduced only in 1974 and importing TV technology was prohibited up to 1972.[2] The delay was due to the apartheid state's ideological suspicion of the medium. Tertiary education institutions responded to TV by introducing film and TV modules, in mostly small-scale ways, from the mid-1970s.

The highly capitalized Pretoria Technikon Film School, established in 1964, was the single exception.[3] This school then operated in a "Whites Only" environment. Its student productions, unlike their counterparts from other universities, were largely apolitical, exploring universal themes and formats.[4] Anti-apartheid English-language liberal and left-wing university courses using super 8, 16mm, and video, tended to promote critical analysis, where other universities adopted commercial models. Most taught classical film theories,[5] cinema literacy,[6] media critique,[7] and film as art in relation to production practices.[8] Political economy studies underpinned sociological approaches.[9]

Some lecturers enunciated critical approaches within the specific production context that was then a new media environment.[10] This environment was characterized by racially restrictive job, exhibition, and capital markets. A number of lecturers drew on radical aesthetics and production practices to equip their mainly white students with approaches enabling a critique of apartheid.[11] Some early discussions on the paucity of appropriate funding models for production courses were published,[12] while one briefly discussed the interrelation between technical expertise and film theory.[13]

The end of apartheid and the dawn of a tentative democracy offered freedom and opportunities not previously possible. One of the flaws in apartheid had been the lack of a viable internal market, as blacks were largely excluded through class repression. In feature film production, the lack of a viable white cinema-going audience had been compensated for by state subsidies for qualifying films.[14] The late introduction of TV had stunted employment opportunities for graduates though the feature film industry had performed relatively well up to the late 1980s.[15] However, during the last 16 years of apartheid, TV directors and scriptwriters had forged significant aesthetic and critical contributions on the growing number of free-to-air TV channels developed by the state-controlled SA Broadcasting Corporation (SABC). While directors usually took audiences into account, their agendas were more likely ideological—opposing, supporting, ignoring, or critiquing apartheid.

The defeat of apartheid brought a number of new factors into play with regard to TV production. First was artistic freedom, which had previously been muted in film (stage drama was always an exception), though the critical films of Ross Devenish and Athol Fugard, and the early corpus of Jans Rautenbach stand out. Second was the revitalization of a moribund economy from late 1974 onwards, which opened up new business opportunities linked to South Africa's inclusion in global trade agreements such as GATT (with import duties on electronic goods being lifted). Film industry infrastructure developed in the late 1980s when a slew of high-budget international feature films took advantage of the last gasps of the state subsidy. This trend continued into the 2010s, but was also susceptible to macro-economic fluxes. In 2006, for instance, 80 percent of the commercials made in the Western Cape, had international clients.[16] A service sector, however, does not grow an industry.[17]

Third was the development of a commercially owned station, M-Net, in 1984. Satellite TV was introduced following the launch of the PAS 4 satellite in 1996, which connected South Africans to global networks. This also enabled South

Africa to open up hundreds of satellite channels across Africa via Direct Service TV (DStv). DStv has a number of channels dedicated to African and South African programming.

The opportunities for film, and especially video, in this newly reregulated and rapidly expanding broadcast environment, aided by the invention of cheap but sophisticated cameras and production technology, were seized by the growing production and education sectors. Complementing universities from the 1990s are a number of prominent private schools such as Open Window, CityVarsity, AFDA, Big Fish, and other smaller outfits, each with its own signature. AFDA's signature is unique in its emphasis on collective filmmaking, in which each key crew member is a respected creative, not just a technician charged with executing the vision of the director. According to Martin P. Botha, AFDA executive chairman Garth Holmes stated in 2004 that auteurism had died with the 1960s French new wave.[18] AFDA's strong emphasis on collaborative learning is inspired by the *ubuntu* philosophy expressed in many African languages, for instance the Sesotho *"muntu umuntu babantu"*—I am a person through other persons. Many AFDA shorts, Botha continues,[19] reveal a distinctive "AFDA brand" almost like in the old Hollywood studio system. CityVarsity and the University of Cape Town encourage the nurturing of directorial voices. Community-based film training such as Community Video Education Trust focuses on community video production, always struggling to survive financially.[20] In the following years, the film training landscape became one of constant change, as South African higher education continued its transformation project.

Little else has been published on production courses in the post-apartheid era,[21] though some commentaries on student films and videos are available.[22] These discuss post-apartheid ideological considerations and aesthetic choices made by students who often have a keen sense of technique but who tend to lack an historical film imagination and knowledge, and who often trade on superficial/literal iconography. Botha spotlights new graduates of some newly established film schools.[23] These graduates, he observed, exuded more originality in short films than occurred in an entire decade of filmmaking in the 1970s. Excellent guides like Leon Van Nierop now bring aspects of African and South African cinema to bear on film studies.[24]

As state subsidies or grants do not support filmmakers in South Africa today, AFDA realizes that the success of its graduates is linked to meeting (or exceeding) the expectations of both industry and target audiences. Senior students at AFDA therefore do internships or have professional mentors to ensure their research projects are applicable to the film industry's needs, and participate in master classes with top industry representatives. As the majority of South Africans continue to live in poverty, training for economic viability is paramount for AFDA. A national research and development project is under way regarding competitive advantages of South African cities in the film industry, as well as the feasibility of bringing small container-based cinemas to informal settlements, creating audiences and leisure spaces where currently there are none.[25] Such audience development will increase awareness of making films for entertainment. A successful

South African film producer, David Wicht, highlights the need for training for entertainment:

> [We need] to come up with films that the public will pay good money to see. We need to build up confidence not only with investors, but with the cinema going public as well. Mostly they stay away to avoid the "cringe factor." Foreign buyers just roll their eyes at the memory of the box office death of the worthy but dreary anti-apartheid films that have been made about us (albeit by foreign filmmakers.) We need to grasp the fact that we're in the entertainment business, not sociology, and that film is an expensive medium that cannot serve the whims of a minority audience.[26]

Taking up this task of training and development, AFDA's pedagogy uses a work-integrated approach, fusing a safe learning environment with exposure to audiences and industry, while making it necessary for students to work together and forge long-term partnerships for entrepreneurial efforts in the industry.

Teaching Film Production for the Market:
Work-Integrated Learning

Assessments are done by means of film, video, and multi-camera television productions in a simulated work environment. At exit level, assessment is inter alia done by a paying audience comprising lay members of the public, specifically of the target audience of the graduation film, and not just by academics, critics, and filmmakers. The curriculum embraces the notions of entertainment value and the creation of products for target markets. As AFDA CEO Bata Passchier puts it: "A discipline has no value outside of a production. Discipline standards can only be assessed within the context of a production. Production standards can only be assessed by a target market."[27]

This assessment framework, which aims to make graduates immediately employable or self-employable, incorporates both an academic and an ideological position since AFDA's mission statement includes its aim to contribute to the development of the local film industry and to nation building. In this context, nation building is an uncynical, constructive, diverse, and inclusive process, contributing significantly to sociopolitical and economic healing. Making films for one's self is replaced by AFDA's mission to get to know our new nation, to nurture young filmmakers who continuously construct a nation, as "a strategy to create popular cinema for the people, by the people."[28] Where AFDA offers a commercial and audience-led imperative, Botha argues for diversity of theme, not just "getting buttocks on seats."[29] Self-expression means enabling voices silenced during apartheid: blacks, women, gays, and lesbians. This argument would insist that students be alerted to the need to study films in relation to national aesthetic histories and to the sociopolitical context.[30] At AFDA, the most important voices to enable are those of the subcultures portrayed in the films, and the audiences to whom they are relevant. The values to which AFDA is committed in order to nurture this ethos are humility and openness, relevance, and work ethic.[31]

Work ethic is described as reliability and self-discipline, for instance being open to the brief of a commissioning editor or an executive producer; or to audience response, as compared with prioritizing an individual need for creative expression. Aesthetic, technical, and attitudinal skills enabling aspiring filmmakers to be open and responsive to such briefs and feedback are inculcated by means of the pitch, preproduction, and audience response processes. Although many film schools have such pitching sessions in crews, the Centre International de Liaison des Ecoles de Cinéma et de Télévision (CILECT) conference of 2012 highlighted debate revealing that AFDA was the only film school present to have made group assessments an integral part of the curriculum from the most junior level, with marks for projects being shared equally among students participating in the making of a given film. At other schools, it became clear, such processes were often postponed until the postgraduate level. Thus, at AFDA assessment rewards students who share creative, technical, and academic responsibility in a scaffolding network. The tasks and film projects of each academic term are also communicated as a learning narrative in which the student is described as a member of a crew and cast, as someone who has been commissioned to deliver a certain entertainment product, or who has decided to initiate a product as an entrepreneur. Thus AFDA learning is team-based, as tackling problems requires effective cooperation between students with different roles and expertise. Such learning can also be seen as fostering a capacity to deal effectively with changing circumstances. Furthermore, as students are in control of the sets and productions, AFDA learning is: autonomously managed by the student; problem-based, since students tackle problems of production, which in turn allows them to learn from their work activities; and innovation-centered, which creates opportunities for learning and provides experience of managing change.[32] Students' research projects have to be linked to their intended outcomes in terms of engaging the audience, and have to be shared with all members of the crew and collated. Thus research at AFDA is applied, and the curriculum's different disciplines well integrated. Pedagogic terms to describe these curricular elements include life-long learning systems; research-based learning; scaffolded learning; action learning; experiential learning; inquiry learning; and simulated learning.[33]

So AFDA is firmly rooted in a practice-oriented environment, and conscious of its position in the developing South African economy. The AFDA curriculum incorporates the following salient features:

1. Written examinations are replaced with film and television projects from first year through to the master of fine arts. Undergraduate examinations are conducted in a simulated work environment. Postgraduate students engage with the real industry.
2. In group projects, students share the same grades.
3. Students are expected to forecast the entertainment value of their proposed productions in preproduction presentations, supported by research, and to reflect on its realization in postproduction and exhibition reviews.
4. At graduation film festivals, the audience completes response questionnaires. At the same time, students have to conduct question and answer

sessions with the audience. At the end of the process, students are given access to the data from the audience response to their film, and are invited to reflect on the emerging patterns, and to compare them to their forecast of audience opinion.

5. The theoretical framework is the theory of engagement as devised by Bata Passchier. Passchier posits that entertainment value is generated when a film is conceptually and emotionally relevant to its target audience.[34] Emotional relevance arises from the process of developing characters who grapple with problems in subcultural contexts that resonate with the target audience. Conceptual relevance arises when a character solves an event problem with the limited resources within the environment. Novelty comes from original use of existing resources to generate unexpected solutions to relevant event problems.[35] Thus, the central theory allows for creativity and the developing of creative voice. Passchier uses metaphors from neuropsychology and evolution to develop his thoughts about creativity. Thus, innovation is described as an "evolutionary force" that results in "novel mutations generating more fruitful organisms, as enmeshed bundling of emotional and conceptual relevance (character development and event problem) is evident in the human body and in story. Physiological and neurological networks represent these two highways in the body. Their meshing together in a story is captured in the Aristotelian adage: Action is character."[36]

Similarly, Passchier believes that AFDA's collective approach provides not only scaffolded learning, but also peer pressure to sharpen the individual student's performance standards and innovative skills.[37]

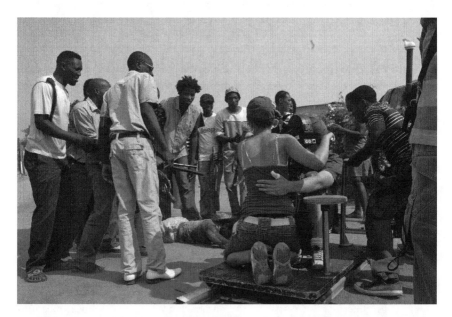

Figure 1.1 Courtesy of AFDA, Scaffolded learning: AFDA students supporting each other.

The curriculum is integrated around this theoretical framework. A core course provides a direct link between theory and practice, between research and production. This core course provides broad conceptual resources for divergent thinking and all students attend it. The core course consists of five subjects designed around Passchier's theory of entertainment, namely narrative, performance, medium, aesthetics, and control. In preproduction pitches, students are required to analyze their films along the lines of these five subject areas, and to answer set questions to motivate how they forecast their production's entertainment value. For this, they have to apply the core course material in such a way as to bring together their thinking around the group's shared collective film outcome. And in the context of audience response, the questionnaires ask audiences the same questions as those signaled by the five core course subjects. As the preproduction questions and the audience response questions assess the same entertainment values, it becomes possible to measure how accurate the predicted entertainment value was in preproduction. Thus the core course fuses theory and practice, and provides the creative glue within a project team. As Garth Holmes puts it:

> Core course was initially conceived as a means to give students an accelerated insight into the complexity of our *humanity* [Holmes's emphasis] through providing *experiential* and *research* opportunities for students to examine and use in their creativity. At the heart of this strategy lies the need to stimulate and broaden the largely immature/undeveloped thinking of emergent entertainment practitioners (whose average age is between 18 and 19 years) so as to create relevant and novel concepts.[38]

Production cycles and academic terms are structured through phases that integrate a supportive learning environment with work principles. In the first phase, students use "conceptual modeling" to develop an idea for a production that will provide entertainment value for the intended market. This mimics the film industry's concept of a development phase. It is iterative, as is typically the case for processes that refine or develop an abstract idea into a concrete reality. Conceptual modeling, although linear, is a dynamic and integrated process that operates on both individual and collaborative levels.[39] The second phase is called "perceptual modeling," during which teams envisage and plan for the execution of their projects. This mimics the industry's preproduction phase. The third phase is "concrete modeling," which is when students execute their planning, thereby mimicking the industry's production and postproduction phases. Finally, they reflect on their execution, and on where it succeeded or failed. This mimics the industry's postproduction, distribution, and exhibition phases.

Every term, students receive their exam project tasks in the form of "learning narratives." Whereas most film schools afford students full creative freedom to originate and produce their films, AFDA projects are conducted in a highly regulated context. Each learning narrative first and foremost identifies an exhibition platform for an intended audience, which must be taken into account in the conceptualization of film and television projects. These include, for example,

films for direct distribution to DVD in a chosen local community, and social awareness films for Nongovernmental Organizations (NGOs). Learning narratives also place constraints on the perceptual modeling in each discipline. For instance, if the term's project is an in-flight film for a local airline, screenwriting might call for scripts without dialogue.

As Bata Passchier has explained in an interview, the rationale behind learning narratives is value-based:

> The system of learning narratives looks at learning value within the full production environment from conceptualizing an entertainment product to exhibiting the product to the intended market. As such it does not only teach students the practical skills of filmmaking but also to consider the entertainment value of a production. As we know, a film that exhibits outside of its value system fails to realize its value.[40]

The learning narratives match the value in the work they produce through the learning they provide. It is an inculcation of the inputs of the core course, technical and craft discipline, and concrete environmental challenges. This system simulates the real world environment where at least 80 percent of all filmmakers who succeed in making a living in their profession do so within the strict parameters of market requirements.

There is a graveyard of filmmakers who tried to make a living on purely subjective notions of narrative appeal and entertainment value, and this is particularly true for the South African film industry. It is AFDA's intent to educate and train filmmakers and performers through learning narratives that expect them, for instance, to originate stories for direct release to DVD, or for release on YouTube, where they have the opportunity to analyze hits and incorporate feedback from the market.

In keeping with the philosophy of integrated learning, the learning narratives also ensure that all disciplines focus on the task at hand and learn to work together, as they share a joint responsibility to deliver each of these projects and thereafter to face the assessment of a critics' panel. A professional film requires the work of hundreds of individuals, even though the audience receives only one product. As such, the AFDA curriculum simulates this professional environment within the conceptual requirements for appealing narratives, well-defined perceptual models for preproduction and planning, and the execution of accurate and concrete models to realize the planned production.

So the learning narrative poses the student as the protagonist of her own learning. In response to the challenges of a stable income in the context of the South African film industry, aspirational goal-setting is a conscious part of the AFDA curriculum.[41] Alumni achievements function as role models through visual imagery of their achievements on campus, and also by encouraging networks among alumni. Evidence of student achievements is displayed on campus where student traffic is high. Examples include photos of an AFDA student receiving the Honorary Foreign Film Award at the 33rd Annual Student Academy Awards in 2006; the certificate of an AFDA film nominated in the

Cannes Festival Court Métrage professional short film category, and news of 13 nominations out of a possible 15 South African Film and Television Awards (SAFTA). Such displays help creative students to project their self-image as filmmakers and work back from the goal to focus on becoming precisely that. Similarly, the curriculum culminates in the goal of film screenings at the graduation festival. In a subsequent awards evening aspirational self-visualization is further supported when discipline chairs from the industry confer awards for excellence and top audience ratings are celebrated. Aside from providing opportunities to experience and reflect on audience engagement, these events also hone attitudinal skills: celebrating success stimulates aspirational goal-setting. Students learn to visualize success, and to applaud peers' success even amid their own disappointment. Students also experience the challenges of arranging their own festivals and awards ceremonies as valuable opportunities to develop skills in event management.

By not making films for herself but in an integrated team and for an audience, the AFDA student, at this point, has experienced the following benefits from a work-integrated learning curriculum:

- Academic benefits: deeper thinking about her own discipline of specialization and its aesthetics, increased motivation to learn and improved performance, lifelong learning habits, and increased insight into their contexts.
- Personal benefits: enhanced communication skills, increased initiative, better teamwork and cooperation, adaptability, the capacity to manage her own creative cycles, and the joy of creative passion.
- Career benefits: a greater sense of, and clarity about career identity, increased employment opportunities, personal coping strategies for changing industry contexts, and higher salaries.
- Work skills development benefits: positive work values and ethics, enhanced competence, and greater technical knowledge and skills.

It is almost a commonplace that people learn by doing. This is consistent with pragmatist philosopher John Dewey's belief that all genuine education comes through experience.[42] Experience in a real-life filmmaking context provides the four conditions for effective learning: a knowledge base, a motivational context, learning activity, and interaction,[43] all in an especially complex and fast-changing environment.

As a result of such training, students are better positioned to enter the developing South African film industry and to forge partnerships within it. Their profiles reflect an understanding of a real-world context, and their having practiced problem solving. The latter takes the form of students identifying appropriate research for a given production with the aim of using the relevant findings to generate a novel concept that is then applied (by means of high-end craft skills) to a product intended for a market.

Other South African schools have developed different models. However, apart from some early discussions on the topic, little has been published on recent developments in the area of production matters.

Figure 1.2 Courtesy of AFDA, Learning by doing: AFDA students collaborating on a film project.

The Future

The landscape of higher education in South Africa is fast changing. Compared with the paucity of underfunded training institutions in the 1980s, there is now a much wider range of opportunities spanning both the public and private sectors. In the current situation there is a skills shortage on the one hand and stringent rules governing access to higher education on the other. Access to higher education is still a site of struggle. All higher education institutions are accountable to the Department of Higher Education and Training, but private institutions receive no state funding, student loans, or research grants. No qualification may be offered without the department's accreditation, and accreditation requirements form continuous and complex bureaucratic mazes.

The massive growth of the media sector since the late 1990s enabled the contingent establishment of scores of tertiary training facilities. This superseded an early ideal for a national film school, called for in a 1996 white paper produced by the National Film and Video Foundation. Debate continues about the desirability of a national film school. While the 1996 recommendation was made by the industry itself, in the aftermath of apartheid, it is now opposed by

discipline-based bodies such as the South African Communication Association (SACOMM, submission to minister, October 23, 2009). Instead, SACOMM proposed that the minister provide bursaries to students to attend existing film schools.

The proposal for a national film school needs to be assessed within a political environment where state-owned enterprises (SOEs) constitute a very significant component of the national economy. Some of these have been privatized, re- and de-regulated since the end of apartheid.[44] More film students are registered at private film schools than at public educational facilities. The ideological tension is thus clear as the state loses ground to the private sector. Ruth Teer-Tomaselli[45] identified initial post-apartheid impulses for structural change within the state's economic sector. In the second post-apartheid decade, policy moved more toward growth, capital generation, wider ownership, reduction of state debt, and competitiveness. The state has since been accused of being the architect of its own poverty by Moeletsi Mbeki, as the original neoliberal impulses gave way to narrow elite formation.[46] Further, since the proposed film school would not be located within a ministry of education but would be under the Department of Arts and Culture, such a school might be run like an SOE pursuing political rather than educational objectives.

Meanwhile the South African society is in urgent need of skills development, especially self-reliance skills through entrepreneurship. The South African unemployment rate was 38 percent in the first quarter of 2012, (using a broad definition of unemployment; the official rate is 25.2 percent). To address this, South Africa needs education and skills development.[47] In the same quarter, South African income inequality rose to the highest in the world. In terms of the Gini coefficient, which measures the extent of income inequality within a society, South Africa has for the first time in 2012 become the most unequal country in the world. The gap between South African rich and poor is 63.6 percent.[48] Although such high inequality creates good business opportunities for entrepreneurs at opposite ends of the economic spectrum, it does not bode well for a country's social stability and economic growth potential. AFDA's approach is to address this condition at the level of training, the aim being to produce graduates who are employable or will have the capacity to take the steps needed to become self-employed.

As South Africa shed apartheid sanctions and the economy opened up to global forces, a new awareness of and pride in local identity developed. AFDA's narrative assessment structure encourages stories with specific relevance for and research on South African subcultures. At the same time, steps have been taken to reach out to film schools across the world through exchange programs. Initiatives along these lines have provided opportunities to explore the transferability of AFDA's educational model. The National Film and Television Institute in Ghana (NAFTI) reported success in applying the AFDA model for entertainment value, while Scandinavian film schools invited AFDA lecturers to share the preproduction pitch process that aims to help students to forecast the entertainment value of their projects. Also, the phases of conceptual, perceptual, and concrete modeling form an axis in a north-south exchange program. Partners in this exchange program include two Finnish film schools, two South African

universities and a film school, and a Ghanaian film school. The participating students make short documentary films on intercultural themes. At the same time, new production technology makes it possible for schools and students located in different hemispheres to collaborate on productions. Networks of film entrepreneurs can now stretch around the world.

The AFDA curriculum has been developed to stimulate collaboration between disciplines, to entertain audiences. The feedback from AFDA alumni in 2012 was positive on this point—85 percent felt that the AFDA course enabled them to form sustainable networks with each other, and with industry. Within these networks, they could initiate projects for audiences. Finally, AFDA alumni played a significant role in the increase of film production in 2012.

Notes

1. Barry Standish and Antony Boting, *A Strategic Economic Analysis of the Cape Town and Western Cape Film Industry* (Unpublished report for Cape Film Commission by Strategic Economic Solutions cc, 2007).
2. Ruth E. Tomaselli et al., eds, *Broadcasting in South Africa* (London: James Currey, 1989).
3. Fanie van der Merwe and C. H. Theunissen, "Film Produksie by Die Technikon van Pretoria," *The SAFTTA Journal* 1, no. 2 (1980): 15.
4. Johann Grove, "First National Student and Video Festival: Two Views. View One: Theory or Practice," *Critical Arts* 2, no. 2 (1981); Keyan G. Tomaselli and Graham Hayman, eds, *Perspectives on the Teaching of Film and Television Production* (Grahamstown: Department of Journalism and Media Studies, Rhodes University, 1984).
5. Alex Davids, "Film as Art at UCT," *The SAFTTA Journal* 1, no. 2 (1980).
6. Leon Van Nierop, Norman Galloway, and Tascoe Luc de Reuck, *Seeing Sense on Film Analysis* (Pretoria: Van Schaik, 1998).
7. Jeanne Prinsloo and Costas Criticos, eds, *Media Matters in South Africa* (Durban: Education Resource Centre, University of KwaZulu-Natal, 1991); John Van Zyl, *Image Wise: Competence in Visual Literacy* (Sandton: Hodder and Staughton, 1987).
8. Gertruida M. du Plooy and Pieter J. Fourie, "Film and Television Training at the Dept. of Communication at UNISA," *The SAFTTA Journal* 1, no. 2 (1980); Pieter J. Fourie, *Aspects of Film and Television Communication* (Cape Town: Juta, 1998).
9. Keyan G. Tomaselli, *The Cinema of Apartheid* (Chicago: Lake View Press, 1988).
10. Graham Hayman, "Television in Journalism: Problems, Aims and Solutions," *The SAFTTA Journal* 1, no. 2 (1980); John van Zyl, "Beyond Film and Television Studies: With Jobs for Whom?" in *Perspectives on the Teaching of Film and Television*, ed. Keyan G. Tomaselli and Graham Hayman (Rhodes University, Grahamstown: Department of Journalism and Media Studies, 1984).
11. Peter Anderson, "The Tiakeni Report: The Maker and the Problem of Method in Documentary Video Production," *Critical Arts* 4, no. 1 (1985); Keyan G. Tomaselli, "The Teaching of Film and Television Production in a Third World Context: The Case of South Africa," *Journal of the University Film and Video Association* 34, no. 4 (1982); Keyan G. Tomaselli, "Communicating with the Administrators: The Bedeviled State of Film and Television Courses in South African Universities," *Perspectives in Education* 9, no. 1 (1986).

12. Tomaselli, "Communicating with the Administrators"; Keyan G. Tomaselli and Arnold Shepperson, "Gearing up the Humanities for the Digital Era," *Perspectives in Education* 21, no. 2 (2003).
13. Keyan G. Tomaselli, "Film Schools—Their Relevance for the Industry," *The SAFTTA Journal* 1, no. 2 (1980).
14. Tomaselli, *The Cinema of Apartheid*, Ch. 2–3.
15. Johan Blignaut and Martin Botha, eds, *Movies—Moguls—Mavericks: South African Cinema, 1979–1991* (Cape Town: Showdata, 1992).
16. Standish and Boting, *A Strategic Economic Analysis*: 3, 9, 13.
17. Centre International de Liaison des Ecoles de Cinéma et de Télévision, "The AFDA Master of Fine Arts, Johannesburg," *CILECT News* 43 (Dec 2005): 14.
18. Martin P. Botha, "The Song Remains the Same: The Struggle for a South African Film Audience, 1960–2005," *CILECT News* 43 (Dec 2005).
19. Ibid.
20. Ibid.
21. Garth Holmes, *Motivating a Learning Approach for Tertiary Level Students to Originate Market Related Aesthetic Choices in their Design Concepts and Products* (Unpublished Master's dissertation: University of Cape Town, 2011).
22. Keyan G. Tomaselli et al., "Bumping into Reality, Brutal Realism and Bafundi 2009: Some Thoughts on a Student Film Festival," *Journal of African Cinemas* 1, no. 2 (2009); Keyan G. Tomaselli, "Bashed by Booms: The 2008 Bafundi Film and TV Festival," *Journal of African Cinemas* 1, no. 1 (2009).
23. Martin P. Botha, "The Song Remains the Same."
24. Leon Van Nierop, *Movies Made Easy: A Practical Guide to Film Analysis* (Pretoria: Van Schaik, 2008).
25. Nyasha Mboti, "ReaGilè in South Africa's Townships: Tracing the Design and Development of a 'Small' Idea for Life-size Community Upliftment," *Commonwealth Journal of Youth and Development* (forthcoming).
26. South African History Online, "What are the Challenges that Face the South African Film industry?" *South African History Online* (n.d.), http://www.sahistory.org.za /what-are-challenges-face-south-african-film-industry (accessed June 28, 2012).
27. Bata Passchier, "The Learning Programme" (unpublished presentation to CILECT Conference, Cape Town, May 1, 2012).
28. Centre International de Liaison des Ecoles de Cinéma et de Télévision, "The AFDA Master of Fine Arts, Johannesburg," 15.
29. Botha, "The Song Remains the Same," 23.
30. See, for example, Martin P. Botha, *South African Cinema, 1986–2010* (Bristol, UK: Intellect Books, 2012) and Keyan G. Tomaselli, *Encountering Modernity: 20th Century South African Cinemas* (Amsterdam: Rozenberg, 2007).
31. AFDA, *AFDA Academic Yearbook 2012* (Johannesburg: The South African School of Motion Picture Medium & Live Performance (Pty) Ltd t/a AFDA, 2012), http://www. afda.co.za/yearbook.php (accessed June 28, 2012).
32. John Brennan and Brenda Little, *A Review of Work Based Learning in Higher Education* (Sheffield: Department for Education and Employment, Great Britain, 1996), 3.
33. Mary Atchison, Sarah Pollock, Ern Reeders, and Janine Rizzetti, *Guide to Work-Integrated Learning* (Melbourne: RMIT, 1999).
34. Bata Passchier, "EVAM: Entertainment Value Assessment Matrix," *CILECT News* (2007).
35. Ibid., 1.

36. Bata Passchier, *The Biology of Narrative* (unpublished presentation at the Helsinki Narrative Conference, 2009).
37. Passchier, "The Learning Programme."
38. Holmes, *Motivating a Learning Approach*, 58.
39. Ibid., 59–60.
40. Bata Passchier, unpublished interview by Anton Basson. Johannesburg, February 28, 2012.
41. Passchier, "The Learning Programme."
42. John Dewey, *Experience and Education* (New York: Macmillan, 1938), 25.
43. John Biggs, *Teaching for Quality Learning at University: What the Student Does* (Buckingham, UK: Open University Press and Society for Research into Education, 1999), 73, 78.
44. Ruth Teer-Tomaselli, "Transforming State Owned Enterprises in the Global Age: Lessons from Broadcasting and Telecommunications in South Africa," *Critical Arts* 18, no. 1 (2004).
45. Ibid.
46. Moeletsi Mbeki, *Architects of Poverty* (Johannesburg: Picador, 2009).
47. STANLIB, "SA Unemployment Rate Back Above 25% in Q1 2012. Labour Force Rose by 207 000 in Q1 2012, But Employment Fell by 75 000," STANLIB, http://www.stanlib.com/EconomicFocus/Pages/SAunemploymentrateQ12012.aspx (downloaded July 13, 2012).
48. An Hodgson, "Special Report: Income Inequality Rising Across the Globe," *Euromonitor International*, http://blog.euromonitor.com/2012/03/special-report-income-inequality-rising-across-the-globe.html (downloaded July 13, 2012).

Bridging the Gap: Answering the Questions of Crime, Youth Unemployment, and Poverty through Film Training in Benin, Nigeria

Osakue Stevenson Omoera

There is a connecting link between poverty, unemployment, youth restiveness and development in Nigeria. Among the Millennium Development Goals' (MDGs') target of 2015 is poverty alleviation and wealth creation in sub-Saharan Africa and other developing areas of the world. In a recent publication, the United Nations Conference on Trade and Development (UNCTAD) has identified the burgeoning video film industry in Nigeria as a veritable small and medium enterprise (SME) tool that could be used to alleviate poverty, create jobs for teeming Nigerian youth, and contribute to the global value chain of wealth creation.[1] The questions of youth restiveness, unemployment, and all shades of crime have taken a dominant space in global discourse, even as youth intransigence is threatening to shred the fabric of Nigerian society.[2] Indeed, Otive Igbuzor warns that several intelligence reports on Nigeria indicate that if the country is unable to create about 24 million jobs for its growing population by 2015, it could become a failed state.[3] This is a grave issue that demands urgent attention considering Nigeria's role in sustaining peace in the West African subregion and indeed in the whole of Africa.

Across the globe, vocational and technical education, whether at the formal or informal level, has been found to be a strong bastion in invigorating economies and empowering youth between the ages of 15 and 35 with lifelong skills and the knowledge needed to create wealth, and thereby to drive the socio-economic development of society.[4] It is with reference to such findings that this chapter explores the potential of hands-on film education to empower the Nigerian

youth, and, indeed, to encourage young people to take to productive ventures instead of to cybercrime (commonly called "Yahoo Yahoo"), kidnapping, prostitution, and other antisocial tendencies. To achieve this, specific attention is paid to the Benin video film. The phenomenon in question is an aspect of the larger Nigerian film industry, which has itself been named Nollywood because of its economic and artistic propensities.[5]

The problem of development has occupied the attention of scholars, activists, politicians, development workers, and local and international organizations for many years, and with greater intensity in the last decade. Otive Igbuzor opines that though there are different perspectives on development, there appears to be a general consensus that it ought to lead to positive change, as manifested in people's increased capacity to exercise control over material assets, intellectual resources, and ideology; and in their enhanced ability to access the physical necessities of life (food, clothing, and shelter), employment, equality, participation in government, political and economic independence, adequate education, sustainable development, and peace.[6] This is probably why some scholars and organizations have argued that the purpose of development is to improve people's lives by expanding their choices, freedom, and dignity.[7]

Furthermore, I. A. Ademiluyi and O. A. Dina assert that the agenda driving the Millennium Development Goals (MDGs) is an attempt to conceptualize and find solutions to some of the most serious challenges facing mankind.[8] The Nigerian experience, as far as poverty reduction and employment generation are concerned, is quite appalling. Globally, the country ranks very low on all the eight points to which the policy of MDGs is addressed, including job creation and poverty reduction. The United Nations Human Development (UNHD) agency, in one of its reports in 2006, ranked Nigeria nineteenth among the least livable countries of the world, behind even war-torn Rwanda.[9]

This ranking by a key international agency poses a challenge for stakeholders in what we might call "Project Nigeria," with the government, intellectuals, and business people all needing to find ways to improve the country's living standards. It is, however, a worrisome fact that the rate of population increase and its unbalanced distribution in Nigeria are clearly unsustainable. Population growth directly and indirectly affects Nigeria's economic development, and has especially strong implications for per capita income, infrastructure distribution, and workers' capacity to find gainful employment.

Poverty persists in Nigeria in the midst of plenty. Although the Nigerian Economic Summit Group (NESG) argues that there has been a steady economic growth in the last few years,[10] there are doubts as to whether the benefits have been evenly distributed, especially to the poor, the unemployed, and those young men and women who find themselves excluded from the mainstream of economic productivity across the country. In fact, Nigeria remains among the 20 countries in the world with the widest gap between the rich and the poor.[11] Corroborating this position, the UNDP report on the human development index, as well as other studies, put Nigeria at twenty-fifth in Africa and at 142nd in the world, with an index ranking of 0.423 in the global human development index.[12]

Reflecting on Nigeria after 50 years of postindependence existence, Wale Omole asserts that all statistics for the country are against jubilation and represent systemic failures.[13] He points out that 40 years ago (in 1970), life expectancy was 54 years, whereas in 2010 it is merely 48 years. Poverty was 45 percent at that time, and is now at 70 percent. Unemployment was 15 percent then and is now above 60 percent. An analysis such as Omole's makes it crystal clear why the crises of youth restiveness, joblessness, and crime in virtually all regions of Nigeria have reached an alarming point. Youth constitute a critical segment of society whose biophysical development, energy, and ambition need to be captured and channeled toward productive ends. Opportunities available in the film industry and within the larger entertainment sector have a decisive role to play in this regard.

Theoretical Context

The African popular arts paradigm as espoused by Jonathan Haynes provides an acceptable theoretical infrastructure for this study.[14] According to Haynes, the paradigm in question developed fairly recently in the context of an interdisciplinary project that traces its intellectual genealogy to, among others, social history (Terence Ranger), anthropology (Johannes Fabian, Ulf Hannerz, Christopher Waterman), Marxist literary criticism (Biodun Jeyifo), and Birmingham-style cultural studies, and literary theory (Karin Barber). Concept development linked to the project has been facilitated by accounts of various Nigerian arts, especially the Yoruba traveling theater and the musical forms of *fuji* and *juju*, examples of which have now been captured on video through certain technological negotiations.[15]

The African popular arts category is a loose one comprising cultural forms that occupy an indeterminate space between the traditional and the modern/elite, produced mainly by and for the heterogeneous masses of (Nigerian) African cities. Culturally, these arts tend to be syncretic, functioning (as African cities themselves do) as brokers between the rural-traditional realm and the wider world from which modernity has been imported.[16] Indeed, participation in these popular Nigerian arts, including the video film, does not require much capital or formal education on the part of the practitioner; they are produced in the nonformal or informal sector of the economy, usually without state support but with critical implications for development.

Haynes's approach to the popular arts of Africa poses a productive and different set of questions than does film criticism and points toward a distinctive cultural matrix and dynamic that vitalizes this study's interest. Again, he affirms that the kind of performances we find in popular culture have become, for the people involved, more than ever, ways to preserve some self-respect in the face of constant humiliation, and to set the wealth of artistic creativity against an environment of utter poverty. All this is not to be dismissed off-hand as escape from reality; it is realistic praxis under the concrete political and economic conditions that reign.[17]

Thus, the Nigerian video film as a form of African media production locates itself outside the rubric of western film training or education that follows western

and highly orchestrated models at work in the formal school systems. In other words, the production and transfer of knowledge and skills among filmmakers / would-be filmmakers/practitioners in Nollywood are largely through informal channels of apprenticeship. In the context of this chapter, the relevant processes are referred to as artisanal trainings. In his study entitled *History of Education in Nigeria*, Babs Fafunwa largely agrees with this characterization of Nollywood's processes of learning as informal. What is more, he sees education as "the aggregate of all the processes by which people develop abilities, attitudes and other forms of wholesome behavior."[18] Drawing on this, film training could be seen as a wholesome human behavior. Fafunwa's emphasis on informal learning enjoys the support of Austin Emielu who states that "the current formal school system and [its] curricula can never suffice to give people the knowledge and skills needed in a world of change."[19] Following the foregoing but with specific concern for training in the arts, including video filmmaking, Mathew Umokoro asserts that serious doubts have been and continue to be expressed as to whether academic/formal schooling is the best training for most branches of the arts.[20]

The kind of informal training that is currently occurring in the Nollywood sector needs to be supported, not necessarily by full-blown film programs or traditional conservatoire-style film schools, but by artisanal training engagements at the various production sites scattered across the different regions of Nigeria. This is expected to provide a congenial environment for the training of a large number of trainee filmmakers, as anticipated in this discourse. Such a platform will readily democratize/liberalize training in the diverse arts and crafts of filmmaking that could accommodate a large pool of persons, including many of Nigeria's jobless, hungry and angry youths who roam the streets daily, without any marketable skills. This is consistent with the observation of Kamol Jiyankhodjaev that "non-formal training plays a compensatory role and provides some options in the fields, which formal education currently is not able to cover with regard to the choice of education and training of individuals to meet the emerging demands of new skills and competences."[21]

It is in the context of claims about formal and informal modes of learning that this chapter explores the potential of video filmmaking, a popular Nigerian art form and industry, to create jobs and reduce poverty and crime in the Benin area of Nigeria today. The focus of this study therefore is the emergence of the Benin film culture as a significant component of Nollywood, and how it could be used to negotiate the contemporary challenges of poverty, youth unemployment, and crime. Remarks about the Benin people and their geographical location, as well as about the methodology used to advocate certain forms of institution building in the present study help to set the stage for the discussion of the state of film education in Nigeria.

The Study Site

Today, Benin City is the ancestral home of the Benin people. The city is the seat of Edo State's government in old mid-western (now south-southern) Nigeria and

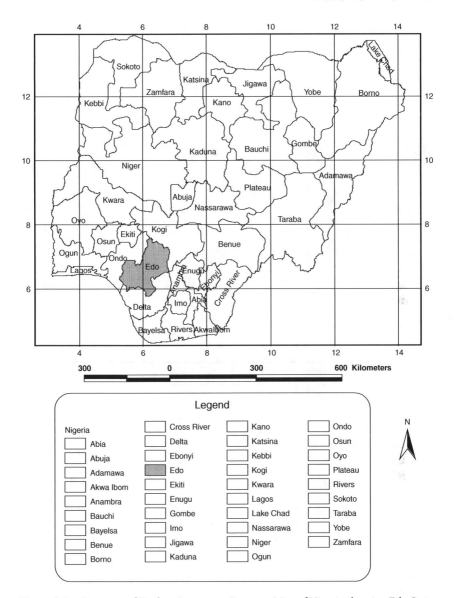

Figure 2.1 Courtesy of Osakue Stevenson Omoera, Map of Nigeria showing Edo State.

also the hub of the ancient Benin kingdom, which now comprises seven local government areas (LGAs), namely, Orhionmwon, Oredo, Ikpoba-Okha, Ovia North-East, Ovia South-West, Egor, and Uhunmwode. The term Benin is vested with several meanings and connotations, the earliest of which dates back to between 900–1200 AD, when the area started enjoying the status of a kingdom ruled by the Ogisos.[22] Benin is used interchangeably with the term Edo.[23] Aside from being a geographical entity, Benin is also used to describe the people and the language spoken in this region.

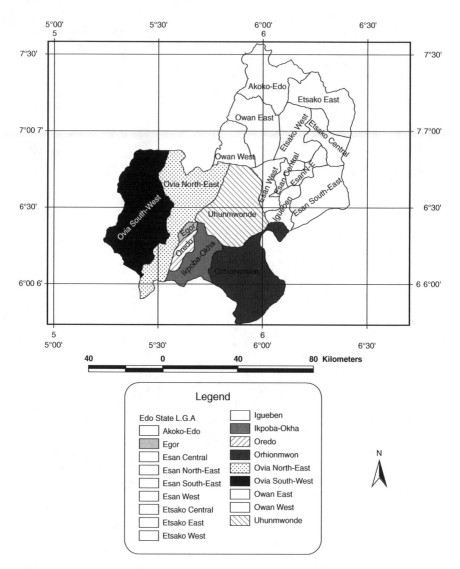

Figure 2.2 Courtesy of Osakue Stevenson Omoera, Map of Edo State showing the study area.

The inhabitants of the area are mainly native speakers of the Benin language and the primary market target of all the Benin video film producers / videographers who make local vernacular movies. The nonnative residents of Benin communities within Nigeria, the general viewing public in Nigeria, and diasporic Nigerians constitute a further, secondary market. Although there are many primary, postprimary, and tertiary educational institutions, mass media outfits, and modern markets, as well as sites of historical and cultural significance strewn across Beninland, many of the Benin youths are not in school and

have no entrepreneurial/marketable skills. This reality has serious implications for security and development in this area.

The Benin language film subsector of Nollywood has produced some significant movies such as *Ikoka 1, 2 & 3* (dir. Peddie Okao, 2003), *Ebuwa 1 & 2* (dir. Lancelot Imasuen, 2009), and *Adesuwa* (dir. Lancelot Imasuen, 2012), which are local and international award winners. Some of the prominent cineastes of Benin language films are Ozin Oziengbe (aka Erhietio Sole Sole), Peddie Okao, Lancelot Imasuen, Eunice Omoregie, Omadeli Uwagboe, among other cultural and entertainment product producers. These figures have worked tirelessly, and, indeed continue to work to "oil the wheel" of the emerging micro-nation's film culture. As a result of their efforts, the Benin locality is fast becoming one of the new frontiers of Nollywood, as Omoera notes.[24] This growing stratum—that is, the Benin video film subsector of Nollywood—has contributed close to 400 films and has considerably enriched the corpus of indigenous language films in Nigeria and indeed in Africa.[25]

Figures 2.1 and 2.2 are maps of Nigeria and Edo State showing the location of Edo State and the Benin-speaking area respectively.

Methodology

This study adopts an historical approach as its method of examining issues surrounding hands-on artisanal training of trainees in the arts and sciences of video filmmaking in Benin, from 1992, when Aghabiomo Ogbewi's Uyiedo Theatre Troupe produced the first commonly acknowledged Benin video drama *Udefiagbon*, until now, when the video culture is bursting at its seams. This is complemented by interviews with actor, director, and producer Peddie Okao and by an ethnographic reading of the Benin video culture, the idea being to elicit information about how film training could be used in combating poverty, youth unemployment, and crime among the Benin youth in Nigeria. The interest of this study thus has to do with its foregrounding of the artistic and economic possibilities of the Benin language film subsector of Nollywood.

Film Education in Nigeria

Apart from the Nigerian Film Corporation (NFC), located in Jos, whose training arm, the National Film Institute (NFI), awards degrees/diplomas/certificates in film studies in affiliation with some universities in Nigeria,[26] a few privately owned film schools, such as the Pencil's Film and Television Institute (PEFTI) in Lagos and the Film and Broadcast Academy (FABA) in Ozoro, run National Board for Technical Education (NBTE) accredited programs in filmmaking. While PEFTI, Lagos was established in 2004 by Wale Adenuga Productions, FABA, Ozoro was set up in 2009. These specialized institutions were established to create opportunities for both greenhorns and practitioners to acquire proficient professional training in the diverse disciplines of film and television.

PEFTI and FABA programs range from one week, three months, six months, and one year to two years, offering professional courses in screenwriting, cinematography, editing, directing, film sound, and film production design, among other specialist areas in film studies. Students who graduate from the two-year program are awarded the National Innovative Diploma (NID). The average student intake of both FABA and PEFTI is 2000 per session for the two-year NID program. Students are provided with facilities for specialized training, and expertise in virtually all filmmaking trades and professions. Alongside these formal platforms are consortia/groups that organize film training or education services now and then, ostensibly to increase the density of professional filmmakers in the country. For instance, Del-York International, in collaboration with the New York Film Academy in New York, organized a training program for budding filmmakers in Lagos, Nigeria, in August 2011.

Beyond this, there are some universities that only recently renamed their theater arts programs in an effort to reflect contemporary job market demands and to deepen specialization in film studies, including practical film training. However, this change of name is not matched with any kind of commensurate equipping of the departments along the lines of what is needed efficiently to teach film studies with a significant element of practice. For instance, the Ambrose Alli University in Ekpoma, the University of Calabar, and the University of Port Harcourt (all in southern Nigeria), renamed their theater arts programs so as to become theatre and media arts, theatre and media studies, and theatre and film arts respectively. Similarly, the University of Jos, Jos and the University of Nigeria, Nsukka, in central and southeastern Nigeria respectively, renamed theirs to become theatre and film arts. These universities basically offer courses in film appreciation and criticism. Other tertiary institutions merely teach aspects of film studies in their theatre/drama/mass communication/performing arts departments.

It is thus fair to say that film education or training, especially in any formal sense, is still in its infancy in Nigeria when compared to countries like the United States, India, and Britain, all of which can boast of enduring institutional structures and a well-developed infrastructure in the area of film education. Haynes underscores this point when he says: "The tragic condition of the Nigerian universities, which imposes a maddening array of obstacles, deprivations, frustrations, and distractions on everyone trying to produce scholarship in them, has taken its toll on film studies as on every other field. Academic film studies was especially vulnerable because its roots in Nigeria are so shallow."[27]

However, there appears to be much hands-on film training going on at the informal level, with specific reference to the significant contribution of Nollywood to contemporary world film culture. Many Nollywood content creators learn by rote, through apprenticeship, or through other informal hands-on film education arrangements and they have had a remarkable impact on different aspects of film production, both within and outside Nigeria. Virtually all the video film production sites in Lagos (e.g. Idumota Street), Onitsha (e.g. Iweka Road), Benin (e.g. New Benin), and Kano, Calabar, Markudi, and Jos, among other places, serve as artisanal film training centers for budding Nigerian filmmakers, directors,

actors/actresses, cameramen, costumiers, and makeup artists, to mention a few key roles.

Video film production companies such as Lancewealth Images, Mount Zion Productions, Wells Entertainment, Opa Williams Productions, Wale Adenuga Productions, Mainframe Productions, Prolens Movies, and Pictures Communications (among others) that operate in these sites have inadvertently become informal training centres for a considerable number of film professionals in Nollywood. Popular cineastes like Funke Akindele, Mike Bamigboye, Fred Amata, Zeb Ejiro, Ini Edo, Akanni Niji, Chico Ejiro, Jeta Amata, Emem Isong, Uche Jumbo, Lancelot Imasuen, Mercy Johnson, and Kunle Afolayan largely learned the arts and sciences of filmmaking by attaching themselves to active film production companies that offered them practical opportunities to hone their skills in the practices of filmmaking. Many of these professionals have gone ahead to make significant movies that have had impressive outings in both national and international film circuits. Works like *Amazing Grace* (dir. Jeta Amata, 2006), *Ikuemitin* (dir. Lancelot Imasuen, 2007), *Aramotu* (dir. Niji Akanni, 2011), *Black Gold: Struggle for the Niger Delta* (dir. Jeta Amata, 2011), and *The Figurine: Araromire* (dir. Kunle Afolayan, 2012) are especially notable in this regard.

It seems clear that in the Nigerian case, informal hands-on film training has much more to offer than formal film education. If the provision of such training is developed on a sufficiently large scale, the implications for job creation and poverty alleviation could be quite significant. In this sense, informal training that is typically short-term, punctual, project-based or delivered through peripatetic, transnational workshops and partnerships may be able to achieve social results that the providers of formal film education have been unable to deliver because of certain constraints in the Nigerian environment. Alessandra Meleiro argues that the film and video industry, if properly developed, can indeed be a potential source of employment generation, wealth creation, and skill development in Nigeria and other parts of West Africa.[28] This is particularly so because the hordes of youths under focus do not have the financial wherewithal or required entry qualifications to enroll for degree/diploma/certificate programs in film studies or cognate disciplines. Hence the need to explore the potential of artisanal film training as it is commonly practiced by videographers/filmmakers in the various production sites in Nigeria.

Benin Youth in Perspective

With the problem of chronic poverty and unemployment, which many see as having been spawned by a series of putsches and bad leadership in Nigeria, the country now finds itself in dire straits. In the words of Patrick Iroegbu, "Nigerian leaders have created a 'culture of poverty' or insufficiency for the generality of Nigerians."[29] Similarly, Pat Utomi noted in *The Punch* (Nigeria) article of May 23, 2012 that "Nigerian leaders have failed their generation and that of their children but must wake up now in order not to fail that of their grand children."[30] Emerging research on youth reveals that the current population of young people all over the

world is approximately 1.2 billion, representing about 25 percent of the world's total population.[31] Out of this overall population it is estimated that 208 million live in abject poverty; 130 million are illiterate; 88 million are jobless and about 10 million are infected with diseases such as HIV/AIDS and other debilitating ailments. It is important to note that 85 percent of this global population of youth is in the developing world.[32] Nigeria is an important part of this picture, for its many slums and unplanned towns and cities (also in the Benin-speaking area) breed multitudes of currently restive, but potentially creative youths.

The average Benin youth is clever but needs the right environment to excel. There is so much talk about youth empowerment and development without commensurate action actually to provide templates for the youths to unlock their creative abilities. For this reason, the level of unemployment among the Benin youth remains considerable. A majority of youths in the area under study do not have the financial means to acquire formal education; they lack marketable skills and are chronically poor. Furthermore, there are few socio-economic structures to support or empower the youth to fend for themselves and this contributes to the underdevelopment of Benin and indeed Nigeria. In this regard, it has been observed that "a country cannot be said to be growing when its economy [and] social life…are deteriorating and [when] poverty, unemployment, insecurity, armed robbery, cybercrime and other social challenges are on the increase."[33]

Moreover, many Benin youths who are able to acquire formal education wait endlessly for white collar jobs. This is probably because the society lays more emphasis on paper qualifications/certificates instead of the practical skills that are very much needed in an information- and knowledge-based society. Also, it is unfortunately the case that much of the so-called gainful employment is unavailable to the teeming youths who are churned out by colleges and universities yearly; the few vacancies that do exist are quickly filled by the children of those at the helm of affairs. It is no surprise therefore that many a Benin youth is hungry, despondent, restive, and desperate to do anything to survive. This partly explains why antisocial behavior is on the increase in the area, with young people responding to various stressors (unemployment, hunger, lack of opportunity) by turning to prostitution, kidnapping, and other vices as coping methods.

Young people are the "mitochondria" (in biology, a cell's powerhouse) of society and neglecting them amounts to putting our collective future in jeopardy. For instance, the "Boko Haram" crisis in northern Nigeria, the "Movement for the Actualization of the Sovereign State of Biafra" (MASSOB) agitations in the eastern flank, as well as the "Niger-Delta" militants and "Odua People's Congress" (OPC) activities in the south-southern and south-western parts of the country respectively, are signs of greater problems that may arise if nothing concrete is done soon to address the issue of the tens of thousands of able-bodied young men and women roaming the streets. Omole observes that in the Benin locality, much as in Nigerian society more generally, "hundreds of thousands of our youth…seek admission into schools, but cannot be placed because of limited vacancies…Those that passed the admission examination cannot matriculate. They have no option of vocational schools; neither do they have jobs to occupy

their hands and minds."[34] Rather than becoming part of a process of national development, they become a threat to national security.

A UNESCO study focusing on youth issues globally offers a broader perspective, arguing that "the landmarks of the new generation of young people from the 1980s onwards have been the sudden but urgent concerns with 'survival', 'under-employment', 'defensiveness', [and] 'anxiety'."[35] This study informed Ugor's position when he says that the UNESCO's observations "are evocative of an emerging social turbulence amongst youth at a global scale." Ugor further contends that "the looming youth crisis is located within the supposedly intrinsic capacities of young people for intransigence as a result of their unique physiological make-up at that phase of biophysical development."[36] Perhaps the seriousness of this global issue, with regard to the Nigerian situation, is underscored by Kandeh Yumkella's statement that "Nigeria is treading on water."[37] It is not hyperbolic therefore to suggest that in the case of Benin the issues are serious enough to warrant the declaration of a state of emergency by the relevant public authorities. Such a measure would help to refocus the attention of all stakeholders on ways of effectively bridging the interstitial gaps in the net of socioeconomic relations, especially with reference to the aspirations of young people. Concrete action of a concerted nature is required if the negative social consequences toward which the current situation clearly points are to be avoided.

Video Film, Youth, and the Economy

In Nigeria, the deterioration of state structures has led to a corresponding increase in the uncertainty and insecurity of daily living. Freedom Onuoha has consistently argued that challenges such as endemic corruption, violent crimes, ethnic militancy, worsening poverty, gender inequality, high unemployment, infrastructural decay, ethno-communal conflicts, and religious violence have aggravated the state of insecurity, which has resulted in stunted national development in Nigeria.[38] Traditional means of social mobility—such as formal education or employment in public office—are no longer available or effective. In such a context, the potential social benefits of moviemaking become especially salient. Moviemaking has proved to be a profitable activity and could become a means of socio-economic promotion and hands-on, informal education for the creative but unemployed youth. In a recent interview that Mwenda wa Micheni granted Tony Anih, the executive secretary of Africa Movie Academy Awards (AMAA), the filmmaker discussed the state of African cinema and asserted that in addition to creating huge employment opportunities, the video film is capable of restoring lost African values and traditions.[39]

Corroborating this view, Peddie Okao, (Benin video film actor, director, producer, and chief executive officer, Prolens Movies Nigeria Limited) argued in 2011 that the Benin video film has become a means of teaching both the young and old about great historical incidents, feats, and events that have helped to shape the social/linguistic/cultural consciousness of the average Benin person

of today.[40] This is consistent with the United Nations' thinking that film is a window to indigenous culture and heritage. The global body underlined this philosophy when it marked the 2010 edition of the International Day of the World's Indigenous Peoples (IDWIP) by celebrating indigenous filmmaking.[41]

The Benin video subsector of Nigeria's Nollywood currently has two major production blocks with a number of sites of production and release. The first is Benin City, the capital of Edo State, Nigeria, while the second is Lagos, Nigeria's commercial nerve center. While a number of film production and marketing companies operate in these sites, the focus here is on the first of the two, because there is more emphasis there on using the production outfits as film training centers targeting young people, especially in Benin. A majority of these video film production outfits metamorphosed from existing theatre and cultural groups (TCGs). Originally, these TCGs performed drama or dance or libretto pieces at social events or at the behest of important personalities in the society for a fee. So they always had a pool of both practiced artistes and trainee performers who learned theatrical skills in the process of rehearsals and performance engagements. But today, many of the TCGs have taken advantage of digital technologies to package their performances in video formats while still retaining their tradition of providing artistic training through youth apprenticeship of some sort in the Benin area. Cineastes such as Johnbull Eghianruwa (Sir Love), Eunice Omoregie (Queen of Benin movies), Omo-Osagie Uteteneghiabe (the unmistakable voice of Benin movies), Loveth OKH Azugbene (Emama no kasedo / Ovbesa kpooo), Omadeli Uwagboe (the golden lady of Benin movies), Ozin Oziengbe, Lancelot Imasuen, and Osagie Legemah, among others, are products of this system. It is in view of this that this study suggests that these TCGs now turned film production companies should be used as artisanal film training sites for the hordes of jobless, crime-prone youth in the region.

Benin City has the largest concentration of film production outfits roughly spread across the main business districts: New Benin / New Lagos Road axis; Oba Market Road / Ekenwan Road axis; Third East Circular / Sokpoba Road axis; and Oliha / Textile Mill Road axis. The New Benin / New Lagos Road axis, as a point of film release, has Soul 2 Soul Films Nigeria Limited, Soundview Films, Supreme Movies, Steve Film Centre, Universal Films Centre, and Osagie Mega Plaza Nigeria Limited, among others. The Oba Market Road / Ekenwan Road axis has Nelson Films Nigeria Limited, Moonlight Video Centre, Pictures Communications, Prolens Movies Nigeria Limited, and Great Events Organizers (Nig) Limited, among others. The Third East Circular / Sokpoba Road axis of Benin film production has Scotland Movie Centre, Rainbow Theatre Troupe, Akpola Films, Silver Entertainment, and Midland Entertainment Centre Nigeria Limited, among others, while the Oliha / Textile Mill Road axis has Triple 'O' Films Nigeria Limited, Ninety-Nine Entertainment Centre Nigeria Limited, and Ozin Oziengbe Films, among others. Although many of the filmmakers or content creators in Benin hastily put together their films with little concern for finesse but with strong commercial intent (the Benin videographers call this the "Kpakpakpa" philosophy of production), the videos still satisfy some of the locals' entertainment, cultural, and economic needs.

In *Principles of Education for African Teachers*, Harold Jowitt notes that education, from the societal perspective, is "the effective organization of (man's) experiences so that his tendencies and powers may develop in a manner satisfactory to himself and to the community in which he lives by the growth of socially desirable knowledge, attitudes and skills."[42] To a large extent, Emeka Nwabuoku agrees with Jowitt, asserting that "education is [a process of] acquiring appropriate and positively desired habits."[43] Drawing on such educational principles, which emphasize values and engagement as much as skills, the practiced filmmakers who run the film production outfits, cultural enthusiasts, and local experts in entrepreneurial and vocational education should all be encouraged to come together to mount training programs aimed at equipping the growing mass of jobless youths in the Benin area. The hands-on film training should be skewed positively toward the bricks-and-mortar enterprises that would readily attract and consequently engage the teeming Benin youths, thereby helping them to become responsible persons in society. What is envisaged here is a further development of the kind of informal training that some of the production units are already offering.

In a thought-provoking article entitled "The Case of Central Asia: Non-formal Skills Training as a Tool to Combat Poverty and Unemployment," Kamol Jiyankhodjaev points to the considerable success of informal education in central Asia. More specifically, in Kyrgyzstan, Tajikistan, and Uzbekistan such skills are shown to have played an important role in combating poverty and unemployment. Jiyankhodjaev further contends that "non-formal education (NFE) and training contributes toward alleviating poverty and increasing the overall quality of life. The role of NFE becomes vitally important if opportunities for formal education are not accessible or are limited in size and quality."[44] The general and ultimate good of society must be central when choosing an appropriate educational system, defining its goals, and assessing its quality. In view of the situation on the ground in the Benin locality, where a large number of youths have no form of formal education and no marketable skills—and cannot hope to acquire either in the near future, due to their socio-economic handicaps—informal, hands-on education in the various crafts or entrepreneurial activities of filmmaking offer a good starting point for positive change.

Film is primarily a practical, not a theoretical art. Hence, experts of proven experience and accomplished local filmmakers or videographers should be brought together to constitute a faculty of some sort in the identified film production sites. Over time, the youths training under them in these practice-based film training centers or schools will gain from their expertise and become proficient in the practical aspects of filmmaking they may have chosen to train in. Such proficiency is empowering and, given the youths' insertion within specific production sites, a likely path to productive activity. It can be noted that the Federal Government of Nigeria (FGN), as part of its amnesty program for repentant militant youths in the Niger Delta, has trained some of them at the Film and Broadcast Academy (FABA) in Ozoro-Delta State. Film training is a proven means of empowering jobless youths and of forging their connection to an economic sphere from which they are otherwise excluded.

The youths were trained in screenwriting, acting, music, camera work, scripting, directing, makeup and costume design, among other arts and crafts, for a period of six to twelve months at FABA. The government provided them with all the necessary support, including giving them food allowances. Accomplished Nollywood practitioners such as Richard Mofe Damijo, Segun Arinze, Zeb Ejiro, Fred Amata, and Chico Ejiro were brought in to teach and inspire the trainees as well as give them the necessary contacts to provide them with a soft landing in the industry.

The proposed acquisition of filmmaking skills by Benin youth can be likened to the idea of value adding, as put forward by Jerry Mander.[45] According to Mander, the notion of "value added" is one of the elements within the creative matrix of commercial or economic value. Agreeing with Mander, Stephen Ogunsuyi argues that thinking about value adding is traceable to all the processes that alter a raw material from something with no intrinsic economic value to something that has precisely that form of value.[46] Each change in form, say, from iron ore in the ground to iron or steel, and then to a car that is heavily advertised, adds value to the material. It is, therefore, in the very nature of profit seeking to convert as much as possible of what has not been processed and exists in its own right into something with the potential for economic gain. In educational contexts, use is increasingly made of the concept of value adding, and it does indeed make economic sense to enable the Benin youth, through film training, to add value to themselves and to their families and communities, by training to become actors, actresses, and screenwriters, and camera men, among other possibilities. The different productive activities within the creative matrixes of filmmaking where cultural and entertainment products are produced have much to offer within a general framework focusing on value adding, for the gains are not merely personal (although they are this too), but more broadly social, and thus not only economic.

To achieve the sort of transformation outlined above, a synergy of efforts involving both local and international organizations is necessary, all of which are expected to mobilize financial and technical support for the proposed program of hands-on, informal film training. This is because its largely artisanal outlook will readily provide the urgently needed atmosphere to equip and empower youth with skills and competencies in diverse areas of filmmaking that may spark their interest and fully engage them. Hence, governmental organizations (GOs) such as the National Poverty Eradication Program (NAPEP), the National Directorate of Employment (NDE), and Bank of Industry (BOI) need to work in concert with Nongovernmental Organizations (NGOs) and other development partners, such as the United Nations Industrial Development Organization (UNIDO), to put necessary structures in place. In doing this, community-based organizations (CBOs)—such as Lift Above Poverty Organization (LAPO)—that focus on poverty reduction, the development of small and medium sized enterprises (SMEs), employment generation, and vocational and technical education should be identified and encouraged to include the local Benin film industry in their programs.

In a relevant study on the video film, Babson Ajibade asserts that "Nigeria is a country with vast social and economic possibilities."[47] And in a forthcoming

article entitled "An Assessment of the Economics of the Benin Language Film in Nigeria," Omoera argues that the viability of the Benin video film creates room for economic and artistic possibilities.[48] Following these sorts of arguments, development agencies should be encouraged to map out training programs for the unemployed and crime-prone Benin youth, using identified production sites within the Benin locality as centers of teaching and learning. A good number of these youths will over time become responsible and self-reliant and could even become employers of labor if the right environment is provided. Those involved in developing the various production companies into sites of teaching and learning should be mindful of the profiles of the youths with whom they are working. Different categories, arguably with different needs, exist: (1) those with formal education but without jobs or any marketable or entrepreneurial skills or competences; (2) those without formal education or without any form of education at all; (3) those who may still be in school but need one form of hands-on training or the other so that they do not graduate to swell the number of unemployed youth in the locality.

Filmmaking is a collaborative business that incorporates the inputs of a number of creative hands. In the context of a discussion of the development of the Nigerian film industry, Hyginus Ekwuazi has noted that "there are 253 trades and professions involved in a movie production according to academy standards."[49] The youths can be encouraged to choose to train in any of the arts, trades, crafts, or sciences within the filmmaking matrix. If the Benin youth in question were to be trained in these different specialist crafts of film production, a form of empowerment would have been created. Also, the growing Benin video film subsector of Nollywood would receive a boost, with more artists and artisans seeking their livelihood within the industry. There is, without a doubt, a huge population and market to support this growing creative business. In "Nigerian Video Film Cultures," Melita Zajc observes that filmmaking, which for a century was a privilege of the richest while the poor could only afford the cinema ticket, has been transformed into an informal, private sector–based enterprise in Nigeria.[50] Many marginalized but innovative urban youth could actually acquire skills and earn a decent living by producing cultural and entertainment products for the Nigerian populace whose attraction to the video industry has been established.

To build a progressive and stable society, Joy Umobuarie suggests that CBOs, GOs, NGOs, and political leaders should "pay attention to the needs and aspirations of the youths" who are "invaluable assets" with clear implications for a given society's future.[51] Public office holders and leaders at all levels must shun the primitive accumulation of wealth and other corrupt tendencies, which appear to be the bane of contemporary Benin society. The point being made is that if the present greed of the political class combines with the massive poverty, youth unemployment, and almost complete absence of social support structures, Nigeria may well go under.

As the Nigerian elite flaunt their ill-gotten wealth, it will be difficult to convince the youth to shun antisocial behavior without a corresponding plan meaningfully to engage them in sustainable livelihoods. The elite has much at stake in investing some fraction of their resources toward setting up and strengthening

skills acquisition centers, reformatory institutes, and the arts and culture industries, as part of a panoply of concrete strategies constructively to engage the growing untrained and crime-prone youth population in Benin and other areas of Nigeria.

Conclusion

Digital cinema is ultimately the future of the global motion picture phenomenon and Nigeria appears to have taken advantage of new technologies to carve a niche for itself in this evolving film culture. At least from the standpoint of output, Nollywood has an undeniable "presence," even though training in its various strata is largely informal. However, this study finds that stakeholders, including the government and other development agents, have yet to exploit the huge potential of this entirely home-grown creative culture to deal with the challenges of poverty, unemployment, and crime that currently beset many areas of Nigeria, including the Benin locality. At another level, the creative output of the various strata of Nollywood could contribute to the transformation of the Nigerian economy from a largely primary commodity exporter to one of higher values, of the kind that are in greater demand today in the global economy.

In sum, the claim is that an effective hands-on training program aimed at exploring the abundant economic possibilities inherent in the film industry for the benefit of Nigerian society is very much needed. Modest but concrete efforts in the Benin video film area of Nollywood could transform the art and business of moving images into a more functional resource capable of combating the challenges of youth restiveness, social deviancy, kidnapping, street gangs, armed robbery, and other antisocial behavior confronting the Benin locality and, by extension, the Nigerian society of today. A planned and sustained practice-based film education, delivered in the context of functioning production centers rather than universities and film schools, and with the support of governments, development agencies, arts and culture promoters, and stakeholders within and outside the Benin community in Nigeria, will make a considerable impact in response to questions of crime, youth unemployment, and poverty.

Notes

1. United Nations Conference on Trade and Development (UNCTAD), *Integrating Developing Countries' SMEs into Global Value Chains* (New York and Geneva: United Nations, 2010), 99.
2. Paul U. Ugor, "Youth Culture and the Struggle for Social Space: The Nigerian Video Films" (PhD Diss., University of Alberta, 2009), 4.
3. Otive Igbuzor, "The Millennium Development Goals: Can Nigeria Meet the Goals in 2015" (paper presented at a symposium on Millennium Development Goals and Nigeria: Issues, Challenges and Prospects, organized by the Institute of Chartered Accountants of Nigeria [ICAN], Abuja, Nigeria, July 27, 2006), 3–4.

4. Patrick E. Iroegbu, "Active Poverty as Elusive Culture in an African Political Environment: Implications for the Vulnerable Population in Nigeria," *Enwisdomization Journal* 4, no. 3 (2010): 65.

5. Jonathan Haynes, "'Nollywood': What's in a Name?" *Film International* 5, no. 4 (2007): 106; UNESCO Institute for Statistics, "Analysis of the UIS International Survey of Feature Film Statistics: Nollywood Rivals Bollywood in Film/Video Production" (Paris: UNESCO, 2010), 1, http://www.uis.unesco.org/FactSheets/Documents/Infosheet_No1 _cinema_EN.pdf (accessed December 19, 2012).

6. Igbuzor, "The Millennium Development Goals," 1.

7. UNDP, *Millennium Development Goals: A Compact among Nations to End Human Poverty* (New York: Oxford University Press, 2003), 4; Uma S. Kambhampati, *Development and the Developing World* (New York: Blackwell Publishing Inc., 2004), 96; National Economic Empowerment and Development Strategy [NEEDS], *National Economic Empowerment and Development Strategy Report* (Abuja: National Planning Commission, 2004), 2; Shetty Salil, "Millennium Declaration and Development Goals: Opportunities for Human Rights," *International Journal on Human Rights* 2, no. 2 (2005): 66; C. Abani, Otive Igbuzor, and J. Moru, "Attaining the Millennium Development Goals in Nigeria: Indicative Progress and a Call for Action," in *Another Nigeria is Possible: Proceedings of the First Nigerian Social Forum*, ed. J. Moru (Abuja: Nigerian Social Forum, 2005), 5–6; Ugor, "Youth Culture and the Struggle for Social Space," 11; Felix E. Enegho, "Philosophy as a Tool for Sustainable Development in Nigeria," *Enwisdomization Journal* 4, no. 3 (2010): 2–3; Tekena N. Tamuno, *Oil Wars in the Niger Delta 1849–2009* (Ibadan: Stirling-Horden Publishers Ltd., 2011), 83; Jimi Kayode and Raheemat Adeniran, "Nigerian Newspaper Coverage of the Millennium Development Goals: The Role of the Media," *Itupale Online Journal of African Studies* IV (2012): 2.

8. I. A. Ademiluyi and O. A. Dina, "The Millennium Development Goals and the Sustainable Future for Nigeria's Urban Environment: A Railway Strategy," *Journal of Human Ecology* 33, no. 3 (2011): 203.

9. UNHD, *Least Livable Countries of the World—United Nations Human Development Report* (New York: United Nations, 2006), 1.

10. NESG, *17th Nigerian Economic Summit* (Abuja: NESG, 2011).

11. Ademiluyi and Dina, "The Millennium Development Goals," 204.

12. UNDP, *Human Development Index and its Components* (New York: United Nations, 2010), 1, http://hdr.undp.org/en/media/HDR_2010_EN_Table1_reprint.pdf (accessed January 10, 2012); Tammy Ballantyne, Angélique Saverino, Xoliswa Sithole, Florence Mukanga, and Mike van Graan, compilers, *Arterial Network Arts and Culture Information Directory 2011* (Cape Town: Arterial Network, 2011), 27, http://www .arterialnetwork.org/uploads/2011/09/Arterial_Network_Directory_2011_(1).pdf (accessed January 7, 2012).

13. Wale Omole, "Nigeria at 50 Searching for Gold with a Corroded Pathfinder," *The Constitution: A Journal of Constitutional Development* 10, no. 3 (2010): 2.

14. Jonathan Haynes, "Introduction," in *Nigerian Video Films* (revised and expanded edition), ed. Jonathan Haynes (Athens, Ohio: Ohio University Centre for International Studies, 2000), 13.

15. Ibid.

16. Ibid., 13–14.

17. Ibid., 18.

18. Babs F. Fafunwa, *History of Education in Nigeria* (Ibadan: NPS Educational Publishers, 2002), 3.

19. Austin Emielu, "Music and National Development: A Reflection on Academic and 'Street' Musicianship in Nigeria," *The Performer: Ilorin Journal of the Performing Arts* 10 (2008): 96.

20. Mathew Umokoro, *The Performing Artist in Academia* (Ibadan: Caltop Publications, 2000), 8.

21. Kamol Jiyankhodjaev, "The Case of Central Asia: Non-formal Skills Training as a Tool to Combat Poverty and Unemployment," *Adult Education and Development* 77 (2011): 159.

22. Jacob U. Egharevba, *A Short History of Benin* (Benin City: Fortune and Temperance Publishing Company, 2005), 1; Naiwu Osahon, "The Correct History of Edo," http://www.edo-nation.net/naiwu1.htm (accessed December 20, 2012).

23. Rebecca N. Agheyisi, *An Edo-English Dictionary* (Benin City: Ethiope Publishing Corporation, 1986), 39; O. S. B. Lawal-Osula, *Edo-Benin Grassroots Voice* (Benin City: Arala Osula Press, 2005), 2; Osahon, "The Correct History," 1.

24. Osakue S. Omoera, "Benin Visual Literature and the Frontiers of Nollywood," *International Journal of Multi-Disciplinary Scholarship (Special Issue – Motion Picture in Nigeria)* 3–5 (2008): 234; Osakue S. Omoera, "A Taxonomic Analysis of the Benin Video Film," *Ijota: Ibadan Journal of Theater Arts* 2–4 (2008): 51.

25. Osakue S. Omoera, "An Assessment of the Economics of the Benin Language Film in Nigeria," *Quarterly Review of Film and Video* 31, no. 5 (forthcoming).

26. Hyginus Ekwuazi, "Perspectives on the Nigerian Motion Picture Industry," in *Making the Transition from Video to Celluloid*, ed. Hyginus Ekwuazi, Mercy Sokomba, and Onyero Mgbejume (Jos, Nigeria: National Film Institute, 2001), 9.

27. Jonathan Haynes, "A Literature Review: Nigerian and Ghanaian Videos," *Journal of African Cultural Studies* 22, no. 1 (2010): 109.

28. Alessandra Meleiro, "Nigerian and Ghanaian Film Industry: Creative Capacities of Developing Countries," *Revista de Economía Política de las Technologías de la Información y Comunicación* XI, no. 3 (2009): 6.

29. Iroegbu, "Active Poverty as Elusive Culture," 48.

30. Pat Utomi, "Kongi is a Spirit," *The Punch* (Nigeria), May 23, 2012.

31. Ugor, "Youth Culture and the Struggle for Social Space," 7.

32. UNESCO, *Youth in the 1980s* (Paris: UNESCO Press, 1981); United Nations, *The Globalization of Youth in the 1990s: Trends and Prospects* (New York: United Nations, 1993); Ugor, "Youth Culture and the Struggle for Social Space."

33. Osakue S. Omoera, "Reinventing Igbabonelimhin: An Icono-Cultural Emblem of the Esan," *Journal of the Nigerian Association for Semiotic Studies* 2 (2011): 59.

34. Wale Omole, "Rethinking Tertiary Education Financing in Nigeria," *The Constitution: A Journal of Constitutional Development* 11, no. 3 (2011): 66–67.

35. UNESCO, *Youth in the 1980s*, 17.

36. Ugor, "Youth Culture and the Struggle for Social Space," 4, 5.

37. Kandeh K. Yumkella, "The Bank of Industry 10th Anniversary Lecture" (paper presented at the tenth Anniversary of Bank of Industry of Nigeria, Ibadan, Nigeria, December 16, 2011), 16.

38. Freedom C. Onuoha, "Yet Unanswered? The Youth and Gender Questions in a Decade of Democratic Governance in Nigeria," in *A Decade of Redemocratisation in Nigeria: 1999–2009*, ed. O. S. Ilufoye, O. A. Olutayo, and J. Amzat (Ibadan: Department of Political Science, 2009), 176; Freedom C. Onuoha, "Youth Unemployment and Poverty: Connections and Concerns for National Development," *International Journal of Modern Political Economy* 1, no. 1 (2010): 115; Freedom C. Onuoha, "Religious

Violence and the Quest for Democratic Consolidation in Nigeria: 1999–2009," *The Constitution: A Journal of Constitutional Development* 11, no. 3 (2011): 8.

39. Mwenda wa Micheni, "African Filmmakers Meet in Nairobi to Count Blessings and Plot," *African Review*, February 14 (Nairobi: Nation Media Group, 2011), 5, http://www.africareview.com/Arts+and+Culture/Africa+got+a+reason+to+celebrate/-/979194/1107332/-/xdo84xz/-/ (accessed February 16, 2011).

40. Practitioner's interview, conducted by Osakue S. Omoera, November 28, 2011.

41. Centre for World Indigenous Studies, *International Day of the World's Indigenous Peoples – Celebrating Indigenous Filmmaking* (New York: United Nations, 2010), 1, http://www.un.org/en/events/indigenousday/ (accessed December 20, 2012).

42. Harold Jowitt, *Principles of Education for African Teachers* (London: Longman and Green, 1958), 48.

43. Emeka T. Nwabuoku, "Cultural Dissonance and Tenacity: The Aniocha Paradigm," in *Theatre Arts Studies: A Book of Reading*, ed. Dapo Adelugba and Marcel A. Okhakhu (Benin City: Amfitop Books, 2001), 103.

44. Jiyankhodjaev, "The Case of Central Asia," 170.

45. Jerry Mander, *Four Arguments for the Elimination of Television* (London: The Harvester Press, 1980), 118.

46. Stephen A. Ogunsuyi, *African Theatre Aesthetics and Television Drama in Nigeria* (Abuja: Roots Books and Journals, 2007), 39.

47. Babson Ajibade, "From Lagos to Douala: The Video Film and its Spaces of Seeing," *Postcolonial Text* 3, no. 2 (2007): 1, http://postcolonial.org/index.php/pct/article/view/524/418 (accessed January 7, 2012).

48. Omoera, "An Assessment of the Economics of the Benin Language Film."

49. Hyginus Ekwuazi, "Nigerian Literature and the Development of the Nigerian Film Industry," *Ijota: Ibadan Journal of Theatre Arts* 1, no. 1 (2007): 130.

50. Melita Zajc, "Nigerian Video Film Cultures," *Anthropological Notebooks* 15, no. 1 (2009): 74.

51. Joy O. Umobuarie, "Empowering the Youth through Weaving," *Emotan: A Journal of the Arts* 4 (2010): 142.

3

Global Interchange: The Same, but Different

Rod Stoneman

International Relations: The Imposition from Elsewhere

Reflecting on international film and media training in the current epoch, we inevitably navigate within the framework imposed by a global monoculture. Even the terms and categories of this discussion—"film" and "media," "training" and "education"—carry complex distinctions and connections that are ultimately caught up in the multiform contention of power relations between different parts of the world. Over the last ten years, I have been involved in several small-scale initiatives bringing new filmmakers from the south together for short series of workshops to develop and strengthen their projects. Inevitably they begin by negotiating existent structures and dominant ideas of film production both within their cultures and outside of them. Both filmmakers and their eventual audiences are unavoidably influenced by the modes of representation that are part of a cultural industry that has spread across the world, but was manufactured elsewhere. Part of the process of training is to define and strengthen the direct speech of indigenous voices in film and other media that may take or leave elements of an imposed monoculture.

Many of the prevailing cultural modes that envelop and penetrate indigenous cultures encounter degrees of resistance, and there are significant counter-flows against the centripetal movement that carries dominant models toward prevalence. Digital means facilitate mash-ups that challenge the one-way flow of television and cinema; hip-hop and laptop music mixing create new versions of combined music. Graffiti changes the visual fabric of the city and offers a sub-environment with stencils, tags, and pieces that move around the edge of our everyday vision in cities. The subculture of street graffiti and tags may have emanated from subways in New York[1] to skateboard arenas in Los Angeles in the 1970s but they now reach vehicles and walls in the whole world's urban spaces, a route for artisanal and libertarian access to the public domain.[2]

There are also sets of economic and technological factors that have changed the cultural environment decisively over the last decades and continue to affect it. The political economy sets some of the parameters, while global connections enable finance and labor to flow in new patterns that maximize capital accumulation. The reciprocal interaction of economic factors with technological developments also supports the centralized dissemination of the audiovisual. But as the conflict over copyright and downloading indicates, counterculture can realize strong and effective action to deflect commercial control. Shops and stalls selling pirated videos in Amman or Hanoi or Caracas also seek to insinuate the indigenous among the most recent outputs of Los Angeles studios; much Bollywood distribution works in this way and Nollywood is entirely sold by DVD networks.

The reductive and negative misperceptions of southern cultures established in previous centuries during a colonial era are still layered into modern ideologies in the reproduction of Otherness.[3] Edward Said's *Orientalism* and *Culture and Colonialism*[4] offered a critique of historical impositions in the 1980s and explored the interrelationship between both cultural and material exploitation. The postcolonial politique has had some significant impact though this has largely been confined to the academic domain: to courses, conferences, and publications that open up these issues. However, many of the ideological assumptions and global imbalances that were analyzed and exposed in Said's critical account are still widespread in forms of popular culture that reproduce the hegemony of the north as the place to be, the way to look, and the lifestyle to aspire to. The epoch of colonialism has been brought to an end, but the representational and power relations are still operative in the contemporary recycling of the orientalist clichés, albeit in less overt ways.

News reporting and factual genres representing the global south often take the form of superficial and inaccurate parachute journalism. Michael Grade, when he was chief executive of Channel 4, launched *South*, a magazine program made by filmmakers from Africa, Asia, and Latin America and quipped that "most British television research into the third world takes place in Terminal 3 of Heathrow airport."[5] In the last 20 years, the declining budgets available to newspapers and television stations has led to a reduction in the number of foreign correspondents with the beginnings of local knowledge that any western news organization can afford to keep in the field. However, there is a new and positive version of direct speech from the south—material shot and uploaded to YouTube by nonprofessionals reporting human rights abuses and often challenging aspects of northern news reporting. Direct speech was a central concept to many areas of commissioning and programming in the early period of Channel 4's existence; in the department I worked in this was evident in *People to People*, a community access strand, and *Cinema of Three Continents* and *South* for the third world. At least there is reduced mediation of the images when uploaded material is selected and verified for broadcast.[6]

The very high degree of selectivity in factual representations can take fact toward what we normally understand as fiction. It is not that the depictions are untrue in any simple way, but that they are such a chosen, partial medley that

they may frequently be contested as misrepresentation, a drastically incomplete or biased picture from start to finish. The sense that reported "facts" are one-sided or deficient often arises if we are involved in the issue depicted and have a sense of its complexity. It is then that the truncated and misshapen version offered by the professional media comes into starker focus. We somehow comfort ourselves with the disingenuous assumption that when we ingest television news bulletins we are watching summary updates on local and world events in order to be better informed. However it is often true that they function as pleasurable distractions, a succession of out of focus fragments that float past without offering us the analysis or background that could provide a deeper framework for understanding.

Even the formal arrangements of news formats impose specific understandings of the world: binary thinking and structures of repetition, narratives used to interpret complex situations in countries distant from the transmission centers. The sets, the presenters behind their uncluttered desks, reading autocues *over* emphasizing arbitrary *syll*ables to inject meaning into a bland *text* that they have not written and have no relationship with. Studio newsreaders frame short sequences mediated by reporters striding toward the camera, explaining the world, the imprimatur of reality visually present over their shoulder.

It is significant that non-western news sources replicate existent formats exactly; Al Jazeera, Al Arabyia and teleSUR are carbon copies of western news designs. But within these formats there are important nuances of perspective and perception, the underlying viewpoint is often significantly different and this can provide a commutation test. Newspaper, television, and online practices

Figure 3.1 *Cross Cultural Television*, Hank Bull and Antoni Muntadas/Western Front Video Production, 1987.

appear to work within the established genre of factual reporting, retaining the status of balanced and truthful coverage bolstered by both sourced and anonymous quotations. Although the format is ubiquitous, it is regularly misused. To take an example from Latin America, there are many consistent stories about Hugo Chávez that look like traditional journalistic reports, but are disingenuous and dissembling as they are clearly an ensemble of meanings intentionally put together to create an overall sense that Chávez was authoritarian and ridiculous and the attempted social revolution in Venezuela a failure.[7] The black propaganda has already been effective in creating a loose penumbra of negative connotations around Chávez and his politics. The repeated application of such pejorative reporting has led most people, even those on the liberal left, to assume that Chávez was some combination of clown and dictator and that any supposed attempt at social change in Venezuela over the last ten years has been a complete disappointment.

The flows of media are accessed by broad and unstable categories: documentary and fiction, magazine programme and chat show, advertisement and reality television. Fiction features and television drama formats mostly emanate from the bottom left hand corner of the United States. They constitute a dominant mode of representation that continues to pervade our screens. As Robert Olson noted in *Hollywood Planet*, we live in a world where the global audience is 100 times more likely to view a Hollywood product than a film from elsewhere—Africa, Asia, Latin America, even English speaking Europe, Canada, or Australia.[8] The 2005 UNESCO "Convention on the Protection and Promotion of the Diversity of Cultural Expressions" reaffirmed the role of free-flowing cultural exchange in the full realization of human rights, fundamental freedoms, and sustainable development.[9] But many western spectators cannot even guess what films from distant or foreign places could look like because they have not encountered them.

Images are taken and then reimported to the locals by a dominant cinema that even their national television seeks to imitate. Telenovellas, popular Latin American soap operas, generally dramatize the loves and losses of the white, wealthy elite; illicit romances and dangerous liaisons are played out in marble villas or in the backs of sports cars. And the indigenous Indian woman who sits glued to the screen every night enjoying her favorite drama watches herself being acted out of history. The possibilities of intelligence and curiosity that should arise from our encounter with an unfamiliar place or culture on another part of the planet are diminished and dislocated; these settings are absorbed by narratives that contain them as potential tourism within images that can be adequately controlled and sold.

An omnivorous global phenomenon like *Avatar* (dir. James Cameron, 2009) centers on a two-and-a-half hour feature watched (in 2D or 3D versions) in a short period of time by a high proportion of the world's population.[10] At a superficial level, there are aspects to the text that catch the eye as progressive, but as Slavoj Žižek has pointed out, beneath the would-be liberal implications on the surface of *Avatar* lies the reactionary myth that it is (still) only benevolent whites who can save the natives.[11]

Another redemptive narrative that expresses the underlying compassion and munificence of the West is *Born into Brothels* (dir. Zana Briski and Ross Kauffman, 2004). This Oscar-winning documentary describes a workshop using photography to help the children of sex workers in Calcutta. The children's parents are shown as incapable and the American photographer and filmmaker is constructed as the children's only hope, their agency for redemption, as she is the only caring person able to offer the children an opportunity to escape from their oppressive environment and the chance to find fulfillment elsewhere. But again *Born into Brothels* raises questions about the provenance and determinations of the images and sounds we have been listening to. A partial story told by whom? For whom?

I was present at the Havana film festival in 1985 for the premiere of *Missing* (dir. Costa Gavras, USA, 1982). On that occasion the Cubans greatly appreciated that the stars of the movie, Jack Lemmon and Sissy Spacek, had broken the American embargo on the island and come to Cuba to be present at the screening. But, in the bar afterwards, I heard the quiet mutterings of reasonable reproach: "It took the murder of the one American boy in the football stadium to get a movie made about the coup in Chile." There is an exchange in Michelangelo Antonioni's 1975 fiction film *The Passenger* when the journalist, played by Jack Nicholson, proposes an interview with an African tribesman who says "Mr. Locke there are perfectly satisfactory answers to all your questions, but I don't think you understand how little you can learn from them. Your questions are much more revealing about yourself than my answers will be about me."[12] Without dismissing or diminishing progressive films made by northern filmmakers, the imperative at this point in time surely should be to develop and circulate direct speech from the south. What is needed are new voices that will offer, in addition to new narratives and perspectives, different modes of thought.

The Role of Workshops: Capacity Creation

Training collaborations between the north and south contribute to building the capacity for new formations of indigenous filmmaking from those cultures that have been made peripheral. At their best, short-term workshop interventions are small-scale openings for the exchange of ideas and expertise. These interventions are often based on the model of the short peripatetic project-focused workshops developed in 1988 by European Audiovisual Entrepreneurs (EAVE) and funded by the EU MEDIA initiative. Combining experienced practitioners from the north and south with participating filmmakers from the region, they function as the temporary space for interchanges as compared with the more fixed transmissions of such permanent structures as state-run film schools. Various involvements in workshop series in the Maghreb, Vietnam, West Africa, and the Middle East over the last ten years have been revelatory and formative for me.[13]

Joining the team at the end of the first year of Med Film Development in Marrakech in December 2006, I became involved in pedagogically shaping a further two years of that EU funded project. Working closely with Dora

Bouchoucha and Lina Chaabane of Sud Ecriture on a francophone script development workshop founded in 1997 and based in Tunis, it was immediately clear to me that their approach was informed by their work in an independent production company, Nomadis Images, making fiction films such as *Satin Rouge* (*Red Satin*; dir. Raja Amari, Tunisia, 2002) and *Les Secrets / Anonymes* (*Buried Secrets*; dir. Raja Amari, Tunisia, 2009) and documentaries like *It Was Better Tomorrow* (dir. Hinde Boujemaa, Tunisia, 2012). We went on to organize Beyond Borders, a MEDIA-funded workshop held in Djerba in July 2010 and this collaboration has continued with Med Film Factory based in the Royal Film Commission in Amman, Jordan, which began in 2011 and runs for three years.[14] The starting point for offering experience and expertise from the West is a commitment to indigenous forms, which leads to approaches to training that are based on experiment and choice. What is sought is the encouragement of diversity rather than the western industrial model of replication and mimesis in formulaic filmmaking.

The holistic approach we adopted ensures that the creative and financial elements are seen as integrally related. European training, in the 1980s and 1990s, had begun to adopt a "businesslike" approach; fuelled by a desire for film to be understood as an industry with serious economic potential, the model privileged entrepreneurial producers and underplayed creative dimensions. We developed workshop series that were addressed to writers, producers, and directors, but in a way that ensured that the delineation of interlocking functions were thought through in the process. In one Marrakech session, a counterintuitive role-reversal exercise involved the project producers outlining the narrative and creative elements and the directors talking through the financial plan.[15]

Working through the parameters of proposed projects over a one-year period is a productive starting point for understanding international interchange—the reflexivity and pluralism of critical practice offers an implicit challenge to dominant models and carries ideas through to new forms of fabrication. The expositions from the south relativize an insular and self-perpetuating image system from the north; such discourses may begin as productions of individual self-expression by the filmmaker and can go on to realize a broader social effect as they spread through their audiences.

Clearly, the terms of academic activity and judgment deployed in global exchanges are not neutral or objective, but specific and determined. Without conscious or conspiratorial intent they can reinforce the channels of one-way transmission and influence and efface the way in which Otherness is manufactured, experienced, and understood in the world. Anglophone conceptions of knowledge and methods of teaching are institutionally widespread. The tunnel vision of the western academy often replicates structures of knowledge that transmit discourse and power from the north to the south of the world. It is often preferable, in relation to many systems of education based on western models, to break with the mode of secondary education and its process of memorized regurgitation, learning by rote, and individual assessment for exams. Instead, one can explore the reconstitution of the experience of primary education with its focus on play, curiosity and exploration, and group work.

It is in the small print of our transactions and tools of understanding that we find the traces of Eurocentric ideological process: although the 1973 Gall-Peters projection challenged previous two-dimensional maps of the world, the Mercator projection that inflates the sizes of regions according to their distance from the equator is still the most commonly used.[16] The history of the development of color film was dominated by the need to reproduce Caucasian skin tones. Indeed, the color of Technicolor was specifically chemically balanced with this in mind, a process always understood as natural and neutral. Representing the company, Natalie Kalmus addressed Hollywood technicians about "Colour Consciousness": "An enhanced realism enables us to portray life and nature as it really is."[17] Godard famously refused to use Kodak film during a 1971 assignment in Mozambique on the grounds that it was "inherently racist." Hegemony is present even in the telephone number system—the US code is 00 1.

Short-term works based on practice-based collaborations can transform conceptual relations between places and people into reciprocal activity; minor alteration and thoroughgoing change are both possible by bringing ideology into visibility, relativizing and undermining those pervasive but imperceptible forms of influence.

The three personal examples below are used to illustrate aspects of the global dynamic between cultures. They emanate from an earlier period when I was working for British television to support the production and transmission of films from the south, part of a policy to increase the volume and presence of direct speech from Africa, Asia, and Latin America on Channel 4 by screening a wider range of cinema. This was developed and carried out within the Independent Film and Video department, led by Alan Fountain and with Caroline Spry.[18] They illustrate the provenance of my understandings and raise issues about the dynamics involved in the construction and circulation of films from all parts of the world. They also underline the necessity of supporting the development of a continuous capacity for direct production in the south and, in my mind, carrying that production to wide reception in the north. I have found them useful in opening up debates about training processes.

1) Space and perspective in images of war: The Wild Field

In 1991, I went to Hanoi several times to view and select feature films as part of the programming of a season called Vietnam Cinema. Some of the films dealt with the war, but most of them were concerned with other aspects of experience and were part of our attempt to bring a wider range of world cinema to British television screens. The eight-week season was scheduled for transmission when, at the last minute, Liz Forgan (the head of Factual Programmes) explained that it would have to be cancelled and delayed. The logic was explained in a fierce exchange of memos: the first Gulf war had just begun and she felt it was inappropriate for the channel to be showing films that "depict American soldiers being killed when real American soldiers are dying in the desert." I tried to explain that

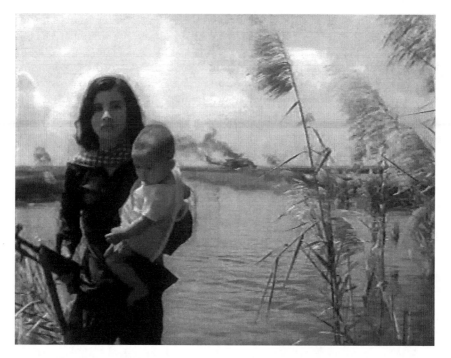

Figure 3.2 *The Wild Field.*

the indigenous Vietnamese films were broadly humanist and even antiwar in approach and that they could not be described as simply "anti-American." This was to no avail—it was a "judgement of taste"; the season had to be delayed until the war was over.

So many films have been produced *about* Vietnam while the nuances and complexities of its own culture and cinema remain hidden; our visual memory is already saturated with images of this country, but only seen through western viewfinders. We recognize the familiar sight of the boy on the back of an ox rising out of the rice paddy field from some of the 600 cinema and television films that Hollywood has produced over the years. When we think of the Vietnam War, it is the American movie genre that looms into view; even the label is different, for the Vietnamese call it the "American War" (to distinguish it from the "French War" and the "Japanese War"). Indigenous films from Vietnam are invisible and unavailable. With the exception of *The Green Berets* (dir. John Wayne and Ray Kellogg, USA, 1968)—the only American film made while the war was being fought and with the motive of overtly supporting government policy—the many well-intentioned, "liberal" movies like *Apocalypse Now* (dir. Francis Ford Coppola, USA, 1979) or *Platoon* (dir. Oliver Stone, USA, 1986) act out moral dilemmas, issues, and conflicts that seem distant and irrelevant when viewed from a non-American perspective. Inevitably, it is films like these that provide the terms and assumptions with which western audiences understand that particular war as well as more current conflicts.

The perspective is physically and dramatically reversed in *The Wild Field* (dir. Hong Sen, Vietnam, 1979), one of the Vietnamese films we screened in the Channel 4 season, for in this film the attacking swoops of helicopter gunships are viewed from the ground. The young couple and their small baby boy live on a platform and hut suspended on bamboo poles above the flood plain of the Mekong Delta, which are adjusted seasonally according to the water level. There is a sequence where they have to dive beneath the surface to hide from predatory American helicopters (they breathe underwater though hollow reeds and hide their baby underwater in the bubble of an air-filled plastic bag). This is in stark contrast to our experience of the aggressive exhilaration of a formation of choppers, accompanied by Wagner, swooping on a Vietnamese village from a height in *Apocalypse Now.*

The questions asked by *Loin du Vietnam* (*Far From Vietnam*; dir. Jean-Luc Godard, William Klein, Claude Lelouch, Chris Marker, Alain Resnais, and Agnes Varda, 1967), which was made in France at the height of the war, are still valid for wars in the Middle East: "It is there, all around us, within us. It begins when we start to understand the Vietnamese are fighting for us and to measure our debt to them…Faced with this challenge, our choice in rich societies is simple: we must either implement the physical destruction of all that resists us, a task which risks going beyond our means of destruction, or we must undertake a total transformation in ourselves."

This is not just a question of historical representation, for these examples from films from and about Vietnam that I saw decades ago still seem pertinent when viewing contemporary cinema: the thrills of contemporary films like *Blackhawk Down* (dir. Ridley Scott, USA, 2001) take the viewer to a vicarious version of an adrenalin-soaked soldierly exhilaration in killing. This fiction film brings to mind the disturbing *Collateral Murder* video released by Wikileaks where, on July 12, 2007, a dozen civilians, mostly journalists working for Reuters, and two children were shot from the air by Apache helicopters circling a Baghdad suburb (the voices comment: "Nice"…"Good shooting!" "Thank you"). It is as if the adults and children ("Well it's their fault for bringing their kids into a battle") are figments in a video game, bits of other human beings' bodies blown away as if they were stray pixels.[19] There is a safe psychological and spatial distance that makes violence easier—a military technician in Nebraska becomes a video game player guiding a drone attack in Afghanistan.[20]

Theory: Critical Context

A range of new training practices have been developed in different contexts permitting the framework of critical ideas and theory to play a role in opening a longer-term dialogue around the choices that new generations of filmmakers can make. There is a horizontal articulation between their approaches and a vertical channel extending to the work of previous generations.

The tool box of theory is part of the constructive process of critical reflection, developing forms of viewing and production where detachment allows ideas to

be brought to bear on practical skills. The significance of viewing a wide range of films and developing agile reflexive thought and detailed readings of how meaning is made are crucial in the training and support of new generations of independent filmmakers. The curiosity and experimentation that are encouraged in critical practitioners make their approach distinctive and support the making of films with something to say. This is distinct from and opposed to the fixity and replication of "correct" professional craft training predicated on mimesis—the perpetuation of established methods.

The vocabulary of "theory" draws on ideas and reflections, including those that have emerged from the diverse instances of creative thinking by filmmakers in the past such as Sergei Eisenstein, Maya Deren, Robert Bresson, and Andrei Tarkovsky. Their writings exemplify the brave aspiration to develop their own configurations of sound and image and to think them through as alternatives to the dominant mode of production. As a student in the 1970s and 1980s, I encountered some fruitful examples of filmmaking practice working through theory: Malcolm LeGrice, Noël Burch, Peter Wollen, and Laura Mulvey in England; Jean-Luc Godard, Jean-Marie Straub/Danièle Huillet, Guy Debord, Dušan Makavejev, and Alexander Kluge on the continent.

A pluralist approach to politicized aesthetics should start with the productive interdependence between at least three distinct levels of engagement, each with different audiences: filmmaking oriented toward agit prop, propaganda, and the theoretical/experimental. Agit prop is immediate and addresses urgent and local issues; propaganda works with longer-term subject matter; and, at its most productive, theory and experimentation with radical form can open and shape new forms and spaces for other areas of practice. There is no reason preemptively to confine this third area of political filmmaking to small audiences.[21] Possibilities for reception for indigenous production in the south are also affected by the political economy of the funding and distribution context.[22]

Many southern filmmakers start with a conception of being an auteur who stands against the division of labor encountered in industrial production structures.[23] Directors are generally also the writers of their features (and in many cases they are producers as well). This may offer occasional opportunities to destabilize and challenge the simple and divisive boundaries of both artisanal and industrial approaches. The side effects of the auteurial aspiration became clear at the FESPACO Newsreel workshops held at the Imagine Film School, set up in February 2003 by leading West African director Gaston Kaboré. This small independent school is exemplary—an individual initiative to provide a space for flexible, targeted training that is much more adaptable than that provided by large-scale unwieldy state institutions. FESPACO, the Pan-African film festival, is held in Ouagadougou, Burkina Faso every two years. In 2009, 2011, and 2013 we ran workshops for students, enabling them creatively to shape pieces within a preformed magazine format. In the first year, the newsreel configuration proved difficult for some students because they were worried that it would truncate their artistic choices—for them the priority was to write and realize short fiction films. The concept of the audience is relevant to resolving these contradictions and, as

Orson Welles once suggested in an apocryphal remark, "The lack of limitations is the enemy of art."

Entering the established structures of television and cinema in order to change and undermine repetitive industrial formats and to introduce glimpses of progressive agendas within these frameworks is, in the longer term, imperative. Films found in festivals, at art houses, and on DVDs offer a challenge to dominant genres, but, to be effective, effort is needed to use such possibilities to reach beyond their initially limited audiences. Audience expectations for action narrative can confine the personal filmmaking that emanates from developing countries to festivals and export unless strategies of presentation and marketing are developed to counter this.

2) Textures of tenderness: Zan Boko

Supporting the conditions for direct speech and dissemination on Channel 4, I became aware of the subtle understandings available through different forms of film. Having purchased Gaston Kaboré's *Wend Kuuni* (Burkina Faso, 1982) for screening in *Africa on Africa*—a season on Channel 4 in the summer of 1984[24]—I arranged support for a new feature with this filmmaker with a pre-purchase, a more helpful form of coproduction that provides some finance up-front.

The feature film *Zan Boko* (Burkina Faso, 1988) emerged from this. And in this film there is a moment when two women sit outside their huts in a village

Figure 3.3 *Zan Boko.*

to talk. One woman has a baby and she hands the baby to an elder daughter to look after as they chat: "How's the baby?" "How are things going with your husband?" As they talk there is a lilting sound, for each of them makes a gentle background hum under the other's words; when one is talking, the other is going "mmmm...aahh." Each of their voices hums under the other's speech, and we sense the exquisite granularity of a culture, a moment of recognition—but also of dissimilarity.

What the two women are doing is perfectly recognizable in many cultures. It is an intimate instance of the everyday tenderness that flows between people. Everywhere around the world, women friends have intimate conversations with each other about how their lives and homes are going, how their babies are doing and how their domestic spheres connect. Whether it is in Caracas or Manhattan, Rome or Hong Kong, forms of those exchanges and conversations continue. But the actual texture of the exchange in Moré in the village of Tensobentenga in the countryside outside Ouagadougou is completely specific and different, so there is a double movement of something that can be recognized in other cultures but is also, clearly, a different form and version of it. Actually it is a very calm, gentle, and affectionate interchange, one that is probably more difficult to achieve in busy New York or Paris or any other speedy metropolis. Buried in a feature film narrative the double movement of both strangeness and recognition is exemplary as it relativizes and questions our habitual practices as one of its significant effects. It clearly prompts questioning and curiosity in different places in our lives.

Practice: Inside the Sign

Practice-based training involves working on and thinking about the multiple initial steps necessary to develop actual films; intervening with specific projects, it sets in motion the dynamic between both the scripts and their financial plans. In my experience this process is enhanced when it is possible to shoot and edit a short section from the planned films in a practical workshop context, as this invariably proves to be a productive exercise.[25] Whether this process confirms the strategy and aesthetic or provokes thought about modification, it is always a focused one aimed at strengthening a given project through the concrete shaping of its material. The fabrication of a potential sequence, the making of its meanings, initiates a constructive reflection on it and a dialogue between filmmakers and others. Working with the plasticity of sound and picture is a starting point for understanding the way any film will function in the wider context of its reception.

Getting close to the mechanisms and textures of meaning making reveals the choices that constitute cultural specificity. Cultural difference underpins this process and the tutors on the Med Film Development and Med Film Factory workshops in the Maghreb and Middle East were a careful combination of practitioners from the region and from Europe. Creative work within the area of signification can generate new and explicit forms of knowledge, moving viewers and makers from consumption to analysis. However, some elements of the artistic

process will always remain somewhat opaque and impermeable, emanating from other creative sources in the psyche. Ingmar Bergman once talked of pulling "the brightly coloured thread sticking out of the dark sack of the unconscious. If I begin to wind up this thread, and do it carefully, a complete film will emerge."[26] In Marrakech, Hager Karray, a Lacanian psychoanalyst from Tunis, had detailed and productive sessions with writers and directors asking them to examine where the characters that they were forming in their scripts had "come from."

A holistic approach to training and project development endeavors to relate the financial parameters of production to the creative ones, and vice versa. There is always an integrated movement forward and back between creative and financial factors in filmmaking and a clear sense of the ways they have operated, all of which can be captured with different film production case histories. The time span involved in bringing the filmmakers' projects to the three project workshops held during a 12-month period is significant; across a year these workshops are separated by long periods between the sessions when scripts can be redrafted and budgets rethought. Directors can begin to define and orchestrate all the formal parameters of film form. In this connection, authors as different as Noël Burch and Bruce Block are helpful, for they have written useful formalist analyses that can be deployed for the telling of different stories, in different ways, from different perspectives. The orchestration of the visual parameters of a film (space, line, shape, tone, color, movement, rhythm), outlined in Block's *The Visual Story*, is, for example, a stimulating agenda for directors at an early stage of planning the look of their projects. While directing their attention to schematic visual planning, it does not impose style or format—in fact although they were spelled out at the University of Southern California, Block's parameters can be traced to early Soviet formalism.[27]

Countering dominant modes of production involves thoughtful work with forms of sound in combination with image, a reflection on and provisional renegotiation of normative configurations of signifying materials. At the Royal Film Commission in Amman, Larry Sider (2011) and Gary Sanctuary (2012) worked with filmmakers and editors to examine the choices involved in sound design. Calling attention to the "materiality" of film is an activity that refers to the process of filmmaking and to the physicality of its signifiers, while also inviting consideration of the economic context of a given film. Manipulating the calibrations of meaning making in new work, in combination with watching and studying films—observing the codes by which meaning is made—creates deeper and longer-term understandings than is possible with traditional interpretive explanation. The established academic discipline of Film Studies offers discussion of finished texts in terms of detached interpretations that bear little or no relation to the process of production. Through the conjunction and adjustment of diverse signifying materials choice, purpose, and process come into focus. This praxis can be redeployed by new filmmakers from the south of the world to challenge the image systems in the north that permeate their culture. These filmmakers are caught within a complex and reciprocal dynamic between the world and its image in our most visually mediated societies. The symbolic order connects with a social order and these constantly reinforce and renew one another in what is a

pervasive image system that crosses the globe. And that system reiterates authorized narratives that disclose events deceptively.

Movement between training that integrates making new films with the necessity of analyzing and explaining existent media is a continuing dynamic. Both inform each other and bring the detail of a signifying process into conscious focus. "*Ostranenie,*" "making strange," or "defamiliarization" was a term invented by Viktor Shklovsky in the moment of Russian Formalism, as a means to "distinguish poetic from practical language on the basis of the former's perceptibility."[28] The sequences from *The Wild Field, Zan Boko* and *Tinpis Run* (dir. Pengau Nengo, Papua New Guinea, 1991) are mentioned in this essay as examples of the process and highlight the form and conditions of filmmaking in different cultures.

Examining specific differences between versions of a sequence in a comparative analysis leads to an understanding of the deployment of particular cinematic codes in a given historical context, to insight into the politics of representation. This, in turn, sheds light on the responsibilities attached to different forms of signifying practice. The reflexivity of the text points toward choice and a manipulation of image and sound, to the selectivity that delivers and confirms our understandings.

In film practice, the material methods of constructing a sequence may be made evident or may be displaced and disguised. Western film is characterized by an approach to form that masks its own contrivance. The sound and image relation, whether in a news bulletin, feature film, or short advertisement, works to conceal the practices of coding that are constitutive of it. Social engagement makes demands on the imagination rather than encouraging the replication of dominant forms that disguise their fabrication. Some forms of filmmaking from the south challenge the versions of dominant forms that efface their own operation. There are recent and specific examples of such countering that throw the signifier into focus. Relevant here, historically, are films that we supported or screened with coproduction funds at Channel 4, films like Djibril Diop Mambéty's *Touki Bouki* (*The Journey of the Hyena*, Senegal, 1973) and *Hyènes* (*Hyenas*, Senegal, 1992). And more recent examples include *Tropical Malady* by Apichatpong Weerasethakul (Thailand, 2004), or Abderrahmane Sissako's *Bamako* (Mali, 2006), and Merzak Allouache's *Normal!* (Algeria, 2011), all of which point to renewals of the non-realist project of radical form. The manufacture of these new models of image and sound conjunction brings to the center of attention decisions about form and the way in which form calibrates and positions meanings. Implications for power relations embedded in the process of spectatorship are present at every stage, for as Jean-Luc Godard suggested, "these are the forms that tell us finally what is the bottom of things."[29]

Of course the polysemy or ambiguity in an "open text" has implications for its potential audience, and for the specific conditions of reception. Differences between filmmakers and cinemas within the variegated cultures of Africa, Asia, and Latin America are clear—but there is still a binary opposition to western forms. A moment of dynamic expansion is present precisely at the point when the possibilities of change at the end of postmodernism lead to a renewed version of politicized modernism. This refoundation can be sketched: it would

involve reflexive forms of investigation and would be transmitted through new electronic technologies, developing a dynamic beyond the historical moment of Third Cinema and the reflexive process of Modernism in the West. A dialogue leading to a dialectical synthesis, and to an interdependence working between oppositional filmmakers in different parts of the world, refuses a return to old versions of imitation, which were responses to an uninformed appropriation of the cultures of others; the imported socialist realism of some newly independent African states in one direction or Pablo Picasso's requisition of African masks for *Les Demoiselles d'Avignon* (*The Young Ladies of Avignon*) in another.

3) Transcultural passage: Tinpis Run

Carrying through the coproduction of films for a strand like *Cinema of Three Continents* at Channel 4 was a first direct encounter with a range of filmmakers from the south for me. It brought questions of sequence construction and understanding images from other cultures into the foreground as occasionally local specificity stands in the way of transcultural understanding.

I went to Paris to see the rough cut of *Tinpis Run* by Pengau Nengo, the first indigenous feature film to be made in Papua New Guinea in 1991. Viewing a rough cut, no matter how informal, introduces a delicate dynamic into the editing process; I would try to bring a constructive and supportive approach to this most subtle interaction—and in all cases, whether the filmmakers were Papuans or French or Americans, whoever, I would always be trying to feed responses into an understanding of how the film was going to work, acting as a premonition of

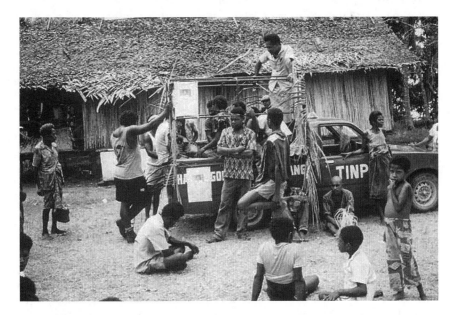

Figure 3.4 *Tinpis Run.*

the audience, without playing the Hollywood producer, wearing jackboots and demanding that "the opening must be re-cut or the ending changed."

I have a memory of viewing a sequence in the rough cut of *Tinpis Run* where there seemed to be a dispute between two men who were arguing outside their houses in a village and then they were scrapping and fighting and then arguing again—it was a confusing mess. I had to say, "I have completely lost the plot here, I can't see what's happening." And the filmmakers explained, "Well the first argument takes place in his village, and then they go to the other guy's village and that's where they have the fight." And I said, "Well how would I know that? They don't travel and it just looks like they remain in the same village!" But they patiently insisted: "Well of course anyone can see they are two different villages because the huts in the first village, which is near the sea, are all two-feet off the ground on breeze blocks, and the huts in the other village, which is up in the mountains, are sitting on the ground." And I said, "Well, thank you for pointing this out to me, but, frankly, that detail is not going to be visible to a Western audience and we need this film to work for British television." However, I hoped I also suggested that this could be dealt with without introducing something completely extraneous into the flow of their filmmaking, just for us. They said they would think about it and they came back with a neat solution: they just added shots of the two guys in a pickup truck going from the first village by the coast into the hills to the other village! They knew that it wouldn't damage the rhythm of the film, or harm the language of the film for their own audience while mere foreigners, who are not used to noticing or understanding the implication of the huts on stilts, could also understand the sequential movement of the narrative better.

A similar issue arose in a more pressurized context with the North American financing of an Irish film, when Miramax, as the co-financiers, looked at a fine cut of the Irish film *Last of the High Kings* (dir. David Keating, Ireland, 1996). There is a sequence where the eldest son and his brothers secretly spike the punch offered up by their mother at a political gathering at their home. As they determine to get everyone drunk at a post election party they pour miscellaneous drink into a bucket to make some highly alcoholic mix, gleefully picking up a bottle and yelling "Poteen—let's use that." Ferdia MacAnna's script was exact—poitín/ poteen is a specifically and highly alcoholic beverage (60–95 percent proof) illegally brewed from potatoes in Ireland. Miramax was concerned that the meaning of this scene would be lost as "poteen" would be an unfamiliar and opaque term to most American cinemagoers. An eventual compromise involved retaining the scripted and culturally authentic "poteen" while adding the extraneous exclamations "moonshine, hooch," dubbed onto to the soundtrack in postproduction.

Connection: The Exchange of a Process of Change

Inevitably, seeing the world from different places leads to different working approaches to all the dimensions of filmmaking, in terms of political perspective and cultural form, as well as to different attitudes toward the use of technology in a production process. The context that is brought to shooting sequences during the

directors' workshop in the Med Film Factory workshops in Amman de-emphasizes the dependence on elaborate equipment encouraged in western production culture. For example during a discussion held at the School of Sound in London in 2011, Gaston Kaboré surprised the audience by talking of the simplicity of means in his approach to using sound and making film. For him, complex digital hard- and software is not the centre of the creative process, which must be based on authenticity and integrity.[30] There are also significant differences in the sense of whom one is making a film for, the emphasis in Kaboré's case being on the film's role and place in his own culture at a particular historical moment.[31]

The differences between polished student work from well-equipped high-tech vocational schools in London or Berlin or New York that provide professional training and the output of peripatetic workshops in Tunis or Ouagadougou or Hanoi can be considerable. The impact of glossy new student films from prominent national film schools in the West generally involves the kind of ego confidence that is necessary for a young person to push into highly competitive, prestigious, and lucrative industrial careers. But, occasionally one can be forgiven for feeling that the meretricious surface and specious content raises the question "Why bother to make this film at all?" Like much of the output of the culture industry itself, many of the films are precisely *about nothing*. The environment in which they are produced encourages such film-school films to manifest a severe disconnect from any aesthetic-cultural or political-social frame of reference.

Many western film schools set student exercises that consist of producing bogus advertisements, of taking a product in order to rehearse the production of a replica commercial for it. The permeation of commodities, it seems, has extended outwards from the over 3,000 advertising images that it is estimated we see every day.[32] The majority of terrestrial and satellite television channels are interspersed with advertisements, as is a large part of the audio and visual landscape (radio, the internet, billboards, newspapers, and magazines). The interruptions in question are part of the rhythm of our existence; they are the very sinew of our culture, and a kind of interference that is so much part of the surrounding visual signal that it is difficult to notice it, let alone criticize it. The spaces of higher educational initiatives provide opportunities to assess the impact and implications of consumer culture in late capitalism. If young filmmakers are exposed to some form of critique they will at least possess the critical perspective needed to understand the significance of the flow of commercialized images they are asked to produce, if and when various economic imperatives drive them into work in advertising.

The political economy of the media encourages this—we live in a culture of distraction where short-term, superficial narratives are at the center of media attention while determinant forces in the political economy are seen as insufficiently interesting or attractive to enter the frame of our viewing. We are experiencing an historical moment where, in the judgment of the mainstream media, the considerable scale of the ecological and economic crises does not seem to bring the underlying basis of the social formation into question. There appears to be little appetite to reconsider the overall system and the possibility of retracting

from an economy of perpetual growth. In fact, rather than "wasting a crisis," financial forces continue to press forward against a weakened state sector and, having eviscerated public service television, propose new incursions into the public domain in order to create new mechanisms for making profit in health and education.

It is also true that new filmmakers from the south (who have generally been through a longer and slower process leading to an apprenticeship in filmmaking) are often looking to replicate models from the institutionalized modes of representation, which are, of course, equated with commercial success. But although the filmmakers' aspirations are inevitably influenced by visual hierarchies built elsewhere, the latter are necessarily approached from a different cultural context. As a result of the often contradictory provenance of these filmmakers' work, the films end up having a different potential and often lead to useful workshop debates with a group of peers, with input being further provided by practitioners from the region and elsewhere.

Is it far-fetched to imagine that new varieties of images and sounds might be transposed to other forms and processes? Is there a connection between this kind of transposition and the ways of questioning and working that have been evoked here in connection with various peripatetic workshops? And is the change implied in contemporary versions of art and politics a significant factor? Med Film Development and Med Film Factory workshops have taken place in the Maghreb and Middle East alongside the recent political mobilizations of the Arab Spring. Many of the participants' projects explore the human dimension of politics and the drama of historical change in a time of turbulence.[33]

"Occupy" and "Indignado" movements represent different versions of a concrete claim to the commons and have precipitated a resurgence of interest in understanding social participation in political terms. Movements in different parts of the world are exploring radical shapes for participatory democracy in order to find forms to effect change. The "Plea for Products of High Necessity" issued in 2009 by nine intellectuals from Guadeloupe inspired a resolute reaffirmation of the utopian; it reasserts the need for that which gives meaning to our lives: the poetic, the imaginative, and the reflective and insists on the aspiration to self-fulfillment nourished by music, sports, dancing, reading, philosophy, spirituality, and love.[34]

There is always a difficulty of moving from description and analysis of existent societies to claims about what *might be*, yet new social formations do depend on inventive explorations of the route and the means toward envisaged futures. If the future of film training is to avoid the danger of becoming an appropriated and emptied concept, we have to refind the concrete moments of radical history that can be carried to the future. But, as industrialized culture and its perpetuation through marketing is countered through new progressive praxis, this may also create a starting point for the creation of a more reciprocal and sustainable community in all parts and places; a polyphonic many-sided dialogue begins with an approach to training that engages with the fiercely inequitable divide between north and south.

Notes

1. Mervyn Kurlansky and Jon Naar, text by Norman Mailer, *Watching My Name Go By* (London: Mathews Miller Dunbar, 1974).
2. Julian Stallabrass, *Gargantua* (London: Verso, 1996), 141.
3. Ryszard Kapuscinski, *The Other* (London: Verso, 2008).
4. Edward Said, *Orientalism* (London: Routledge & Kegan Paul, 1978); *Culture and Colonialism* (London: Chatto & Windus, 1993).
5. *South* was launched at the Venezuelan Embassy on September 19, 1991; Terminal 3 facilitated all intercontinental flights at that time.
6. Companies like Storyful work to verify and validate material for networks of broadcasters, "discovering the most relevant content from the social web, filtering actionable news from the noise," http://storyful.com/ (accessed December 17, 2012).
7. Peter Sherwell, "President Hugo Chavez's Revolution in Venezuela Limits Singing in Shower," *The Sunday Telegraph*, November 29, 2009; Rod Stoneman, "The Ever Bizarre Rules of British Journalism," http://www.irishleftreview.org/2010/01/12/everbizarre-rules-british-journalism/ (accessed January 8, 2013).
8. Scott Robert Olson, *Hollywood Planet, Global Media and the Competitive Advantage of Narrative Transparency* (London: Lawrence Erlbaum Associates, 1999), 30.
9. UNESCO, "Convention on the Protection and Promotion of the Diversity of Cultural Expressions," http://portal.unesco.org/en/ev.php-URL_ID=31038&URL_DO=DO_TOPIC&URL_SECTION=201.html (accessed September 9, 2012).
10. It was released during Xmas 2009 and quickly achieved the largest box office gross in history: $2,782,275,172. http://boxofficemojo.com/movies/?id=avatar.htm (accessed December 19, 2012).
11. Slavoj Žižek, "Return of the Natives," *New Statesman*, March 4, 2010, http://www.newstatesman.com/film/2010/03/avatar-reality-love-couple-sex (accessed June 29, 2012). The accounts of Palestinians projecting the film on the walls of houses in Gaza suggest that the superficially radical layer of the narrative can be read in an emancipatory way.
12. Significantly this film was cowritten with Mark Peploe and Peter Wollen. The latter played a key role in introducing politicized structural theory to film studies in the anglophone world.
13. The Hanoi Academy of Theatre and Cinema, Vietnam 2005; a script workshop at Imagine, Ouagadougou, Burkina Faso 2005; Med Film Development, Marrakech, Morocco 2006–2008; FESPACO newsreel workshops, Ouagadougou 2009, 2011, and 2013; Beyond Borders, Djerba, Tunisia 2010; Med Film Factory, Amman, Jordan 2011–2013.
14. http://www.medfilmfactory.com/about.php (accessed December 27, 2012).
15. Devised by visiting tutor David Keating.
16. http://commons.wikimedia.org/wiki/File:Gall-peters.jpg and http://commons.wikimedia.org/wiki/File:Mercator-projection.jpg.
17. Brian Winston, *Technologies of Seeing* (London: BFI, 1996), 43.
18. The Department's work is described in detail in Rod Stoneman, "Sins of Commission," *Screen* 33, no. 2 (1992); republished in *Rogue Reels, Oppositional Film in Britain, 1945–90*, ed. Margaret Dickinson (London: BFI, 1999).
19. http://www.collateralmurder.com/ (accessed July 8, 2012).
20. The experiences enacted in the action narratives of so many war films serve to confirm the predisposition to obedience to authority figures indicated by Stanley Milgram's well-known 1961 experiments at Yale.

21. It is clear from my experience at Channel 4 that, carefully positioned and presented, there are significant audiences for "difficult" work; these practical experiences are discussed in detail in "Sins of Commission."

22. Rod Stoneman, "African Cinema: Addressee Unknown," *Vertigo* Summer/Autumn (1993); republished as "South/South Axis: For a Cinema Built By, With and For Africans," in *African Experiences of Cinema*, ed. Imruh Bakari and Mbye Cham (London: BFI, 1996).

23. Rod Stoneman, "Under the Shadow of Hollywood: The Industrial Versus the Artisanal," *The Irish Review* 24 (1999); republished in *Kinema* 13 (2000).

24. The season was transmitted from 25 June–23 July 1984.

25. My remarks refer to experiences in the context of the Moonstone workshop, held annually in Renvyle, Connemara, Ireland 1999–2003; FESPACO newsreel workshops at Imagine, Ouagadougou, Burkina Faso 2009 and 2011; Med Film Factory in Amman, Jordan 2012.

26. Quoted by Lee R. Bobker, *Elements of Film* (New York: Harcourt Brace & World, 1969), 157.

27. Noël Burch, *Theory of Film Practice* (London: Secker and Warburg, 1973) and Bruce Block, *The Visual Story* (Oxford: Focal Press, 2008).

28. Lawrence Crawford, "Viktor Shklovskij: Différance in Defamiliarization," *Comparative Literature* 36 (1984).

29. "Que ce sont les formes qui nous disent finalement ce qu'il y a au fond des choses," *Histoire(s) du Cinema* 3a, directed by Jean-Luc Godard (Switzerland, 1988–1998).

30. Described in detail in "Isn't it Strange that 'World' Means Everything Outside the West?" an interview with Rod Stoneman in *De-Westernising Film Studies*, ed. Will Higbee and Saer Maty Ba (London: Routledge, 2012).

31. The frame around the work to develop production capacity in film is the simple disparity: Average GNI per capita per annum in Burkina Faso $550 (life expectancy at birth 55 years) and USA $47,340 (life expectancy at birth 78 years). Figures 2007–2011 from http://econ.worldbank.org/WBSITE/EXTERNAL/EXTDEC/0,,men uPK:476823~pagePK:64165236~piPK:64165141~theSitePK:469372,00.html (accessed June 3, 2012).

32. Price Waterhouse Coopers, *Global Entertainment and Media Outlook: 2006–2010* (New York: PWC, 2006).

33. Jean-Pierre Filiu, *The Arab Revolution* (London: C. Hurst & Co., 2011).

34. Ernest Breleur et al., "Plea for Products of High Necessity," originally published in *Le Monde*, February 16, 2009; available from *L'Humanité in English*, http://www.humaniteinenglish.com/spip.php?article1163 (accessed December 18, 2012).

Part II

The Middle East

Branch-Campus Initiatives to Train Media-Makers and Journalists: Northwestern University's Branch Campus in Doha, Qatar

Hamid Naficy

In recent years, several prestigious American and European universities have opened campuses in the Persian Gulf region with the aim of transferring to it knowledge, educational systems, and a whole way of seeing and making the world. This was part of the "internationalization" of American and European higher education, which also included the recruitment and enrollment of large numbers of foreign students at American and European universities. These initiatives were also part of the rigorous efforts of the governments in the Persian Gulf region to import higher education, culture, and media industries in order to develop cultural and other forms of capital and to diversify their economies away from extractive industries such as oil and gas. While these efforts at internationalization and globalization are commendable and productive in many ways, there are certain liabilities associated with them as well. After laying out the terrain, this chapter will deal with a new effort by Northwestern University to create a third campus in Doha, Qatar (the other two campuses are in Evanston and downtown Chicago). The campus in question here offers undergraduate degree programs in two areas—communication and journalism—both of which integrate histories, theories, and practices of film, television, new media, and journalism. The aim is to examine some of the advantages and liabilities of such transfers of media and culture industries, and of educational systems, from the global north to the global south.

Transferring Foreign Students

Internationalization by recruiting foreign students has a longer history than internationalization by campus transplantation. Top-tier American and European

universities (particularly private ones) interested in enhancing their international prestige, budgets, and cultural diversity, have long pursued foreign students. Their numbers are not small. In the academic year 2011–2012, for example, 764,321 international students enrolled in American universities, with the following comprising the top ten sending countries: China (194,029), India (100,270), South Korea (72,295), Saudi Arabia (34,139), Canada (26,821), Taiwan (23,250), Japan (19,966), Vietnam (15,572), Mexico (13,893), and Turkey (11,973).[1] Three of the top five American universities for international students that year were private universities: University of Southern California ranked first with 9,269, followed by New York University with 8,660 (ranked third), and Columbia University with 8,024 international students (ranked fifth).[2] The international students who enrolled at Northwestern University in the fall of 2011 totaled 3,156, with the top five sending countries being China (626), South Korea (322), India (283), Canada (151), and Taiwan (100).[3]

The enrollment of such large numbers of foreign students, particularly from rich countries in the global south, cushioned the private universities of the former colonial and new neocolonial global powers against the vagaries and fluctuations of an increasingly capitalistic global higher education market. The money that international students contributed to the American economy and universities was sizeable. In 2001, they contributed more than US$11 billion to the US economy and almost US$500 million to the economy of the state of Illinois through tuition and living expenses, "making higher education the country's fifth-largest service sector export."[4] The September 11, 2001 attacks on the United States, however, lowered the roster of students and prompted worries among administrators at elite private universities such as the Illinois Institute of Technology, where "almost one-third of the students" came from abroad. The concern, more specifically, was that "restrictive student visa procedures stemming from the war on terrorism could dampen foreign interest in the school."[5] But these worries were overcome, for by the fall of 2006, the number of international students enrolled in American colleges and universities had risen by 3.2 percent and their contribution to the US economy had increased to US$14.5 billion.[6]

Significantly, these funds helped subsidize the education of American students, as many Ivy League schools and top state schools whose budgets had been cut by the state legislatures in the wake of the Great Recession of 2008 (such as the University of California, Berkeley) used the international students' tuition along with the out of state tuition and private donations to fund financial aid to in-state middle-class students.[7] Also, these foreign student funds may have helped shore up the unprofitable humanities programs at the American campuses.

While many of the western-trained international students return home and also contribute to the growth of the economies of their own countries, many others stay in the West after completing their higher education, furthering those countries' industries and economies. Some of the top tech industry leaders and innovators in the United States emerged from this group of international students. Among these are: Pierre Omidyar, eBay founder (French born, Iranian ancestry, BA Tufts University); Sergey Brin, Google cofounder, (Russian born, BA University of Maryland, PhD in progress at Stanford University); Eduardo

Saverin, Facebook cofounder, (Brazilian born, BA Harvard University); Jawed Karim, YouTube cofounder (German born, Bengali-German American, BA University of Illinois, Urbana-Champaign); Steven Chen, YouTube co-founder (Taiwanese born, BA University of Illinois, Urbana-Champaign); and Naveen Selvadurai, Foursquare cofounder (Indian born, degrees from King's College, London, and Worcester Polytechnic Institute, United States). One can argue that by staying in the West these entrepreneurs robbed their home countries of their contribution; but, again, many of these are multi-sited citizens and there is no guarantee that, had they returned to one of their homes, they would have been successful or even welcomed.

Many successful international students give back in other ways, some generously donating funds to their American alma maters. In the case of Iranians, several philanthropists have funded programs designed to encourage the study of their home cultures and society and to beef up the field of Iranian studies. Examples of such donations include the US$10 million gift that two Princeton alumni gave the university to establish the Sharmin and Bijan Mossavar-Rahmani Center for Iran and Persian Gulf Studies in 2012; the US$3 million leadership gift that the Roshan Cultural Heritage Institute (founded by Elahé Omidyar Mir-Djalali, mother of eBay founder Pierre Omidyar) made in 2007 to University of Maryland College Park Foundation to establish the Roshan Center for Persian Studies at the University of Maryland and a major and a minor in Persian Language and Studies; and the US$2 million gift that Fariborz Maseeh, an MIT PhD holder, made to University of California, Irvine, to establish the Samuel Jordan Center for Persian Studies and Culture, and to fund a department chair and two professors, one each for humanities and Persian performing arts.[8]

In this form of internationalization involving a transfer of students, western universities not only import foreign students to their campuses, but also export their own students to foreign countries. Small and large universities vying to position themselves as "global universities" send away a massive number of students through their study-abroad programs. For example, in 2008, 25 percent of New York University's large student body, many of whom refer to their alma mater as "Global U," enrolled in one of the university's eight study-abroad programs—in London, Paris, Madrid, Berlin, Prague, Florence, Shanghai, and Accra.[9] NYU's plan was to increase the percentage of student enrollment to 50 percent within two years. By 2012, the University had increased the number of its programs by five with four of them abroad—Abu Dhabi, Buenos Aires, Sydney, and Tel Aviv—and one in a domestic location—Washington DC. Reflecting its new global brand with elements referencing both international and domestic locations, the NYU study-abroad program's web site began to carry a new sub-heading "Study Abroad: Study Away in the U.S. and Around the World."[10]

Transferring Branch Campuses

The second form of internationalization, the subject of this chapter, involves exporting western universities by transplanting branch campuses to the global

south, particularly to the oil-rich countries of the Persian Gulf. Partly in response to the criticism that their educational systems were "weak and limited in scope," three Persian Gulf countries pushed aggressively in the late 2000s to import high quality academic programs, particularly from the United States.[11] Qatar began the process by inviting prestigious universities to bring in only one or two of their outstanding programs, instead of transplanting a replica of their entire university or of an entire college, to the tiny country whose own native population was some 300,000, while its foreign migrant worker and expat population was around 1.6 million. These included the program in Medicine from Cornell University, Foreign Policy from Georgetown, Business and Computer Science from Carnegie Mellon, Engineering from Texas A & M, Visual Arts from Virginia Commonwealth, and Communication and Journalism from Northwestern. All of these programs were funded by the multibillion-dollar Qatar Foundation for Education, Science and Community Development (established in 1995 and commonly known as Qatar Foundation), which is chaired by the second of the Emir's three wives, Sheikha Mozah bint Nasser Al Missned. All these programs, and those added later, were brought together under the rubric of an entity called Education City and they were located adjacent to one another to form a vast 2,500-acre complex of campuses—with classrooms, auditoria, residential halls, recreation facilities, and research centers, such as teaching hospitals, engineering and science laboratories, libraries, and film and media production and postproduction studios. This multiple campus entity, Education City, formed not a series of entirely autonomous universities but what might be called a unique "multiversity," allowing for cross-fertilization of all sorts among these elite programs, such as joint hiring of faculty; collaborative research, teaching, and creative initiatives; and student registration across the campuses. This arrangement allowed the Qataris to benefit from the excellence of each selected program without suffering from the liabilities of importing an entire university or college, the programs of which may not be uniformly excellent or needed. Of course, such a multiplicity and diversity of institutions, each with its own distinct culture, could create new challenges: instead of synergy and collaboration there might be duplication, conflict, and lack of coordination. Also, these institutions' English-language instruction and their media-centric western culture and curricula could clash—productively or destructively—with the indigenous Muslim and Arab languages, cultures, and traditions.

Qatar invested massively in the "knowledge industry" with the intent of educating its own citizens and the children of highly skilled expats, and thus refused options pursued elsewhere, such as grandiose and flashy Las Vegas type entertainment complexes, which are subject to the vagaries of global finance, tourism, and market forces. Other Gulf Cooperation Council countries (CCC) such as Dubai, invested in for-profit "knowledge villages" and "education malls." Designed to educate their own citizens and their large expat populations, who are seen as the backbone of their economies, such investments were less driven by the oil and gas industries than other options might have been. Dubai, too, later launched a more ambitious transplantation of not-for-profit high-end western universities by creating an International Academic City, involving, among others, Michigan

State University, Harvard University, and Rochester Institute of Technology. Abu Dhabi also started its own version of the Education City, University City, importing among others, Paris-Sorbonne, MIT, and Johns Hopkins's Public Health graduate program.

Some have characterized this mode of creating a "Global U" as involving a new neoliberal colonial paradigm that primarily benefits the western powers financially and in terms of diplomacy or soft power.[12] But the flows of power, knowledge, and benefits are more multidirectional and complex than that. Universities in the West accrued great benefits in this process because the costs of establishing and operating these branch campuses were entirely picked up by the host countries. As Daniel Ballard, director general of the Paris-Sorbonne University in Abu Dhabi stated, "It is a pity, but I must say that we are only in Abu Dhabi because Abu Dhabi proposed to pay for all of our expenses."[13] The money is no small amount, with Cornell, for example, having reportedly been promised US$750 million over a period of 11 years by the Qatar Foundation to cover the cost of its branch campus in Doha.[14] Apparently, Dubai "lost" NYU to Abu Dhabi due to the university's demand for US$50 million up-front in addition to covering the construction cost and operating expenses of NYU's liberal arts and performing arts university. In the case of Northwestern's Doha campus, the Qatari government, through the Qatar Foundation, underwrote "all start-up and operational costs, including construction of a new building and faculty and administrative salaries."[15] This financial arrangement allowed these universities to expand their international presence and consolidate their Global U "brand" without incurring any expenses. The global north, particularly the American and European governments, economies, and societies, also stood to benefit enormously from this educational export. This was especially true since the rise of Islamic militancy after the Iranian Islamic revolution of 1979 and the Alqaedah terrorist attacks on United States and Europe in the 2000s, which inaugurated not only a new hot war, the "global war on terror," but also a new soft war, the turbocharged "new public diplomacy" through which the United States and the Persian Gulf monarchies marshaled enormous cultural and media resources to speak to their foes and disaffected populations and to convert and win friends across the globe. As I have documented extensively in the case of Iran, this public diplomacy not only involved antagonistic governments but also non-state actors and institutions. Through a "cultural turn" attempts were made to recruit film, television, radio, Internet, and educational media and formations—of a domestic, diasporic, and international nature—and this from various governmental, para-governmental, nongovernmental, and private sectors. The point was to harness energies for relevant public diplomacies, and at times such pursuits had dire consequences for the participants.[16]

The host countries of the global south, too, benefited from their high investments in bringing western higher education campuses to their shores. But these gains were not evenly distributed, for it appears that mostly a narrow segment benefited. This consisted of the native population and the children of expats working in high-end jobs whose families were either white or already among the

educated elite of the workforce. Excluded from the benefits were the much larger numbers of children of construction workers and service industries workers who were primarily people of color and from the global south. Although the financial gains initially favored the guest institutions, host countries, such as Qatar, also positioned themselves some day to become producers of world-class knowledge and products, and generators of lucrative downstream income from their knowledge industries. This positioning was achieved by investing in modern research, technology, and production centers attached to the branch campuses and by providing funds for conducting research, pursuing inventions, patenting, and product development. Indeed, Qatar has already moved to the next stage, having established a Science and Technology Park near Education City, which is destined to become an incubator for start-up enterprises and is poised to attract technology-based companies from around the world.

In addition, the host societies gained because the transplantation of western campuses was based on the idea that the education to be provided to the global south would be equivalent to what was offered at the various home universities. According to Northwestern's dean of communication, Barbara O'Keefe, who was intimately involved in the transplantation of the Northwestern campus to Doha, "One of the things we have assured the Qatar Foundation is to provide an equivalent education in Doha to the one we are providing in Evanston," noting that "the best way to do that is to simply expand our faculty and each year rotate a portion of our faculty through the Doha campus."[17] Similar expectations and promises were at work in the transplantation of other American schools, such as New York University in Abu Dhabi, Texas A&M in Qatar, and Michigan State University in Dubai. This mode of internationalization by branch campus transfer was particularly embraced by Arab and Muslim women, as will be seen in the case study of Northwestern University's campus in Doha.

Nevertheless, there are elements of neocolonialism in this relationship and in the flow of knowledge and power, as this exchange relation is likely to result in the triumph of western ways of knowing and doing over the traditional and indigenous ways, paving the way for neocolonial dependency and neo-Orientalist self-othering, whereby the recipients of western education may begin to see themselves through western paradigms, as the "self-consolidating other" of the West.[18] Additionally, these western branch universities were not immune to domestic and global economic and political fluctuations. The financial crisis in Dubai, for example, caused by the "unraveling" of its real estate market in 2009, forced Michigan State University to shut down its undergraduate program there. Reasons given for this decision include "the departure of overseas workers and their families, who make up more than 80 percent of the population."[19] That same year, George Mason University closed its Ras Al-Khaimah campus in the United Arab Emirates. The university's web site cited "the global economic crisis" among "several issues" that intersected in such a way as to make it impossible to achieve the institution's goals of providing "the same vitality and academic quality" that George Mason offered at its US campuses.[20]

Programs in Film Studies and Media Production

Film and media schools were popular with the Persian Gulf states, perhaps because these states were driven by a desire not only to create new knowledge industries but also to repair their national images and to create and project new national narratives and imaginaries. In a book and documentary that are both entitled *Reel Bad Arabs: How Hollywood Vilifies a People*, Jack Shaheen memorably noted that when it came to Arabs, Hollywood movies were obsessed with "the three Bs"–belly dancers, billionaire sheiks, and bombers.[21] It was to combat such tawdry and stereotypical images that Arab self-representation acquired the status of a national initiative toward self-empowerment. When the BBC Arabic-language channel, a joint venture with the Saudi-owned Orbit Communication, fell through, the Emir of Qatar, Shaikh Hamad ben Khalifa, provided a loan to sustain the operation, which by November 1996 became Al Jazeera Satellite Channel, with six hours of programming, which was boosted to 24 hours in 1999. While Al Jazeera was not the first Arab news channel and while it stayed away from offering news about its own country of Qatar, it became a highly controversial and influential force in journalism. With its mix of news, documentaries, discussions, interviews, call-ins, and debate programming, all of them presenting news from a "contextually objective" perspective that "reflected all sides of any story while retaining the values, beliefs, and sentiments of the target audience," Al Jazeera gave voice to Arab, Muslim, and other underserved populations, challenging both monarchical Arab rulers' and western broadcasters' monopoly on what constituted news.[22] Soon, regional initiatives in film production also emerged. Invited by the Abu Dhabi Authority for Culture and Heritage, the New York Film Academy, a for-profit film school, opened, in 2008, the New York Film Academy Abu Dhabi (NYFA) in the United Arab Emirates' capital. This was not an isolated instance of institution-building, as it came in the wake of the inauguration of the Abu Dhabi–based Middle East Film Festival, which was launched in 2007, and the creation of the Abu Dhabi Film Commission and a multimillion dollar Film Fund.[23] Although NYFA Abu Dhabi was self-funded, the Emirati cultural organization helped with filming permits and locations. The Academy's Abu Dhabi and US curricula were the same, as were the tuition fees of US$15,000 for a two-year filmmaking diploma.[24] NYFA was the first accredited American film institution to begin operating in the region, but it was not the first such institution, for the American University in Dubai had in 2007 launched its Mohammed Bin Rashid School for Communication, the first media school commissioned under Dubai prime minister Sheikh Mohammed's patronage. The school teaches journalism and filmmaking.

Out of an encounter between then Prince Abdullah of Jordan (now King Abdullah II) and a Hollywood mogul, Steven Spielberg, who was location scouting in the late 1980s for his movie *Indiana Jones and the Last Crusade* (1989), emerged the Red Sea Institute of Cinematic Arts (RSICA) in 2008. This was a joint effort of the Royal Film Commission of Jordan and the University of

Southern California's School of Cinematic Arts, on whose board Spielberg serves. Located in Aqaba, a Special Economic Zone in Jordan on the Red Sea bordering Saudi Arabia, Egypt, and Israel, the Red Sea Institute of Cinematic Arts offers a two-year masters of fine arts in film, television, and the still evolving screen-based media. Its Wikipedia website states that this institute "is in line with His Majesty King Abdullah II's efforts to expand the skills of young Middle East and North Africa filmmakers and artist[s] by giving them training in the use of latest technologies in filmmaking and production." The ambition went beyond just training national subjects, for it is "part of the monarch's vision of establishing a hub for intellectual and creative capital in Jordan and the MENA (Middle East and North Africa) region."[25]

RSICA's first cohort graduated in 2010, on which occasion the institute's dean, James Hindman, emphasized the aim of the institute: "We always say, who will tell your stories? It shouldn't necessarily be Americans or Europeans; it should be people from the region. That's why the Red Sea Institute is so important. It's to empower people to tell their own stories."[26] Daniele Suissa, who taught film at RSICA, invoked the contention of the 1960s radical filmmakers about filmmaking being a tool for social change to talk not so much about fomenting a revolution (something that Middle Eastern autocrats promoting these western institutions wish to avoid) but about bringing the different cultures and societies of the region together: "We have 35 millimeter [equipment] with 24 bullets a second. That's really the best gun, the best tool, the best weapon you can have to talk about peace, to talk about human beings, to talk about who you are. It's a beautiful weapon and I think if we knew more about who everyone is we would have the beginning of an opening to a dialogue."[27]

New York University established NYU Abu Dhabi in 2010, a university that "fully integrates a liberal arts and science undergraduate college, organically linked to a major university in the United States." The idea was for the two campuses to form "the backbone of a Global Network University, creating a unique and unprecedented capacity for faculty and students to access all the resources of a research university system across five continents."[28] NYU Abu Dhabi's administrators called it the "world's honors college," with the first class being "made up of 150 students who speak 43 different languages in all and hail from 39 countries."[29] Admitted students who could demonstrate financial need were eligible for interest-free aid of up to US$62,000 per year, which included the cost of two round-trip tickets home and a US$2,000 stipend. The School's Film and New Media undergraduate degree "offers students the opportunity to study the arts and histories of international screen cultures with an equal emphasis on practical creative work and critical scholarly inquiry. In this multi-platform discipline, the major engages students with classic cinema, popular drama and comedy, animation, documentary, and mobile and interactive media."[30]

In the remainder of the chapter, I offer a close-up look at one of these film and media institutions, the one I know best and where I taught for two years: Northwestern University in Qatar. Because much of this section is based on my own experiences and observations, the tone is personal.

Northwestern University in Qatar (NU-Q)—a Profile

Northwestern's branch campus began operating in Doha, Qatar, in 2008, and offered its first cohort of 36 students the bachelors of science undergraduate degrees in journalism or communication in 2012. These degrees were offered in a liberal arts context that aimed to prepare the students for professional and leadership roles in the global, digital media industries. Students took small classes with faculty members who were either actively involved in media production and journalism, or in conducting academic research geared toward publications in film and media studies. The students also benefited from working in the state-of-the-art production studios and postproduction facilities that often surpassed, both quantity- and quality-wise, the equipment and facilities available to the students in the United States at Northwestern's "mother campus" in Evanston. Moreover, upon enrollment all students received the latest Mac laptop computer equipped with full suites of Office and Adobe editing and other production software. Finally, they could not only take classes in their majors at NU-Q but also cross-register for other courses at the other five universities in Education City. Internships, professional residencies, and travel and studies abroad complemented the students' academic learning with real-world experience.

NU-Q's journalism program—with concentrations in print, broadcast, and multimedia journalism—was designed to make students skilled not only in writing, reporting, editing, production, and critical thinking but also in using multiple platforms (print, online, broadcast, and wireless) so that they could create compelling, high-impact journalism for increasingly interactive audiences. The communication program offered a major in Media Industries and Technologies, with curricular offerings in communication theory, film and media studies, and various film, TV, and digital media production fields. The students wrote screenplays, took acting classes, and made documentaries, animations (2-D and 3-D), and fiction films. They studied the critical histories of film production and exhibition, and analyzed the uses of online communities in professional and social contexts. They studied national cinema histories, gender and sexuality theories, and the histories of various film forms.

The journalism program aimed to prepare the students to work in journalism and related fields as producers, writers, reporters, editors, photographers, or public relations professionals. Students learned by doing the same work that journalists around the world do, by finding and cultivating sources and by producing content for print, web, radio, and television. The communication program prepared the students to work in film, advertising, cyberspace, and television and entertainment fields as media executives, screenwriters, producers, directors, policymakers, or media analysts.

The NU-Q student body came from some 17 countries. Although they were mostly from the Middle East region, there were quite a number from other places, as near and as far away as Jordan, Lebanon, Tanzania, Egypt, Bangladesh, India, Canada, and the United States. During the time I was teaching in Qatar, NU-Q was keeping Qatari student admittance at about 40 percent. In a nation where men outnumber women by a ratio of at least 2-to-1, the NU-Q student population

was overwhelmingly female, comprising about 85 percent of the student body. Among traditional Arabs with means, young men can, and do, generally go abroad for higher education, while "girls"—the cultural name for young women in Arab Muslim societies—generally stay closer to home. As a result, education at NU-Q and other Education City campuses offered the girls exposure to the outside world without the exposure to most of the hazards of the outside world. In addition, while some boys may go into the family business and become highly successful without higher degrees, university education can provide the girls with a launching pad for a rise in social status, better career opportunities, and perhaps even enhanced marriageability. So it was not hard to understand why Qatari girls would generally be more motivated than the boys to attend universities and to do well while there.

Because of Qatari citizenship rules, many of NU-Q's students, although born and raised in Qatar, are not considered Qatari, as citizenship is based not on the place of birth (as is the case in the United States), but on blood (as was the case in Germany until 2000). A sizeable portion of the student body was multicultural with roots in more than one place, culture, and language. As such, NU-Q was an experiment in cross-cultural education, with benefits and challenges not only for the student body but also for the NU-Q faculty and administration.

Challenges of Teaching in a Transplanted Branch Campus—a Personal Narrative

One challenge for the NU-Q faculty was that Arab and Qatari societies tend to be conservative, tribal, family-oriented, and Muslim. As a result, in these societies there is a sharp demarcation between the private and public self, between male and female spheres, and insiders and outsiders, all emblematized by the variety of strategies, including veiling, which aim at modesty and privacy. Such strategies are maintained by both men and women and find expression in Qataris' friendly but guarded social demeanor; in demure eye contacts, vocal expressions, and body contacts between the sexes; and in the city planning and architecture, which is characterized by gated communities, high walls, tall hedges, closed windows, and drawn curtains. The webs of family kinship and tribal loyalties keep a powerful hold over the Qataris, slowing the emergence of democratic state formations and modern individualized subjectivity but offering rewards and protection to autochthonous authenticities and collectivities.

How did Northwestern faculty deal with these cultural orientations and how did they impact the curriculum? We organized orientation sessions for parents and students during which we not only introduced the communication and journalism programs' teaching philosophies, curricular offerings, and faculty but also drove home various important points: the students' primary task while in college was to study; they should be given room to be alone to study; if family guests arrived they should not expect to be entertained for long, just as students should not be shy about insisting that they be given individual and private times and spaces for studying. Such explicit directives were necessary,

as many students had complained of family obligations cutting into their study time. Daughters' envisaged participation in extracurricular activities, such as outings, lab work, sports, and foreign travel created another situation at odds with tradition, but in all cases permission was secured thanks to the willingness of the Qatari families to change their traditional patterns for the sake of their children's education.

Another challenge surfaced in designing the syllabi for film and media courses: how to select the movies for class screenings so as not to offend the Islamic and Arab sensibilities and customs regarding nudity and bad language? This was a delicate task for a teacher, as one wants to expose the students to the best films without offending them too much, and also without censoring the works. My strategy was to publish on my syllabi a statement saying that all films would be screened in the class as they were released—without censorship. This was an unusual tactic, for in Qatar movies shown in public cinemas and on television are routinely and heavily censored for nudity, kissing, necking, and bad language, although not generally for violence. In fact, during my two-year stint in Qatar most of the films on the various movie channels seemed to be violent terrorism and police action movies made in the United States. If I planned to show a film that contained more than passing nudity or sexual situations, I forewarned the students and allowed them to turn away or to leave for a few minutes.

In the time that I taught at NU-Q, only two female students left the class during the screenings and returned soon thereafter. Two wrote letters to the NU-Q dean complaining about the films I had shown (I don't know if they were the same two). One offending work was Fatih Akin's award-winning Turkish-German film, *Gegen die Wand* (*Head On*, 2004), and the other was the classic ethnographic film by Robert Gardner, *Dead Birds* (1964). *Head-On* is a hard-hitting film, which has nudity and sexual scenes that are integral to an intercultural "crazy love" story between a German-Turkish man and woman. And *Dead Birds* follows the hunting of giraffes by the Tung Bushmen, who wore very little clothing throughout the film. Yet, their nudity is customary not sexual. Another professor related to me that a student had complained to the dean about having been shown the celebrated shower sequence from Alfred Hitchcock's film *Psycho* (1960), citing excessive nudity as the reason for the complaint. Interestingly, there is neither total body nudity nor actual violence in this sequence, only suggestions thereof.

Cultural considerations also entered the design of the syllabi. The basic rule required an adaptation of the curriculum and syllabi, not their wholesale transfer, and a maintaining of the rigor and quality of the American education. In this manner, the teaching of film and media production in the humanities and journalism fields was brought into contact with the receiving communities. For the three courses I taught there—Middle Eastern and North African National Cinemas, Documentary Film Theory and Practice, and Cultural Theory and Media Institutions—I chose outstanding readings and film examples from around the world so as to familiarize the students with the canons of cinema. I also selected a sampling of films made by Middle Eastern and North African filmmakers—and their associated readings—in an effort to deepen students' understanding of their own cinematic heritages and cultures. Because students

were familiar with some of these eastern examples, they found a measure of empowerment in them, and thus opened up to unfamiliar western theoretical paradigms and texts. In the process, they found ways of critiquing their own cultures and their products. On the other hand, because of the defamiliarization that results when western theories are mobilized with reference to unfamiliar examples, the relevant conceptual frameworks were themselves examined rigorously, and even critiqued.

Professors with a deeper understanding of Middle Eastern and Islamic societies and histories included more contextual, ethnographic, artistic, and theoretical accounts in their courses. Students' work in the areas of research, production, and multimedia reporting naturally took the societies and cultures around them as appropriate foci. As Ibrahim Abusharif, a NU-Q journalism professor of Palestinian origin said, "People here need the skills to tell their own stories, rather than relying on a western-centric narrative. Our students are incredibly bright and I can't wait until they begin telling their own stories, honestly and openly."[31] The last point about honest and open reporting is as important as the first point about self-narrativization, for honest and open reporting about the self is a rare phenomenon in the authoritarian and collectivist societies of the Persian Gulf. To accomplish the kind of teaching that is scientifically rigorous, historically informed, and culturally sensitive, Northwestern University brought professors from the Evanston campus to Qatar. It also, however, hired new ones, some of whom were familiar with, had conducted research and produced publications about, and had ancestral roots in, the Middle Eastern societies. These bicultural and bilingual professors—among them Ibrahim Abusharif—were good intercultural role models for the students both personally and professionally.

As for my own strategies, I broadened the usual definition of the Middle Eastern and North African Cinemas region to include not only Arab and Muslim countries, such as Egypt, Tunisia, Algeria, Morocco, Palestine, and Lebanon, but also non-Arab but Muslim countries like Turkey and Iran and the non-Arab, non-Muslim Jewish country, Israel (something that I do in Evanston, too, when I teach this class). The idea was to expose the students to national cinemas they might not easily encounter due to politics, historical rivalry, and national and ethno-religious preferences and prejudices.

Also, I supplemented the classroom films by arranging visits by filmmakers from Qatar and around the region, who screened their films at NU-Q and discussed them with the students. This group included: the Qatari filmmaker Hafiz Ali Ali, who screened *Abaq al-Thalal* (*A Scent of a Shadow*, 2009), about the history of film exhibition in Qatar; the Palestinian-American documentarist residing in Jordan, Annemarie Jacir, who made a presentation about her documentary film practice under constraints imposed by Israel's occupying forces; the Iranian documentarist Ramin Lavafipour, who screened his feature film about human smuggling in the Persian Gulf, *Aram Bash va ta Hatf Beshmar* (*Be Calm and Count to Seven*, 2008); the Iranian-American art filmmakers Shirin Neshat and Shoja Azari, who premiered their feature film *Zanan-e Bedun-e Mardan* (*Women Without Men*, 2009) at NU-Q (and went on to win awards for it); the

Qatari film actor Abdullah Buainaine, who presented his fiction movie *Aqareb Al-Saah* (*Clockwise*, 2010), directed by Khalifa Almuraikhi. Produced by Qatar's Ministry of Culture, Arts, and Heritage, *Clockwise* is the first Qatari feature film, its production history demonstrating the policy of the state to fund the films it supports (and to censor other projects by withholding funding, among other measures). That most of the film's production staff were expats and foreigners also showed the underdevelopment of the technical infrastructure, something that the NU-Q-trained alumni would hopefully offset. These visiting filmmakers not only familiarized the students with the issues of funding, producing, censoring, acting in, and exhibiting films in the MENA countries but also provided them with successful local and regional role models.

I also tried to incorporate film research into extracurricular activities. Together with a journalism faculty member and two staff members, I took 15 students to Tanzania in 2010 for a weeklong service visit (14 girls and one boy). We broke into four groups, each assigned to an educational or public health institution. Half of the day our groups worked in such places as a school for street children, a hospital, and a primary school, cleaning floors and furniture, painting walls, and computerizing patients' files, and in the afternoon we would break into different smaller groups to work on research projects. I worked with the communication students to develop a quick research project about film exhibition in the town of Moshi (located near Mount Kilimanjaro). My group visited movie houses, interviewed film projectionists, house managers, and street vendors of movies on video cassettes and DVDs, and took pictures and videos. After our return to Doha, we had an event at NU-Q where students made public presentations about their experiences, research projects, and findings.

Another problem with censorship had to do with ordering foreign books and videos for the university library. Intriguingly, decisions made by the Qatari customs office varied. For two years, the NU-Q library could not get Marjane Satrapi's graphic novel *Persepolis*, an international best seller, out of the hands of the Qatari customs officers, but the library did get the film version. Georgetown University's library in Qatar, on the other hand, received the book both in hard copy and in a Kindle version. The point is that there is not only censorship but also that it is nonsystematic. I myself had ordered two books on the Al Jazeera TV station for my own library, one of them by Mohammad Zayani, a faculty member of Georgetown University in Qatar. One of the books arrived in the mail, but not the other—Zayani's. When I told him the story he was most surprised. It seemed that he himself was able to teach in Qatar, while his book had difficulties entering the country. In any event, after a while I received a notice from the censorship bureau asking me to visit their office about the book. It took me a while to go there, and when I did they were closed. I went there a second time and found on the floor of the censorship office dozens of bags containing books with the name of Aljarir Bookstore on them—either awaiting censorship or waiting to be picked up by the bookstore. The official took the notice about my book and went to a back room and after a while returned with the book, which he handed to me. When I asked why the customs officers had held the book, he shrugged his shoulders and replied, "I have no idea!"

In these transplanted western campuses, faculty members not only teach the students but also learn from them. We learn about teaching in general, about how to teach more effectively when returning to the United States, about ourselves as teachers, and of course about other countries and their traditions, cultures, and politics. English is not only the language of instruction at NU-Q but also the lingua franca for its multicultural and multilingual student body. Because of their different origins, the students speak a variety of Arabic dialects, some of which are hardly comprehensible to others, making Arabic less than ideal as a lingua franca.

Transplanting western campuses to teach media to the Persian Gulf's Muslim and Arab countries internationalizes not only these campuses but also the host countries. Such academic transplantation is only one of several steps these countries have taken in recent years to import and create indigenous film, media, and arts institutions, such as film festivals and museums. In the case of Qatar, mention can be made of the Doha Tribeca Film Festival and Doha Tribeca Film Institute, which were created in collaboration with their American counterparts. Some countries attempted to bring in Hollywood productions by investing heavily in them, by offering amenities and services such as landscapes, scenery, and crowds, and by creating a Hollywood of their own on the Persian Gulf. In addition, several countries, including Qatar, invested massively in creating Islamic art museums, designed by world-class architects, to house the great artistic and architectural achievements of the Muslim and Arab worlds. I. M. Pei, for example, designed Doha's beautiful Islamic Museum of Art. Planning and construction of national museums, national concert halls, national symphonies, and national theaters followed both in Qatar and in other places.

The film and media production and education programs discussed here should be seen in the context of the efforts of the Persian Gulf's autocrats to construct both new national narratives of modernity and to create a modern imagined nation out of the disparate, disputed, and disrupted national, historical, tribal, and religious societies of the Middle East. If, as Benedict Anderson argues, literacy and newspapers were instrumental in creating imagined communities and in the spread of nationalism in eighteenth-century Europe, then for the Arab and Muslim nations of the Middle East and North Africa in the twenty-first century it is the broadcasting, film, and media industries that serve the same functions.[32]

Student's Filmic Creativity and Output

NU-Q students were active in applying to the real world what they were learning in the classroom, which in turn helped to problematize the unidirectional colonial and neocolonial formulation of branch campus initiatives. The students took an active part in their own education. For example, less than a year after the campus was launched, the communication students started a film society, NU-Q Film Society, consisting of three members and a faculty advisor. The group organized a weekly film screening, usually on Wednesday nights, and they guided the post-screening discussions with the audience. Through this project they learned

film programming, curatorial work, and how to make effective public presentations. Sometimes they would invite filmmakers or guest speakers as well. Students also organized other professional associations, such as the photography club Oh Snap! and the journalism club, Society of Professional Journalists.

Students at NU-Q responded avidly to the social turmoil that enveloped the Arab and Muslim world in the late 2000s, what was later dubbed the Arab Spring. No sooner had the uprisings started in Tunisia and Egypt than the students began to think about how to cover them. When her home country Egypt erupted, female Egyptian student Ethar Hassaan was drawn to it not only for personal reasons but also for journalistic reasons. She wanted to witness and document this momentous event. But it involved some risks, which she was willing to take—hallmarks of a good journalist and documentarian. She persuaded all her professors to let her go for a week of filming. The short piece she made, *What I Saw* (2010), was an emotionally charged film focusing on the protests in Cairo's Tahrir Square that brought tears to the eyes of many of the students and adults who had come to my class for its premiere.

That Hassaan had decided to concentrate on the emotional and internal dynamism of the uprising instead of on more factual and external elements showed a keen sense of judgment, given the massive coverage of the event by outsiders. Eschewing what other sources were already making available, Hassaan brought attention to another aspect of the uprising. In so doing, she also demonstrated an ability, as an aspiring media professional, to make judicious decisions about what is right and appropriate (see figures 4.1 and 4.2).

The widespread Arab Spring upheavals energized other forms of student documentation and journalism. An outstanding example was *Lyric Revolt*, a documentary about the role of Arab hip-hop in articulating youth sentiment and mobilizing young people throughout the region against oppressive regimes. This film, which began as a student project by four enterprising female NU-Q students, Ashlene Ramadan, Rana Khaled, Melanie Fridgant, and Shannon Farhoud, evolved into a full feature film. It was premiered on the opening night of the "Made in Qatar" series at the 2012 Doha Tribeca Film Festival (DTFF). This series consisted of 19 films that had been made in Qatar, four of them by NU-Q students and alumni. In addition to *Lyric Revolt*, the other three films were: *Bader*, a documentary about a young poet, made by Sara Al-Saadi, Latifa Abdulla Al Darwish, and Maaria Assami, which won DTFF's "Made in Qatar" Award; *Brains of Empowerment*, a 3-D animated film made by Amna Al-Khalaf, and *Ghazil—The Story of Rashed & Jawaher*, a family drama that takes place a century ago, made by Sarah Al-Derham. There were several other films of note that NU-Q students had made. Two were nominated in the "Promising Films" category at the eighth Al Jazeera International Documentary Film Festival in 2012. These were *Behind the Walls*, which then NU-Q seniors Zainab Sultan, Amit Chowdhury, and Nazneen Zahan had made, and *Salma's World*, which Zainab Sultan had directed. Finally, communication majors Jassim Al-Rumaihi and Rezwan Islam received awards at several festivals for their documentary, *A Falcon, a Revolution*. It was screened at both the 2011 Doha Tribeca Film Festival and at the 2012 Tribeca Film Festival in New York.

Figure 4.1 Framegrab from Ethar Hassaan's film *What I Saw.*

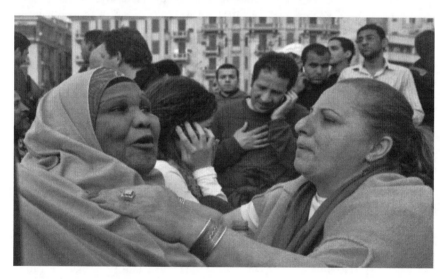

Figure 4.2 Framegrab from *What I Saw.*

In addition to these filmmaking and journalism initiatives, several of the new alumni of NU-Q programs collaborated to establish technology and media start-ups. In addition, barely a year after their graduation, some found good positions in the media industry. Among these was Jassim Al-Rumaihi, codirector of the award-winning film *A Falcon, a Revolution*, who began to work full-time in the Al Jazeera Arabic newsroom, partly as a result of his strong debut film. The film, media, and technology initiatives that the first NU-Q alumni cohort undertook, as

well as those of the alumni of the other campuses in Education City not discussed here, demonstrate that the seeds of a potentially robust culture and media industry have been sown in a fertile soil. The sense of empowerment that media and journalism education offers the new alumni is palpable. Al-Rumaihi, whose father is a retired journalist, states that the most important skill he developed at NU-Q, in addition to technical filmmaking skills, is "the ability to express himself confidently and compellingly through any medium," adding that "my father always emphasized the importance of media for our region. Now that I really understand how media can be a powerful tool for change and improvement in society, I cannot wait to be part of the Arab world's most influential media organization."[33]

Notes

1. Institute of International Education, "Top 25 Places of Origin of International Students, 2010/11–2011/12," *Open Doors Report on International Educational Exchange*, http://www.iie.org/Research-and-Publications/Open-Doors/Data/International-Students/Leading-Places-of-Origin/2010–12.

2. Institute of International Education, "Top 25 Institutions Hosting International Students, 2011/12," *Open Doors Report on International Educational Exchange*, http://www.iie.org/Research-and-Publications/Open-Doors/Data/International-Students/Leading-Institutions/2011–12.

3. International Office, Northwestern University, "International Student Population—A Statistical Report by the International Office—Fall 2011," http://www.google.com/url?sa=t&rct=j&q=&esrc=s&source=web&cd=1&cad=rja&ved=0CC4QFjAA&url=http%3A%2F%2Fwww.northwestern.edu%2Finternational%2Fabout%2FINTLStudentStatistics_Fall_2011.pdf&ei=zBqtUMn0M7KvygHdpIEY&usg=AFQjCNEstnoUmb9ZgRQBdefeg9SoCSNOfw.

4. Linn Allen, "Schools Fear Waning Interest in Study Abroad," *Chicago Tribune* November 1 (2001): 2c1, http://search.proquest.com/docview/419470517/13A89FADC0676CF69E9/16?accountid=12861.

5. Ibid.

6. Eugene McCormack, "Number of Foreign Students Bounces Back to Near-Record High," *Chronicle of Higher Education* 54, no. 12 (November 16, 2007), http://chronicle.com/article/Number-of-Foreign-Students/35582.

7. Jennifer Medina, "Like Ivies, Berkeley Adds Aid to Draw Middle-Class Students," *The New York Times* (December 14, 2011), http://www.nytimes.com/2011/12/15/education/berkeley-increasing-aid-to-middle-class-students.html?_r=0.

8. Office of Development Communications, Princeton University, "$10 million gift establishes Mossavar-Rahmani Center for Iran and Persian Gulf Studies," *News at Princeton* (November 16, 2012), http://www.princeton.edu/main/news/archive/S35/30/15O69/index.xml?section=topstories; School of Languages, Literatures, and Culture, University of Maryland, "About Roshan Center For Persian Studies," University of Maryland, http://sllc.umd.edu/persian/about; and Samuel Jordan Center for Persian Studies and Culture, "Dr. Fariborz Maseeh," University of California, Irvine, http://www.humanities.uci.edu/persianstudies/about/founder.php. See also Jennifer Delson, "$2-Million Gift to UC Irvine Will Fund Center for Persian Studies and Culture," *Los Angeles Times* (April 22, 2005): B8.

9. Andrew Ross, "Global U," *Inside Higher Education*, February 15, 2008, http://www.insidehighered.com/views/2008/02/15/ross.

10. http://www.nyu.edu/admissions/study-abroad.html.

11. Zvika Krieger, "Academic Building Boom Transforms the Persian Gulf," *The Chronicle of Higher Education*, March 28, 2008: A26–29.

12. Andrew Ross, "Global U."

13. Krieger, "Academic Building Boom," A29.

14. Ibid., A26.

15. Jodi Cohen, "Northwestern Expanding to Mideast," *Chicago Tribune*, November 8, 2007, http://articles.chicagotribune.com/2007–11–08/news/0711070611_1_middle-east-al-jazeera-journalism.

16. Hamid Naficy, *A Social History of Iranian Cinema. Volume 4: The Globalizing Era (1984–2010)* (Durham: Duke University Press, 2012).

17. Cohen, "Northwestern Expanding to Mideast."

18. Gayatri Chakravorty Spivak, "The Rani of Simur," in *Europe and its Others*, vol. 1, ed. Francis Barker et al. (Colchester: University of Essex, 1985), 130.

19. Vir Singh, "Universities Withstand Dubai's Financial Crisis," *The New York Times*, September 19, 2010, http://www.nytimes.com/2010/09/20/business/global/20iht-educSide20.html?_r=0.

20. George Mason University, "Ras Al-Khaimah Campus in the United Arab Emirates," George Mason University, http://rak.gmu.edu/.

21. Jack G. Shaheen, *Reel Bad Arabs: How Hollywood Vilifies a People* (Northampton, MA: Olive Branch Press, 2009).

22. Mohammed El-Nawawy and Adel Iskandar, *Al-Jazeera: How the Free Arab News Network Scooped the World and Changed the Middle East* (Cambridge, MA: Basic Books, 2002), 27.

23. Ali Jaafar, "Abu Dhabi to Open Film School," *Variety*, July 6, 2007, http://www.variety.com/article/VR1117968152?refCatId=2523.

24. Danah Karam, "Western Programs Reach Out to Region," *Variety*, June 9, 2010, http://www.variety.com/article/VR1118023627.

25. http://en.wikipedia.org/wiki/Red_Sea_Institute_of_Cinematic_Arts.

26. Shirley Jahad, "USC-Affiliated School Graduates Filmmakers from Mideast and North Africa," KPCC Radio (May 23, 2011), http://www.scpr.org/news/2011/05/23/26849/usc-affiliated-school-graduates-filmmakers-mideast/.

27. Jahad, "USC-Affiliated School Graduates Filmmakers."

28. http://www.nyu.edu/global/nyu-abu-dhabi.html.

29. Andrew Mills, "New York U.'s Abu Dhabi Campus to Start With Academically Elite Class," *The Chronicle of Higher Education*, June 21, 2010, http://chronicle.com/article/New-York-Us-Abu-Dhabi-Campus/66005/.

30. http://nyuad.nyu.edu/academics/catalog/majors.html?id=11&view=overview.

31. Staff writer, "NU-Q Faculty Members Discuss Teaching in Qatar," *Time Out*, March 28, 2010: 4. (*Time Out* is the *Gulf Times'* magazine).

32. Benedict Anderson, *Imagined Communities: Reflections on the Origin and Spread of Nationalism* (new edition) (New York: Verso, 2006).

33. Northwestern University in Qatar, "Young Qatari Carries on the Family Media Tradition," Northwestern University in Qatar, May 7, 2012, http://qatar-news.northwestern.edu/family-tradition/.

Film Education in Palestine Post-Oslo: The Experience of Shashat

Alia Arasoughly

Context

Inquiry into Palestinian film education, or film education for Palestinians, are two quite different explorations, because of the conditions of dispossession and diaspora in which Palestinians live. Each of the lines of inquiry thus requires a definition of the geographic scope in question, and of what is meant by "Palestinian." This chapter will focus on the Post-Oslo years, after the formation of the Palestinian National Authority in 1994 in certain areas of the West Bank and in Gaza. The chapter, more specifically, will focus on the experiences of the cinema NGO Shashat, which I played a central role in founding.

Palestinian film education during the much-celebrated Palestinian Revolutionary Cinema Period in Lebanon (1968–1982), was spurred by scholarships given by different Eastern Bloc countries to Palestinians affiliated with different factions of the Palestine Liberation Organization, not only the leftist ones. These were part of a larger framework of educational and training scholarships to sustain the institutional emergence of Palestinian national identity and its resistance to liquidation by the American, Israeli, and Arab states.

The initiatives in question involved the training of medical, engineering, and military personnel, in addition to film practitioners, visual art "cadres," and other specialists. These cinema training scholarships, combined with the hands-on knowledge acquired by Palestinian technical crews who worked in the sixties in Arab television stations, as well as the joining of the Palestinian resistance in Lebanon by Arab filmmakers, contributed to a vital and dynamic environment for the emergence of collective and clandestine armed resistance cinema in Lebanon in the years referred to above. Included in the group that was active in

Lebanon were figures such as the following: the Iraqis Qassem Hawal and Qais El-Zubaidi (both of whom worked with the Popular Front for the Liberation of Palestine), the Lebanese Rafiq Hajjar (who worked with the Democratic Front for the Liberation of Palestine), and Nabiha Lotfi (who worked with the Palestine Liberation Organization's Fatah-operated central cinema body, the Palestine Cinema Institute).

The committed presence and involvement of European filmmakers such as the German Monica Maurer and the Dutch George Sluizer during that period, in addition to the short visit by Jean-Luc Godard and Jean-Pierre Gorin—as part of the Dziga Vertov Group to make *Jusqu'à la victoire* (*Until Victory*)—are also relevant. (*Until Victory* is a pro-Palestinian film on the Black September battles between the emerging armed Palestinian resistance and the Jordanian monarchist regime. Its footage was later used by Godard and his Swiss wife Anne-Marie Miéville for the better known 1976 film *Ici et ailleurs* [*Here and Elsewhere*]). All this helped further to spur a Palestinian institutional as well as public awareness of cinema as primarily a political act with the aesthetics to give more power and poignancy to the political dimension.

What was this political dimension? If we want to generalize and cast a wide net, we can say it is in the obsessive, ever-repetitive recounting of the narrative of national loss in all of its manifestations: loss of identity, of the self, of family, land, and status, with all these mirroring the foundations of Palestinian reality. The political dimension underlies the retelling of loss, the reconfirming of it, and its reproduction in images that are also about the fear of its being forgotten.

The controversial Oslo Accords of 1993 brought with them the promise of a Palestinian state with a fully functioning social and economic structure that includes the media—films, TV, and so on. However, this structure brought further occupation, the wall, checkpoints, invasions, and an apartheid reality. Most of the media training taking place in Palestine after Oslo was supported by international organizations such as the United Nations Development Program (UNDP), the United Nations Development Fund for Women (UNIFEM), the United Nations Population Fund (UNFPA), the Danish International Development Agency (DANIDA), the United States Agency for International Development (USAID), and the Goethe Institute. Their efforts involved different types of state and non-state media training, with some focusing on the official Palestine Broadcasting Corporation, some on the 30 or so independent local community TV stations, and others striking out on their own. The new state was to have a professional and free media with women in key positions, so that it could mimic other nations. International cultural NGOs, however, focused on discovering and training "young filmmakers" in search of the next international talent.

These two approaches—the one TV-oriented, the other more cultural and artistic—made the greater part of these training programs ineffective. With regard to the former, there was a tendency, for example, for donors to compete to bring their own trainers, to buy equipment from their own countries, and to build spheres of influence among the media. The result was that in the final analysis donor money benefited the donor in many ways, much less so the

grantee. It was a lot of activity leading nowhere if measured by the money and human resources invested and the final results. As for the second approach, year after year international cultural NGOs trained another group of "young filmmakers" who made their first film and then were left to fend for themselves. There emerged a plethora of Palestinian directors with first films, but with little hope of making a second film. This did not build trained technical personnel or infrastructure. The programs in question were shortsighted for they did not take into account the fact that vision and talent mature through work, and with experience and age, and that not everyone is under 30 years of age. Also, they did not develop the existing professionals who had acquired skills working as runners for the international news agencies that camped in Palestine waiting for the "dramatic event"; these persons were not taken to a more professional advanced stage.

The post-Oslo political developments in Palestine have significantly complicated the mobility of cultural products and people and markedly transformed the Palestinian cultural landscape by concentrating most cultural activity in the central areas of Ramallah, Bethlehem, and Jerusalem, with the rest of Palestine cut off from other areas, and from the center. Israeli closures and barriers through the wall and 580 checkpoints manned by its army have resulted in the creation of 50 isolated enclaves in the small geographic areas of the West Bank and Gaza Strip. The fragmentation of Palestinian communities into smaller and smaller units of villages and towns, which lack mobility and communication with each other, has led to a concentration of cultural activity in the center of Palestine and cultural poverty in the rest of it.

The considerable obstacles to mobility and to the circulation of cultural products have marginalized Palestinian communities already economically and socially impoverished and disenfranchised by the wall, and by being an occupied people with no power over its own life or resources. The circumstances of Palestinians were reduced to a daily struggle for survival, with cultural activity becoming a luxury.

SHASHAT'S Training

"SHASHAT Women's Cinema" is a formally registered cinema NGO in Palestine, licensed by the Palestinian Ministry of Interior and the Ministry of Culture and focusing on women's cinema and the social and cultural implications of women's representations. Shashat also aims at building the capacity of the Palestinian filmmaking sector, especially among women filmmakers. *Shashat*, which means "screens" in Arabic, was founded in 2005 in order to provide sustainability and continuity to these objectives. Shashat received the Palestinian Ministry of Culture's only institutional "Award for Excellence in Cinema" in 2010.

SHASHAT is based in Ramallah, Palestine, but in its commitment to reaching underrepresented communities, it has established partnerships with nine

Palestinian universities in the West Bank and Gaza Strip and over one hundred cultural and community organizations. This is part of its pro-active strategy to assure territorial reach in areas where cultural life is weak, and in order to provide nontraditional audiences with exposure to films, particularly by women filmmakers. Shashat is a unique NGO in Palestine, as it is the sole organization in the country to have cinema as its sole focus and to have identified women's representations in film and video as its priority. Shashat believes that culture and media can play a transforming role and may serve as an interventionary agent in changing cultural attitudes about women. Shashat is also unique in its exclusive focus on building the capacity of the Palestinian filmmaking community. This community has suffered fragmentation due to internal and external conditions. Competition and exclusiveness have marked much of the production activity due to limited resources. Israeli conditions of closure and checkpoints have also contributed significantly to this fragmentation. As a result, Shashat is intent on creating networks and partnerships among members of the Palestinian film-making community, and also between it and other regional and international film communities. By providing technical support to Palestinian women film-makers, Shashat aims at increasing their economic opportunities by focusing on film production as a new economic sector of employment for women. Shashat introduces a contemporary and innovative intervention in the empowerment and training of Palestinian women by focusing on the contemporary and socially transformative creative skills of filmmaking.

Shashat works in four areas of activity: an Annual Women's Film Festival; Capacity Building of the Palestinian filmmaking sector with an emphasis on women filmmakers; "Films for Everyone," a "Year-long" Screening/Discussion Program; and Cultural Outreach. I shall describe each of these areas below.

SHASHAT's Annual Women's Film Festival in Palestine

The festival is the longest running film festival in Palestine and the longest running women's film festival in the Arab world. It showcases the creativity of Palestinian, Arab, and international women filmmakers. The Women's Film Festival was first held in 2005, and has continued annually until the present, with the eighth edition held in 2012. The festival now opens in two cities—Ramallah and Gaza City—before going on a national Palestinian tour, in partnership with ten universities and 25 cultural and community centers. This tour is a means of combating the restrictions placed on Palestinian mobility and the cantonization of Palestinian communities.

Festival activities include:

- Promoting the visibility of Palestinian women filmmakers;
- Featuring contemporary films and classics by Palestinian, Arab, and international women filmmakers;
- Encouraging networking with the regional and international film community;

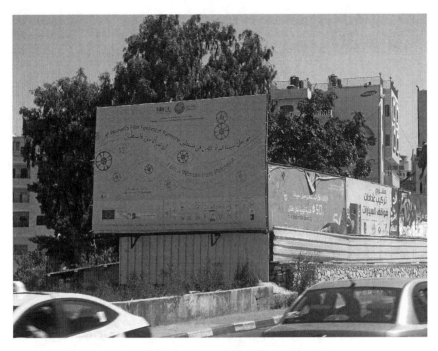

Figure 5.1 Courtesy of Shashat, 8th Festival, Ramallah Billboard.

- Conducting professional workshops to help build the capacity of the Palestinian filmmaking sector;
- Holding public panels and conducting discussions with the directors and experts following the film screenings;
- Holding screenings for youth in schools and colleges;
- Touring cities in the West Bank and Gaza Strip;
- Subtitling films into Arabic;
- Recognizing the excellence of a woman filmmaker by granting her the "Sulafa Jadallah Award."

Capacity Building of the Palestinian Filmmaking Sector with an Emphasis on Women Filmmakers

Shashat's efforts in the area of capacity building have focused on:

a. Promotion and networking of Palestinian cinema nationally, regionally, and internationally;
b. Training workshops and consultancies on production, project development, pitching, and funding resources for professional filmmakers (both men and women);
c. Intensive young women's summer video training programs encompassing three stages: beginner, intermediate, and advanced. For the most

part, Palestinian filmmakers are the trainers for these training/production programs;

d. Subsidized equipment rental to the filmmaking sector.

The activities under (c) above have yielded a number of short film collections: *Confession* (2008), *A Day in Palestine* (2009), *Jerusalem...So Near, So Far* (2009), *Masarat* (2009), *Palestine Summer* (2010), *Crossroads* (2010), *Worlds* (2011), and *I am a Woman* (2011 and 2012).[1]

"Films for Everyone," a Year-Long Screening/ Discussion Program

In the belief that "culture is a human right," Shashat has held over 1500 screenings throughout the last eight years, primarily of women's cinema, in partnership with over 100 community organizations and nine universities in towns, villages, and refugee camps throughout the West Bank and Gaza Strip. Shashat's film packages are distributed free-of-charge to cultural, community, and women's organizations and to universities for their use.

Cultural Outreach

Shashat has pursued cinematic cultural outreach by means of the following:

a. Library activities: Shashat has founded three decentralized film libraries in different sites to address the lack of mobility in Palestine: at Shashat in Ramallah in the mid-West Bank region; at An-Najah National University in Nablus in the North; and at the Bethlehem Peace Center in Bethlehem, in the South.

b. Research and publications: two publications (in Arabic) are forthcoming: *Palestinian women filmmakers—Strategies of Re-presentation and Conditions of Production* and *Women's Cinema in Palestine.*[2]

c. Weekly screenings/discussions curated through the Ciné-Club "Film Conversations," featuring masterpieces of world cinema, to promote awareness of international film heritage.

Training: An Historical Perspective

With two Palestinian Ministries of Culture (in Ramallah and Gaza), each with its own cultural policies, and with both ministries having equally minimal human and financial resources for coping with even simple cultural activities, it is not realistic to talk of the promotion or "education" of a new generation of Palestinian filmmakers by national bodies. In the absence of a Palestinian National Film Center, Film Board, or Film Commission, training falls on universities and colleges, production on a handful of production companies, and practical training, production, and exhibition on nongovernmental organizations like Shashat.

With its first Women's Film Festival in 2005, Shashat began to organize training workshops, conducted by international filmmakers, for professional Palestinian filmmakers (both men and women). The aim was to build networks for them through interaction with international guests of the festival. The assumption was that these guests would be able to introduce them to the international funding landscape of proposal writing, preparation of trailers, pitching, and the key players. The idea was that Palestinian filmmakers would generally be introduced to how the international film system works, with its connecting networks of funds, markets, festivals, and producers. Our focus, then, for the first several years, was on international trainers bringing skills and contacts to professional Palestinian filmmakers.

Many of the filmmakers who attended these workshops and consultancies learnt filmmaking from apprenticing with other internationally connected West Bank Palestinian "filmmakers," who for the most part worked as "runners" for international news agencies during the first Intifada (uprising). The first Intifada, from December 1987 to the official signing of the Declaration of Principles on the White House lawn on September 13, 1993 (more commonly known as the Oslo Accords), led to the founding of a Palestinian National Authority. This uprising also brought international media attention to Palestine and made the Arabic word in question part of the international lexicon. The joke at the time was that at every corner there was a news agency's armored vehicle waiting for "action" and that there were more such vehicles around than Israeli army jeeps. Fearing for their own lives in the midst of the confrontations, many of the international news agencies trained Palestinians on the simple operations of a camera, so that they could shoot the confrontations, as they could blend in more easily. Many Palestinians on the West Bank and Gaza Strip who became filmmakers or opened production companies or news agencies in the wake of the Oslo Accords learnt their filmmaking skills from these international news crews.

After Oslo, many of the Palestinians who worked for these international news bureaus contacted them and became their local correspondents or bureau chiefs. Another strategy adopted by others was to open news bureaus handling different broadcasters, with the material shot used for different networks by just switching the microphone cover, and the same question repeated again for another network. This provided the media practitioners with the resources to buy equipment and hire crews, and enabled some of them to begin making their own films. It was a profitable arrangement for both the international broadcasters who did not have to bring in crews every time something happened—with all that this entailed in terms of paying for hotels and airplane tickets, not to mention worries about equipment—and the local media practitioners. The international broadcasters now had a local person on the ground whom they knew and with whom they had worked in the past, and who was on immediate call. The arrangement was also profitable for the local news bureaus, for they now received pay more in line with international news pay. This in turn allowed them to support their media outfits as they moved into different areas of production.

The money previously paid to Palestinian "runners"—as they were called given that they could not be called camerapersons since that title was reserved for

the international person hiring them—was US$100 a day, a fortune at the time. This money enabled some of them to buy cameras later on and to become film-makers themselves. Their aspiration often was to shoot images for themselves and not the "drama" sought after by the international crews. The dynamic that emerged between those Palestinians "on the street" and the international crews who hired them—and who were getting all the credit for the "intifada" news footage in addition to the quite high "danger" bonus pay that came with it— led some of these international crews to help their "surrogates." Some took seri-ously the task of teaching them about shooting and respected their desire to take images of their own and not according to the requirements of international news agencies. Others either bought them cameras abroad at nearly half the exagger-ated local price or brought them cheap used cameras. Sometimes when a camera was inoperational due to having been dropped in the midst of confrontations, the crews would allow them to have it and would see about repairing it, or would turn a blind eye to a camera "lost" in the midst of confrontations.

This was the dominant trend in the founding of film production companies on the West Bank and the Gaza Strip after the Oslo Accords and by the time the PLO came to Palestine and the Palestinian National Authority (PNA) was formed. These professionals shared the euphoria of the time and of the promise of a nation and a national identity; they wanted to make Palestinian images and tell Palestinian stories outside of the framework of international news media needs or the constrictions of Israeli censorship. They were practically the only people with offices and equipment. University media departments were also being established at the time, with most of them opting to concentrate on print media due to a lack of equipment and a shortage of personnel with knowledge of video production. These "former runners" became practically the only source for hands-on train-ing and apprenticing for the first post-Oslo generation of young Palestinians who wanted to become filmmakers. Some of these aspiring filmmakers were expatri-ates who had studied filmmaking as undergraduates in Egypt or the United States and who had returned to Palestine wanting to be part of the new emerging nation and to make Palestinian films. It is possible to draw up a list of the names of that first young post-Oslo generation of filmmakers and to correlate it with the pro-duction offices or bureaus with which each person apprenticed.

But what these young filmmakers learnt was news; that is, shooting for news stories. Having apprenticed in the manner just described, the first generation of post-Oslo filmmakers began making documentaries in a documentary style consistent with typical news stories. Suddenly there were Palestinian films, and not just from the two or three internationally known names, for many names were emerging. These were given importance by international film festivals not necessarily on account of their cinematic skills, but on the basis of their location and the subject matter with which they dealt. This had a very negative impact on Palestinian filmmaking, as would become clear nearly a decade later. Given their reception internationally, the filmmakers of course thought they were being judged on their filmmaking talent. Also, the favorable response they received sent a signal to the now second generation of filmmakers, who were at university, that this was the way to make films.

The ongoing critique of Palestinian documentary film has been that it has stayed within the news reportage model and has rarely produced more creative and dramatic documentaries. The cause of this shortcoming is traceable to the early training of that first generation of post-Oslo filmmakers who then went on to train some of the members of the second generation. Now, with more exposure to international styles of documentary filmmaking, and with more young second-generation filmmakers emerging, including expatriate Palestinian filmmakers who have studied at film schools in the United States and in Jordan, we are beginning to see a change, with more dramatic and creative styles emerging. But that early phase in the training of Palestinian filmmakers handicapped Palestinian filmmaking for over a decade.

International Training

Several problems regularly emerged from the training consultancies and training programs that Shashat held with international trainers since 2005. In mentioning the problems, I in no way minimize the great gifts some trainers gave through their training. There were many cases of outstanding personal generosity with information and professional contacts and follow up. Years later, some of the trainers were still in contact with some of the filmmakers they had trained, having continued to provide them with support. I identify the problems because I think they shed light on film training in Palestine.

It is important to note that all these training sessions and consultancies were free-of-charge to the filmmakers taking part in them, that lunch was provided, and that in most cases transportation was also covered for out-of-towners (from outside Ramallah).

The problems that emerged were as follows:

A sense of entitlement: There was a feeling of entitlement on the part of the Palestinian filmmakers. Some felt that because they were living under Israeli occupation and suffering its humiliations and hardships daily, they were entitled to special treatment and redress for this international injustice. They thought there should be special funding set aside for Palestinians by the international film funds. The international trainers/professionals explained that filmmakers in their home countries had to pay for workshops and training, and worked night or day jobs to make ends meet, and that filmmakers from all over the world compete intensely for production funding. I saw this dynamic in all types of contexts, friendly and hostile, and in all sorts of intensities, and very recently in a major European Union audiovisual gathering when a participant put it bluntly and aggressively—"You owe us, that's why"—when there were queries as to why international film funds should put monies aside for Palestinian filmmakers.

Lack of sensitivity to key problems: On the other hand, there was a lack of appreciation for a very concrete problem faced by Palestinian filmmakers selected to take part in regional or international training programs or festivals. More specifically, they felt that all their land travel expenses should be covered and, furthermore, that they should be helped when seeking travel permits from the

Israelis when they need them. Due to the fact that there is no airport in Palestine, all travel in and out of Palestine is done through third countries—Amman/ Jordan for "green" ID holders (West Bankers); Tel Aviv/Israel for "blue" ID holders (Palestinian residents of Jerusalem and Palestinian-Israelis); and Cairo/Egypt for Gaza residents. Festivals and training workshops cover airplane tickets only and do not cover land travel as most people travel from their own countries. In Palestine, what is involved is not national land travel, but international land travel to another country in order to leave Palestine. This is quite costly, especially as travel to Jordan sometimes requires further land travel within Jordan and hotel accommodation if the flight time does not coincide well with the operating hours of the Allenby / King Hussein Bridge (used by Palestinians to cross into Jordan). In addition to the time that is needed, and the stress of Israeli security procedures including interrogations and searches, there is the issue of cost. A round-trip to Jordan can cost anywhere between US$200 and US$400, quite a sum for anyone, and especially for young filmmakers who are expected to dish it out from their own pockets. For Gaza filmmakers, the expense is even greater. The trip to Cairo is more harrowing and costly, for, having crossed the Rafah Border crossing (when it is open), filmmakers have to cross Sinai by car to Cairo. The seven-hour trip is sometimes hazardous, and, once again, hotel accommodation is needed (as is often the case, since people cross earlier due to the day-long land trip to Cairo, and because of the unpredictable opening and closing of the Rafah checkpoint).

Difficulties arising from group discussions: Quite early on, we realized that it was counterproductive to have group sessions to discuss projects or trailers or conduct pitching. We thought that in a group session filmmakers would benefit from the discussions of each other's projects. But we found out that filmmakers did not want to see their ideas "stolen" or the good parts of their projects appropriated by others, something several filmmakers experienced. By the time they had raised the money for their films, the "special" parts of their film projects were already in another filmmaker's film, albeit in a form that was less original than the initial conception, with both filmmakers losing out as a result. The more salient reason, however, why discussions were difficult was that these "professional" filmmakers did not want their colleagues to witness them being criticized or given advice attesting to the fact that they were not that "professional" after all, and this in spite of everyone being part of the same process. Most of the trainers were usually very professional and were either replicating training methodologies they had worked with at their film schools or in previous training sessions, or duplicating the conditions of pitching at markets.

There were a couple of cases of filmmakers getting into arguments with the trainers and challenging them. The claim was that they did not know anything about the Palestinian situation, so could not provide "feedback" on the Palestinians' projects or trailers. Some filmmakers left in a huff and others more quietly (by just not showing up for the remaining part of the workshop). Some trainers answered back and were forceful when explaining that in the context of international funding and pitching, filmmakers have to defend their projects. They further indicated that for the most part juries or pitching teams, more often

than not, do not know much about the Palestinian situation, or many other situations for that matter, even when it comes to projects in their home countries. Yet, they sit in judgment on the dramatic and artistic merits of a project and ultimately decide whether it should be supported or not.

Selective attention: There were also occasions when trainers were "shopping" for the next talent from Palestine and would be attracted to one project or one filmmaker, thinking they were discovering the next Elie Suleiman or Michel Khleifi. They would devote more time and attention to the Palestinian filmmaker in question, and to his or her project; and if it was a woman, this was compounded by the issue of physical attraction. The other filmmakers of course felt that there was no genuine interest in their projects and that the trainers did not think much of them. Sometimes this kind of situation was what elicited the backlash mentioned in the previous point.

Self-interest: Often the trainers/filmmakers were themselves looking for a project to undertake in Palestine, the training being a means of getting someone else to pay for their visit and their development research. Filmmakers sometimes felt the line of questioning regarding their projects was not that central to them and was more focused on the "education" of the trainer. The trainer would also be preoccupied with making arrangements for his or her own research, and with collecting information on production issues such as travel, crews, and equipment. What was lacking was a whole-hearted commitment to the training.

Competition: Since many of the trainers were themselves filmmakers or producers and most had some relationship with Palestine, they were accused of usurping the few funding opportunities available for films on Palestine. Filmmakers felt that this funding could have been available to Palestinian filmmakers to make films about their own lives, but that it was more favorable for European funders and TV stations to have European filmmakers, or, even better, Israeli filmmakers make films about Palestine, with Palestinians becoming the object and subject of someone else's film rather than the authors of their own film stories. The trainers/filmmakers usually conceded that many European TV stations and funders opt for non-Palestinian filmmakers when looking for Palestinian stories. They cited several factors and not merely the fear of being accused of being pro-Palestinian and attacked. They also conceded that the situation was different, for example, for black South African filmmakers or Afro-American filmmakers. In these other contexts it was always more favorable to have a filmmaker from inside the community make a film about the community in question. They explained that usually the European filmmakers, and the Israeli filmmakers for that matter, are already connected to the international network and know the lingo and styles of what funders and TV programmers want, and so shape their projects accordingly. The trainers also referred to the lack of Palestinian producers and to the abundance of Palestinian directors, a situation that was seen as prompting concerns on the part of funders about whether the final film would be completed on time and within the budget. Usually, the trainers also emphasized that an outstanding and unique project will always demand the attention of funders and TV programmers, and will stand out in any context. Yet, Palestinian filmmakers felt that the hurdles were set higher for them. Relatively mediocre projects on

Palestine by European filmmakers and/or Israeli filmmakers, they said, received funding and even a good deal of appreciation, whereas Palestinian filmmakers had to break through more barriers to get their films funded. The trainers also emphasized that Palestinians should not feel that they are the only ones who can address the Palestine issue.

Obstacles to Palestinian filmmakers' networking: There were difficulties organizing joint training sessions or consultancies for filmmakers living in the West Bank and in Jerusalem, and those inside Israel, especially during the years when the checkpoints were very difficult to cross and it sometimes took three hours to reach Ramallah from Jerusalem, which is actually a 20-minute trip. Also, we did not have the luxury of organizing two or more meetings—one for the Jerusalem filmmakers (who could come to Ramallah), and one for the Ramallah filmmakers (most of whom can not enter Jerusalem). These challenges hampered the networking and collaboration among the Palestinian filmmakers. Meeting with Gaza filmmakers was a known impossibility.

"Privilege guilt": There were also variations of the "privilege guilt" syndrome, some trainers having been so sympathetic to what Palestinian life is like that they excused irresponsible and noncommitted behavior. That is, they simply required less from their Palestinian trainees, because of what the Palestinians had to go through daily. The trainers rationalized the Palestinian filmmakers' demoralization and depression, seeing them as understandable under the circumstances. In reasoning this way, the trainers inadvertently fuelled a syndrome that some of us who work in development in Palestine fight on a daily basis: blaming all shortcomings on the occupation to the point of removing personal responsibility.

Hierarchy: For the most part, we always tried to team up an international trainer with a Palestinian trainer so that the Palestinian trainees would not only look up to an international trainer but also realize that Palestinians can have expertise if given the opportunity. Also, we wanted to pass knowledge and know-how to the Palestinian trainer, in terms of how training is conducted. And third, we wanted the Palestinian trainer to be a sort of "sounding board" for the Palestinian trainees, and to be available to explain things that they might find difficult to articulate in English, or to speak to cultural misunderstandings or any lack of clarity or misunderstanding. Some of the international trainers were very supportive and sought to empower the Palestinian trainer by discussing the training with him or her beforehand and by holding briefing meetings afterwards, also in order to go over the day together. They also "shared" the training so that the Palestinian trainer trained in some segments and they sat on the side. Others treated the Palestinian trainer as a training assistant rather than a co-trainer, as someone who was there to take care of their logistical and training needs, rather than as a fellow professional. Still other trainers were very demanding in terms of the availability of equipment and resources and had a running complaint about how difficult it was to train without this or that.

Orientalism: There was interest from some trainers who were in Palestine for the first time in projects that had some kind of critique of Arab or Islamic culture, and so trainees were effectively encouraged to develop negative aspects or the downsides of their culture in their projects. A certain orientalism also seeped

into the feedback on both the documentary and the fiction projects, with the exotic or the "different" being played up. Some directors went along with this, given their feeling that this was what "success" required; others responded that they wanted to make films for Palestinians, their own audience, and that they wanted to focus on the familiar. The trainers' response was that it was important to have an outside eye. This issue was a point of ongoing contention between the filmmakers and the trainers and manifested itself in different ways, including, with regard to subject matter, an emphasis on the oppression of women, minorities, sexual taboos, and so on. It also gave rise to vigorous discussions about audiences—for whom were the films being made?—and about films that are shown only at international film festivals, as compared with films that talk to local audiences.

Repetition: Another issue that usually surfaced in the training with international trainers is that the same film was being made again and again by the Palestinian filmmakers. They referred to the checkpoints, the occupation, the wall, and the humiliations as recurring motifs and icons of Palestinian films without providing a new angle on any of them. This issue of repetition was usually very explosive, as the trainers tried to elicit new perspectives from the workshop participants. They typically felt that the Palestinian filmmakers' films had not captured the full force of their daily situation, with all its Kafkaesque dimensions.

Excess: Trainers complained that Palestinian documentary projects tried to say everything and were simply crammed with information, because of the filmmakers' desire to try to "explain" as much as possible about the "Palestine issue." Trainers pointed out that this was the main problem they had seen in many Palestinian documentaries and/or proposals. There were too many characters and incidents, and too much information, which weakened the film and made it lose its focus and its emotive power. They explained that sometimes a small incident serves to explain the situation, and in a way that is far more poignant and powerful than what a whole lot of characters and issues can evoke. The trainers claimed that the same problem was evident in the trailers they saw in connection with funding applications. Most trailers, they explained, were done like American movie trailers, with fast clips showing a variety of footage. Trainers pointed out that sometimes one simple and moving clip can do the job better than a lot of short clips.

2008—the Beginning of Palestinian-Palestinian Training

We are whom we train... silenced, marginalized, oppressed and in the shadows... living the same life as our trainees, not able to parachute in or out of it. We are as locked-in as they are to our fate as Palestinians living under occupation.

Shashat's 2nd Women's Film Festival in 2006 toured the films of nine Palestinian women filmmakers to ten Palestinian universities. The audience evaluations stated that the students were aware of the names of these women filmmakers but had never seen their films. Audiences also pointed out that all the women filmmakers came from the center—that is, from the Ramallah/

Jerusalem/Bethlehem axis—and that there were no filmmakers from the other cities of Nablus, Jenin, Tulkarem, and Hebron, let alone Gaza. They raised questions about why there were no Palestinian women filmmakers from these areas, which constitute the majority of Palestine.

In 2008, as a response to those evaluations, we embarked on the training/ production program *Confession* featuring young women filmmakers from these very areas. We wanted to know what stories they had to tell about their lives. The key features of this young women filmmakers' training/production initiative, which continues today, are as follows:

Palestinian trainers: The trainers for most of our young filmmaker training programs are Palestinian filmmakers. We wanted to build connections between the Palestinian professional film community and the emerging young second-generation Post-Oslo women filmmakers from the provinces and thought it best if this was done in a practical way, through a training and mentoring relationship.

Access: As the Palestinian filmmakers live and work in Palestine, the young trainees can have ongoing access to, and interaction with them, beyond the actual training days. This has facilitated some very valuable collaborations and made possible assistance on other projects as well as ongoing mentoring.

Local knowledge: Also, the Palestinian filmmakers know firsthand the conditions of production in Palestine, both technically and security wise, and can provide valuable assistance to the girls regarding how best to handle the problems they encounter in their productions.

Social change: In our training program we did not want merely to pass on technical video skills. We also wanted the video training/production to explore the lives of young women throughout Palestine and, further, to get their concerns onto the national agenda through a nationwide screening/discussion program. The long-term developmental objective of our training/production program for young women filmmakers was to create social change through culture, so that women become producers of Palestinian culture.

Completed works: None of the trainees' films were left unfinished. We made a special effort to make the trainees proud of their hard work and effort. All the films were finished—with online (fine editing, color correction, sound mix, titles, and credits) and subtitling—and packaged.

Thematic foci: We usually have a theme for each year's training program and the girl trainees choose the films they want to make within the context of that theme.

Institutional lacunae: A major question that emerged for us at Shashat had to do with trying to understand why none of the women who had graduated from what seemed to be well-established and well-functioning media departments at several Palestinian universities had gone on to become directors.

Shashat organized "Documentary Film Day at Palestinian Universities" in the 2007 fall semester, at seven Palestinian universities' media departments, the event being scheduled so as to coincide with our 4th Women's Film Festival. The women filmmakers/trainers and their assistants (consisting of a young group of women filmmakers who trained in connection with the *Confession*

short video collection, discussed below) were selected on the basis of their participation in previous training sessions held by Shashat. To realize this initiative, Shashat partnered with all the major universities in Palestine: Arab American University, Jenin; An-Najah National University, Nablus; Al-Quds University; Birzeit University; Bethlehem University; Dar Al-Kalima College; and Hebron University. The "Documentary Film Day" made it possible for us to provide the students with an evaluation form/questionnaire whereby they themselves could identify the problems they faced in their media education.

Due to the fact that there were many student strikes at Palestinian universities during the fall of 2007, some lasting for one week, the workshops sometimes were cancelled at the last minute and had to be rescheduled several times. We could not organize a workshop in Gaza at Al-Aqsa University, which has a poorly equipped Communication College, because of the difficulty of finding a professional woman filmmaker to do the training. The Islamic University in Gaza has a communications department that is better equipped, but the institution is more conservative socially than Al-Aqsa University and has a religious bent. Unfortunately, we have seen this conservatism make inroads at Al-Aqsa University over the last several years, as the institution's attitude toward girls became consistent with the general social atmosphere in Gaza. The professors at Al-Aqsa University and Islamic University in Gaza are predominantly Egypt educated, holding PhDs from universities such as Ain Shams and 6th of October. Their expertise is mostly in public relations and the field of print media, where they are strong. Their knowledge of English is next to nonexistent, as is their awareness of technical or professional developments in the field. Al-Aqsa University, however, had been part of Shashat Women's Film Festival tour since 2006, showing women's films and discussing them with its male and female student bodies in gender-segregated classes.

What became evident from the student evaluations/questionnaires is that each university media department had its problems, which partially explained why no Palestinian filmmaker has emerged from these departments, let alone women filmmakers. The insider information and interaction with the students made us aware of several issues that have hampered the development of different media departments, one of them being the lack of connection to the professional filmmaking community. Such a connection is important, for it facilitates the acquisition of practical skills and knowledge, and also the development of networks for future generations of Palestinian filmmakers. Also, we noted a separation between the academic and the technical production components of the education, and the low-ratio of equipment to students, which had a big impact on production training, especially of girl students.

The picture that consistently emerged was that girls were less likely to handle equipment than boys. This was due to several factors, among them the socialization of boys who were used to playing with all kinds of equipment and used to exploring how it operates, pushing buttons without fear of the equipment breaking down. Girls were much more intimidated by the equipment and only touched what they were told to press. No special effort was made by the university trainers to give them more time to grasp the functioning of the equipment or to

experiment with its capabilities. Although the low ratio of equipment to students no doubt played a role here, there was also an attitude in these training classes to the effect that girls "do not understand equipment." As a result, girls and boys further internalized the stereotypes, and any initiative a girl might have been inclined to take to break with these attitudes was severely dampened. Also, during the periods of practical training, the boys would gather around the trainer and the relevant piece of equipment. The girls, most of whom were veiled, did not want to crowd close to the boys for fear of accidentally physically touching them, and so they stayed in the background, sometimes barely able to see the piece of equipment and what the trainer was demonstrating in his explanations of how it worked.

This lack of gender sensitivity and awareness had a multiplier effect on the girl students and helped us understand why these well-established university media departments throughout Palestine did not graduate any women filmmakers. When the students began to work on their class or graduation projects, the students who knew the equipment were the boys and so de facto they became the technical crew—the camera person, the sound person, and the editor—which provided them with further technical training. They acquired the skills (and the credit on the film) needed to secure apprenticeship positions with the private local community TV stations, which again led to another layer of practical technical training. The girls became the field researchers and the production coordinators for the graduation projects, which significantly limited the types of jobs they were able to get after graduation. The point is, the education they received gave them neither the skills nor the opportunities to become filmmakers in their own right.

Seeking to redress this situation, Shashat began contacting university media departments in the spring of each year, just prior to graduation, asking them to recommend two of their best graduating girl students for further practical training at Shashat over the summer. We conducted interviews with the two girls and picked one for our training program. This is how our video training/production program for young women emerged. It has been offered every summer over a period of four months from 2008 till now.

The "Documentary Film Day at Palestinian Universities" workshops were quite successful, except at the Arab American University, Jenin, which was just starting its media program at the time. The faculty responsible for setting it up did not have sufficient experience in the field of visual media, nor were they acquainted with equipment. Most were coming out of a literary background and concentrated on print media. An-Najah National University, Birzeit University, and Al-Quds all have well established media departments, with An-Najah University even holding an annual student film festival. What we discovered, however, having compiled the student evaluations, was that students at An-Najah University complained that their professors were not filmmakers and had never made a film and so were unable to link theory and practice. Production training was left to technicians who knew how to operate the equipment but did not know how to make a film, and were not helpful in terms of explaining the various stages of production, the aesthetic implications of the shots used, the sound construction,

dramaturgical construction, and character development, and so on. An-Najah University has since established a Media Center funded by the Kuwaiti Fund to the tune of US$5 million, with state-of-the-art facilities and equipment. The University is now launching a satellite channel that will provide apprenticeship and employment opportunities for their students and graduates, showing that a serious attempt is being made to redress the split between theory and practice. But the lack of well-educated teachers with relevant expertise remains the main problem at most university media departments.

Students at Al-Quds University and Birzeit University did not have any background in the history and development of documentary film and were ignorant of the heritage of documentary film, although they were producing short documentary films as their graduating projects. Most of these productions were more like news feature stories than documentaries. At Birzeit University, academic courses focusing on the media were taught at its Media Institute, whereas production courses were taught at the Media Development Center, the result being that aesthetics and theory were not linked to production. The Media Development Center's Radio and TV unit at Birzeit University emphasized radio, as this medium is less technically intensive than TV, whereas the TV courses focused on practical training. Also, the students complained about a lack of professional filmmaker mentoring during the production process. Since then, the institute has hired a working filmmaker as director of training. They have also hired the Swedish trainer whom Shashat used, PeA Holmquist, to conduct training sessions for them on the West Bank and in Gaza, and this on virtually an annual basis. The split between academic and practical work is an institutional fact at Birzeit University, with the Media Institute providing the academic track and the Media Development Center providing the practical training.

The students at Al-Quds University had a very low student to equipment ratio, with over 20 students to one camera (which broke down often due to this intensive use). The department in question has since hired filmmakers to provide practical training to students, but the situation, in terms of availability and access to equipment, remains problematic. Also, the filmmakers who have been recruited do not have the educational level needed to link theory and practice. They emerged from a learning environment where production skills were learnt in a hands-on way and typically know how to make films that are consistent with the norms of TV news stories. The production training may have improved but the theoretical training has not.

The students at the then newly founded Dar Al-Kalima College (offering a two-year diploma) were being given a balanced dose of theory and practice, with professionals in the field teaching most of the courses. We heard informally that the fact that the college is part of a Christian consortium, Diyar, has not encouraged students from different backgrounds to join. The students at Hebron University had access to better equipment but no professor who knew how to use it, only technicians, so once again the theoretical and practical tracks were not linked.

In sum, the media students generally complained about the very low level of practical training they received, and the near-total irrelevance and obsolescence

of their theoretical training. This was largely the result of an outdated teaching style based on rote repetition and note taking with little discussion or genuine understanding. The more serious problem, however, with the theoretical track is that most of the professors with PhDs (at Al-Quds University, An-Najah University, and Hebron University) are graduates of the former Eastern Bloc countries, where they studied on scholarships in the 1970s and 1980s. They know Russian as their second language and not English, and as a result their knowledge of media theories is necessarily outdated. Most of the developments in this field, and in the analysis of new styles of filmmaking, have emerged since the 90s and have mostly been articulated in English.

Confession (2008)—Funded by Goethe Institute Ramallah,
with additional funding from Göteborg International Film
Festival (4-month training/production program)

"Confession" was the first Shashat training/production program to give advanced practical training to university students. The project had as its theme the lived reality of young Palestinian women, of 18–22 years of age, the idea being to explore what it is like to be a young woman in Palestine. Issues discussed in the training were: How do you discover your body and your sexuality? How do you live love? How do you see your parents, your teachers, and brothers? and most important of all, How do you see yourselves as young women? We selected six girls from different social backgrounds, mostly from the more traditional governorates of northern Palestine, Jenin, Tulkarem, and Nablus, to take part in this training. A collection of seven short videos was made, all of them daring, amusing, and ambitious. Through this training/production project we sought to create a space for these girls' dreams, ambitions, and fears, in a society that is saturated with violence, chaos, and the effects of the occupation.

A key problem encountered in this first of Shashat's training/production projects had to do with the checkpoints being very tough to cross and involving hours of waiting. It took girl trainees from the northern cities of Jenin (two hours to Ramallah), Tulkarem (one-and-a-half hours to Ramallah), and Nablus (one hour to Ramallah), at least double that time actually to reach Ramallah, and the same was true when they went back. We could not train in the north either, as at that time the Israelis, fearing coordination of resistance activities, did not allow transportation between the cities, but did allow transportation from all of them to the central axis of Ramallah. So if someone from Jenin (north) wanted to go to Nablus (a half-hour ride), she first had to come south to Ramallah in order then to take transport north again to Nablus.

The situation on the ground was also not safe for there were frequent tear gassings and confrontations at the checkpoints. Also, the girls did not want to stay beyond 4 p.m. as by that time workers had left work and public transportation to these cities was less readily available and involved waiting in garages— sometimes for up to an hour—while the group taxi filled up. Once full, there was the journey itself, after dark on long and deserted dirt roads so as to avoid

regular checkpoints and flying army checkpoints. The whole context was neither comfortable nor safe for anyone, let alone young women.

These complicated circumstances left little time for training as the girls arrived tired and shaken. We decided that the only option was to have the trainees sleep in Ramallah. This is a culturally sensitive subject as Palestinian girls do not sleep outside their homes except at the homes of immediate family members, and here we were, asking that they sleep in Ramallah in a hostel on their own. We called for a meeting with the parents, at Shashat, in order to discuss the situation. The problem was obvious to all, whereas the solution was not. The parents dismissed the possibility of their daughters sleeping outside their homes outright, but their daughters were very enthusiastic about the training. So we decided to think matters over. Things got worse at the checkpoints and it was pointless for the girls to make the dangerous trip in order to get a maximum of two hours of training.

The father of one of the trainees, who had occasional business in Ramallah, began to drop by our office whenever he was in the city. He would just pop up, look around, check to see what was happening in the office and then leave, sometimes without even talking to us. After he had checked us out for a while he agreed that his daughter could sleep in Ramallah. The other parents soon agreed after he did, as this family was the most conservative.

Out of the five trainees who produced films in the "Confession" series, three continued their training with Shashat over a three-year period, with work at

Figure 5.2 Courtesy of Shashat, *My Lucky 13* by Dara Khader.

for future employment. The Palestinian trainees were not as proficient technically but were very knowledgeable about the kind of films they wanted to make and about the context of the films, which was Palestine. The Palestinian trainees felt that they would be short changed if the credits were done on a purely technical basis, for this would then marginalize them in the filmmaking process. After much discussion, it was agreed that there would be only one credit: "A film by," followed by a list of the people who actually worked on the film. The credit line did not provide any differentiation, in terms of who did what, as most of the tasks were in fact shared by all involved.

Second, one of the Palestinian trainees and a Swede, who was also the only man in the group, differed in their interpretation of the material that had been shot for their film at the girl's family's house. The boy edited a version that upset her because he only used clips showing her brother either bodybuilding or watching Intifada and Jihadist websites while telling his sister that she cannot have a boyfriend whereas he himself has a girlfriend. The girl felt that the film misrepresented her brother and created a narrative about him as a violent and sexist Arab man and even, possibly, as a potential terrorist, through stringing one type of clips together. She and her family were actually concerned that the representation in question could lead to the arrest of the brother by Israeli intelligence, since the family lives in Jerusalem. The Palestinian trainee edited her own version of the footage, which focused on her and not on her brother, showing how she manipulated the family discussion in order to disclose to her brother and her family that she had a boyfriend, a taboo. She made a subtle and tender film about family gender dynamics while the Swede made a dynamic "orientalist" film.

Palestine Summer (2010)—Major Support from the
Ford Foundation and Additional Support from the
European Union and Heinrich Böll Foundation

This project had as its theme "What does summer mean to young Palestinian girls?" and was designed to enable a group of young Palestinian women filmmakers from different cities to produce a number of summer video stories. Of all the videos in the collection, *Girls and the Sea* by Taghreed El-Azza created the strongest audience response. It combined resistance against parents' control of girls' movements with resistance against the restrictions on mobility by the occupation—against permits and checkpoints—in a manner that was organic, energetic, and youthful. Three girls sneak out of the house to go to the sea but the Israeli soldiers at the checkpoint tell them they have no permit to go to the sea and they "should go home." The girls then create their own "sea." They empty the water bottles they have into the inflatable plastic pool they have brought with them. Sitting within eyesight of the soldiers who are manning the checkpoint in the hot mid-day sun, the girls put their feet in the make-believe sea, put suntan lotion on, and relax. *Girls and the Sea* is an intelligent, funny, and subversive film that creates a connection between social and political restrictions pertaining to women and women's agency in resisting them.

Worlds (2011)

Worlds was a training/production project aimed at building the capacity of nine Palestinian women filmmakers, the goal being to enable them to tell more effective stories about their lives through the acquisition of dramatic filmmaking skills. The project involved both Palestinian and Italian trainers and yielded nine short films, with a total length of 53 minutes. The collection, entitled *Worlds*, was produced by Shashat on behalf of the Italian Ministry of Foreign Affairs—Italian Cooperation. Additional funding was provided by the Emilia Romagna Region to provide six of the nine filmmakers with online training at the Cineteca di Bologna, and for a seminar at the University of Bologna, "Women's Cinema in Conflict Areas: Freedom and Constraints." One of the trainees, Omaima Hamouri, received a master's scholarship to RSICA (Red Sea Institute of Cinematic Arts) on the recommendation of Shashat and on the basis of her sample videos. She recently made a professional film, entitled *White Dress* (2012), produced by Shashat through funding from the European Union.

Of these nine films, *Just Forbidden* by Fadya Salah-Aldeen was the most controversial. Indeed, it was banned by many of the screening sites. The reason was a three-second shot of a small blotch of blood on a sheet, in a scene where a young teenage girl discovers she is menstruating for the first time. Universities and certain organizations told us that it is not appropriate to show women's menstrual blood, as it evokes women's private parts. We asked about the difference between menstrual blood and other blood of women, our point being that it is all from the same body. And the blood of Palestinian women has been shown abundantly on TV, with women bleeding as a result of Israeli bombardment or attacks.

I Am a Woman (2011 and 2012)—Training in Gaza

The "I am a Woman" two-year project (funded by the European Union, Heinrich Böll Foundation and the Göteborg Film Fund) had as one of its components an intensive beginner and intermediate training/production program in Gaza, one designed to build the capacity of eight girl media students through practical video production. The training led to the production of twelve films, six in each of the two years in question, all of them focusing on the girls' lives in Gaza. I never imagined training in Gaza would be so difficult. At times it was even nightmarish, and it was always surreal. The problems we faced with the Gaza training/production project can be summarized in seven points.

(1) *Equipment*: Bringing equipment into Gaza and getting hard drives with film material on them in and out of Gaza was extremely difficult. Due to the siege of Gaza by Israel, we were unable to send equipment, whether by courier or by ordinary means of transportation, as it is extremely difficult to get permission to get anything through the Erez checkpoint to Gaza. Even diplomats need prior coordination and permission. As this project was an EU-funded project, we were able to bring equipment in with EU cars going to Gaza, but these were not traveling according to a regular schedule. Sometimes there would be a car going

in once every two weeks and sometimes there was no space in it for any of our equipment, as other grantees were also sending things to Gaza this way. We also needed to get hard drives back and forth in order to work on the films or to use the material we had for the TV programs. We contacted other diplomatic missions to see who was going to Gaza and when, and then tried to send things with them in a piecemeal fashion. The task of coordinating the sending of things in and out of Gaza was time-consuming and stressful, as sometimes cars were cancelled at the last minute for various reasons including the security situation.

(2) *Lack of supplies*: Again, because of the siege in Gaza, it was not possible to buy some of the minor supplies we needed in Gaza, such as cables to set up the editing system. Items that were to be found in Gaza were prohibitively expensive compared to prices on the West Bank, as they are all brought in through tunnels (and on the West Bank, prices are already about one-third higher than prices in Israel). Also equipment bought in Gaza was not to be trusted. A camera may have a Sony body but insides put together from older cameras in what is quite a sophisticated reconstruction process.

(3) *Limited technical know how*: Technical know how is limited in Gaza and we had a hard time finding an editing trainer who knew Final Cut Pro well.

(4) *Permits*: Applications for permits for West Bank trainers to enter Gaza were for the most part rejected by the Israelis. We could not meet with our senior trainer face-to-face, as he was unable to get a permit to come to the West Bank to meet with us. We both travelled to another Arab country in order to meet and discuss the training. We tried to bring trainers through the Rafah checkpoint, which involved travel from the West Bank by land to Jordan, then from Jordan to Egypt by plane, followed by land travel from Cairo to Rafah, then waiting at the Rafah checkpoint for entry to Gaza, and then finally land travel to Gaza city. Under the best of circumstances, this trip would take three days, although making the trip directly by car from Ramallah to Gaza City (had this been possible) would only have taken two-and-a-half hours. The surreal quality of the travel arrangements and coordination efforts wore us down. Having managed to arrange the Rafah entry once, we found that the Rafah checkpoint was closed for weeks. Another time there was shelling in Gaza and conditions in Sinai were not safe so everything was cancelled hours before the travel began.

(5) *Fuel and electricity*: Because of the siege of Gaza, fuel is allowed only in small amounts just to "maintain" things, but not in sufficient quantities to support the electrical plant providing electricity to all of Gaza. Electricity is rotated among neighborhoods on a schedule of about eight hours per neighborhood in any given 24-hour period. The schedule itself also rotates, so that the eight hours could be from 10 p.m. to 6 a.m. for a particular neighborhood and then later from 2 a.m. to 10 a.m. This is a very difficult situation to deal with while, for example, editing. The girls cannot leave their homes in the middle of the night to edit. What is taken for granted elsewhere, electrical current, is a luxury in Gaza, and this affects the charging of mobiles and the internet, bringing all communication to a standstill at times.

(6) *Lack of face-to-face communication*: Lacking face-to-face communication with the trainees or the Gaza trainers, we had to work through email, phone,

Skype, and Vimeo to provide feedback. This doubled the training time and effort for all of us. Everything was difficult although it did not have to be, but was made so because of the political conditions.

(7) *Bombing*: We also could do nothing about the bombing. The most disturbing thing of all was, we would be talking to the girls and then the bombing would begin. They would apologize for having to get off the phone in order to hide! It broke our hearts.

This is video training in Palestine!

Notes

1. Further details about these collections can be found on the Shashat website, www.shashat.org, Facebook (shashat.org), Twitter ShashatOrg, and YouTube (shashatfilms).
2. Alia Arasoughly and Dalia Taha, eds, *Palestinian Women Filmmakers—Strategies of Re-presentation and Conditions of Production* (Ramallah: Shashat, 2013); Said Abu Maalla, Rima Nazzal, and Alia Arasoughly, eds, *Eye on Palestinian Women's Cinema* (Ramallah: Shashat, 2013).

Art and Networks: The National Film School of Denmark's "Middle East Project"

Mette Hjort

Within a period of just half a decade, partnerships between political elites in the Middle East and the governing bodies of various top-tier American institutions have led to the creation of a number of high profile (and often architecturally remarkable) branch campuses in the region. A central element in a still-quite-novel "global network university"[1] paradigm, the branch campus phenomenon is associated with those parts of the world—the United States and the United Kingdom—that have traditionally dominated the highest levels of the university league tables. In the Middle East, branch campuses operated by major American research universities with well-established reputations in the area of practice-based film education promise new opportunities for aspiring film practitioners, as well as the kind of capacity building that political elites committed to the development of thriving film industries consider relevant. New York University has operated a branch campus in Abu Dhabi since 2010, Northwestern University has run a campus in Education City, Doha, Qatar, since 2008 (see Hamid Naficy, this volume), and the University of Southern California has a significant presence in the region through the Red Sea Institute of Cinematic Arts in Jordan, which opened its doors to students in 2008.

Yet, not all of the non-local institutions with a film training presence in the Middle East are American, or rooted in large nations. The focus of this chapter is on the still-evolving presence in the Middle East (and as of 2012, North Africa) of a stand-alone, conservatoire-style Nordic film school. The National Film School of Denmark's development of pedagogical initiatives focusing on the Middle East puts quite a different model on the film training agenda as compared with that of the branch campus phenomenon. Inasmuch as funding for these initiatives is provided by various Danish sources, the rationale is not linked to profit seeking,

the recruitment of fee-paying students, or the globalization of a brand. The model adopted by the National Film School of Denmark (henceforth NFSD) emphasizes a peripatetic, project-based, low-cost approach, and the freedoms—artistic and otherwise—that come with low levels of institutionalization and the terrain of mostly informal partnerships built on artistic and personal affinities.

The NFSD has not been directly involved in institution building, but it is closely affiliated with Danish initiatives that have sought to provide an enduring, yet modest base for documentary film training in the Middle East. Funded by Danish sources and initially located in Amman, Jordan, the Arab Institute of Film (AIF) became Screen Institute Beirut (SIB) when it was relocated from "rented space" to "permanent accommodation in Lebanon."[2] Chaired by Henning Camre—former head of the National Film School of Denmark, former CEO of the Danish Film Institute, and current executive director of a film and film policy think tank— SIB is closely related to the NFSD's training initiatives in the Middle East. The NFSD's Documentary & TV Department also works closely with the documentary film festival CPH:DOX. With its DOX:LAB, the latter has established training-oriented twinning initiatives that complement the work of the school's Middle East Project, providing further opportunities for partnerships between Danish and Middle Eastern directors. For example, Mahasen Nasser-Eldin, one of Palestinian NGO Shashat's trainees (see Arasoughly, this volume) partnered with Camilla Magid to make *From Palestine with Love* (2010) through DOX:LAB.[3]

The focus here is on the NFSD's "Middle East Project" and the institutions/ organizations that have been *directly* involved in actually mounting it. Related phenomena, such as the history of the AIF, the still ongoing development of SIB (which is increasingly linked to the project), and cases of capacity-building twinning through DOX:BOX will be explored elsewhere. The point here is to make a case for seeing the NFSD's Middle East Project as fueled by an interest, consistent with a small-nation outlook, in the advantages that working on a modest scale brings. Also meriting recognition is the project's commitment to the fostering of transnational and interregional artistic networks by means of artistic exercises with rules or setups carefully designed to create certain conditions of possibility or "affordances."[4]

The NFSD's Middle East Project has been developing since around 2006 and has produced a significant body of films, some of them quite remarkable. In the course of its existence, the project has evolved from an arrangement whereby students from the school were sent to the Middle East, to one that also brings students from the Middle East to Denmark. The task, as I see it, is not only to describe the project's phases, but also to articulate the value and efficacy of a process-based, art-focused, network-oriented philosophy of transnational film training that encourages student filmmakers to think deeply about what they are doing as filmmakers, and why. Eva Mulvad, an award-winning documentary filmmaker and graduate of the NFSD, describes the approach of the Documentary & TV Department, which also informs its efforts in the Middle East, as follows:

> The whole point was that we had to look deep into ourselves to discover what moves and drives us. Our teacher, Arne Bro, often evokes the distinction between what's

somehow been given to us and what's been explicitly learnt or acquired. You can be good at learning something that everyone can learn, but there are other things that you, specifically, have been given. And the point is to connect and work with those specific gifts. This is a very private and personal process involving a lot of introspection and that's why he defines documentary filmmaking as art.[5]

In a world where many of the films that get made are ultimately not worth the time it takes to watch them, let alone the time and money required to make them, there is a strong need for practice-based film education that teaches a lot more than filmmaking techniques and skills. The NFSD's Middle East Project brings issues such as the student filmmaker's self-confidence, personal agency, and stance toward the world into clear focus, and this in the context of a setup that fosters an authentic interest in realities lying well beyond a taken-for-granted (national) comfort zone. For these reasons and more, the project has much to offer.

On Method and Theory

My approach emphasizes what I call "practitioner's agency."[6] The aim, in other words, has been to grasp the self-understandings of a significant number of the agents who have been involved in the Middle East Project. These agents include film students, film teachers, producers, and consultants, some of them based in Denmark and some in the Middle East. They also include individuals and organizations responsible for devising and/or funding specific transnational filmmaking-as-film-training opportunities.

Questionnaires with a core set of questions, as well as ones focusing on the making of specific films and on the precise contributions of individuals and organizations identified in the films' credits, were sent to a large number of the student filmmakers featured on the DVDs entitled *Arab Institute of Film* (two disks, first eight films; no date), *6 Film fra Mellemøsten* (6 Films from the Middle East, DR/IMS/CKU/The National Film School of Denmark, 2006), *5 Films from the Middle East* (The National Film School of Denmark / IMS, 2008), *6 Documentary Films from Lebanon and Denmark* (The National Film School of Denmark / IMS, 2009), and *12 Documentary Films by Lebanese, Iranian and Danish Directors* (The National Film School of Denmark / IMS, 2010). Analysis of the responses to these questionnaires focused not only on their content, but also on the kind of language with which the respondents chose to express themselves. The decision, for example, to describe a person, identified as a consultant in the credits, as a friend (rather than as a mentor, a teacher, or an assessor) was seen as indicative of the philosophy underwriting the training and of the nature of the student filmmakers' experiences through it.

Phone interviews were also conducted from Hong Kong in the spring of 2012. Interviewees included Corine Shawi (Lebanese filmmaker), Mikael Opstrup (head of studies, The European Documentary Network [EDN], previously co-owner of Final Cut Productions, Copenhagen), and Julie Tarding (head of productions, TV & Documentary Department, the National Film School of Denmark).

At an earlier stage, face-to-face interviews were conducted with Poul Nesgaard (since 1992 director, the National Film School of Denmark), and with Rasmus Steen (program manager, International Media Support [IMS]). Email exchanges with Arne Bro (head, TV & Documentary Department, the National Film School of Denmark) in the course of 2010, helped to clarify the phases of the school's involvement in the Middle East.

Some of the research is document-based. It was a matter, for example, of analyzing documents prepared in connection with a review of the school's Documentary & TV Department in 2008, for the light they shed on the institution's commitment to art and personal expression, and on the criteria used to select a small number of applicants to the documentary programs from a large applicant pool. Annual reports produced by International Media Support (IMS), the school's partner in connection with the Middle East Project, helped to shed light on the scope of the IMS's activities in the Middle East, and on the implications of its emphasis on concepts of twinning and coproduction in contexts of capacity building and training. Especially important are the four documents describing the assignments that students participating in the Middle East Project were given in 2006, 2008, 2009, and 2010, for these provide the frameworks within which the films mentioned above were made. These documents are: "Moderne sprog i Mellemøsten / Unge kunstnere i Den Arabiske Verden" (Modern Languages in the Middle East / Young Artists in the Arab World; devised by Arne Bro, Mette-Ann Schepelern, and Louise Kjær, 2006); "Moderne sprog i Mellemøsten / Unge kunstnere i Den Arabiske Verden" (devised by Arne Bro and Mette-Ann Schepelern, 2008); "Destination Beirut: One Woman / One Camera / One Sound" (devised by Arne Bro, Karin P. Worsøe, and Helle Pagter, 2009); "Destination Beirut: One Woman / One Camera / One Sound" (devised by Arne Bro, Karin P. Worsøe, and Max Kestner, 2010). A fifth document from 2012, entitled "Exchange Program for Documentary Film Makers from Iran/Syria/Lebanon/Egypt/Libya/Tunisia/Morocco/Denmark—Investigating: One (Wo)man / One Camera / One Voice" (devised by Arne Bro), details the rules of a filmmaking-cum-film-training project that is ongoing at the time of writing. As will become clear, this most recent document affords insight into the school's approach to the development of a transnational and interregional artistic network. Here too, in the context of these five documents, a clear preference for certain kinds of phrases and a consistent eschewal of others—especially those now dominant within the increasingly bureaucratized tertiary sector in which universities and their film training programs operate—are seen as significant.[7]

The conceptual framework for the analysis is informed by concepts of gift culture, affinitive transnationalism, creativity under constraint, and practitioner's agency, as analyzed previously in connection with small-nation filmmaking.[8] Additionally, basic intuitions drawn from the literature on networks are helpful in the present context. Much of that literature, as Mark S. Granovetter memorably put it in an early and still-influential article, involves a "technical complexity appropriate to such forbidding sources as the *Bulletin of Mathematical Biophysics*."[9] Granovetter went on to note that the complexity in question reflected researchers' commitments to "developing a theory of neural, rather than social,

interaction,"[10] his point being that a more qualitative approach was entirely legitimate in a more social context of analysis. Mathematically complex analyses of the transnational, regional, and interregional network(s) that the Danish film school is involved in developing would likely be off-putting, both to film scholars and to the many practitioners who have generously made time to respond to research questions; they are also beyond the scope of my abilities. Recent work on artists' networks persuasively argues that many of them play an important role in "replac[ing] models of market capitalism with those of community and inclusion," [11] and the Danish film school's activities in the area of transnational film training appear to be consistent with claims along these lines. In developing this point, through an account of the phases and dynamics of the Middle East Project, I rely on Granovetter's basic distinction between "strong" and "weak" ties, and on his conclusions regarding weak ties. Granovetter defines the strength of ties in terms of a "combination of the amount of time, the emotional intensity, the intimacy (mutual confiding), and the reciprocal services which characterize the tie."[12] Neglected by earlier scholars, weak ties are considered potent by Granovetter and anything but negligible, for he sees them as playing a powerful role in the diffusion of ideas, in the creation of opportunities for social mobility, and in the fostering of a sense of community. The Middle East Project, as will become clear, achieves its network aspirations through a mix of strong and weak ties.

In what follows, I begin with a description of the NFSD, since its identity as an elite, conservatoire-style film school with a firm commitment to a concept of film as art has clear implications for its efforts in the Middle East. I go on to provide an account of the phases of the school's activities in the Middle East. Inasmuch as this account seeks to identify the partners who have been or continue to be involved in the Middle East Project, it also sheds light on the dynamics of the network to which the school's transnational film-training activities contribute. The third section takes the discussion of networks one step further, by looking at how the frameworks or rules of the students' assignments create network affordances. The fourth step in the argument involves an unpacking of the implications of the assignments' "no budget" dimension, and this in terms of different kinds of freedom. In the final section, the issue of personal filmmaking is briefly taken up, with reference to the impact of the Middle East Project on student filmmakers traveling to Copenhagen from the Middle East.

The National Film School of Denmark

Established in 1966 the NFSD is part of a system of tertiary institutions in welfare-state Denmark, where the cost of education is fully assumed by the state. The principle of fully subsidized education is reflected in the basic parameters of the school's Middle East Project, with student filmmakers from the region being charged no fees and receiving support for room and living expenses while in Copenhagen. The school belongs to the portfolio of the Danish Ministry of Cultural Affairs, not the Ministry of Education. The difference, as Director

Poul Nesgaard points out, is not lost on teachers at the school, nor on its alumni. Indeed, when talk of moving the school to the Ministry of Education has surfaced on occasion, teachers and alumni have fought hard to defend it from proposed changes seen as threatening its status as an elite, small-scale, conservatoire-style institution devoted to art. Referring to the Bologna process, Nesgaard insists that the identity of the NFSD would be impossible to sustain, were it to become subject to the standardization and bureaucratization that are some of the cultural entailments of "mass" universities. Scale, claims Nesgaard, is a crucial factor, because small cohorts make possible an approach aimed at drawing out potentially unique and personal expressive capacities, and this through exercises designed with the needs of specific students in mind.[13] The importance of the NFSD's (small) size cannot be emphasized enough, for, when combined with certain teaching styles and values, the scale in question allows for great intimacy and mutual involvement, for the emergence of what Granovetter would call "strong" ties. The school offers a number of programs, and in the present context it is the two offered by the Documentary & TV Department that are relevant, for they are the ones that have provided a basis for partnerships with filmmakers, production houses, and NGOs in the Middle East. Documents from a 2008 review of the Documentary & TV's Department's two programs provide further details regarding the issue of scale. The school accepted 45 students in 2007, 10 of whom were non-local.[14] Of the 45 students who were accepted, 9 were offered admission through the Documentary & TV Department.

The Documentary & TV Department was established in 1992 and is celebrating its twentieth anniversary at the time of writing.[15] While the NFSD has been associated internationally with the achievements of its fiction filmmaking graduates—with such figures as Lars von Trier, Susanne Bier, Lone Scherfig, and Thomas Vinterberg—the quality of the education provided by the Documentary & TV Department is increasingly acknowledged. Many examples of this tendency could be provided, and the following two are merely indicative:[16] Mira Jargil, who made Grace (2010) in Lebanon as part of the Middle East Project, won CILECT's (International Association of Film and Television Schools) Best Student Documentary Prize for Den tid vi har (The Time We Have, 2011) in 2012. Rania Tawfik, who was born in Lebanon to a family with roots in Iraq, graduated from the Film School's Documentary & TV Department in 2011, with a multi-camera diploma film entitled A Light Breeze, which won the Best Short Film Award at the Gulf Student Short Competition in Dubai in 2012. In 2006, her film about blind people, entitled The Eternal Night, was honored at the Al Jazeera International Documentary Festival with the Silver New Horizon Award.[17] Tawfik is of particular interest in the present context, for she has played a key role in the NFSD's Middle East Project. In addition to making Kiss My Pain Away in Lebanon as part of the "twinned" "Destination Beirut" phase in 2009, Tawfik appears in the credits of many of the NFSD's student films, having served as a friendly advisor, translator, and mediator with respect to Middle Eastern realities (including linguistic ones) and contacts.

As with most initiatives that prove to be inspiring, creative, and transformational, the Documentary & TV Department's Middle East Project is inextricably

linked to a person who is widely seen as an exceptionally gifted leader: Arne Bro. Bro's practices and values as a teacher and facilitator have, as we shall see, been decisive for Middle Eastern students' experiences of the NFSD's transnational film training initiatives. Bro's unique profile as a documentary film educator is evident in the reasons given when he was awarded the Danish Film Institute's Roos prize in 2006. Established in 1995, the Roos prize (named after Danish documentary filmmaker Jørgen Roos) aims to honor remarkable efforts on behalf of documentary filmmaking. A jury consisting of Mikala Krogh, Henning Camre, Agnete Dorph Stjernfelt, and Max Kestner awarded Bro the prize on the following grounds:

> For his unfailing ability to discern the inherent potential of [documentary] material. For being able to discern dramas, comedies and tragedies in even the most fragile and underdeveloped material.
>
> For being able to see what nobody else sees, what's not yet there. For seeing the potential in a person—and for knowing what that person needs to encounter in order to realize his or her potential.
>
> For working with love as the driving force. A love for his students—both those enrolled at his school, and those who are not. A love, that is tireless.
>
> Because he has built a unique documentary program from scratch. A program that takes its distance from criticism and humiliation and which instead insists on what is constructive and enables growth. A program that knows that the student must actually experience something first hand in order to understand.[18]

The "Middle East Project": Phases, Partners, and Networks

The DVD collections mentioned above point to five phases of the NFSD's Middle East Project. The first two (2006 and 2008) saw students from the NFSD being sent to the Middle East, with a specific filmmaking assignment based on a one-(wo)man band approach. That is, self-reliance was central to the setup from the start. The three most recent phases (2009, 2010, and 2012) included an element of "twinning" or exchange, with filmmakers from the Middle East receiving training at the NFSD as well as mentoring in connection with a specific film project. Before describing the phases of the project and identifying the Middle Eastern partners who have contributed to it, it is important to note that Danish partners have been part of the NFSD's initiative from the outset, their priorities and networks having helped to shape it.

According to Julie Tarding, the Documentary & TV Department has always been committed to ensuring that its students carried out one filmmaking project abroad, this commitment being reflected in an earlier partnership with the Danish International Development Agency (DANIDA).[19] With Denmark spending just under 1 percent of its GNI on development aid, DANIDA supports a considerable number of projects, linkages, and partnerships focusing on "freedom, democracy and human rights," "growth and employment," "gender equality," "state-building in fragile states," and environmental protection.[20] The credits for the DVD entitled *6 Films from the Middle East* (2006) list three Danish organizations, in addition to the NFSD: The Danish Centre for Culture

and Development (DCCD), International Media Support (IMS), and the Danish Broadcasting Corporation (DR). Among many other projects, the DCCD funds the Images Festival (established in 1991), which aims to introduce Danish audiences to "the most up-to-date examples of cultural expression from developing countries" and this in order to undermine stereotypes, challenge "prejudice" and open "people's eyes to unknown, inaccessible areas...of the world." In 2006, which was the first year of the NFSD's Middle East Project, the Images Festival focused on the Middle East. Reasons for the focus in question can be sought in the crisis that erupted in September 2005, when the daily *Jyllands-Posten* published cartoons of Prophet Muhammad in a putative attempt to highlight the problem of self-censorship in an increasingly multicultural Danish society. The NFSD's "Middle East Project," as some interviewees have suggested, was to some extent prompted by realities that the Cartoon Crisis made salient. Viewed in this way, the initiative is consistent with a position articulated by Najat El Ouargui, the International Project Manager in Theater and Film for C:ntact at the Betty Nansen Theater in Copenhagen. Linking "creativity" to people who see or solve "things in a non-traditional manner," Ouargui suggests that certain "social issues" may require creative approaches that are not typically found within the contexts of official political praxis.[21]

IMS is by far the most important of the Danish partners, having helped to shape the "Middle East Project" from the very outset, and becoming the sole Danish partner as of the project's second phase, in 2008. Established in 2001 in response to conflicts in Rwanda and the former Yugoslavia, the IMS "is a non-profit organization working to support local media in countries affected by armed conflict, human insecurity and political transition."[22] The organization emphasizes "close partnership[s] with local media support organisations nationally as well as internationally"[23] and aims to be able to "react rapidly and flexibly to the needs of local media."[24] The partnership between the NFSD and IMS grows out of the latter's "media and dialogue activities...in the Arab world and Iran."[25] Of the IMS's many projects in the region, the following are especially relevant in the present context and indicative of the scope of the organization's activities: the IMS funded and played a central role in establishing the Arab Institute for Film (AIF) in Amman, Jordan, in 2005, an institution devoted to documentary film making and training. Rasmus Steen, program manager (twinning) at IMS, describes the aspiration as follows: "The guiding idea was to establish a training center or a school, as a regional program in the Arab world. We felt that collaboration across borders in the Middle East would be able to strengthen the film milieus there, just as it has in the Nordic countries. So we drew up a model which brought five countries—Egypt, Palestine, Jordan, Lebanon, and Syria—into the process of establishing the AIF."[26] The decision, about which there are divided views, was subsequently made to move the AIF to Beirut, where it became Screen Institute Beirut (SIB), which is also funded by IMS.

IMS also funded and helped to implement the Dox Box festival in Syria, in partnership with filmmakers Diana El Jeiroudi and Orwa Nyrabia, both co-founders of ProAction Film, Damascus. IMS sees capacity-building and opportunity-generating "twinning" between media workers in Denmark and

Iran and the Middle East as especially fruitful.[27] Steen draws attention to two projects in particular, the film *An Arab Comes to Town* (2008), which is the result of collaboration between Lebanese filmmaker Ahmad Ghossein and Danish filmmaker Georg Larsen. The other project emphasized by Steen is Diana El-Jeiroudi's first feature-length documentary, *Dolls—A Woman from Damascus* (2007), about the Middle Eastern equivalent of the Barbie doll, Fulla. In this case, the collaborating partners, under the aegis of the IMS's twinning program, were the Syrian filmmaker and producer (and later festival organizer) El-Jeiroudi and producer Mikael Opstrup, now at the European Documentary Network (and in that capacity closely involved with the Syrian Dox Box festival), but at that time co-owner of Final Cut Productions. The exchange aspect that became a feature of the NFSD's "Middle East Project" in its later incarnations and phases reflects the IMS's commitment to the concept of twinning, which is seen as emphasizing mutuality and partnership, as opposed to hierarchical and unilateral knowledge flows.

Finally, Steen regularly contributes to film training workshops in the Middle East. As he puts it, "We don't see ourselves as just a donor organization. We see ourselves as a participating donor organization. That is, I don't just throw money at a workshop that I get someone else to organize. I'm part of the workshop."[28] Steen's comments about the nature of his involvement in peripatetic workshop training are borne out by student testimonials, which refer to his enthusiastic and inspiring role in the "Middle East Project." Katrine Philp, who was part of the first student cohort to be sent to the Middle East, points out that "Rasmus was incredibly committed to it all and his enthusiasm was really contagious and had an impact on the whole project. We also drew on his experience as we prepared for our trip."[29] Anita Hopland, who was part of the fourth cohort, describes Steen as a "kind and curious man who is interested in stories from around the world." She goes on to identify what she sees as driving that interest, which she shares: "For me this is important: telling stories from around the globe to make it less divided."[30]

In the context of the training workshops conducted in the Middle East, Steen and Bro are often partners, their collaboration thus extending well beyond the design and funding of the NFSD's "Middle East Project." During an interview conducted in December 2011, Steen indicated that he and Bro increasingly use SIB as a base for various workshops and that he had just returned from one that they had run together. The two film trainers had worked with documentary film directors from Tunisia, Egypt, Lebanon, Syria, Iraq, and Iran, all of them selected according to the criteria that the IMS typically uses: prior experience with film-making (the emphasis being on providing training opportunities for people who are "professional amateurs or semi professionals"), a written application focusing on a filmmaking idea, and a "product of some kind that has nothing to do with film—a poem, a painting, a photo series." The aim, as Steen put it, is "to involve people who have a broad creative horizon and who want to experiment with new things. That kind of curiosity is a really good thing in creative work with film." Steen sees all of the dimensions of IMS's training and capacity building in the area of creative documentary filmmaking as working together, through an extensive,

multifaceted network: "What happens is that there's a kind of meta-network that emerges. The films speak one language. The directors speak another language. And then perhaps the network speaks a third language. And all of this is inter-connected and intertwined."[31]

With these remarks about the larger collaborative context for the NFSD's Middle East Project, let us now look at how it has evolved, over the course of several iterations. Inasmuch as many of the partners, concepts, and emphases identified during the early phases remain very much in play in the later stages, the aim below is to pinpoint new elements as they emerge. One of the constants, for example, is that the students from the Documentary & TV Department at the NFSD were all sent to the Middle East (and most recently also North Africa), as an integral part of their training, for one month, and this about halfway through their four-year program. Another constant is that funding has been provided by IMS throughout (for students leaving the NFSD for destinations in the Middle East, as well as for those traveling to the NFSD from the Middle East and North Africa).

Phase I: 2006

Two student filmmakers from the NFSD were sent to Egypt and three to Jordan. A sixth student was to have been sent to Egypt (Olavi Linna), but was prevented from traveling due to passport problems. Instead, Linna produced a web-based film focusing on the Egyptian artist Doa Aly, entitled *Some Movements for Web Camera*. The 2006 project description identifies two levels of cooperation, the one focused on collaboration with local artists in the host country, the other on the students' connection to a "production base that is a company devoted to film pro-duction, a place for film artists and technicians and the future base for a Middle Eastern film school." The Arab Institute for Film, and the IMS's involvement with it, were thus part of the picture here. The production bases to which the students were connected were described as possibly being able "to help with a transla-tor" or as "having a good sense of the artistic milieu," as encompassing "friends, colleagues, assistants" and "perhaps future partners."[32] Pioneers Production in Jordan, the Royal Film Commission in Jordan, and Semat Cairo were the salient Middle Eastern partners. Ali Maher at the Royal Film Commission, Diana El-Jeiroudi and Orwa Nyrabia at ProAction Film, and Hala Galal at Semat Cairo, among others, figure in the credits of the students' films.[33]

Phase II: 2008

Three student filmmakers from the Danish Film School were sent to Egypt and two to Syria. The films produced during this phase are identified as copro-ductions between the NFSD, IMS, ProAction Film in Damascus, Beirut DC, and Semat Cairo. As the explicit involvement of Beirut DC suggests, Lebanon was to have been one of the student destinations, but was ultimately deemed unsafe.[34]

Phase III: 2009

A "twinning concept" was introduced. Three student filmmakers from the NFSD were sent to one county in the Middle East: Lebanon. Three young Lebanese documentary filmmakers were brought to the NFSD, also for one month. This phase of the project built on what Arne Bro describes as a "preliminary exploration of an exchange," with five Middle Eastern directors, including Corine Shawi and Serena Abi Aad, having been invited to the NFSD in 2006.[35] The 2009 project description refers to IMS's funding as being derived from the Ministry of Foreign Affairs' "Arab Initiative," which aims "first and foremost at dialogue and partnership and at the exchange of methods and insights... as a means of achieving an overarching goal consisting of dialogue on an equal basis." Although there are no references to Screen Institute Beirut, which was created in 2009, but to a "series of production houses and artistic institutions in Beirut, with an interest in documentary," SIB functions as an important partner institution in the region, alongside the production company Beirut DC.[36] The 2009 project description underscores the importance of having Lebanese and Danish directors "meet each other, share their work and discuss their personal working methods and aesthetics" over a period of one week. The description also refers to the involvement of "consultants" during the process (consultants play an important role at the NFSD more generally).[37] During this phase, key names in the credits include Corine Shawi (as consultant), Helle Pagter (as consultant), Eliane El Raheb (Beirut DC), and Ghassan Salhab.

Phase IV: 2010

The exchange with the Middle East was expanded to include Iran. Three young documentary filmmakers from Iran and three from Lebanon spent one month in Copenhagen, while six students from the NFSD spent one month in Lebanon. Dr. Ahmad Alasti, a film scholar at the University of Tehran, and Mehrdad Oskouei, an award-winning documentary filmmaker, served as contact persons helping to select filmmakers for the exchange program. As in 2009, one week was devoted to filmmaking exercises designed to forge a connection between filmmakers from Iran, Lebanon, and the NFSD. During this phase, names recurring in the films' credits include Corine Shawi (as consultant), Max Kestner (consultant), Daniel Dencik (consultant), Lisbet Obel (consultant), Paul Baboudjian (SIB), Ghassan Salhab (consultant), Ahmad Alasti, and Mehrdad Oskouei.

Phase V: 2012

The scope of the project was expanded to encompass Iran, Syria, Lebanon, Egypt, Libya, Tunisia, Morocco, and Denmark.[38] Reasons for expanding the scope included a desire on the part of the NFSD to ensure that its student filmmakers did not all travel to the same country (as was the case in 2009 and 2010). The weight given to the idea of learning by being removed from a "comfort zone" was thus reflected in

the revised framework. In 2012, students from the NFSD were sent to Lebanon (one student), Egypt (two students), Tunisia (one student), and Morocco (one student). The twinning process from 2009 and 2010 was slightly modified, for reasons of cost in the wake of the financial crisis, but also as a means of creating opportunities for the filmmakers to get to know each other better.[39] The filmmakers were now twinned in ways allowing for interaction throughout the entire process. Filmmakers from Iran, Syria, Lebanon, Egypt, Tunisia, and Morocco spent two weeks at the NFSD, during which time they met and collaborated with the NFSD students participating in the program. The visiting directors from North Africa and the Middle East were provided with a personal consultant (an experienced Danish documentary filmmaker). Student filmmakers from the NFSD expected subsequently to reconnect with the directors from Lebanon, Egypt, Tunisia, and Morocco on their home terrain, and even to work with them as "artistic partner[s]."[40] The conditions for dialogue, partnership, and (possible future) collaboration were significantly enhanced in this phase of the project.

It is clear that a network concept is an important aspect of the NFSD's project. Equally evident are the multiple dimensions of the project's involvement with networks. From the perspective of the NFSD, the existence of an *already actual* network of partners—of known, committed, and involved partners, friends, and resource persons—is critical. The school, after all, sends students to countries where they have never been before and where they are to make a film as a "one-man-documentarian," as Malina Terkelsen, who made *Manar and the Children in the House with a Hole in the Roof* in Damascus in 2008, puts it.[41] The *already actual* network includes resource persons who share relevant stories, insights, and expertise with the film students before they leave. Anita Hopland, who grew up in Copenhagen with a Norwegian mother and Pakistani father, and who made *Michel* in Lebanon in 2010, refers, for example, to lectures by Professor Jakob Skovgaard-Petersen (first director of the Danish Egyptian Dialogue Institute, and professor at the University of Copenhagen). Other filmmakers from the NFSD mention scheduled meetings with artists from Iran and the Middle East, and with journalists from Al Jazeera, among others. The *already actual* network also encompasses the various organizations that provide not just contacts to a professional milieu, but also a kind of "safety net," as Rasmus Steen (IMS) puts it. In some instances, as in the case of Malina Terkelsen, the official link to a production house was not decisive in terms of the development of her project. However, in the case of Katrine Philp, who chose to make a film about young deaf children studying at a Coptic boarding school in Cairo (*Silence in a Noisy World*, 2008), the existing link to Semat Cairo proved to be crucial:

> I used their network a lot.... Sign language is not international, so the chances of getting a translator for Egyptian sign language to English in Denmark were really poor. So I had to do all the translation in Cairo...and the people at Semat were really helpful.... Also, it took quite some time to get the permissions needed to film at the school for deaf children. There were a lot of formalities and things that had to be approved. Again, the people at Semat were incredibly helpful. They got their lawyer to draw up a contract, which was actually necessary.[42]

In addition to relying on an *already actual* network, held together by ties of various strengths, the project anticipates a *potential* network. First, there are those hoped-for ties that are seen as likely to emerge as participants—*known to*, and *selected by* the NFSD—begin to interact under conditions that create the right sorts of affordances. Julie Tarding puts the point as follows:

> When we invite filmmakers from the Region to Copenhagen, we hope that, in addition to becoming part of our larger network, they will develop a network with each other...We're not trying to show anyone anything or to teach this or that. We're just trying to do something, so that these filmmakers can make their own "rings in the water" and so that they can work together in the Region, across borders.[43]

The hopes articulated by Tarding on behalf of the NFSD appear to be consistent with filmmakers' actual experiences, at least on a national level. Rania Rafei, who is a graduate of the Lebanese Academy of Fine Arts (ALBA) and who made *Notes on Love in Copenhagen* in 2009, mentions sharing an apartment with Eli Souaiby (Lebanon) and Selim Mourad (Lebanon) in Copenhagen. She points out that she did not know either of them previously, and that they "helped each other" with various things.[44] Anthony El Chidiac, who holds a BA from Saint Joseph University in Lebanon (IESAV at USJ) and who made a film entitled *Equal Men* (about the gay milieu in Copenhagen) in 2010, mentions having "made friends with [his] local colleagues" (from Lebanon), namely with Tamara Stepanyan and Rana Salem. So far, he says, the "network did not go beyond the national borders," but he is "proud to have been part of it" and "would love to be part of any other kind of exchange."[45]

Second, there is the aspiration to reach out well beyond the *known* network, and thereby to create opportunities for affiliation that will be taken up by *yet-to-be-identified* documentary filmmakers in the future. Tarding's remarks regarding the NFSD's preference for a peripatetic mode of operation, as evidenced by the setup in 2012, are suggestive in this regard:

> We look at the Region and ask ourselves where it would be interesting to send someone. Not for the sake of our students, but in terms of thinking about where we haven't been yet....If there weren't security issues in different places, we'd probably try to send them to even more places, so as to get a network.[46]

Tarding's comments about the inclusion of Iran in 2010 also evoke the idea of a potentially larger network, with links and connections to and between individuals who are, as of now, unknown to and thus unnameable by the school:

> I think someone at IMS knew Dr Alasti and then Arne [Bro] contacted him and told him about the whole project and he was immediately very interested. So he came here to talk about it and the result was that we had three filmmakers from Iran. This means that next time we do something, we have three Iranian filmmakers who know the project whom we can draw on, and who will be able to say "This could be of interest to this person and that person." In this way, it just keeps

growing, and you get an "underground" [network of filmmakers committed to creative documentary filmmaking].[47]

In addition to strengthening an actual network and creating the conditions for an expanded network through a peripatetic and constantly evolving project-based approach, the school aspires to make the network, as it exists following several iterations of the project, more fully *manifest*.

> I think we've made about 60 films since 2006, both with our students and with the directors from the Middle East. And many of those involved may not actually know each other or may not know that so and so was part of all this. So we're thinking of publishing something that will make all this clear.... We feel that we're all part of each other, because we speak the same language of film. But we'd like to make the network more explicit.[48]

The network is seen as rooted in a deep commitment to the art of creative documentary filmmaking, understood as authentic personal expression and a thoughtful, properly responsive engagement with reality. It is viewed as what we might call an "affinitive network," with the filmmakers in it sharing certain artistic values and experiences. To make the links and connections fully manifest is thus, potentially, to encourage artistic partnerships based on shared values and experiences, or, less ambitiously, a more wide-ranging exchange of the "gifts" and kindnesses that are also embedded within the project's approach. The commitment to what I call "gift culture" pervades the artistic setups with which the filmmakers are asked to work. This is reflected in the expectation that artistic partnerships be created, in the anticipated efficacies of a "no-budget" concept, and in the severing of the filmmaker from his or her usual environment. The gift of artistic collaboration plays a central role, taking the network in new directions that could not have been charted in advance. Let us look, then, at the framework that encourages artists to meet as equals, on the terrain of an artistic project that only becomes do-able, that is, executable, when generosity is embraced through gifts of skill and local knowledge, through gifts of trust and of the intimate self.

The Artistic Setup: The Equal Encounter with another Creative Being

In the first two phases of the Middle East Project, one of the "constraints" or "rules" imposed on the student filmmakers was that each of them should "meet" an artist through the making of their films. The requirement that the filmmaker "partner" with an artist was formulated as follows:

> The thought animating this project is that of a meeting as equals.... An artist from here meets an artist from there. It can be put that simply. An encounter. Methods, material and language are exchanged. One works together. One spends time together,... plans activities together. There are encounters over a cup of coffee or a

meal. There is work on equal terms.... The equality arises from the wish really to encounter the other, in the exchange of ideas and language.[49]

The 2006 and 2008 project descriptions further dictated that the filmmaker work with an artist who was not him- or herself a filmmaker. The point of this requirement was to ensure that the student filmmaker developed his or her own "style" or "sound," as a director. There was also a cultural dimension, however, to the rule:

> The rule points to an encounter with artists in the areas of music, dance, performance, film and visual arts. Modern language and modern expressions from a modern world. We want to meet modern, dynamic young people from the Middle East, get to know their way of thinking, sense an interest in the times and contexts in which the artist is immersed. Materials, spaces, light, rhythm.[50]

As is often the case in the context of the NFSD, where the Dogma 95 concept can be seen as originating, constraints in this case were also affordances, or so many creative opportunities.[51] For example, Ditte Haarløv Johnsen (director of *Painting My Secret*, Jordan, 2006) saw the "partnership rule" as helping her to deal effectively with the project's temporal constraint, with the planning and shooting of a film in about four weeks: "The fact of having been given a 'theme' for the film helped me to find a focus in the very short time span that was available."[52] The rule was also, however, an invitation to establish friendships with inspiring, passionate, and courageous people for whom art and art-making, even under the most difficult of circumstances, are a vital expressive necessity. It was an invitation to be touched and changed by these people and their lives, to become connected, in a meaningful and lasting way, with the culture and people of the Middle East.

The student filmmakers worked with a variety of approaches to the partnership requirement. Katrine Philp, for example, "opted to collaborate with a composer [Reem F. Shakweer] who composed music for the film as [she] shot it."[53] For Malina Terkelsen the "collaboration was rather small and fine, but nevertheless [to her] now a quite important part of the film." She "found a singer from the conservatory who was willing to make an improvisational recording with [her]. Mirna Cassis is the young woman singing while the credits are rolling."[54] Maya Albana's *One Woman Army* (made in Cairo with assistance from Semat in 2006) focuses on the musician Naissam Jalal (whose parents are Syrian and who grew up in France) and her collaboration with the western musicians Miles Jay and Colter Frazier. A portrait of a strong, rebellious, and courageous young woman, who is also very vulnerable, the film evidences precisely the kind of respectful and genuine encounter with another artist that was required by the artistic setup. In Simon Lering Wilmont's *Above the Ground, Beneath the Sky* (Cairo, 2008) the camera is used to explore the art of circus performance. The film evokes the dreams of 11-year-old Mahmoud Sameh, and what it takes to realize them, through sequences capturing, among other things, his regular training sessions with his demanding, yet sensitive trainer, Mohamed Kamal. In *Killing My Art*

(Amman, Jordan, 2006), Nicole Horanyi follows the graffiti artist Wesam Farouk Shadid, providing insight into his self-understandings as an artist and the challenges he faces. Especially moving is the depiction of Shadid's mother's support for his artistic practice in the face of hostility from their immediate community, which requires him to efface his work, to "kill" it, as he puts it.

The production history of one of the artist-focused films, Ditte Haarløv Johnsen's *Painting My Secret* (Jordan, 2006), helps to suggest both the gift-like nature of the artistic encounters behind the first 11 films, and the language with which the filmmakers choose to describe them. Having arrived in Jordan, Haarløv Johnsen met Ali Maher from the Royal Film Commission, whom she describes as "very friendly" and as "knowing most Jordanian artists."[55] The artist whose artistic being, circumstances, and work are depicted in the film is the painter Hani Alqam, whom Haarløv Johnsen spent about ten days, that is, one third of her time in Jordan, "finding." Her plan initially was to "do a film about theatre or dance," which she describes as a "physical art" well suited "to the camera." Haarløv Johnsen's account of the process leading to Hani Alqam's becoming her "main character" highlights gifts of mediation and introduction within an existing artistic network, but also the mutuality that explains the sense of intimacy, trust, and involvement that are pervasively present in the film:

> Then I met Hani. I got his number from another artist, from somebody I'd told about my project and who thought I should see him. He came and picked me up where I stayed and we went to his apartment. The moment I stepped inside his space I had the feeling of coming home.... It was easy to be around him. We started spending a lot of time together. And I kept on looking for a theatre person to do my film about. Hani was helping me by introducing me to his friends, but really it was him I wanted to be with. In the end I turned the camera on him. And he wasn't overexcited to be filmed and yet the camera was so much a part of me that he accepted; to make me happy I guess.

Haarløv Johnsen's film shows us Hani Alqam in his studio, preparing for an exhibition of his work at the Zara gallery at the Amman Hyatt, dressing for that exhibition, and interacting with the princess of Jordan during it. Focused images of these spaces and activities contrast with blurred, older looking Super 8 images of sun-baked natural and urban landscapes in Jordan and Amman. Like many of the film students at the NFSD, where the average age of the students on admission is 27, Haarløv Johnsen has a culturally complex identity (having grown up Danish in Mozambique) and formal training in another artistic field. Referring to the mix of two types of images, each with their own materiality and sensibility, Haarløv Johnsen explains that she "has a background as a still photographer," and is especially interested in "the image," and thus decided to bring along a Super 8 camera to Amman, in addition to the camera provided by the school. Her film captures the relation of Hani Alqam to his milieu, through his responses to reviews of the exhibition, poor sales of his work, and questions from the Amman "jet set" about his reasons for painting people "as [deformed] invalids." Referring

to the reviews, he claims that critics purport to describe his "secret," in the sense of what drives him, but are unable to do so. The interaction with the princess of Jordan, while brief in the film, is poignant for reasons about which the film is never explicit yet movingly intimates. The director unpacks the scene that is bristling with tension as follows:

> The Princess of Jordan is an art lover and often comes to openings of exhibitions (of which there were not that many in Amman at the time). Hani's art is so far away from anything else the princess ever sees and he knows that, and he knows where he comes from; the Palestinian refugee camp. And that, added together with the depth of his soul, makes it an awkward situation. And the awkwardness shows Hani's position very precisely; he's always on the outside even when he's inside.

In this film, as in her other films, Haarløv Johnsen saw the documentary process as being about "the encounter" with another human being, about "getting to know another human being, getting under the skin." She describes her "meeting" with Hani Alqam as "full of important moments, as a journey of discovery," one that involved "finding each other in the story." As in any process involving gifts of the self to the camera and filmmaker behind it, the making of *Painting My Secret* required adjustments in a give-and-take process based on mutuality. "The balance of closeness-distance is always the biggest challenge for me," Haarløv Johnsen notes. "Always wanting to be under the skin, and sometimes pressing the limit. I had one conflict with Hani during the time we filmed. He was fed up with being looked at through a camera. I learned to give more space."

Asked to describe the most significant aspects of her film-school project in the Middle East, Haarløv Johnsen talks about the encounter with Hani Alqam, about the process of challenging herself, about "growing as a human being," and about "the fact that [she] forever [has] a friend in Hani." She also describes a sense of connection to the Middle East: "Making the film opened up the Middle East to me, and the feeling of being connected is not limited to the arts milieu, it's deeper. It's about being a human being in a political world and the quest for freedom, both on an individual and larger level." Through these very human and simple descriptions of the efficacies of the NFSD's required assignment, we begin to understand that the point of the challenge to which students are exposed halfway through their program is as much about inner transformation as it is about technical skill. It is about a *process* that is impossible to "measure" using the kind of bureaucratic, technocratic, and "outcomes-oriented" language with which university programs all around the world, even those in which art and creativity figure centrally, are now required to work. One well understands why the NFSD feels that there is a lot at stake in maintaining its status as a conservatoire-style art school, separate from the bureaucratic dicta of the "mass university." Inner transformation and the forging of enduring human connections can be facilitated by the assignments and are anticipated in them, through rules that are also affordances, but they are not promised as the "outcomes" of a given practice-based film pedagogy, nor could they be. After all, in the "one (wo)man" approach what is learnt is not explicitly taught, but personally derived by means of

self-reflection from the student's lived experience of making a film alone at a precise stage in his or her film education.

The Artistic Setup: In Principle There's No Money

The "no budget" concept, or, more accurately, minimal budget concept has been a feature of the NFSD's Middle East Project through all of its phases. During the early phases, the concept was expressed in poetic terms: "In principle there is no money; a situation common to artists in both the East and West. The work is created through those amounts of coffee and materials, and the persons that the artist, using skills of seduction and organization, is able to bring together. There are some rooms, some people, some ideas. A ticket."[56] In the 2012 project description, the same concept is articulated slightly differently: "Modern documentary films will very often encounter restrictions in financing, imposed by funding bodies as [well as] by aesthetic or political ideologies. Because of these restrictions it is an integral part of the documentary filmmaker's craft to be able to work entirely alone as [it is] to master the techniques and methods to conduct and produce an entire documentary film without practical, artistic or economic help."[57] Whereas the first description foregrounds the absence of resources, the second underscores the extent to which resources come with "costs," in the form of imposed constraints (to use Jon Elster's term), and thus a loss of freedom.[58]

The "no-budget" setup as initially described is consistent with the NFSD's emphasis, in all areas of its activities, on equipping its graduates with a capacity to work to creative effect within a small-nation filmmaking context, where resources, especially as compared with those available within the globally dominant film industry, are necessarily limited. Both descriptions articulate an understanding of the sorts of affinities that provide a natural basis for partnerships between filmmakers located in Denmark and in the Middle East. That the terms of the setup effectively reflect some of the filmmaking realities of the Middle East is clearly evident in Lebanese Anthony El Chidiac's remarks about the relevance of his experiences at the NFSD to his local context. Citing a lack of "access to production and a lack of opportunities or support" as the main challenges he faces as a Lebanese documentary filmmaker, El Chidiac sees considerable value in the "One Man, One Camera, One Month" setup: "It let me know that I'm able to make a film at any time with the least production [apparatus] possible. One camera could be enough. But I haven't done it yet. I'm very excited about shooting a similar project here in my own country....One Man, One Camera, One Month would work great here."[59]

The no-budget/minimal budget philosophy of documentary filmmaking is informed, at least as it is adopted in the documents provided by the NFSD, by concepts of freedom. Unsurprisingly, then, a distinction that has been influential in discussions of freedom or liberty for many decades proves to be analytically helpful in the present context. I am thinking here of philosopher Isaiah Berlin's piece entitled "Two Concepts of Liberty," which distinguishes between a positive conception of liberty (focusing on enabling conditions that activate an agent's

capacities) and a negative conception of liberty (understood as the absence of external interferences or of imposed constraints).[60] Although the "One (Wo) Man, One Camera, One Month" setup imposes rules of its own, it is not hard to see that it resonates with a negative concept of liberty. Cinematic agency, we note, ultimately resides in just one agent who, additionally, is to have only the most minimal equipment needs. Thus, the setup effectively trains students in the art of being artistically productive without having to succumb to the visual, narrative, and ideological constraints and interferences that those making major investment decisions typically impose on documentary projects from the outside, as it were. To learn to work with a budget that barely is one, which is what the setup is partly about, is to be free from *external constraints*. And it is this *freedom from* something that is a standard feature of a negative conception of liberty.

More interesting, perhaps (because it is less obvious), is the assignment's relation to a positive conception of liberty. "Positive liberty" is typically seen as capturing the ways in which enabling conditions activate agents' capacities to engage in action, producing a situation where they have the *freedom to* do something. That a concept of "positive liberty" provides an appropriate means of explicating the deeper implications of the filmmakers' lived experiences of the NFSD's "One (Wo)man" assignment is suggested by the very words and phrases toward which the filmmakers gravitate in response to questions about what was challenging and significant about the program. Tamara Stepanyan, a graduate of the Lebanese American University's Communication Arts program (2001–2005), who shot *Little Stones* in Copenhagen in 2010, describes her experience as follows: "In this course one becomes totally *open*, totally *free*.... This course and this film, I must admit, gave me a certain *power*, ... the inspiration and confidence to follow this path which is filmmaking [emphasis added]."[61] Malina Terkelsen (*Manar and the Children in the House with a Hole in the Roof*, Syria, 2008) describes herself as having been "curious and open," as "looking for accidents and magic, for gifts from reality." Terkelsen's film focuses on a lonely mother called Manar who is alone with her children while her husband serves a jail sentence. The film captures the strength of this woman under very difficult circumstances. The director sees the film as having, to a significant extent, been shaped by precisely those "accidents" and "gifts" to which she refers.[62] Sine Skibsholt, who shot *Along the Way* in Lebanon's Sacred Valley of Qadisha in 2010, wrote an email to Arne Bro at the NFSD just before leaving for a second trip into the valley. In it, she refers to how "gratifying it has been to film in this way." She describes her experience of the "One (Wo)Man" assignment as an "exercise in having *confidence in the world* and existing in the *present moment* and *simply looking* with the camera [emphasis added]." In response to research questions, she speaks of being "more confident," of "knowing that [she] can make a film in 4 days," of "trusting [her] eyes," and of "believing in the image, not the words."[63] These filmmakers' testimonials suggest a situation in which negative freedom—a *freedom from* external constraints arising from the power, values, and expectations of those who wield money—combines with the reality of geographical and cultural displacement— with the filmmaker's insertion into a foreign country and culture—to create circumstances that are *affordances* for certain attitudes and capacities. As such,

these circumstances provide a basis for an experience, not merely of negative freedom, but also of positive freedom. What is repeatedly described is an acute experience of enhanced self-efficacy.

Terms like "gifts from reality," "trusting one's eyes," and "having confidence in the world" are poetic and suggestive, but not semantically self-evident. An example of how Sine Skibsholt chose to work when shooting *Along the Way* helps to explicate some of the rich meanings that are signaled by these terms. Although the latter may not literally be used by all of the student filmmakers, they are nonetheless very typical of how these filmmakers choose to describe the capacity-enhancing aspects of their filmmaking assignments in either the Middle East or Copenhagen. One of the effects of cultural and geographic displacement is that certain skills that are culture- and context-dependent—linguistic ones, for example—are temporarily bracketed. In a resource-intensive setup, one allowing for considerable teamwork and a division of labor, this bracketing of skills can be offset through the recruitment of various practitioners with the requisite abilities. In combination, the "no-budget" and "one (wo)man" approaches establish a quite different tendency for the student filmmaker, one that allows the changed terrain of filmmaking, with its new lacks and lacunae, to trigger the personal discovery of new practices and attitudes, and thus of new capacities. Skibsholt, for example, recalls having been unable to communicate linguistically, except in the most rudimentary way—through the best efforts of the mountain guide Fayez Kanafani, who shepherded her into the Sacred Valley of Qadisha on donkey trails. "Trusting the world" and "having confidence in [her] eyes" were a matter of seeing the impossibility of linguistic communication as an opportunity for an intensely visual engagement with the reality being explored. One scene in Skibsholt's film is especially striking. Using static framings and long takes of both people and objects to great effect, Skibsholt shows us a peasant, both in his work environment and in his home. In one long take, lasting about 67 seconds, Skibsholt achieves a connection with the man, which bypasses language. Watching the man's eyes begin to twinkle as the take persists, one senses a reciprocal involvement and mutuality that works, quite simply, through the act of seeing, through a reciprocal gaze mediated and intensified by the camera. As Skibsholt puts it, "Our meeting through the camera made us both smile, and there was some kind of human recognition." That the acquisition of the sorts of attitudes and capacities to which Skibsholt refers can be significant is evident in her remarks about individual style. Skibsholt sees herself as having discovered "a style" through the making of *Along the Way*, one that she developed further in her diploma film, *Ved Havet* (*Aside the Sea*, 2011).[64]

The Artistic Setup: One Voice

One other element of the students' assignments, constant throughout all phases of the Middle East Project, is the call for a personal "sound" or "voice." In the 2012 project description, "voice" is defined in terms of an "individual visual language," encompassing "visual, spatial, editing and character preferences," as

well as "personal themes and motives."[65] The point is to encourage authentic, personal filmmaking that grows out of a genuine interest in and involvement with the film's depicted realities. This aspect of the framework appears to have had the greatest impact on the filmmakers who traveled from the Middle East to Denmark during the exchange phases of the Middle East Project. One of the reasons for this is that at the NFSD these filmmakers were exposed to a new form of film pedagogy emphasizing precisely this personal dimension. Whereas student filmmakers traveling to the Middle East were not explicitly taught during their four weeks there, filmmakers traveling to Denmark were involved in intensive training for a week, followed by close interaction with an established documentary filmmaker serving as a "consultant." The impact of this training is uniformly evident in testimonials provided by Rania Rafei (Lebanon), Tamara Stepanyan (Lebanon), and Anthony El Chidiac (Lebanon), as well as by Corine Shawi (Lebanon), who has spent much longer periods at the NFSD and has gone on to become an important resource person for the school, as a consultant for student filmmakers from both Denmark and the Middle East.

Tamara Stepanyan describes a training process that was "emotional, intense, and demanding." "Arne Bro," she says, "made us explore filmic language...for 12 hours every day for a week. In the day time he would give us assignments to be shot on the same day and then we would go back to class and analyze. After the class, we would get home around 10 p.m. and we would still have a diary to make; a visual one, always with rules to follow. For example: one shot, no close up, about a lover." She describes the methods used at the school as "very interesting and challenging and beautiful," and sees being at the school as a "privilege": "It is a 'privilege' to be in that school and to learn with this method for 4 years. A method where no grades exist, and where there is freedom of the soul and the heart. Explore, write, research, be creative, there are no boundaries and there is no one who is not talented. Every human is unique and is treated as such. There is still a lot to elaborate on this subject."[66] Rania Rafei foregrounds the "generosity and sensitivity" of Helle Pagter and Arne Bro and credits them with having "helped [her] to figure out [her] language and aspirations with [her] film." She sees her encounter with especially Arne Bro as decisive: "For me meeting Arne and learning his method was a life changing experience. For the first time in my life, even if I did many films before, I learned about my filmic language from a very authentic perspective."[67] Corine Shawi's description of Bro's approach echoes the comments made, not only by Rafei and Stepanyan, but by the jury who awarded him the Roos prize in 2006. Bro's method is one that she sees herself as practicing in her teaching of filmmaking at three different institutions in Lebanon. She sees this method as "being based on believing in every human being's potential." Bro, she says, "tries and actually always succeeds in digging out the specific unique visual language every student/director/artist has....It is essential to give confidence and appreciate the other's perspective, pointing out the visual and content elements that are repeated by the filmmaker. To concretely do that, Arne asks for assignments/diaries/exercises with specific rules. Then he analyzes what he gets."[68] Several of the filmmakers contrast Bro's methods with those encountered elsewhere. As Rafei puts it, "In Lebanon I was all the time

taught to do it right. In the film school I was taught to...listen to my inner voice while filmmaking and this changed how I conceive my work."[69] Lebanese filmmaker Serena Abi Aad makes a similar point: "I thought I had learned all the rules of good filmmaking. I later realized, however, how little I knew and how much more there is to learn. This happened when I joined a documentary filmmaking workshop in Copenhagen, Denmark in the summer of 2006. There I met the most wonderful and most influential film scholar, Mr. Arne Bro. He taught me, among other things, that there are no 'rules' in filmmaking. He gave me the courage to break every rule I ever learned in the Lebanese film school, or rather, to break free of rigid conventions and thus to experiment."[70]

A film made in Denmark by a Lebanese filmmaker provides insight into the way in which the assignment's affordances regarding voice and personal filmmaking were actualized. *Equal Men* (2010) by Anthony El Chidiac is a documentary about the gay milieus in Copenhagen. The film focuses on three transvestites—Ramona Macho, Heraldo Balbino, and Lisa (who is bisexual)— and a gay male couple (Mikel Costa and Michael Thomsen). Visually the film alternates between two sorts of images. Some of the sequences are in color and involve mobile framings and a mostly observational approach.

These sequences contrast with a series of static framings of the subjects of the film, being interviewed by the filmmaker (whose voice we sometimes hear), in a mostly empty space with a lamp. Most of these images are shot in black and white, the only exception being a highly personal sequence with Ramona. The sequence

Figure 6.1 *Equal Men*, a documentary by Anthony Chidiac (Lebanon).

in question follows the credits and shows Ramona responding to a question, apparently about her reasons for participating in the film. Ramona's answer points to El Chidiac's deeply personal involvement with the issues explored in the film—"It wouldn't have been interesting to me to sit in front of a, for instance, very, very hetero guy who was just really fascinated by this. 'What is this about you having lady's clothes?' and stuff like that. I do this because you are also very personally involved in this issue [pause]. You ask and you get answers [laughter]." Ramona's answers, highlighted because they provide a kind of coda after the credits, shed light on a series of black and white images of an unidentified man, who never speaks directly to the camera, and who, from time to time, occupies the very place of the interviewees to whom the viewer is explicitly introduced. These images record a process involving the wearing of a wig and, finally, a bra. Through small, carefully controlled variations in the film's visual language, the identity of the unnamed man is subtly revealed. The figure is the filmmaker himself, Anthony El Chidiac. Reflecting on a question regarding the significance of Ramona's response, El Chidiac indicates why it was important, also personally, for him to make the film: "It was more or less about me and my openness to the world. Everyone in the film wanted to tell something to the world I come from, and so did I."

Conclusion

Seen from the perspective of film directors in the Middle East, the NFSD's Middle East Project makes a clear contribution in a number of areas: focusing on documentary filmmaking, it provides opportunities for filmmakers from the region to engage with realities that are important to them, but perhaps difficult to explore without the framework that a training program provides; it introduces filmmakers to a kind of film pedagogy that is seen as deviating from what tends to be on offer in the region's established institutions, a pedagogy that is liberating, engaging, and enabling; finally, it fosters networks, and although some of the ties in question may be weak, they are perceived as a potential basis for further worthwhile filmmaking activities, and thus as enabling. In some cases, student filmmakers from the Middle East have become central to the NFSD's project and key figures within the network. This is clearly the case, for example, for Corine Shawi. The art-based network(s) that the project helps to create may be its most important contribution. Hala Galal, from partner NGO Semat in Cairo, speaks of the "regression and increasing intimidation" that she encounters in her "daily work as a female filmmaker" in Egypt. And she goes on to underscore the importance of the kind of support that a network of friends and fellow travelers can provide: "There are people in other nations who can appreciate my work, despite the differences in ethnicity, religion, and language. This...has strengthened my conviction that we, as human beings the world over, can stand united against injustice and intolerance in all its forms."[71] Film training, in this way of thinking, extends well beyond mere technical skills and into the domain of "world making." Admirably, those working with this kind of model are not afraid to recognize and, indeed, embrace the responsibilities that this entails.

Notes

1. NYU Abu Dhabi University and College in UAE, New York University, http://nyuad .ny.edu/about/index.html (accessed December 17, 2012).
2. Henning Camre's preface to the DVD set entitled *Arab Institute for Film*, 2.
3. My thanks to Alia Arasoughly for bringing this film to my attention, and for introducing me to Mahasen Nasser-Eldin.
4. James Gibson, "The Theory of Affordances," in *Perceiving, Acting, and Knowing*, ed. Robert Shaw and John Bransford (Minneapolis: University of Minnesota Press, 1977).
5. Mette Hjort, Ib Bondebjerg, and Eva Novrup Redvall, *The Danish Directors 3: Dialogues on the New Danish Documentary Cinema* (Bristol: Intellect, 2013).
6. See Mette Hjort, *Lone Scherfig's "Italian for Beginners"* (Washington, Seattle and Copenhagen: University of Washington Press and Museum Tusculanum, 2010) for a discussion of practitioner's agency.
7. For a discussion of innovative approaches to institution building, see Meaghan Morris and Mette Hjort, eds, *Creativity and Academic Activism* (Chapel Hill and Hong Kong: Duke University Press and Hong Kong University Press, 2012).
8. Mette Hjort, "Affinitive and Milieu-Building Transnationalism: The Advance Party Project," in *Cinema at the Periphery*, ed. Dina Iordanova, David Martin-Jones, and Belén Vidal (Detroit: Wayne State University Press, 2010); Mette Hjort, *Small Nation, Global Cinema* (Minneapolis: University of Minnesota Press, 2005).
9. I am grateful to my colleague Peter Baehr for bringing Granovetter's work to my attention. Mark S. Granovetter, "The Strength of Weak Ties," *American Journal of Sociology* 78, no. 6 (1973): 1361. For recent technical work on networks, see M. E. J. Newman, *Networks: An Introduction* (Oxford: Oxford University Press, 2010).
10. Granovetter, ibid.
11. Clayton Campbell, "Creative Communities and Emerging Networks," in *Cultural Expression, Creativity & Innovation*, ed. Helmut Anheier and Yudhishthir Raj Isar (London: Sage Publications Ltd., 2010), 188.
12. Granovetter, "The Strength of Weak Ties," 1361.
13. Interview conducted by Hjort at the National Film School of Denmark in January 2009.
14. National Film School of Denmark, review documents "Bilag [Appendix] 10.1" and "Bilag [Appendix] 13.1" (2008).
15. The Danish Film Institute's FILMupdate from November 27, 2012 reproduces the seven rules that provided an initial framework for the Department's programs. These make references to linguist Noam Chomsky, theologian Knud Ejler Christian Løgstrup, physicist Niels Bohr, psychiatrist Jacques Lacan, semiotician Roland Barthes, and to Fred Wiseman's Urban Planning film series, and John the Baptist. "Filmskolens TV-uddannelse fylder 20 aar" (The Film School's TV program is 20 Years Old), www.dfi.dk/Nyheder/FILMupdate/2012/november/Filmskolens-TV-Uddanelse- (accessed November 27, 2012).
16. See Hjort, Bondebjerg, and Redvall, *The Danish Directors 3*, for a fuller evocation of the impact of the School's documentary programs.
17. DOX:LAB, "Filmmaker Rania M. Tawfik, Denmark" (2011/2012), http://www .cphdox.dk/doxlab/dir.lasso?n=52 (accessed June 30, 2012).
18. "Roos Prisen 2006," Danish Film Institute, November 9, 2006, http://www.dfi.dk /nyheder/nyhederfradfi/arkiv/roosprisen-2006.aspx.
19. Julie Tarding, phone interview conducted by the author, May 10, 2012.

20. Ministry of Foreign Affairs of Denmark, "Activities," http://um.dk/en/danida-en/activities/ (accessed December 17, 2012).
21. Najat El Ouargui, "Cultural Creativity: Catalyst for Social Development," in *Viewpoints Special Edition—State of the Arts Volume VI: Creative Arab Women* (Washington, DC: The Middle East Institute, 2010), 26.
22. Screen Institute Beirut (SIB), http://www.screeninstitutebeirut.org/donors.html (accessed December 17, 2012).
23. International Media Support (IMS), "About," http://www.i-m-s.dk/about/ (accessed December 17, 2012).
24. International Media Support (IMS), "What We Do," http://www.i-m-s.dk/files/publications/1609%20AboutIMS.final_web.pdf (accessed December 17, 2012).
25. SIB, http://www.screeninstitutebeirut.org/donors.html (accessed December 17, 2012).
26. Rasmus Steen, interview conducted by the author at the IMS office, December 15, 2011.
27. International Media Support (IMS), "Annual report 2008," http://www.i-m-s.dk/publication/ims-annual-report-2008/ (accessed December 17, 2012).
28. Rasmus Steen, interview, December 15, 2011.
29. Katrine Philp, response to questionnaire, May 8, 2012.
30. Anita Hopland, response to questionnaire, May 6, 2012.
31. Rasmus Steen, interview.
32. Arne Bro, Mette-Ann Schepelern, and Louise Kjær, "Moderne sprog i Mellemøsten/Unge kunstnere i den arabiske verden" (Modern Languages in the Middle East/Young Artists in the Arab World), NFSD project description, 2006.
33. Security issues arising from the "Cartoon Crisis" threatened to scupper the launch of the program. As Ditte Haarløv Johnsen puts it: "I was part of the first group that did the Middle East project, and everything was literally up in the air. A major drawback at the time was the so-called 'Drawing Crisis,' which meant that some countries would not receive us, as they could not guarantee our safety. Until the last minute we didn't know which country we would be going to or if we were going at all." Response to questionnaire, May 1, 2012.
34. Malina Terkelsen, director of *Manar and the Children in the House with a Hole in the Roof*, remembers the situation as follows: "First I was supposed to go with Andrea Koefoed to Beirut, but then it seemed to be dangerous, or at least the Ministry of Foreign Affairs in Denmark was warning Danish citizens not to go there, and therefore it was also decided that we couldn't go. Andreas was then sent to Cairo with Simon [Lereng Wilmont] and Katrine [Philp] and I was sent to Damascus with Kristoffer Kiørboe." Response to questionnaire, May 8, 2012.
35. Arne Bro, email exchange, February 26, 2010.
36. Julie Tarding, phone interview.
37. Ibid.
38. Tarding points out that no student filmmakers were sent to Iran or Libya, for security reasons, and that the filmmaker who was to have joined the project from Libya was prevented from doing so.
39. Julie Tarding, phone interview.
40. Arne Bro, "Investigating: One (Wo)man / One camera / One voice," NFSD project description, 2012.
41. Malina Terkelsen, response to questionnaire.
42. Katrine Philp, response to questionnaire.
43. Jule Tarding, phone interview.
44. Rania Rafei, response to questionnaire, May 2, 2012.

45. Anthony Chidiac, response to questionnaire, May 7, 2012.
46. Julie Tarding, phone interview.
47. Ibid.
48. Ibid.
49. Bro, Schepelern, and Kjær, "Modern Languages in the Middle East/Young Artists in the Arab World," 2006.
50. Bro and Schepelern, "Modern Languages in the Middle East/Young Artists in the Arab World," 2008.
51. See Mette Hjort and Scott MacKenzie, eds, *Purity and Provocation: Dogme 95* (London: BFI, 2003).
52. Ditte Haarløv Johnsen, response to questionnaire, May 1, 2012.
53. Katrine Philp, response to questionnaire.
54. Maline Terkelsen, response to questionnaire.
55. Ditte Haarløv Johnsen, response to questionnaire. All subsequent citations are from the same set of responses.
56. Bro, Schepelern, and Kjær, "Modern Languages in the Middle East/Young Artists in the Arab World," 2006.
57. Bro, "Investigating: One (Wo)man / One Camera / One Voice," 2012.
58. Jon Elster, *Ulysses Unbound: Studies in Rationality, Precommitment, and Constraints* (Cambridge: Cambridge University Press, 2000).
59. Anthony Chidiac, response to questionnaire.
60. Isaiah Berlin, "Two Concepts of Freedom," in *Liberty: Incorporating Four Essays on Liberty*, ed. Henry Hardy (Oxford: Oxford University Press, 2002).
61. Tamara Stepanyan, response to questionnaire, May 4, 2012.
62. Malina Terkelsen, response to questionnaire.
63. Sine Skibsholt, response to questionnaire, April 24, 2012.
64. Ibid.
65. Bro, "Investigating: One (Wo)man / One Camera / One Voice," 2012.
66. Tamara Stepanyan, response to questionnaire.
67. Rania Rafei, response to questionnaire.
68. Corine Shawi, phone interview, April 26, 2012.
69. Rania Rafei, response to questionnaire.
70. Serena Abi Aad, "Thinking Outside the Box," in *Viewpoints Special Edition—State of the Arts Volume VI*, 33–34.
71. Hala Galal, "Creativity in Disclosing Injustice," in *Viewpoints Special Edition—State of the Arts Volume VI*, 35–36.

Part III

The Americas

Goodbye to Film School: Please Close the Door on Your Way Out

Toby Miller

I am not an expert on film schools, though I used to work in one. Nor have I undertaken an exhaustive analysis of the six hundred such entities that supposedly exist across the United States.[1] But here I am, writing about that symbolic behemoth of the film school, the United States.

Three film schools stand out among the putative six hundred: the University of Southern California (USC—a private university in Los Angeles), the University of California Los Angeles (UCLA—part of the state's élite ten-campus public system), and New York University (NYU—also private, and where I taught for over a decade). *The Hollywood Reporter*'s list of the top 25 film schools has those three in the top five, along with the Beijing Film Academy and the American Film Institute.[2] I am particularly interested in these three universities because they are Research-One schools and hence produce ruling-class hegemons and scholarly researchers as well as factory fodder / creatives for world cinema. And their film academies started early—USC in 1929, UCLA in 1947, and NYU in 1965. I've drawn on experience, anecdotal repute, and political-economic-environmental analysis to investigate the culture of these film schools, their employment impact, their cost, and their future.

Here's my headline: film schools shouldn't exist. They should be schools of media and cultural studies, dedicated to displacing both the residual humanities (textual analysis and history) and the emergent humanities (business studies). The humanities' share of US students stands at 8–12 percent of the nation's 110,000 undergraduates.[3] That's less than half the proportion from the 1960s and the lowest point since World War II, apart from Ronald Reagan's recession. Conversely, between 1970 and 2005, business enrollments increased by 176 percent.[4] Business studies may not lead to successful employment any more than

does Italian, but its claims to do so and its subsumption of general-education requirements have seen it supplant the humanities as the basis of liberal education (apart from at fancy schools).

As we think about the frantic defensive measures adopted by true believers in the *haute couture* humanities of fancy universities, as opposed to the co-optive capture by capital of creationists in more applied colleges, a key question arises: What sense of the public interest should reform the anachronism that is the film school? My argument is that the core componentry of a liberal education should include media production, albeit with some distance from the film-school model, and that business should be contested as the new omnibus undergraduate field by a materialist media and cultural studies. An answer to the query above comes from the former *New Statesman* editor Peter Wilby:

> The idea that the media aren't worth studying is as foolish as the idea, which survived into the 20th century at elite universities and public schools, that science and engineering were not proper subjects for young gentlemen. The media industries, apart from their contribution to G[ross]D[omestic]P[roduct], now impinge on people's lives to an extent unimaginable even 20 years ago....Some education in the media is surely essential. But it suits the industry's owners if citizens lack the skills and knowledge to sustain critical attitudes.[5]

Of course, we face insistent skepticism that the tastes of the Great Unwashed may override those of the Great and the Good. Consider this epigraph from Don DeLillo's postmodern campus novel *White Noise*: "There are full professors in this place who read nothing but cereal boxes....It's the only avant garde we've got."[6] More importantly, the fact that there is an apparent utility in fields once thought of as only indirectly instrumental, as providing a civilizing training in leadership, makes the new humanities, the one that synchronizes with postindustrialism, a bit of a problem. Forty years ago, Richard Hoggart posed the following question, even as he championed the expansion of cultural studies into the popular and the practical:

> What is one to make of a medieval historian or classicist who finds nothing odd— that is, nothing to be made sense of, at the least, if not opposed—in the sight of one of his new graduates going without second thoughts into, say, advertising; or of a sociologist or statistician who will undertake consultant work without much questioning the implications of the uses to which his work is put?[7]

Three decades later, Reaganite journalist Virginia Postrel wrote a *Wall Street Journal* op-ed welcoming media and cultural studies as "deeply threatening to traditional leftist views of commerce...lending support to the corporate enemy and even training graduate students who wind up doing market research."[8] Ten years on, she luxuriated in its depoliticized maturity: "Fortunately, a field that was once little more than an excuse to bash capitalism has evolved over time, attracting curious scholars who, for all their Marxist-inflected training, genuinely want to understand the phenomena of modern, commercial culture."[9] The point of Marxism is not to understand it, but to change it, apparently.

But back to US film schools. To me, they resemble dinosaurs, rather like their less glamorous siblings, journalism schools. Exhibition is really just a marketing tool now, and multiplexes in the United States will cease showing "films" in 2013, when they conclude the transition to digital formats.[10] So the very term is a misnomer, one of those bizarre aspects of residual hegemony, a vestigial creature clinging to the wreckage of an ebbing life.

Yet, film schools are *not* dinosaurs—or if they are, they attract lots of paying customers to the interactive mausoleums where they are housed. 136 of them submitted work to the Student Academy Awards in 2010, up from 102 the year before. Nearly 5000 people applied for 300 places at USC in the fall of 2011, up from fewer than 3000 the year before. Similar numbers apply at all prominent colleges.[11] China is sending flocks of students, especially women, to the big three US film schools. They reportedly like the equipment and the liberty. At UCLA, the numbers from China are leaping by 50 percent a year, at USC they are doubling, and there is steady growth at all the named institutions, which are sending satellites to Asia and requiring Yanqui students to learn Putonghua.[12] Of course, this is not just about film schools. We have well over 150,000 Chinese students in the United States, for the first time more than South Asians.[13] It's all part of the stay-rich-quick strategy that characterizes the exploitative greed / secondary accumulation of contemporary western universities.

In any event, despite the anachronistically romantic nomenclature, students pile into film schools right across the United States. And the top institutions receive headline-grabbing philanthropy. USC, for instance, has a gift of US$175 million from George Lucas.[14] (It paid for hideous, dysfunctional buildings that he designed. Despite his desire to make the exteriors resemble movie studios, Lucas "ordained" that only digital projection be available inside; "desperate faculty pleas secured one room where film could be screened.")[15] These donations feature as school publicity to demonstrate proximity to Hollywood and urge others to give, give, give. They also feed into the auteurist fantasies of *bourgeois* individualism that nourish film schools across the nation in their restless quest to summon, to govern, and to commodify humanism.[16]

Famous names seem to matter a great deal in this galaxy. James Franco received a "D" at NYU because he spent most of his acting class absent, filming *127 Hours* (dir. Danny Boyle, 2010). His professor, José Angel Santana, was dismissed by the school and filed a lawsuit in the Manhattan Supreme Court alleging retaliation. Santana also claimed that Franco had been given an easy time of it because another faculty member had received screenwriting credit on one of his films.[17] You can see this unfortunate unfurling drama parodied in an acute Taiwanese animation.[18]

The people running these establishments are studies in privilege. I once drove a friend to a Hollywood luncheon put on by the Academy of Motion Picture Arts and Sciences. Like the other chauffeurs, I was not welcome to sample the delights of the big house. My counterparts stood around in peaked caps, smoking cigarettes and comparing limos. But after dropping off my passenger and parking my compact, I sat down in the hotel lobby to read Hegel. About an hour and a half later, my friend emerged with the dean of a leading film school. "—, this is

my driver," he said. She walked 360 degrees around my copy of the *Philosophy of Right*, looked me up and down, said "Hmm, not bad," and walked away. This seigniorial attitude did not warm the heart of my inner Marxist or my outer driver.

I tell this story in part because it fits US film schools' systematic objectification of the other. Some 30 years ago, Michelle Citron and Ellen Seiter published a groundbreaking study, "The Woman with the Movie Camera," about the widespread misogyny in US film schools.[19] Citron and Seiter explained that women were marginalized in production classes and victimized in production texts. Seiter recently revisited that work.[20] She found that nothing had changed in terms of the taste of film-school men for aggression toward women as the touchstone of their art. The University Film and Video Association's 2010 conference dedicated special sessions to the tendency for US film-school students from across the world to emphasize brutal violence directed at women in their work.[21] When I was at the Tisch School of the Arts, I served on a committee charged with stopping male directors from cutting female actors' bodies in the name of attaining authentic performances from them.

There *have* been changes. Women have made sizeable and long-lasting employment gains in US cable TV. These successes are in postproduction computing work rather than in *auteurist* positions, but they are significant, and in children's television, women are central across the creative spectrum. And even retrograde places like film schools must adjust to the prevailing political economy. At USC nowadays, women faculty are in charge of sound design, gaming, and editing, and female students make up half the MFA program. Directing is, of course, another thing—and so are dramatic themes, which remain remorselessly violent and misogynistic.[22] No wonder USC promotes its film history with a portrait of Greta Garbo kneeling in front of Cecil B. de Mille as he holds a starting gun.[23]

Two Cultures

US film schools are now more than the frothy, slightly illegitimate end of campus. They are central to the university's mission of making money, serving capital, and producing workers. In that sense, film schools modeled the transformation of the humanities to the creative industries that was heralded—80 years late—by true believers in Schumpeterian mythology across Europe and Asia. Film school epitomizes and generates the free and discounted labor that dominates work in postindustrial economies.

More interestingly, film schools are merging the "Two Cultures" that the noted physicist and novelist C. P. Snow detailed 50 years ago. Fearing that "the whole of western society is increasingly being split into two polar groups,"[24] Snow saw the "Two Cultures" as a distinction between those who could quote the histories of Shakespeare and those who could quote the laws of thermodynamics[25]— that is, people fated to repeat the past versus people destined to build the future. Snow would move from South Kensington to Greenwich Village and encounter the same artistic discourse. Each site had "about as much communication with M.I.T. as though the scientists spoke nothing but Tibetan,"[26] because arts and

humanities people strolled through life "as if the natural order didn't exist."[27] The "clashing point" of these discourses had the potential "to produce creative chances." Yet, "very little of twentieth-century science has been assimilated into twentieth-century art" because "literary intellectuals, are natural Luddites."[28]

On the other side of the Atlantic, the economist Fritz Machlup, a neoclassical prophet of the knowledge society, was developing typologies of postindustrial work to help make the United States a research leader by focusing its efforts within a pragmatic opportunity-cost paradigm. While public intellectuals were debating the two cultures, Machlup was publishing a less-celebrated but massively influential paper, "Can There Be Too Much Research?"[29] He went on to write *The Production and Distribution of Knowledge in the United States*,[30] a bedside essential for emergent ideologists of human capital that showed how the research-and-development emphasis of US industry, state, and education was crucial to both economy and society.

Cut forward a few years to Reagan's successful 1966 campaign for the governorship of California. He launched it on the campus of—where else?—USC, with the following words: "I propose ...'A Creative Society'...to discover, enlist and mobilize the incredibly rich human resources of California [through] innumerable people of creative talent."[31] Reagan's rhetoric publicly birthed today's idea of using technology to unlock the creativity that is supposedly lurking, unbidden, in individuals, thereby permitting them to become happy and productive. This idea of the "creative society" was specifically opposed to the "Great Society," a term coined by the Edwardian Fabian Graham Wallas.[32] Wallas's student Walter Lippmann spoke of "a deep and intricate interdependence" that came with "living in a Great Society." It worked against militarism and other dehumanizing tendencies that emerged from "the incessant and indecisive struggle for domination and survival."[33] This idea was picked up by Lyndon Johnson and became the argument for competent and comprehensive social justice in ways that are anathematic to the Republican Party.

Film school encapsulates Reagan's counter-ideology and answers Snow's conundrum. For, as Thomas Pynchon put it, looking back on Snow's *Two Cultures* a quarter of a century after its publication, "All the cats are jumping out of the bag and even beginning to mingle.... The most unreconstructed of Luddites can be charmed into laying down the old sledgehammer and stroking a few keys instead."[34] That trend has accelerated. Today's computer scientists and engineers fetishize narrative, while textual critics and artists fetishize code. The two groups wear the same clothes, go to the same clubs, take the same drugs, sleep with the same people, and play the same games. Relations across the cloisters have changed, with computing technology and its applications to storytelling and art-making known to people in every corner of campus.

Changes in the media and associated knowledge technologies are likened to a new Industrial Revolution or the Civil and Cold Wars, touted as a route to economic development as well as cultural and political expression. Since the 1970s, "knowledge workers" have been identified as vital to information-based industries that generate productivity gains and competitive markets.[35] To Cold War futurists such as former national security advisor Zbigniew Brzezinski, cultural

conservative Daniel Bell, and professional anti-Marxist Ithiel de Sola Pool,[36] converged communications and information technologies promised the permanent removal of grubby manufacturing from North to South and continued US textual and technical power, provided that the blandishments of socialism, and negativity toward global business did not create class struggle. In the humanities, film schools have been model futurists since before Reagan's prescient announcement and the plans of his fellow travelers.

Work

So film-school graduates are doing things their forebears never expected. But these activities are not all inspired attempts to bridge the gap between cultures. And the way the top film schools function does not prepare their graduates for what they are poised to create and receive as citizens or workers, let alone in a way that enables social justice.

Since 2006, the Hollywood studios have seen revenue from home entertainment drop drastically, as the marvel of DVD was followed by the failure of Blu-ray. In other words, the technological model of built-in obsolescence driving customers to buy new versions of loved texts has ceased to work for the first time since the advent of television in the 1950s. As a consequence, the Hollywood studios have cut expenditure on scripts, limited onsite demountable deals with producers, and slashed junior staff jobs. In doing so, they have severely constricted the pipeline used by both élite and wannabe film schools.[37] Once they have graduated, folks traipse off to Los Angeles to serve me and people like me coffee and cocktails—having been hired for a minimum wage based on professional head shots, prerequisites to becoming wait staff.[38] A colleague from one of the top schools often bumps into *alumni*. All goes well until he asks what they are up to. "Oh, I'm working," they say. If further details are grudgingly divulged, it is usually because they are making porn movies in the San Fernando Valley for online, cable, and satellite consumption. They don't use their own names, and they're unhappy, but it *is* helping with student loans.

If these alums answer their former teacher in more fulsome detail, it is probably because they are employed, on a precarious basis, by one of the thousands of small firms dotted across the hinterland of California that produce DVD film commentaries, music for electronic games, or reality TV shows.[39] The evidence suggests that they are increasingly looking for jobs in visual effects, animation, and video-game development.[40] They might also be making programs for YouTube's 100 new channels, the fruit of Google's 100 million dollar production (and 200 million dollar marketing) bet that five-minute online shows will kill off TV. Explosions are routinely filmed for these channels near my old loft in downtown Los Angeles. The workers blowing things up are paid $15 an hour.[41]

Or these folks might be working for an advertising agency like Poptent, which undercuts big competitors in sales to major advertisers by exploiting prosumers' labor.[42] Needless to say, it does so in the name of "empowerment." That

empowerment takes the following form: the creators of homemade commercials make $7500; Poptent receives a management fee of $40,000; and the buyer saves about $300,000 on the usual price.[43]

Other film-school graduates find employment with talent agencies, doing useful things like associating B-list celebrities with social causes in order to raise their profiles: find a major issue such as a new environmental problem or geopolitical hot spot, pitch it to your guy, set up a foundation, and await admiring press coverage. This is part of the de-professionalization and pseudo-democratization of the media. It takes many forms. Fans become creators as they write zines that in turn become story ideas. Marketers trawl street fares, clubs, and fan sites to uncover emergent trends. Coca-Cola hires African Americans to drive through the inner city selling soda and playing hip-hop. AT&T pays San Francisco buskers to mention the company in their songs. Street performance poets rhyme about Nissan cars for cash, simultaneously hawking, entertaining, and researching. Subway's sandwich commercials are marketed as made by teenagers. Cultural studies graduates become designers, and graduate students in New York and Los Angeles read scripts for producers and then pronounce on whether they tap into audience interests.

Semiotics textbooks that critically deconstruct commercial culture adorn advertising executives' bookcases. Precariously employed part-timers prowl the streets with DVD players under their arms to ask target audiences what they think of trailers for upcoming movies, or while away their time in theaters spying on how their fellow spectators respond to coming attractions. Opportunities to vote in the Eurovision Song Contest or a reality program determine both the success of contestants and the profile of active viewers who can be monitored and wooed. End-user licensing agreements ensure that players of corporate games online and contributors to official discussion groups about film or television sign over their cultural moves and perspectives to the companies whom they are paying in order to participate.

How might we theorize these developments? The Reaganite futurist Alvin Toffler invented the useful concept, "the cognitariat" a quarter of a century ago.[44] Sometimes those people get something right. The idea has since been taken up and redisposed by the left. Antonio Negri, for example, applies the term to people mired in contingent media work who have educational qualifications and facility with cultural technologies and genres. The cognitariat plays key roles in the production and circulation of goods and services, through both creation and coordination. This *"culturalization of production"* enables these intellectuals by placing them at the center of world economies, but simultaneously *disables* them, because it does so under conditions of flexible production and ideologies of "freedom."[45]

What used to be the fate of artists and musicians—where "making cool stuff" and working with relative autonomy was meant to outweigh the regular wage and dull security of ongoing employment—has become a norm. The outcome is contingent labor as a way of life. This new proletariat is not defined in terms of location (factories), tasks (manufacturing), or politics (moderation of ruling-class power and ideology). It is formed from those whose immediate forebears, with similar or less cultural capital, were confident about healthcare and retirement

income. They lack both the organization of the traditional working class and the political *entrée* of the old middle class.

Film schools simultaneously model and contribute to the cognitariat. They are also at the forefront of militarism, in keeping with their taste for hyper-masculinity. The Pentagon sends scientists to film school to produce positive images of violent technocracy and educrats and Hollywood élites invite the military to town to explain their needs and hopes for future ideological representations.[46] This relationship has become more systematic, under the stimulus of media convergence and imperial conjuncture. In 1996, the National Academy of Sciences held a workshop for academia, Hollywood, and the Pentagon on simulation and games. The next year, the National Research Council announced a collaborative research agenda on popular culture and militarism and convened meetings to streamline such cooperation, from special effects to training simulations, from immersive technologies to simulated networks. Since 2001, electronic gaming has become a crucial tool tactically and strategically, because fewer and fewer nations permit the United States to play live war games.[47]

USC's Institute for Creative Technologies (ICT)[48] was set up in 1998 to articulate film-school faculty, movie and TV producers, and game designers to the defense budget. Film school meets fighter jet, if you like. Formally opened by the secretary of the army and the head of the Motion Picture Association of America, the institute's workspace was dreamt up by the set designer for the *Star Trek* franchise. Initially funded by $45 million of military money, that figure doubled in its 2004 renewal and trebled to $135 million in 2011. By the end of 2010, its products were available on 65 military bases.[49]

The institute also collaborates on major motion pictures, for instance *Spider-Man 2* (dir. Sam Raimi, 2004), and produces military recruitment tools such as *Full Spectrum Warrior* that double as "training devices for military operations in urban terrain": What's good for the Xbox is good for the combat simulator. The utility of these innovations continues in the field. The Pentagon is aware that off-duty soldiers play games and wants to invade their supposed leisure time in order to wean them from the skater genre in favor of what are essentially training manuals. The Department of Defense (DOD) claims that *Full Spectrum Warrior* was the "game that captured Saddam," because the men who dug Saddam Hussein Abd al-Majid al-Tikriti out had played it.[50]

Put another way, ICT uses Pentagon loot and Hollywood muscle to test out homicidal technologies and narrative scenarios, under the aegis of film, engineering, theater, and communications professors. To keep up with the institute's work, I recommend the podcast *Armed with Science: Research and Applications for the Modern Military*, available via the DOD.[51] You will learn that the Pentagon and USC are developing *UrbanSim* to improve "the art of battle command" as part of Barack Hussein Obama II's imperial wars. This is described as a small shift from commercial gaming: "Instead of having Godzilla and tornados attacking your city, the players are faced with things like uncooperative local officials and ethnic divisions in the communities, different tribal rivalries," to quote an institute scholar in the pod.[52]

You might also visit ICT's Twitter address <@usc_ict>, blog <http://ict.usc.edu>, and Facebook page <http://www.facebook.com/USCICT>, where hortatory remarks of self-regard abound to an extent rarely seen in the postwar era: the institute "is revolutionizing learning through the development of interactive digital media" because by "collaborating with our entertainment industry neighbors, we are leaders in producing virtual humans," thereby furthering "cultural awareness, leadership and health." When universities promote themselves in this way, warning bells ring out like a James Brown funk grunt/auto alarm.

All this is some distance from emulating the directors whose names are rolled out before aspiring entrants to famous film schools. The idea of artistic yet commercially viable filmmakers with the vision and capacity to tell stories continues to enchant people. At NYU, the *alumni* most often mentioned were Martin Scorsese, Spike Lee, and Jim Jarmusch. Yet, for most graduates, the reality will be surviving a complex web of casual labor, working and living precariously and weighed down by debt, as film schools replenish the cognitariat. Perhaps in the future those renowned directors will be supplemented or supplanted in advertising material by porn *auteurs* and Pentagon *аппарáтчик* (apparatchiks).

Money

In 2011, USC charged $42,000 a year in tuition; NYU $45,674; and UCLA, being a public school, $12,842 for Californians and $35,720 for others. By comparison, Beijing Film Academy prices were $1,240–1,550 for locals and $6,665–$7,905 for foreigners; La Fémis $517 for the French and $15,334 for the rest of us; and the Prague School $45,674 (it appears to be pegged to Tisch).[53]

When I arrived in New York in 1993, 45 percent of undergraduates nationwide borrowed to pay tuition. Now that proportion is 94 percent. Almost 9 percent of debtors defaulted on student loans in 2010, up 2 percent in a year. The average debt in 2011 was $23,300. Across the country, people who graduated with student loans that year confronted the highest unemployment levels for recent graduates in memory: 9.1 percent.[54]

The US population has borrowed $1 trillion to pay tuition. The federal government guarantees these loans, which encourages universities to charge more and financial institutions to lend more. Of the trillion dollars owed, upward of $900 million comes from the state.[55] Why? Because whereas tuition accounted for 38 percent of the cost of public schools in 1998, the proportion was over 50 percent in 2008. That trend doubled student debt between 1992 and 2000 and again over the next decade.[56]

Of course, the United States is not alone in having this problem, though elsewhere students are more likely to perceive it as part of a wider political issue. In Chile, student strikes against fees and the commodification of universities have been under way for some time. Rodrigo Araya, from the Pontificia Universidad Católica de Valparaíso, says students see university as reflecting social inequality and demand a "new social contract." Anamaria Tamayo Duque of the Universidad de Antioquia in Colombia showed me recent photos of riot police

confronting students demonstrating against fees. Protesters responded to fear-somely adorned officers by kissing their helmets, brushing clean their shields, handing them flowers and cuddling them. In Québec, hundreds of thousands have protested against tuition hikes.[57]

So where do we go from here?

Media and Cultural Studies—a Future

How should film schools be transformed to counter their sexism, militarism, and exploitation? Can they help build a new humanities field *contra* business studies?

I favor media and cultural studies, a *portmanteau* term to cover a multitude of social and cultural machines and processes. There is increasing overlap across media, as black-box techniques and technologies, once set apart from audiences, become subject to public debate and utilization. Consumer electronics connect to information and communication technologies and *vice versa*: televisions resemble computers; books are read on telephones; newspapers are written through clouds; films are streamed via rental companies; commercials are shot with phones; and so on. Genres and gadgets that were once separate are linked. Hence the media component of the field, with "film" being a tiny, tiny element, both technologically and programmatically.

At the same time, the significance of culture has widened in terms of geography, demography, language, genre, and theory. This is a consequence of several connected socio-economic forces. The 1940s–1970s compact across the West between capital, labor, and government has been renegotiated, reversing that period's redistribution of wealth downward. Key sectors of the economy were deregulated and consumption was elevated as a site of social action and public policy. There have been changes in the international division of labor, as manufacturing leaves the global north and subsistence agriculture erodes in the South. Population has grown through public-health initiatives. Refugee numbers have increased following numerous conflicts among former satellite states of the United States and the fallen Soviet Union because these struggles were transformed into intra- and transnational violence when half of the imperial couplet unraveled. Human trafficking was vastly augmented. Islam and Christianity revived themselves as transnational religious and political projects. And civil-rights and social-movement discourses and institutions developed, extending cultural difference from tolerating the aberrant to querying the normal, then commodifying and governing the result.

In the United States, the nineteenth century's great wave of immigration left the country 87 percent European American, a proportion that remained static thanks to racialized immigration laws and policies up to 1965. But about a 100 million US residents are today defined as minorities. Latin@s and Asians in the United States are proliferating at ten times the rate of Euro descendants, such that white America is now 64 percent of the population and projected to be 53 percent in 2050. According to the 2010 Census, 50.5 million people (or 16 percent

of the total population) are Latin@, up from 13 percent in 2000. The foreign-born segment of the country is double the proportion in 1970 and half as many again as 1995. As for the labor force, in 1960, one in seventeen workers came from beyond the United States (mostly Europe). Today, the proportion is one in six, the majority from Latin America and Asia. In addition, hybridity is increasingly the norm. In 1990, one in twenty-three US marriages crossed race and ethnicity. In 2010, one in seven did so.[58]

Universities are being transformed by these trends. In the decade to 2008, the proportion of white college students in the United States dropped by 8.6 percent, though they remained the majority ethnic group. Latino numbers grew 5 percent annually, African American 4 percent, and Asian American 3 percent.[59] The humanities have responded to these developments via an unsteady if understandable oscillation between being "cultural gatecrashers and agents of radical social change or cultural gatekeepers and champions of tradition."[60]

What kind of curriculum should replace the banal Arnoldian education of the traditional humanities and the supine vocational training of film school and business studies? What can substitute for nostalgic parthenogenesis and instrumental instruction? A third form of life must arise from a blend of political economy, textual analysis, ethnography, cultural production, and environmental studies, such that students learn the materiality of making, conveying, and discarding meaning.

Roger Chartier[61] and Pierre Macherey[62] offer promising programs for the humanities. They suggest that the study of textuality must take account of linguistic translations, material publications, promotional paratexts, archival categorizations, and the like—an historical and spatial approach that focuses on conditions of existence. Texts accrete and attenuate meanings on their travels as they rub up against, trope, and are troped by other fictional and factual texts, social relations, and material objects, and as they are interpreted—all those moments that allow them to become, for example, "the literary thing."[63]

Such an approach fruitfully connects the study of culture to what Ian Hunter calls an "occasion...the practical circumstances governing the composition and reception of a piece."[64] This is in accord with Alec McHoul and Tom O'Regan's "discursive analysis of particular actor networks, technologies of textual exchange, circuits of communicational and textual effectivity, traditions of exegesis, commentary and critical practice."[65] In a similar vein, there is much to be gained from actor-network theory in tracking the career of globally circulating texts. Bruno Latour[66] and his followers analyze cars, missiles, trains, enzymes, and research articles by allocating equal and overlapping significance to natural phenomena, social forces, and textual production. This is the "cultural science" about which Stephen Muecke has written so evocatively, "diplomatically engaging with all the human and non-human things in the ecology."[67]

I also find useful Néstor García Canclini's alternative to the nativism of Yanqui multicultural discourse via what is referred to in Latin America as interculturalism.[68] Canclini demonstrates that accounts of culture must engage with three key factors. First, there is a paradox: globalization also deglobalizes, in that its dynamic and impact are not only about mobility and exchange, but also

about disconnectedness and exclusion. Second, minorities no longer primarily exist within nations—rather, they emerge at transnational levels due to massive migration by people who share languages and continue to communicate, work, and consume through them. Third, *demographic* minorities within sovereign states may not form *cultural* minorities, because majoritarian *élites* in one nation often dispatch their culture to another where they are an ethnic minority. In any search for a "common culture," the risk is totalitarianism,[69] unless commonality refers to a metacultural concept that is rooted in the negotiation of cultural difference and sameness and opposed to a privileged unity (which generally means some form of exclusionary nationalism).

The fundamental message I take from these models is this: understanding culture requires studying it up, down, and sideways, in accord with Laura Nader's call for an ethnography of the powerful as well as the oppressed[70] and George Marcus's endorsement of multi-sited analysis that focuses on how and where meaning emerges, exists, and expires.[71] That means knowing which companies make texts, physical processes of production and distribution, systems of cross-subsidy and monopoly profit making, the complicity of educational canons with multinational corporations' business plans, and press coverage, *inter alia*.

Put another way, if film schools are primarily concerned with making meaning, they must consider the wider political economy, not simply in terms of culture as a reflective or refractive index of it, but as *part of* that economy, because culture is the creature, *inter alia*, of "corporations, advertising, government, subsidies, corruption, financial speculation, and oligopoly."[72]

Many students at the big three schools know change is necessary. And they see an education in media and cultural studies (but please don't call it that—the preferred terms are "critical studies," "cinema and media studies," and "cinema studies") as much more crucial than before by contrast with production.[73] Changing the current *doxa* of film schools and their kind could enrich students' and professors' knowledge base, increase their means of intervention in cultural production, counter charges of social and commercial irrelevance, and make the area's citizenship and social-movement claims more credible.

Notes

1. Elizabeth Van Ness, "Is a Cinema Studies Degree the New M.B.A.?" *New York Times*, March 6, 2005, http://www.nytimes.com/2005/03/06/movies/06vann.html?_r=1& pagewanted=2.

2. Tim Appelo, "The 25 Best Film School Rankings," *Hollywood Reporter*, July 27, 2011, http://www.hollywoodreporter.com/news/25-best-film-schools-rankings-215714; "A Conversation with Patricia Meyer About Producing, Screenwriting, Women of Brewster Place, Oprah," culturalstudies, http://culturalstudies.podbean.com /2011/05/01/a-conversation-with-patricia-meyer-about-producing-screenwriting -women-of-brewster-place-oprah/.

3. There is some dispute over the percentages. Some sources say humanities majors accounted for about 8 percent of graduates in 2009; others say the figure is closer

to 12 percent. Dan Berrett, "Humanities, for Sake of Humanity," *Inside Higher Ed*, March 30, 2011, http://www.insidehighered.com/news/2011/03/30/scholars_seek _to_craft_argument_for_urgency_of_the_humanities_in_higher_education.

4. Patricia Cohen, "In Tough Times, the Humanities Must Justify Their Worth," *New York Times*, February 24, 2009, http://www.nytimes.com/2009/02/25/books/25human .html.

5. Peter Wilby, "I Sued and Won," *New Statesman*, August 20, 2009, http://www .newstatesman.com/uk-politics/2009/08/soft-media-services-britain.

6. Don DeLillo, *White Noise* (London: Picador, 1986), 10.

7. Richard Hoggart, *Speaking to Each Other Volume One: About Society* (Harmondsworth: Penguin, 1973), 100.

8. Virginia Postrel, "The Pleasures of Persuasion," *Wall Street Journal*, August 2, 1999, A18.

9. Virginia Postrel, "A Power to Persuade," *Weekly Standard*, May 29, 2010, http://www .weeklystandard.com/articles/power-persuade?page=1.

10. John Fithian, "CinemaCon State of the Industry" (speech given at the CinemaCon 2012, Las Vegas, Nevada, US, April 24, 2012), http://www.natoonline.org/pdfs/JF%20 Speech%20-%20CinemaCon%202012%20-%20Distribution%20Version.pdf.

11. Michael Cieply, "For Film Graduates, an Altered Job Picture," *New York Times*, July 4, 2011, C1.

12. John Horn, "Reel China: Land of Cinematic Opportunity," *Los Angeles Times*, October 2, 2011, http://articles.latimes.com/2011/oct/02/entertainment/la-ca-china -film-students-20111002.

13. Institute of International Education, "Open Doors 2011: International Student Enrollment Increased by 5 Percent in 2010/11," *Open Doors*, November 14, 2011, http://www.iie.org/en/Who-We-Are/News-and-Events/Press-Center/Press-Releases /2011/2011-11-14-Open-Doors-International-Students.

14. Michael Cieply, "A Film School's New Look is Historic," *New York Times*, February 9, 2009, C1.

15. David James, "Letter to Paul Arthur (Letter with Footnotes)," *Moving Image Review & Art Journal* 1, no. 1 (2012): 30, 33.

16. Lisa Helen Henderson, "Cinematic Competence and Directorial Persona in Film School: A Study of Socialization and Cultural Production," Dissertations Available from ProQuest, paper AAI9026571 (January 1, 1990), http://repository.upenn.edu /dissertations/AAI9026571; Lisa Helen Henderson, "Directorial Intention and Persona in Film School," in *On the Margins of Art Worlds*, ed. Larry Gross (Boulder: Westview Press, 1995).

17. Abby Ellin, "Failure is Not an Option," *New York Times*, April 13, 2012, ED1; Jamie Schram and Frank Rosario, "Professor Claims NYU Fired Him After He Gave James Franco a 'D,'" *New York Post*, December 19, 2011, http://www.nypost.com/p/news /local/manhattan/the_franco_cut_kIRVk4WuVdydz59WZ4I5tL.

18. NMA.TV, "James Franco's NYU professor fired for giving bad grade?" NMA. TV, December 20, 2011, http://www.nma.tv/james-francos-nyu-professor-fire d-giving-actor-bad-grade/.

19. Michelle Citron and Ellen Seiter, "The Woman with the Movie Camera," *Jump Cut: A Review of Contemporary Media* 26 (1981).

20. Ellen Seiter, "On Cable, Tech Gods, and the Hidden Costs of DIY Filmmaking: Thoughts on 'The Woman with the Movie Camera,'" *Jump Cut: A Review of Contemporary Cinema* 53 (2011), http://www.ejumpcut.org/archive/jc53.2011 /seiterProdnTeach/index.html.

21. Jennifer Proctor et al., "Woman with the Movie Camera Redux: Revisiting the Position of Women in the Production Classroom," *Jump Cut: A Review of Contemporary Cinema* 53 (2011), http://www.ejumpcut.org/archive/jc53.2011/womenProdnClass/index.html.

22. Seiter, "On Cable, Tech Gods, and the Hidden Costs"; also see John Anderson, "The 'Invisible Art': A Woman's Touch behind the Scenes," *New York Times*, May 27, 2012, AR10.

23. http://cinema.usc.edu/about/history/index.cfm.

24. Charles P. Snow, *The Two Cultures and a Second Look: An Expanded Version of the Two Cultures and the Scientific Revolution* (Cambridge: Cambridge University Press, 1987), 3.

25. Ibid., 15.

26. Ibid., 2.

27. Ibid., 14.

28. Ibid., 16, 22.

29. Fritz Machlup, "Can There Be Too Much Research?" *Science* 128, no. 335 (1958).

30. Fritz Machlup, *The Production and Distribution of Knowledge in the United States* (Princeton: Princeton University Press, 1962).

31. Ronald Reagan, "The Creative Society," (speech at the University of Southern California, US, April 19, 1966), http://www.freerepublic.com/focus/news/742041/posts.

32. Graham Wallas, *The Great Society: A Psychological Analysis* (Lincoln: University of Nebraska Press, 1967).

33. Walter Lippmann, *The Good Society* (New York: Grosset & Dunlap, 1943), 161 and 376.

34. Thomas Pynchon, "Is it O.K. to be a Luddite?" *New York Times Book Review*, October 28, 1984: 1, 41.

35. François Bar with Caroline Simard, "From Hierarchies to Network Firms," in *The Handbook of New Media: Updated Students' Edition*, ed. Leah Lievrouw and Sonia Livingstone (Thousand Oaks: Sage, 2006).

36. Zbigniew Brzezinski, *Between Two Ages: America's Role in the Technotronic Era* (New York: Viking Press, 1969); Daniel Bell, "The Future World Disorder: The Structural Context of Crises," *Foreign Policy* 27 (1977); Ithiel de Sola Pool, *Technologies of Freedom* (Cambridge, Mass.: Harvard University Press, 1983).

37. Michael Cieply, "For Film Graduates, an Altered Job Picture."

38. http://www.getabarjob.com/category/los-angeles-jobs/page/10/.

39. Miranda Banks and Ellen Seiter, "Spoilers at the Digital Utopia Party: The WGA and Students Now," *Flow* 7, no. 4 (December 7, 2007), http://flowtv.org/2007/12/spoilers-at-the-digital-utopia-party-the-wga-and-students-now/.

40. Cieply, "For Film Graduates, an Altered Job Picture."

41. Sam Thielman, "YouTube Commits $200 Million in Marketing Support to Channels," *AdWeek*, May 3, 2012, http://www.adweek.com/news/technology/youtube-commits-200-million-marketing-support-channels-140007.

42. George Ritzer and Nathan Jurgenson, "Production, Consumption, Prosumption: The Nature of Capitalism in the Age of the Digital 'Prosumer,'" *Journal of Consumer Culture* 10, no. 1 (2010).

43. Dawn C. Chmielewski, "Poptent's Amateurs Sell Cheap Commercials to Big Brands," *Los Angeles Times*, May 8, 2012, http://articles.latimes.com/2012/may/08/business/la-fi-ct-poptent-20120508.

44. Alvin Toffler, *Previews and Premises* (New York: William Morrow, 1983).

45. Antonio Negri, *Goodbye Mister Socialism*, trans. Paola Bertilotti (Paris: Seuil, 2007), 229.

46. Van Ness, "Is a Cinema Studies Degree the New M.B.A.?" Jamie Wilson, "US Military Sends Scientists to Film School," *Guardian*, August 4, 2005, http://www.guardian.co.uk/world/2005/aug/05/usa.film; David M. Halbfinger, "Pentagon's New Goal: Put Science Into Scripts," *New York Times*, August 4, 2005, http://www.nytimes.com/2005/08/04/movies/04flyb.html?pagewanted=print.

47. Timothy Lenoir, "Programming Theaters of War: Gamemakers as Soldiers," in *Bombs and Bandwidth: The Emerging Relationship Between Information Technology and Security*, ed. Robert Latham (New York: New Press, 2003), 190; Mike Macedonia, "Games, Simulation, and the Military Education Dilemma" in *The Internet and the University: 2001 Forum* (Boulder: Educause, 2002); Arun Kundnani, "Wired for War: Military Technology and the Politics of Fear," *Race & Class* 46, no. 1 (2004).

48. http://ict.usc.edu/.

49. There is skepticism about the efficacy of such work as military training, see Bruce Newsome and Matthew B. Lewis, "Rewarding the Cowboy, Punishing the Sniper: The Training Efficacy of Computer-Based Urban Combat Training Environments," *Defence Studies* 11, no. 1 (2011); Andy Deck, "No Quarter: Demilitarizing the Playground," Art Context (2004), http://artcontext.org/crit/essays/noQuarter; David Silver and Alice Marwick, "Internet Studies in Times of Terror," in *Critical Cyberculture Studies*, ed. David Silver and Adrienne Massanari (New York: New York University Press, 2006), 50; Nick Turse, *The Complex: How the Military Invades Our Everyday Lives* (New York: Metropolitan Books, 2008), 120; W. J. Hennigan, "Computer Simulation is a Growing Reality for Instruction," *Los Angeles Times*, November 2, 2010, http://articles.latimes.com/2010/nov/02/business/la-fi-virtual-reality-20101102; USC Institute for Creative Technologies, "USC Institute for Creative Technologies Receives $135 Million Contract Extension From U.S. Army," USC Institute for Creative Technologies, September 1, 2011, http://ict.usc.edu/news/usc-institute-for-creative-technologies-receives-135-million-contract-extension-from-u-s-army/.

50. Jonathan Burston, "War and the Entertainment Industries: New Research Priorities in an Era of Cyber-Patriotism," in *War and the Media: Reporting Conflict 24/7*, ed. Daya Kishan Thussu and Des Freedman (London: Sage Publications, 2003); Stephen Stockwell and Adam Muir, "The Military-Entertainment Complex: A New Facet of Information Warfare," *Fibreculture* 1 (2003), journal.fibreculture.org/issue1/issue1_stockwellmuir.html; Robin Andersen, "Bush's Fantasy Budget and the Military/Entertainment Complex," *PRWatch*, February 12, 2007, prwatch.org/node/5742; Turse, *The Complex*, 119, 122; Amy Harmon, "More Than Just a Game, but How Close to Reality?" *New York Times*, April 3, 2003; and Nick Dyer-Witheford and Greig S. de Peuter, *Games of Empire: Global Capitalism and Video Games* (Minneapolis: University of Minnesota Press, 2009).

51. http://science.dodlive.mil.

52. http://science.dodlive.mil/2010/03/page/3/.

53. Appelo, "The 25 Best Film School Rankings."

54. Andrew Martin and Andrew W. Lehren, "A Generation Hobbled by College Debt," *New York Times*, May 13, 2012, A1.

55. Toby Miller, "Occupy Movement Takes on Behemoth of Student Debt," *The Australian*, November 30, 2011, http://www.theaustralian.com.au/higher-education/opinion/occupy-movement-takes-on-behemoth-of-student-debt/story-e6frgcko-1226209499684; Martin and Lehren, "A Generation Hobbled by College Debt."

56. Christopher Newfield, "Public Universities at Risk: 7 Damaging Myths," *Chronicle of Higher Education*, October 31, 2008, A128; Christopher Newfield, "Ending the Budget Wars: Funding the Humanities during a Crisis in Higher Education," *Profession 2009* (2009); Henwood, "I'm Borrowing My Way Through College," *Left Business Observer*, February 2010, http://leftbusinessobserver.com/College.html; Donna M. Desrochers et al., *Trends in College Spending 1998–2008: Where Does the Money Come From? Where Does It Go?* (Washington, DC: Delta Cost Project/Lumina Foundation for Education, 2010); The Project on Student Debt, "Student Debt and the Class of 2010," The Project on Student Debt, 2011, http://projectonstudentdebt.org/files/pub/classof2010.pdf.

57. Miller, "Occupy Movement Takes On Behemoth of Student Debt."

58. Toby Miller, *Cultural Citizenship: Cosmopolitanism, Consumerism, and Television in a Neoliberal Age* (Philadelphia: Temple University Press, 2007); United States Census Bureau, *Overview of Race and Hispanic Origin: 2010* (March 2011), http://www.census.gov/prod/cen2010/briefs/c2010br-02.pdf; Pew Research Center, "Marrying Out: One-in-Seven New U.S. Marriages is Interracial or Interethnic," Pew Research Center Publications, June 4, 2010, http://pewresearch.org/pubs/1616/american-marriage-interracial-interethnic.

59. Desrochers et al., *Trends in College Spending 1998–2008*.

60. Gerald Early, "The Humanities & Social Change," *Daedalus* 138, no. 1 (2009): 52.

61. Roger Chartier, "Aprender a leer, leer para aprender," *Nuevo Mundo/Mundos Nuevos*, February 1, 2010, http://nuevomundo.revues.org/58621.

62. Pierre Macherey, "Culture and Politics: Interview with Pierre Macherey," trans. and eds. Colin Mercer and Jean Radford, *Red Letters* 5 (1977).

63. Pierre Macherey, "The Literary Thing," trans. Audrey Wasser, *diacritics* 37, no. 4 (2007).

64. Ian Hunter, "Providence and Profit: Speculations in the Genre Market," *Southern Review* 22, no. 3 (1988): 215.

65. Alec McHoul and Tom O'Regan, "Towards a Paralogics of Textual Technologies: Batman, Glasnost and Relativism in Cultural Studies," *Southern Review* 25, no. 1 (1992): 5–6.

66. Bruno Latour, *We Have Never Been Modern*, trans. Catherine Porter (Cambridge, MA: Harvard University Press, 1993).

67. Stephen Muecke, "Cultural Science? The Ecological Critique of Modernity and the Conceptual Habitat of the Humanities," *Cultural Studies* 23, no. 3 (2009): 408.

68. Néstor García Canclini, *Diferentes, desiguales y desconectados: Mapas de la interculturalidad* (Barcelona: Editorial Gedisa, 2004).

69. John Frow, "Cultural Studies and the Neoliberal Imagination," *Yale Journal of Criticism* 12, no. 2 (1999).

70. Laura Nader, "Up the Anthropologist—Perspectives Gained from Studying Up," in *Reinventing Anthropology*, ed. Dell H. Hymes (New York: Pantheon Books, 1972).

71. George Marcus, "Ethnography in/of the World System: The Emergence of Multi-Sited Ethnography," *Annual Review of Anthropology* 24 (1995).

72. Robert W. McChesney, "My Media Studies: Thoughts from Robert W. McChesney," *Television & New Media* 10, no. 1 (2009): 109.

73. Cieply, "For Film Graduates, an Altered Job Picture."

"An Arrow, Not a Target": Film Process and Processing at the Independent Imaging Retreat

Scott MacKenzie

The history of Canadian educational film practice must be understood in light of the country's close proximity to the United States.[1] This proximity is not simply geographical, but also linguistic. Like other predominantly English-speaking countries (such as the UK), Canadian film production and education has developed in the shadow of the United States' dominance in English language fiction film production. For this reason, the role of documentary filmmaking as an alternative mode of film production and apprenticeship (in both its traditional and experimental forms) has played a central role in the development and perpetuation of Anglo-Canadian film culture, and the production practices that are taught and valued in the country. This is especially true because of the influence of the National Film Board of Canada / Office national du film (NFB/ONF), which for decades has fostered documentary, experimental, and animated film production in Canada.[2] Indeed, even practice-based film education outside the NFB often amounts to responses to the aesthetic and production strategies deployed by the organization and the documentary aesthetic permeates the history of Canadian fiction filmmaking.

Another example of this influence is the ongoing practice in Canadian filmmaking production and education of finding ways to let marginalized groups, both inside and outside academe, develop means of making moving images of their own, so as to depict or express their own realities. This practice of teaching film and video production to disenfranchised and marginalized groups as a means of "getting media into the hands of the people" is a legacy of the different programs that have arisen from the NFB over the last 40 years. From their ground-breaking Challenge for Change and *Société nouvelle* programs in the 1960s and 1970s that aimed to combat poverty and other kinds of marginalization, to their recent

"Filmmaker-in-Residence" program, which links radical filmmakers with activist groups and organizations, the NFB/ONF has been at the forefront of reimagining the ways in which nontraditional modes of education in moving image production can be implemented. These programs are hands-on, access-oriented, and far more interested in providing a space for marginalized voices than in developing an aesthetic. This reimagining of the process of making moving images functions as a catalyst for political involvement, personal empowerment, and social change. Dorothy Hénaut, one of the early film-makers/activists of Challenge for Change, stated that she and colleagues such as Robert Forget and Fernand Dansereau

> saw the need to give public voice to those [who] did not have one, and they proposed a project to use film as a tool for change that would help disadvantaged communities organize themselves and take control of their own destinies....If we really believed [in] people's right to express themselves directly, then we needed to eliminate ourselves from the process and find a way to put the media directly in the hands of the citizens.[3]

This program was an attempt to allow the working classes and disenfranchised to create images of themselves for themselves. Yet, the mandates of Challenge for Change and *Société nouvelle* went beyond the desire to make accurate representations of the working classes; instead, the program strove radically to redefine the way in which communities and audiences were built around films and videos. NFB/ONF directors became "facilitators," whereby they would demonstrate and supervise the functions of the equipment, but the final film or video would be under the control of the community groups. Challenge for Change and *Société nouvelle*, then, had the primary goal of having the working classes film, view, and re-edit the images shot of themselves, by themselves, in order to build a community base for activism. This was accomplished by screening the finished films and videos in union halls and community centers, in order to set up a feedback loop, with participants onscreen being able to critique and change their own images of themselves.

40 years on from this groundbreaking experiment, the NFB's Filmmaker-in-Residence program placed activist filmmaker Katerina Cizek in an urban Toronto hospital. The project is described by the NFB/ONF on its promotional website for the project, in the following way:

> Everyone participates—everyone has a voice—and the message is revolutionary. Take one dynamic filmmaker; add a team of nurses, doctors and community members on the front lines in urban and global health; then introduce interventionist media—and you have Filmmaker-in-Residence, a new model for collaboration now recognized worldwide as a blueprint for positive change in the digital age.[4]

The continual presence and success of these histories and modes of practice have greatly influenced three generations of Canadian *cinéastes*, especially aboriginal, feminist, and queer filmmakers. Of special concern in all these projects was the attempt to find a way of circumnavigating the ethnographer's dilemma of obliterating the culture in front of the camera through the process of rewriting

it; the image-makers who were attempting to address social and political issues, such as chronic unemployment and poverty, especially felt this concern. To this end, those who in the past would have been mere viewers now themselves participated in the creation and dissemination of images. Such inclusion allowed the "voiceless" of society to produce their own representations of themselves, which was seen as bolstering their sense of community while providing them with a means of speaking to larger publics. The political "effect" of these image-making practices, then, was found outside the screening room, in what can be called the "counter" or "alternative" public sphere: a public space where voices from the margins can engage in debate in a way that is not sanctified by the dominant institutions of culture.[5]

The Canadian example, then, points to the ways in which alternative modes of education in filmmaking practice function not simply as means of teaching new skills to people often left outside traditional educational structures, but also as facilitating the articulation of their voices within the public sphere. One of the key outcomes of this process is that participants often found voices that in many cases they did not know they had. These process-based models of educational practice may have far more long-term value than traditional modes of practice-based film education. The two examples from the NFB/ONF point toward the centrality of "process" in the production of alternative modes of practiced-based image-making education in Canada, and the importance of a participatory practice in the development of radical, political modes of moving image production. What the Challenge for Change, *Société nouvelle*, and "Filmmaker-in-Residence" programs develop is a model of a process that is about inclusion of the disenfranchised, with inclusion being secured by letting the subject of the film become, in part, its maker too. Yet, other kinds of "process" have also become central to the ways in which alternative film practice is taught in Canada. The kind of "process" on which I focus in this chapter differs substantially from the participatory models outlined above. In this second example, which is central here, "process" is about the filmmaker being self-reflexively aware of the means by which film is made, where "process" becomes part of a DIY practice. Here, filmmaking is not about getting media back into the hands of the people; rather, it is about getting the means of production back into the hands of the filmmaker.

Film Education: Why Bother?

In the Canadian context, as is no doubt the case elsewhere, one of the key questions that often goes unasked when raising the issue of practice-based film education is: Why bother? If one is to rethink the modes and means of film education, one must also ask the question as to why teaching people how to make films and other forms of moving images is in any way important. In a society that champions an educational regime that foregrounds "learning outcomes" and "work skills" as the central, if not sole, goal of higher education, the idea of teaching more people how to make moving images seems, on the face of it, ludicrous. If

we look at the Canadian example, BFA and MFA programs in film production produce more graduates than can reasonably be expected to become filmmakers, or even to be merely involved in the film industry.[6] Even for those who do get jobs, the Canadian film industry itself often has a branch-plant mentality in relation to the United States, with much of the Canadian industry producing sub-American products, most of which are never seen by anyone. Films that are produced in Canada often use Toronto as an affordable stand-in for any number of American cities, and Montréal for the cities of Europe. So, if the above points are true, is there much of a case to be made for the efficacy of developing practice-based film education in Canada further?

There are causes for hope and a number of preliminary answers one could put forward. The first answer is that the reimagining of what practice-based film education *ought to be* begins with a consideration of what the potential roles of moving images (as cultural, political, and social texts) are, and of the opportunities that such images afford for intervening in the public sphere. The second answer is that there is more than one kind of filmmaking, no matter how dominant what Jean-Luc Godard used to call "Hollywood-Mosfilm," or dominant narrative cinema, seems to be. To acknowledge these differences is perhaps to keep in mind what Alexandre Astruc argued when he outlined the notion of *la caméra-stylo*. Astruc's claims are as follows: the camera "can tackle any subject, any genre. The most philosophical meditations on human production, psychology, metaphysics, ideas, and passions lie well within its province. I will even go so far as to say that contemporary ideas and philosophies of life are such that only cinema can do justice to them."[7] Astruc's manifesto for a new kind of cinema also echoes with the way in which Canadian alternative film-practice education has undertaken projects to get "media into the hands of the people." The cinema evolves not by simply changing the *venues* in which filmmaking is taught but also the way in which *process* is foregrounded as a central aspect of what constitutes practice-based film education, leading to the development of new forms of cinema. The example that I focus on presently foregrounds both the cognitive and material processes that are central to film practice and education. I see it as being of particular interest in the context of *The Education of the Filmmaker in Africa, the Middle East, and the Americas* inasmuch as it involves a rethinking of relevant practices, both for the purposes of pedagogy and as a means of reimagining cinema itself.

The Independent Imaging Retreat, or, "Film Farm"

As a new art form comes in governed by the digital realm and of course fuelled by the commercial film industries, the old forms like 16mm and super-8 are used entirely as an artistic practice, not driven by commerce. People are even making their own emulsions, I suppose readying themselves for when celluloid is gone altogether. I think this is all happening because people realise film is different from the digital. So, it's not going to disappear.[8]

(Philip Hoffman)

Perhaps one of the most innovative examples of practice-based alternative film-making education can be found at Canadian experimental filmmaker Philip Hoffman's Independent Imaging Retreat, more colloquially known as "Film Farm," which has taken place most summers on his 50-acre farm in rural Mount Forest, Ontario since 1994.[9] Responding to the increasing bureaucratization of film production in Canadian higher education, Film Farm is a process-based, artisanal film workshop, where over the course of a week, 10 to 13 filmmakers, both experienced practitioners and graduate students from Canada and abroad, come together to shoot, hand process, tint, tone, and scratch films. By the end of the workshop, some of the participants will have produced a completely finished film, but most of them emerge with a black and white 16mm film that is still a work-in-progress. The darkrooms, screening spaces, optical printers, animation stands, and editing bays for this workshop are all located in a barn, hence "Film Farm." Goats live out back; roosters and hens wander around freely; free-range cows and pigs graze nearby in the adjacent field.

Since its inception, over 125 filmmakers have participated in the retreat, pro-ducing a wide variety of completed films, including *We Are Going Home* (dir. Jenn Reeves, 1998), *Scratch* (dir. Deirdre Logue, 1998), *5 Spells* (dir. Helen Hill, 2000), *Praise* (dir. Barbara Sternberg, 2005), and *Captifs d'amour* (dir. John Greyson, 2011). Almost all the films are set on the farm itself. Initially it may seem incongruous for films, a product of a nineteenth-century *fin du siècle* tech-nological revolution, to be made in an agrarian setting. Yet, as Michael Schmidt, a local organic farmer suggests in Hoffman's film *All Fall Down* (2009), if things are not created on farms, the barns will come down and a way of life will end. Schmidt notes: "Barns fall down because our culture does not understand the need for cultivation...Anything connected to the human spirit which can fill these barns—that keeps them alive." Indeed, the barn and its surrounding natu-ral environs play a key scenic role in a majority of the films made at Film Farm. The productive, cooperative, creative spirit of agriculture in no small way informs the filmmaking that takes place at the retreat.

Before delving too deeply into the actual structure of the Independent Imaging Retreat, a thorough examination of its genesis and *raison d'être* are in order. Like any good film movement, the Film Farm has a manifesto. The key passage for present purposes reads as follows:

Our Mandate: The Independent Imaging Retreat

The Independent Imaging Retreat began in the summer of 1994 as a pro-active response to the increasing cost and commercialization of film production pro-grams, professional development opportunities for artists and filmmaking workshops.

Frustrated with federal and provincial cutbacks to education and limited cre-ative opportunities for independent filmmakers, Canadian experimental film-maker Philip Hoffman set out to create a context in which film could be taught and explored with integrity, innovation and compassion. The workshop would place an emphasis on experimentation, personal expression and the use of hand processing techniques. The Retreat began with a modest budget at Hoffman's

home in rural Mount Forest, Ontario. With the most basic film materials, an anti-quated film processing machine, a makeshift darkroom and screening facility,... it quickly became evident that imperfections and surprises were to become a critical source for creative and aesthetic possibilities and a philosophy for the workshop was born.

Our Mandate:

Is based on the following priorities:

—Maintaining a focus on "artisan" filmmaking.

—Combining a range of artistic disciplines.

—Creating contexts for public screenings and critical discourse.

—Remaining financially accessible to artists.

—Encouraging the participation of artists typically under-represented in main-stream film production.

—Encouraging the participation of artists living and working outside of major centers of film production.

—Providing an opportunity for Ontario based artists to network with interna-tional artists and curators.[10]

The workshop itself is built around a very specific notion of *process* (and one quite distinct from the first kind of participatory process briefly outlined at the beginning of the chapter): not simply the "process" of making films, but also the material process of processing them. The workshop downplays the goal of achieving a preconceived work. More specifically, it is not a matter of producing a prescripted, preordained finished film, and instead the focus is on chemicals and celluloid, chance and creativity; in other words, the workshop concentrates efforts on the creation of the film, both in terms of its material and conceptual charac-teristics, as *process* rather than *product*. What is practiced is a labor-intensive, artisanal form of filmmaking that is also a conscious rejection of the model of industrial-based filmmaking that now dominates North American universities.

Participants cannot preplan what they are shooting at Film Farm. This is only one of the many innovations that the retreat brings to practice-based film educa-tion in its standard form. At the Film Farm, experiencing the moment trumps planning for it. Thus, unlike most university film production courses, the read-ings that participants receive from Hoffman are not obtuse techno manuals or scripting models of the Syd Field variety. The goal is emphatically not that of having the whole film mapped out before exposing the first frame. Hoffman's own cinematic process is inspired by the Beats, and he begins the workshop by giving the participants a series of handouts that describe the philosophy behind process-based filmmaking. What one finds in these handouts points toward the reframing of production that Hoffman seeks to enable and encourage. The packet begins with ten or so pages of quotes, beginning with one by Allen Ginsberg: "It is possible through mindfulness practice to bring about some kind of orderly obser-vation of the phenomenology of the mind and to produce a poetics.... Observe your mind rather than force it, you will always come up with something that links to previous thought forms. It is a question of trusting your own mind finally and trusting your tongue to express the mind's fast puppet...spitting forth intelligence without embarrassment."[11] This quotation sets the framework

for the mental practice Hoffman envisages as central to self-exploration and the creative process. He continues with quotes, referring to memory and the photographic image, taken from Roland Barthes's *Camera Lucida*: "The (true) realist does not take the photo as a copy of reality, but for an emanation of past reality: a magic, not an art...its testimony bears not on the object but on time...the power of authentication exceeds the power of representation;"[12] and from Walter Benjamin's "Theses on the Philosophy of History": "The past can be seized only as an image which flashes up at the instant when it can be recognized and is never seen again."[13] These quotes illustrate the profound role played by chance and serendipity in the practice of filmmaking as a means of self-expression; they bring focus to the thought processes that lie behind experimental and exploratory image-making, placing the oft-fetishized technical skills required to reproduce images that everyone has seen countless times before on the back burner, so as to foreground instead the lived moment as it is experienced and then reimagined and understood through memory. Hoffman also provides quotes from experimental filmmakers like Alain Robbe-Grillet, Maya Deren, and David Lynch, along with excerpts from Robert Bresson's *Notes of the Cinematographer* and writings on the function of memory. Also included are his own notes on process cinema:

> PROCESS CINEMA: collect, reflect, revise—shooting editing writing shooting writing shooting...
> Following "life's threads" in filmmaking through COLLECT REFLECT REVISE,
> PROCESS CINEMA: AN ARROW NOT A TARGET[14]

On a more technical front, he provides notes on hand processing, shooting, tinting and toning, and "Chemistry and Alchemy of Color," a practical and philosophical overview of film chemistry by German experimental filmmaker and "film alchemist" Jürgen Reble.[15] Therefore, both practical and philosophical work is foregrounded as part of practiced-based education, but the canon of texts is strikingly different from that of a typical film school.

To achieve greater clarity about this concept of "process," it is helpful to outline the actual structure of the seven-day program: on the first day, participants shoot some film, familiarizing themselves with the hand-cranked Bolex (many have only used video at this point in their careers and, among other things, are not used to being limited to the 28-second shot), and then proceed to the "Swallow Room" (swallows nest in the rafters above) in the basement of the barn, where the darkrooms are, to hand process their film with the aid of hoses and buckets. It is then left outside to dry overnight on makeshift clotheslines, while screening of experimental, hand-processed works takes place in the upstairs area of the barn. On the second day, the participants run their rushes through 16mm projectors to see what they have captured on film, and to get a better feel for exposures and the texture and materiality of the stock. They then go out and shoot more. In the afternoon, various workshops are run: participants learn about, and practice, reading light meters and setting f-stops, tinting and toning, bleaching, painting on films, scratching off emulsion and dyeing images. The materiality of the hand

processing (the presence of dirt and scratches, for instance) is used to foreground the visual possibilities of the stock and the beauty of chance. On the third day, participants learn about optical printing, which is done by hand in the barn. There is also an animation stand for those who wish to shoot and reshoot frame by frame, or to draw their own animation on makeshift cells. The rest of the week is spent shooting one's film, hand processing it, and editing together the material on one of the four Steenbecks in the barn. On the final day, each participant presents his or her work at a final screening. Throughout the week, each night has a dedicated screening of works that relate to artisanal, process-based filmmaking—on clear nights, the screenings are often held outdoors (each year on average 50 or so films are screened throughout the retreat). This educational process is not simply about learning a skill, but also about incorporating everything into film production that is typically left on the cutting room floor in order to make a perfect product.

The changes in filmmaking that flow from this process are not simply aesthetic ones. Speaking in the context of the disappearance of 16mm filmmaking, and indeed analogue itself, curator and filmmaker Chris Gehman notes: "The Independent Imaging Retreat has played a crucial part in North America in developing and disseminating the basic skills and knowledge necessary for artists to begin taking control of those crucial elements of the filmmaking process that are becoming harder to find from commercial sources." Gehman describes the fundamental relationship between process-based practice and a new form not only of production but also of spectatorship in the following manner:

> The filmmaker builds images, ideas, stories, atmospheres, while at the same time keeping the method of construction of the film, and the images which make it up, present in the viewer's consciousness. In this context, the nicks, scratches and inconsistencies in development which result when a roll of film is processed "spaghetti-style" in a plastic bucket are not seen as a problem—as they certainly would [be] in making a commercial movie!—but become part of the film's style and method. Artists mining this cinematic vein tend also to embrace a process-oriented mode of production, in which the film's form and subject are discovered in the course of the making, rather than following a preconceived script or plan—an art of discovery, then, not only of management and execution. This is what allows these artists to dispense with the predictability of laboratory results, knowing that footage they hoped would be particularly good might not turn out as expected in the processing. It is a practice which embraces genuine experimentation and the discovery of a personal method of production.[16]

This kind of process allows filmmakers not only to discover a different kind of film practice but also to reimagine why one might want to make films in the first place. Filmmaking, as it is understood here, is not a mere means of making a preconceived statement but also a tool for self-exploration. The process involves transforming one's own practice by working creatively with what would typically be seen as mistakes. The point is to reframe these "mistakes" as opportunities actively to engage with the contingencies that inevitably go hand in hand with hand processing.

Capital, or, Find the Cost of Freedom

While liberating the filmmaker from techno-fetishism is a key part of the process of Film Farm, the point is also to take issue with the often unspoken rationales that underlie the assumptions of how "film production" ought to be taught. As can be seen in the "Our Mandate" manifesto, one of the key catalysts for Film Farm was the sterile and stultifying nature of so much that passes for practice-based film education, with its fetishization of technological mastery. Janine Marchessault picks up on this aspect of the philosophy of Film Farm and outlines the pedagogical, and feminist, impetus behind the beginnings of the retreat:

> Hoffman, weary of overseeing large classes and high end technologies at film school, conceived of a different pedagogical model for teaching film production. Instead of the urban, male dominated and technology heavy atmosphere, The Independent Imaging Workshop would be geared towards women and would feature hand-processing techniques in a low-tech nature setting. The process encouraged filmmakers to explore the environment through film, and to explore film through different chemical processes.[17]

In the early years, women made up the majority of the participants in each group; indeed, Hoffman once ran the retreat for women only, creating a space that allowed them to work outside the techno-fetishizing frameworks that often dominate male-centered film production in university classes. Gehman develops these ideas when he notes that the Film Farm was first started "to encourage a direct, hands-on approach to filmmaking that is far removed from the costly, hierarchical and inaccessible industrial model, with its intensive division of labor into many specialized craft areas." He goes on to situate Film Farm as part of a developing trend in film practice and education:

> The retreat is part of a little-recognized international movement towards what might be called an artisanal mode of filmmaking—one in which the artist works directly on every stage of a film, from shooting and editing to the processing and printing of the film stock itself. In the past, even the most solitary of avant-garde filmmakers have usually turned the processing, printing, and negative cutting of their films over to professional film laboratories whose primary products are commercial films, advertisements, television programs, etc. A new generation of filmmakers has emerged, willing to forego the predictability and standardization of industrial processes in favor of direct control of their materials, motivated by a combination of necessity and curiosity.[18]

Hoffman himself astutely articulates the problems surrounding technology and capital in university-run film schools, describing the chicken-and-egg dilemma of the institutional educational space in the following manner:

> The problem that we get into at film schools is that everything needs to be big...We need the newest technology so we need more money....so we need more students...so we get government cuts...and we can't run this big thing that's been

created. It gets out of control. So we started the Film Farm, tore away some of that film school infrastructure so we could get back to the things we like about working in this art form.[19]

When the need for the latest technology becomes paramount in order to offer students "proper" training, then the highly conservative and capitalistic philosophy that underlies this sort of training is drawn into relief. What one finds is that when technology reins supreme, its mastery and deployment often leads to the virtual neglect of the actual creative qualities of the films being produced. This produces groups of students able to shoot technologically advanced films, but with little time left to think about the content of the works and the specificity of the medium (as one of the reasons for wanting to make a film, in lieu of writing a short story or painting a picture).

Material Process, or, Return to Zero

One of the central components of Film Farm is the celebration of the aspects of the material process of filmmaking that are often elided or seen as negative, such as scratching your print. At the retreat, these very "faults" are seen as central to the process of filmmaking itself. As filmmaker Cara Morton notes: "Nothing, I mean nothing, beats stomping on your film, rubbing it against trees, rolling around with it in the grass or even chewing on it like bubblegum."[20] Morton does note that the last example is a hyperbolic one in the context of what she actually did with her film stock at the Film Farm (though if she had wanted to chew on it, no one would have stopped her). All this directly contradicts the philosophy of traditional film schools, which tends to be about a very different kind of control. Indeed, part of the problem with traditional film schools is the fetishization of mastery. In the case of hand processing, Hoffman describes the dialectic between control and its loss as part of the very process of liberation from these forces as follows:

> It's sort of having control of the whole process and at the same time you are out of control. You have a pact with the process...with the world, that it has some say in what the film will be. You have great control in, for example, hand processing the film yourself...you don't have to give it to the man with the white lab coat any more...and all your money along with it....In the hand processed film you are actually putting the film in the developer, swishing it around and putting it into different processes. What's great about hand processed film is that you are never in total control. So it's again being in control and at the same time relinquishing control because within a few seconds you can lose a beautiful image you love by leaving it in a chemical too long or not long enough.[21]

Marchessault also foregrounds the philosophy of hand-processing in the process-oriented model of filmmaking: "Where work prints serve to protect the original negative from the processes of post-production, the films produced at the workshop use reversal stock and thus include the physical traces of processing

and editing, an intense tactility that will be constitutive of the final print of the film." Here, the roughing up of the smooth surface of the film becomes part of the work's projected image and therefore part of the total work itself. She goes on to note the very different role that films made at Film Farm have within a larger scheme of things on account of their status as "works in progress," as compared to finished "works of art."

> Many of the films produced at the workshop are never completed as final works but stand as film experiments—the equivalent of a sketchbook. This is the workshop's most important contribution to keeping film culture alive in Canada. The emphasis on process over product, on the artisanal over professional, on the small and the personal over the big and universal which has been so beneficial for a new generation of women filmmakers, also poses a resistance to an instrumental culture which bestows love, fame and fortune on the makers of big feature narratives.[22]

One of the many achievements of the workshop, then, is that it has brought filmmakers back to some fundamental questions: What might motivate someone to make films in the first place, or, as I put it earlier in the chapter, why would one even bother with practice-based film education? As Morton notes, the Film Farm works as a way of reprogramming, or perhaps, more aptly, reexamining why one would even want to make films:

> I went to the workshop in the first place because I hate film. I mean sometimes I have to wonder, what has gotten into me? Why am I putting myself through this agony? I've spent most of my grant money. I'm in the midst of editing and I find myself asking: what is this damn film about anyway? Why am I making it? At this point those of you who run screaming from process-oriented work can laugh at me. I don't plan much....I like to [let] things happen, letting that creative, unconscious self reign. But sooner or later that insightful...self turns on me and I'm left stranded in the dark editing suite with the corpse of my film and that evil monster self who thinks analytically, worries about money and just doesn't get it.[23]

The cost of making a film at Film Farm runs to about CND$800 and that also includes the participants' food for the week (therefore, no need for craft services). In contrast, in contemporary film production, even at film schools, the cost of making a short film is often prohibitive. Taking the need for limitless capital out of the equation, process-oriented production places the film itself back at centre-stage, relieving the filmmakers of any need to think of their work in terms of big budgets and distribution deals. It is not a strategy for getting rich, but as noted earlier, most film-school graduates do not end up working in the industry, and never produce their imagined blockbuster epics. Artisanal filmmaking refocuses the teaching of film production on the possibilities of the film medium, and not on the ability, and at times all-consuming need, to raise capital. It is also a way forward for the production of artistically viable works in the context of a small nation.

The Experimental Writing Workshop, or, Book Farm

Part of the "Our Mandate" manifesto proclaims that the workshop wishes to "create contexts for public screenings and critical discourse." That aspect of Film Farm has developed greatly over the last four years, with the advent of annual guest curators who select screening programs. This praxis has been further enhanced by the development of the Experimental Writing Workshop or "Book Farm," which runs alongside Film Farm, and brings together academics and curators to workshop their books in progress on nonmainstream image-making practices. Co-organized by Janine Marchessault and myself, the workshop brings together writers to explore creative and critical writing practices outside the confines of traditional educational and institutional contexts. At Book Farm, writers work on their books, giving each other daily feedback as they write in the same process-oriented manner as Film Farm proper, with both groups partaking in communal meals and screenings. The topics covered by writers have been wide and varied, including film manifestos, the cinema of Guy Debord, Hollis Frampton's *Magellan* Project, the early works of John Greyson, experimental 3D cinema in the 1950s and the Festival of Britain, the works of Humphrey Jennings and Jacques Cousteau, among many others. Book Farm applies the process-oriented philosophy of Film Farm to the equally solitary act of academic writing. Most academics get feedback on their work from conferences, by circulating near-finished drafts to their colleagues, or from anonymous peer reviewers. Feedback is rarely, if ever, gained as part of the writing process itself. At Book Farm, the process of writing is, out of necessity, an act of dialogue as the Experimental Writing Workshop takes as a given that writing itself is always an implicitly dialogic process. Therefore, at Book Farm, explicit dialogue between writers takes center stage as part of the creative process of academic and curatorial writing. The integration of writers and filmmakers from the Independent Imaging Retreat and the Experimental Writing Workshop highlights the ways in which both research and creativity are practices centered on the process of bringing ideas into being. As a result, the initiative takes distance from the notion that academic writing is a process-neutral undertaking. Indeed, the workshop accentuates the fact that engaged writing is actually a form of creative and philosophical reportage on various dialogues that the writer has engaged in; dialogues that have spurred the ideas now being committed to paper. What is achieved is a rethinking of what it means to write, specifically to write academic and philosophical work, and of what the communicative, political, and sociological stakes of the writing process are. Writing moves from the solitary actions of writers in rooms of their own and into the public sphere of dialogue and debate.

Lessons in Process, or, Globalized Film Farm

Book Farm is a logical expansion of the Film Farm ethos, and Hoffman has devised other forms of outreach based on the philosophy of process over product.

While Film Farm itself is very localized in nature, Hoffman has taught his hand-processing workshop to different groups and indeed at locations outside the Farm itself. One year, Hoffman adapted the Film Farm Program for children, where they too learned how to make films by hand. He has also run workshops in conjunction with the Durham Fabulous Fringe Film Festival. And, for the last four years, Hoffman has taught a two-week hand-processing course at the International School of Film and Television (EICTV) in San Antonio de los Baños, Cuba. Hoffman has recently released *Lessons of Process* (Canada, 2012), a half-hour experimental documentary about his time at the school, which documents his experiences there teaching hand processing, the devastating Haitian earthquake that took place during the week of the workshop, and the slow decline of his father's health back in Owen Sound, Ontario. The film is an exemplary example of the practice of processing that Hoffman teaches: the film is built around the notion that lived experience and everyday life greatly influence the kinds of films artists make; it shows how these experiences often become part of the work produced; and what happens when a film's making becomes part of the narrative of the film itself. *Lessons of Process* is about symbolic fathers (radical Latin American filmmaker Fernando Birri, who founded and "fathered" the School—with Colombian writer Gabriel García Marquez and Cuban film maker Julio Garcia Espinosa—and who called the institution the "School of Three Worlds") and biological ones (Hoffman's own). The film has a tripartite structure, juxtaposing Cuba, Haiti, and Canada, and thereby allowing these three worlds to speak with each other, but without overdetermining the meaning of the images on the screen, or drawing simple parallels between contiguous events. At the same time, a central feature of the film is how these elements intersect with Hoffman's own life. *Lessons in Process* stands as an exemplary documentary film about the tapestry of these three worlds, but also about process-oriented practiced-based film education itself (as Hoffman says in his process cinema notes: "Following 'life's threads' in filmmaking through COLLECT REFLECT REVISE"). More specifically, the film ruminates on the ways in which filmmakers find their films in their surroundings and lived experiences, as compared with an approach that brings a preconceived, cookie-cutter plan to a film shoot, leading to an inevitable and generic outcome. Process-oriented pedagogy and production center on the journey one goes through while making a film—a process of discovery—and do so to break away from the mantra that shooting is all about getting the preplanned vision of the film onto the screen. The meaning and structure of *Lessons in Process* is discovered through the process of living and working with the captured material, and not through some hermetic world of preplanning and preproduction. This is the real lesson that process-oriented pedagogy aims to impart to students and filmmakers.

In Lieu of a Conclusion, or, the Journey, Not the Destination

In this chapter, I have argued that the new and most radical models of teaching filmmaking practice, at least in Canada, are ones that lie outside the

traditional structures of education in film production (and in Canada these are firmly embedded in the universities). Despite the valid work that these institutions do (indeed, Hoffman himself is a university professor), the migration of educational practice outside the institution allows for a reimagining not only of how film is taught, but of what exactly film is or ought to be. The move to a new sphere and method of practice allows filmmakers to think about how films communicate ideas and how filmmaking allows for political, cultural, and social self-examination. And Hoffman is not alone in getting film education out of the hands of film schools in Canada. Artist-run collectives like LIFT (Liaison of Independent Filmmakers of Toronto), the Saskatchewan Filmpool in the Prairies, and the Double Negative Collective in Montreal all engage in practices that allow aspiring filmmakers to find their own voices, and their own specific models of film production, through processes of trial and error leading to unexpected moments of self discovery. The philosophy of these groups and co-ops is based on the notion that teaching students what filmmaking *ought* to be enables astonishingly diverse forms of expression and radically different voices to emerge in the public sphere, because of the different goals underlying process-based filmmaking.

Film Farm accentuates the aspects of film practice education that are as much about self-learning, self-exploration, and self-reflection as they are about simply gaining marketable skills to turn out more bland products. As experimental filmmaker and Film Farm participant Gerald Saul notes: "Central to the film farm is the barn which houses darkrooms to develop film, open spaces to hang film to dry, screening areas, and relaxation spots to talk, think, or read. No modern complex could be as versatile or accommodating. The so-called enemies of filmmaking: dust, wind, light leaks, and noise, are all acceptable commodities in this environment. To fight the flaws is to fight against nature itself. To accept nature as an external force helps to open the door to express your inner nature."[24] In an age where moving images are ubiquitous, perhaps this is the political, cultural, and aesthetic future of practice-based film education. This is not to deride the goal that many aspiring filmmakers have simply to be in the industry. What does seem clear, though, is that a return to a set of self-reflexive skills that have often existed at the margins of filmmaking practice is necessary, both personally and politically, to understand and produce moving images in the twenty-first century.

Notes

1. My thanks to Janine Marchessault and Phil Hoffman for discussing Film Farm with me in detail, and for offering me the opportunity to be a part of it, and to Anna Westerståhl Stenport for comments on an earlier draft of this chapter.
2. The story of French filmmaking in Canada, and especially Québec, follows a different though equally rich trajectory, but is outside the confines of this chapter. For more on this topic, see Scott MacKenzie, *Screening Québec: Québécois Moving Images, National Identity and the Public Sphere* (Manchester: Manchester University Press, 2004).

3. Dorothy Hénaut, "The 'Challenge for Change/Société nouvelle Experience'" in *Video the Changing World*, ed. Alain Ambrosi and Nancy Thede (Montreal: Black Rose, 1991), 48–49.

4. http://filmmakerinresidence.nfb.ca/blog/?p=152 (accessed June 26, 2012).

5. For more on these programs, see, for instance, Scott MacKenzie, "Société nouvelle: The Challenge for Change in the Alternative Public Sphere" in *Challenge for Change: Activist Documentary at the National Film Board*, ed. Thomas Waugh, Michael Brenan Baker and Ezra Winton (Montreal: McGill-Queen's University Press, 2010); Janine Marchessault, "Amateur Video and the Challenge for Change," in *Challenge for Change*, ed. Thomas Waugh et al.; and Katerina Cizek and Liz Miller, "Filmmaker-in-Residence: The Digital Grandchild of Challenge for Change," in *Challenge for Change*, ed. Thomas Waugh et al.

6. For more on the over-production of filmmakers in university programs, see Toby Miller, "Not Every Film School Graduate Ends Up a Scorsese," *The Australian*, May 16, 2012, http://www.theaustralian.com.au/higher-education/opinion/not-every-film -school-graduate-ends-up-a-scorsese/story-e6frgcko-1226356719938 (accessed June 26, 2012).

7. Alexandre Astruc, "The Birth of a New Avant-Garde: *La caméra-stylo*," in *The New Wave: Critical Landmarks*, ed. Peter Graham (London: Secker and Warburg, 1968), 18–19.

8. Tom McSorley, "Interview: Phil Hoffman," in *Rivers in Time: The Films of Philip Hoffman*, ed. Tom McSorley (Ottawa: Canadian Film Institute, 2008), 57.

9. Hoffman has been working with a core team of filmmakers, curators, and artists to run the workshop since its inception, including Rob Butterworth, Christine Harrison, Deirdre Logue, Karyn Sandlos, Josh Bonnetta, Scott Miller Berry, Mary Daniel, and many others.

10. "Our Mandate," http://philiphoffman.ca/filmfarm/purpose.htm (accessed June 26, 2012).

11. Allen Ginsberg, "Spontaneous," *Public* 20 (2000): 56.

12. Roland Barthes, *Camera Lucida* (New York: Hill and Wang, 1981), 88.

13. Walter Benjamin, "Theses on the Philosophy of History," in *Illuminations: Essays and Reflections*, ed. Hannah Arendt, trans. Harry Zohn (New York: Schocken, 1969), 255.

14. Phil Hoffman, "Film Farm Notes 2012" (photocopy provided by the artist).

15. Jürgen Reble, "Chemistry and the Alchemy of Color," *Millennium Film Journal* 30/31 (1997).

16. Chris Gehman, "The Independent Imaging Retreat: Program Notes for the Hanover Civic Centre," Phil Hoffman website, September 20, 2003, http://philiphoffman.ca /film/publications/Film%20Farm%20folder/The%20Independent%20Imaging% 20Retreat.htm (accessed June 26, 2012).

17. Janine Marchessault, "Women, Nature and Chemistry: Hand-Processed Films from Film Farm," in *LUX: A Decade of Artists' Film and Video*, ed. Steve Reinke and Tom Taylor (Toronto: YYZ/Pleasuredome, 2006), 136.

18. Gehman, "The Independent Imaging Retreat."

19. Aysegul Koc, "Hand-Made (in the Digital Age): An Interview with Phil Hoffman," March 2002, Phil Hoffman website, http://philiphoffman.ca/film/publications /Philip%20Hoffman%20interviews/interview%20march%202002.htm (accessed June 26, 2012).

20. Cara Morton, "Films and Fairy Dust," in *Landscape with Shipwreck: First Person Cinema and the Films of Philip Hoffman*, ed. Karyn Sandlos and Mike Hoolboom (Toronto: Insomniac Press/Images Festival, 2001), 153.

21. Koc, "Hand-Made (in the Digital Age): An Interview with Phil Hoffman."
22. Marchessault, "Women, Nature and Chemistry."
23. Morton, "Films and Fairy Dust," 51.
24. Gerald Saul, *Fragile Harvest: Films from Phil Hoffman and His Film Farm* (Regina: Saskatchewan Filmpool, 2011), 2, available as a PDF at http://www.nmsl.uregina.ca /saul/documents/fragileharvestprogramnotes.pdf (accessed June 26, 2012).

The School for Every World: Internationalism and Residual Socialism at EICTV

Nicholas Balaisis

Cuba in Transition

Recent discussions regarding Cuba have revealed some of the many challenges and contradictions facing the country as it moves into an uncertain future somewhere between socialism and free market capitalism. At a 2008 conference in Manhattan titled "A Changing Cuba in a Changing World," scholars from all political stripes gathered to discuss the future of the island nation.[1] Many of the keynote talks focused on pressing questions both within and outside of Cuba: Where was Cuba headed in the twenty-first century? What economic and political maps should Cuba use? What role, if any, would the international (or specifically American) community play in this future? Like many conferences on the subject of Cuba, the debates were often contentious as economists touting Cuba's repressed entrepreneurial spirit squared off against political scientists sympathetic to the aims and spirit of the Cuban revolution in 1959. While many on the right of the political spectrum envisioned a more "global" Cuba, with open markets freed from restrictions on trade, investment, and entrepreneurship, many on the left were anxious about the risk that these moves posed to key areas of social policy in the country—namely a well-funded, health, education, and cultural sector. However, as the actions implemented by the new commander-in-chief Raoul Castro indicate, change is coming to Cuba. Recent decisions to open up the real estate market, to free up regulations on some forms of small business, and to lay off large sectors of the public service, present major challenges to the revolutionary status quo and will undoubtedly have broad implications for the country in the future.

It is within this changing context in Cuba that I wish to situate the Escuela Internacional de Cine y TV (EICTV) in San Antonio de los Baños, east of Havana.

I argue that the school embodies many of these contradictions within late social-ist Cuba. On the one hand, the school retains important aspects of the Cuban revolutionary ethos in many of its pedagogical, aesthetic, and economic princi-ples. On the other hand, the school is very much embedded in the current global economy, orienting film students not strictly to the highly politicized paradigm of the 1960s, but rather to employment in a more flexible, mobile, and global film marketplace. As many of the students I spoke to at the school described it, the school is in many ways both deeply connected to (and a product of) the socialist, revolutionary efforts of the Cuban revolution, while also uniquely separate from the political restrictions and economic limitations often felt in everyday life in Cuba. While students from the school are exposed to aspects of the radical spirit of the Cuban and New Latin American Left, they are not oriented exclusively by the relevant political project, but rather by a more generalized spirit of interna-tionalism that does not bear the same strident nationalism or fierce identification with Third World solidarity and liberation movements of the 1950s and 1960s.[2] The changes at EICTV thus mirror the broader transformations that have taken place in Cuba since the 1960s, where an ideological alignment with the socialist block and the global south has given way to a less antagonistic engagement with nations of the former first or capitalist world.[3]

The School of Three Worlds

Begun on the cusp of the collapse of the Soviet Union in 1986, EICTV embodied much of the revolutionary spirit of the Cuban revolution and the energy of the 1960s. As Julianne Burton argues, one of the major sites for national reassertion in Latin America was through cinema.[4] In Cuba, as elsewhere in Latin America, the development of local "autochtonous" cinema was in large part a result of a desire to counter the hegemonic presence of global Hollywood. This is docu-mented in an early post-revolutionary newsreel (number 49) that shows Cubans enthusiastically destroying the iconic Warner Brothers icon in Havana in 1960 and thus clearing the path for a Cuban national cinema. This reimagining of cinema was not strictly a nationalist project but extended to include a pan-Latin American solidarity, with Cuba increasingly serving as a center for leftist film-makers from Latin America and beyond. Cuba's central role in this broader coali-tion of leftist filmmakers was confirmed by the relocation of the International Festival of New Latin American Cinema in 1979 from Chile to Cuba.[5] As Anne Marie Stock argues, it is out of this context that the idea for the International School of Cinema and Television was born. Specifically, the idea for the school took shape during a meeting of the Comité de Cineastas de América Latina (Latin American Filmmakers Committee), where they decided that a training centre was needed for Latin American filmmakers with the primary objective of "equipping Latin Americans to depict their own realities on-screen."[6] EICTV thus marked an institutionalization of the energy of the New Latin American left, embodied in many of the writings of the 1960s by authors such as Julio García Espinosa, Tomás Gutiérrez Alea, Fernando Birri, Fernando Solanas, and Octavio

Getino.[7] This euphoria and politicization are reflected in the words of one the founding members of the school, Argentinean filmmaker and essayist Fernando Birri, whose words grace a plaque at the school's entrance: "Para que el lugar de la Utopía, que, por definición, está en 'Ninguna parte', esté en alguna parte." (So that the place of Utopia, which by definition has no place, will exist *some* place).[8] It is also expressed in the words of Cuban filmmaker and theorist Julio García Espinosa in his description of the school's rationale for existence:

> It is indispensible and possible for us to exercise our right to promote and develop national films on our Continent. A country without images is a country that doesn't exist. Everything we do, everything we want to do, is to have the right to be the protagonists of our own image. Another cinema is possible...because the visibility of our countries is necessary.[9]

This ethos is inscribed materially at the school in the colorful graffiti that covers most of EICTV's hallways and common rooms. The comments marked on the walls provide both inspirational messages on the art of filmmaking as well as political directives meant to guide the spirit of the students' films. Francis Ford Coppola's wall marking from 1998 is a quote on aesthetics from Balzac: "1st act clear, 2nd act short, interest everywhere." Other comments left by Cuban film scholar Michael Chanan and American actor Danny Glover express the more politicized tone of much of the graffiti, connecting filmmaking to social justice and political change: "Subvert the dominant paradigm!" (Chanan) and "Do Art, Make Justice" (Glover) (see figure 9.1). Finally, the images and slogans of Che Guevara, ubiquitous all over Cuba, are evident on the walls of the campus, reinforcing the distinctly Cuban dimension of the school's founding revolutionary spirit.

One of the unique aspects of the school is its tri-continental focus. The film school's original name, The School of Three Worlds, highlights the solidarity envisioned by the school's founders between Latin America and the emerging postcolonial nations within Africa and South Asia. This focus on the three continents of the global south reflects a broader discursive shift that occurred in Cuba following the revolution, as Cuba began to define itself as a Third World nation and as the cultural and political vanguard of the postcolonial movement. This discursive shift imagined Cuba not simply as the vanguard of Latin America but also as being in deep solidarity with the sub-developed and poor nations of Africa and Asia. In the words of Fidel Castro, "the history of Cuba was that of Latin America, which in turn is that of Asia, Africa and Oceania; a history of exploitation by European imperialists."[10] In the geographic imagination of the school's founders, EICTV would be a truly transnational film school, devoted exclusively to training of filmmakers from the developing world committed to creating their own national images.

While the student makeup of the school does not reflect as large a population of students from Asia and Africa as its original spirit envisioned,[11] the school remains committed to underwriting the costs for all of its domestic and international attendees, and has worked in particular to recruit filmmakers from

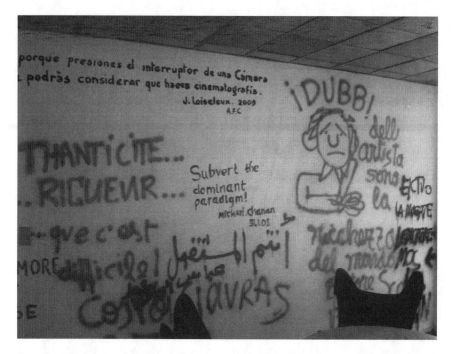

Figure 9.1 Photograph by Nicholas Balaisis, Comments left on the walls at EICTV.

underdeveloped regions of Latin America. This financial commitment remains a key expression of its mandate to make filmmaker training available to students from the developing world. Jorge Yglesias, chair of the Humanities Department, noted that all Cuban students who attend the school are fully subsidized by the Cuban government,[12] while international students pay only for tuition and are fully covered for all other costs—equipment, transportation, food, board, and medical expenses—while they are in Cuba.[13] While EICTV does not cover the entire costs of the schooling for international students, the state and international NGO subsidies that the school receives make it much more affordable to attend than the many private international film schools on the market, such as the New York Film Academy. EICTV is thus a much more affordable film-school option for students from Latin America and beyond.[14] In my discussions with students at the school, nearly all of them mentioned the low cost of the school as one of the primary reasons for attending.

Rural Immersion and Experiential Filmmaking in the Sierra Maestra

Another unique aspect of the school that reflects the legacy of the Cuban revolution is the documentary immersion program in the Sierra Maestra region in eastern Cuba. The rural immersion program is a required element for documentary

film majors at the school and occurs at the end of the students' second year of a three-year curriculum. The program is organized in connection with Television Serrana (TVS), a community media organization based in eastern Cuba that emerged in the wake of the economic crisis of the Special Period in 1993. TVS receives funding from the Cuban state as well as from international NGOs and seeks to aid development in the region, Cuba's most historically rural and disenfranchised. Stressing the interrelation between audiovisual culture and the real needs of everyday people in eastern Cuba, TVS works to "rescue the culture of peasant communities [in the region and to] facilitate alternative communication for communities to…participate in the search for the solutions that affect them."[15] One of the notable developments of TVS in recent years has been the resurgence of traveling or mobile cinema exhibition in the most remote mountainous areas of the region. This project is performed in the spirit of the mobile cinema campaign in Cuba that began in the 1960s and aims to make cinema and audiovisual culture available to peasants who had neither the access nor the resources to attend regional movie houses.[16]

Television Serrana hosts the documentary students while they are in the Sierra Maestra by providing them with film equipment and putting them in touch with local residents, with whom the students live for a month. The primary objective of the program is to foster a unique and intimately "human" experience for the young filmmakers, who come away with more than just technical filmmaking skills as a result. As Humanities Chair Jorge Yglesias argued, the challenges of living in such a remote and rural region, combined with the bonds forged with the rural hosts, make for a rich and rewarding life experience that is unique to EICTV.[17] In emphasizing the human element of the film experience through the close encounter forged between filmmaker and film subjects, the rural immersion program mirrors the ethos of one of the iconic collective actions of the Cuban revolutionary government: the literacy campaign of 1961. The literacy campaign was initiated in the enthusiastic first years following the Cuban revolution and still stands as one of its most stunning achievements. Drawing on the volunteer labor from a number of university students in urban Cuba, the state sent out thousands of volunteer teachers to the remote areas of the countryside with the aim of eliminating illiteracy. In addition to virtually eliminating illiteracy within the country, one of the significant aspects of the campaign was to create "alchemical" conditions for the socialist "new man." Just as the residents would benefit from the tutelage of the volunteer teacher, the teachers themselves would be enriched through their encounter with the spiritual heartland of the nation and its people. As many of the central qualities of the Cuban revolutionary spirit were drawn from romantic associations of rural life, the immersion in rural life and culture was seen as a way to instill an authentically revolutionary spirit within the young and enthusiastic student-teachers, and of transforming them into the socialist "new man."[18]

While the documentary immersion program does not explicitly reflect the political and nationalist objectives of the revolution, it shares an ethos rooted in a romantic view of the eastern provinces as well as an interest in the transformative potential of immersion in the remote and rural countryside of the east. In

describing the rationale for the program, Yglesias argued that the region is used in part because it is a remote area where life is particularly difficult for the film students, who largely have no former experience in living conditions such as those. Similar to the ethos of the literacy campaign, the remote eastern areas of the countryside are seen as useful because the people there, being "very remote and very poor," provide the students with a rich experience distinct from the one they know and live either in Havana or outside of Cuba. The landscape is also a significant aspect of the program. As Yglesias describes, "[In the Sierras the filmmakers] feel small by comparison. You're far from civilization. The air is different, the sound is different, and you meet many people who have to fight to survive every day. For some of the students it is their first time in that kind of environment and they are forced to work in that context."[19] The experience in the Sierra Maestra offers an important pedagogical exercise for the students by placing them in an unfamiliar rural environment where they do not have access to the resources available in Havana or at the film school itself. Not only must they adjust to the fact of living in a remote and more impoverished milieu, but they also have to work within that context, translating their lived experience in the mountains into a short documentary film. The challenging conditions of the immersion program are seen to enrich the quality of the film as well as the character of the filmmakers.

Students who had completed the program expressed similar feelings about the immersive experience and its rich benefits. One of the young Cuban filmmakers at the school, Jorge de León, mentioned that the immersion program was the primary reason why he had come to the school.[20] While de León had already completed a degree at ISA (the Superior Art Institute in Havana), he wished to do a specialization in documentary filmmaking, not offered at ISA. Like Yglesias, de León mentioned that the documentary immersion program was appealing as both a technical and a life-enhancing experience. The experience was the only true auteur filmmaking opportunity at the film school, where one created and directed the film oneself using a minimal crew. At the same time, the immersion experience also offered a unique life experience that carried a great deal of personal and historical significance for students such as de León. The project allowed him the opportunity to immerse himself in an environment distinct from his life in Havana, which he described as being fraught with the busyness and hassle of Cuban street life. It also presented the chance to generate meaningful social connections with his documentary subjects: to "get to know the people and country" of the Sierras. He and other students spoke of the warm relationship that they developed with their rural hosts, and many had made plans to visit their host families again in the future. He also noted the powerful impact of the landscape itself, speaking with particular fondness about the opportunity to bathe in the river every day during his extended stay. Finally, the experience was important for him insofar as it connected him with an important chapter in Cuban revolutionary history: the literacy campaign of the 1960s. He mentioned that his parents had gone to the east of the country as part of the literacy campaign and that he had gone to the region on his own personal campaign with the thought of his parents at the forefront of his mind: "I went to the Sierras with the spirit of a literacy teacher."[21]

Jorge de León's experiences in the program are concretized in the film that he produced as a result of the experience, *La Niña Mala* (The Bad Girl, 2012). His short lyrical documentary foregrounds both the landscape and people that he encountered in his time in the Sierra Mountains. *La Niña Mala* opens with a text that notes the place of the shooting as well as its significantly remote location: "Vega Grande, a 50 km de la ciudad de Bayamo en Oriente, Cuba. En las laderas de la Sierra Maestra. Todavía de difícil accesso." (Vega Grande, 50 km from the city of Bayamo in the Eastern part of Cuba. On the slopes of the Sierra mountains. Still hard to access.) The film then presents a number of long takes of a young girl in her open-air home while diegetic noises from birds and animals suggest the surrounding wilderness. The first sequence is very observational. We witness a number of close-up shots of a young girl as she passes time inside her thatched roof house in the mountains. Her activities are relatively banal: staring awkwardly into the camera as she handles a curtain, chatting informally with her mother, braiding her hair and scribbling on the porch. In the second section, we see the young girl taking part in a small evangelical church service. We see a close-up of the minister who is preaching, followed by subsequent close-ups of parishioners singing, and finally the young protagonist who participates disinterestedly. The film culminates with a series of tight shots of the small community dancing together at a party or festival. The film focuses particularly on the young girl, who pulsates erotically for the camera, staring directly into the lens. This final sequence, demonstrating the young girl's latent eroticism, would appear to be the source of the film's title, the bad girl, as she pulsates intensely for the camera.

As de León mentioned to me, the film is connected to two aspects of post-revolutionary history in Cuba, both aesthetic and political. In the first instance, the film is in direct dialogue with the films of Cuban filmmaker and notorious exile, Nicolás Guillén Landrían, who produced a number of experimental documentaries in the 1960s. Specifically, de León's film recalls Landrían's film *Ociel del Toa* (Ociel from Toa, 1965), an intimate portrait of a young campesino, Ociel, from the Toa river region in eastern Cuba. The film presents the many struggles of everyday life for a young worker in the remote eastern mountains, in stark contrast to the images of revolutionary heroes depicted on the walls of the modest thatched roofed houses in the area. The monotony of his labors (paddling his handmade canoe upstream with a long pole) is broken only by a sequence at the end of the film where he attends a local festival or dance and we see him enjoying himself for the first time. Similar to de León's film, *Ociel del Toa* portrays the rural east as a complex space: monotonous and challenging as well as vibrant and culturally dynamic.

In the second instance, de León's romantic portrayal of the region echo post-revolutionary associations with the Sierra that linked the people and landscape to notions of revolutionary subjectivity and Cuban ethnic identity.[22] As Ana Serra argues, the Sierra Maestra provided a mythical space for the revolutionary imaginary where the inhabitants of the region served "as a living remnant of the purity and spontaneity that the Revolution trie[d] to embody."[23] One of the things that de León relayed to me was his fascination with the rural fringe of eastern Cuba,

not only for its historical links to the Cuban revolution (as the "birthplace" of the revolutionary struggle), but also for a perceived exoticism in comparison with Havana. He spoke to me of feeling like a stranger in the region, despite being Cuban, but noted how much easier it was to forge connections with people there than in Havana because they were more honest and authentic. For de León, the Sierra Maestra in particular evoked associations of a simpler mode of life that was attractive to him as an escape from the hustle of Havana, as well as the insularity of EICTV. These romantic associations of rural life are evident in his final film. In an early sequence, the young girl comes to sit in a bedroom while her grandmother combs her hair, opening the window to reveal a precarious wooden structure nestled within the jungle foliage. In the following sequence, the girl sits alone on the porch braiding her hair while the sounds of tropical birds chirp loudly in the background. Finally, another sequence, shot at a distance, shows her grandmother ambling slowly along a muddy path in the woods. These sequences present rural Cuban life as simple, primitive, and idyllic: a place of quiet activities and modest pleasures underscored by a living connection to nature. The film also stresses the exotic otherness of rural life, particularly in the concluding sequence showing the nighttime dance. The tight shots of dancers framed in high contrast black and white lighting (emphasizing long shadows and the darkness enveloping them) is set to a very steady and deliberate beat. The discontinuity between the non-diegetic rhythm and the slow-motion footage of the dancers conjures up romantic tribal associations of life in the deep Cuban jungle, associations that were relayed to me by the filmmaker himself. The young filmmaker's experience of the east thus exists on a continuum with a tendency in postrevolutionary Cuba where the rural heartland of the country was consistently sought as a refuge from modernity (often linked negatively with colonialism) and as a site of authentic *Cubanidad*: Cuban national and ethnic identity. For de León, one of the main attracting features of EICTV and the immersion program was its facilitating of a deep encounter with a region and people both historically and personally rich in meaning.

From Three Worlds to Every World: EICTV after the Special Period

While the EICTV maintains a commitment to many of the ideals of its original mandate, the school has shifted from its explicitly politicized affiliation and identification with Third World solidarity to a more general global brand and mandate. This more universal or international emphasis reflects broader changes in Cuba as a result of the collapse of the Soviet Union and the consequences of the post-Soviet era, or Special Period. This period officially began in 1990 when Fidel Castro declared that Cuba was entering a "Special Period in a Time of Peace," a period associated with extreme hardship and a dramatic reversal in quality of life for most Cubans.[24] This is most apparent in the discursive shift in the film school's name, from The School of Three Worlds to The School for Every World (see figure 9.2).

Figure 9.2 Photograph by Nicholas Balaisis, EICTV brochure, 2011.

On the school's website and brochure, the school's official name change is described as being a result of EICTV's more international student and faculty population over its twenty-five year history:

> Created in 1986 by the Foundation for New Latin American Cinema, it is distinguished by the vision of its fathers…who conceived a center to nurture creative talent among students from Latin America, Africa and Asia. Since then, thousands of professors and students from over 50 countries have turned it into a space of cultural diversity and multinational scope, better defined as The School of Every World.[25]

The international constitution of the school is certainly no exaggeration. When I visited the school in October 2011, there were instructors from 10 countries other than Cuba who taught at the school. Instructors that month came from Argentina, France, Spain, Belgium, Brazil, United States, Mexico, England, Panama, and Canada.[26] While there is a core faculty that is mostly Cuban who teach at the school all year round, the school benefits from a rotating cast of instructors with different specialties who come usually for two-week periods. The school provides Spanish interpreters for most of the visiting instructors (Spanish being the predominant language spoken by students at the school), allowing foreign instructors to teach in their native language. An assessment committee made up of film professionals and academics from around the world is also charged with evaluating student films at the end of every school year. In 2011, for example, the assessment committee comprised evaluators from Brazil,

France, Spain, Cuba, Poland, Canada, Germany, and Puerto Rico.[27] This teaching structure is sustained by the fact that the instructors teach mostly without pay, receiving only a small stipend for their time in San Antonio de los Baños. While the school covers travel expenses and room and board, it does not pay the instructors a salary equivalent to the international rates that they receive at other universities, training schools, or in the private sector. As Yglesias noted, the international instructors who come to teach at the school do so not for the salary, but for the "agreeable climate of the school."[28] This climate can be understood both in terms of the temperate tropical weather in Cuba and in terms of the isolated nature of the school itself, which lends itself to deep immersion in study that can be rewarding as much for the students as for the instructors. One of the advantages of the school's rural location outside Havana is the fact that there are fewer distractions and diversions, allowing for a more intensive instructional context.

This international emphasis is also evident in the student population and in the school's curriculum. During my visit to the school, I met students from a number of countries beyond the original scope of the Three Worlds, although the vast majority represented Latin America and Europe. Students I met came from the Dominican Republic, Ecuador, Venezuela, Haiti, Uruguay, Austria, France, and Canada. While their reasons for studying at the school were varied, most students spoke of the cost of the school relative to the caliber of instruction they received from international faculty. For many students from South or Central America, the school was accessible to them as a result of scholarships and political arrangements.[29] Many students mentioned the access to important international contacts, the close-knit alumni community, and the school's cosmopolitanism as other principal reasons for attending EICTV. Two students from the Dominican Republic expressed a desire to make films in their native country, but wanted the cosmopolitan experience available to them at EICTV, where they would have access not only to international instructors, but also to the vibrant cinema community nearby in Havana. In addition to providing them with contacts to work in many places in the world, the school also gave them an opportunity to work with global colleagues, which was unavailable to them in their home country. For them, the school truly embodied its moniker, the school of every world, and they noted that they had a chance to meet and work with filmmakers from disparate countries such as Greece, Australia, and Kazakhstan. Other students spoke of the school's strong reputation as a reason for attending, as well as the unique opportunity to live and make films in Cuba.

An important factor for many of the European students I spoke with was the fact that the school offered a faculty and curriculum comparable to those in Europe, a feature that would enable them to access the international job market without any obstacles derived from the school's perceived vernacular tendencies. In examining the curricular documents for the 2011 school year, I was surprised by the parity between EICTV and film-school curricula that I was familiar with from North America. Students at EICTV were exposed to many of the canonical texts and films common in North American film studies departments, such as American film form basics (including David Bordwell and Kristin Thompson)

and European film theorists (Eisenstein, Bazin, and Metz).[30] In examining the three-year humanities curriculum, there was little to distinguish it from North American film studies programs or to mark the site of its delivery as a distinctly Cuban or Latin American film school. What was particularly interesting was the absence of any significant instruction in national or Third Cinema traditions from Latin America and beyond. Jorge Yglesias confirmed this by noting that there is no particular emphasis on Latin American or Cuban film or film theory because EICTV is an "international film school" and thus is not oriented by paradigms of national or Third Cinema. One of the advantages of this curriculum for international students is that it enables its graduates to join the global workplace of film workers. This is particularly notable in the case of the Cuban graduates, who, with very few exceptions, leave the country afterward to work across Europe and the United States. In an interview with the humanities administrator, himself a graduate of EICTV, mention was made of the disappointment he felt about the fact that all of the Cuban graduates in his graduating class had left the country to pursue a career outside Cuba.[31] Like many other Cuban artists whom I have spoken with in recent years, he expressed deep ambivalence about his colleagues' departure, indicating that while he understood the appeal of their exile from the point of view of financial gain, this was nonetheless a great loss for the Cuban film and television community.[32] An exchange student from Austria, who had come to EICTV with the express desire to immerse himself in Cuban film and media culture, relayed another criticism of the school's international curriculum, complaining that the school was quite isolated from Cuban film, society, and culture. As a result of the school's geographic and cultural isolation from everyday Cuban reality, he felt that he had not had a chance to get to know the country and its film tradition as hoped.[33] Thus, while the school's international makeup, curriculum, and instruction clearly have advantages from the point of view of students' future career opportunities, they do have a cost, at least for some. That is, they make difficult a thoroughly immersive experience of Cuban film culture.

The school's name change also reflects broader political changes that occurred in Cuba as a result of the collapse of the Soviet Union and the socialist block. While administrators I spoke with were not able to confirm the exact date of the name change, the change is clearly one of many consequences of the Soviet collapse in the early 1990s. In particular, the name change resonates with broader shifts that have taken place in Cuban political and economic culture in recent years under the banner of market socialism. This term is linked to the transition in the country from the leadership of Fidel Castro in 2006 to his brother, Raoul, who is seen as the principal steward of these new economic reforms. Some of the major reforms associated with Raoul since the collapse of the Soviet Union include the shift toward a tourist economy with capital derived from partnerships with international firms, a relaxing of the laws against private enterprise, and the private sale of homes and vehicles. The August Announcements in 2010, during which Raoul Castro addressed the Cuban National Assembly, reinforced this transition in Cuban economic life from state socialism to market socialism. As Michael O'Sullivan argues, these announcements clarified the Cuban

government's position on two significant areas of Cuban society: what policies the government would adopt to redress the country's sagging economy, and what measures the government would take to assure Cubans that the core values of the revolution would be safeguarded (i.e. health, education, and basic food provisions).[34] These announcements, assuming they are fully implemented, will have enormous consequences for Cubans, as they involve massive layoffs of state workers, and greatly increase the role of the non-state sector, including self-employment and entrepreneurial opportunities.[35] While Cuba has not yet embraced the Chinese model of state capitalism, Raoul's leadership has moved the country toward a more relaxed and less politicized relationship with foreign capital and major signifiers of capitalism such as private ownership and entrepreneurship.[36]

The school's name change appears to reflect these dramatic changes in Cuban political and economic policy, with the Cuban state abandoning strictly socialist policies in favor of an economic model that embraces strategic aspects of the free market and global economy. While the name change ostensibly signifies more openness and internationalism (as the school embraces increasing numbers of students and faculty from the developed world), it also provides a more generic and less overtly political designation that is more easily absorbed by international students intent on pursuing a career in a global industry, and not necessarily committed to political cinema and Third World solidarity. An administrator with the school, when asked about the name change, mentioned that it was "logical to change [as a result of] changing times [and the fact that] socialism fell."[37] This less politicized tone was also expressed in Jorge Yglesias's description of the paradigm of instruction at the school, which is no longer motivated by national or even continental sympathies: "Students should not be limited [in their training at EICTV] by a "localist," continental or Third World point of view; these cannot be the only perspectives learned. Rather, students should have an encounter with the traditions of countries with power and take away a broader vision of the world as a result."[38] This is a significant shift from the postrevolutionary film and discursive traditions in Cuba that often stridently opposed film and ideology from the so-called First World, and fostered instead an appreciation and cultivation of film traditions from Eastern Europe and the new Latin America Left.[39] Yglesias's comments speak to a general softening of the socialist and revolutionary impulses within Cuba since the collapse of the Soviet Union. The former geopolitical antagonisms that governed the Cold War reality of postrevolutionary Cuba, pitting capitalist nations against socialist nations, no longer persist with the same severity. At this point, the school does not aim to create filmmakers armed with the radical ideas of Third World nationalism and liberation, set to battle the political and economic tyranny of the capitalist first world. Instead, current filmmaking students at EICTV are instructed in a context that, despite much of the graffiti that envelops their instruction, cannot be said to harbor an ardent enmity toward capitalism and capitalist nations. Rather, as Yglesias intones, students are taught to appreciate film traditions and perspectives that encourage what he describes as a global or universal vision of the world.

Observing Cuba with New Eyes

This shift away from the older paradigms of Third Cinema and nationalism is seen as a strength according to the humanities director Yglesias, particularly in the possibilities it offers for new representations of Cuba. Yglesias noted that because students were not restricted by any particular aesthetic or political paradigm, they were free to explore the country with fresh eyes. The incorporation of students from so-called First World countries helps produce a broader (and less dogmatic) perspective on life in Cuba. Yglesias argues that Cuba benefits from having international filmmakers record their impressions of the country in their practice without the political restraints or ideological imperatives experienced in other film agencies within Cuba (i.e. the state film institution, ICAIC). Indeed, the ideological restrictions facing media-makers in Cuba's film and television industry was one of the other reasons given for the large exodus of Cuban students after finishing at EICTV. These new visions of Cuban life by both domestic and foreign filmmakers provide diverse views of Cuba that contrast starkly with more conventional representations of Cuba as evidenced on state television or on public billboards.

These new "vistas" onto Cuba were evident in a film program that Yglesias curated for an experimental Latin American film festival in Toronto in 2010. The title of the program, "Everyworld the World," is emblematic of the school's discursive shift beyond the antagonistic Third World paradigm. Instead, the title suggests some of the more utopian aspects of globalization: the eradication of borders and the free movement of ideas and people without nationalist prejudices. One of the films that was screened, *Pasajeros* (Passengers, 2009) by Portuguese filmmaker and EICTV student Claudia Alves, demonstrates some of the aesthetic vision proposed by Yglesias, one where ideological frames for interpreting the world are replaced by a genuine attempt to see the world (and in this case, Cuba) as it is. The film presents a series of long takes of everyday life in Cuba that is framed at the beginning and end of the film by two static shots of a passenger train during predeparture (being boarded) and after its arrival as people disembark. The activities recorded in the film offer disparate snapshots of daily life in Cuba: a cook chops papaya; a bodybuilder poses in front of a mirror; a student practices reading aloud in a classroom; a man cuts weeds in a field; a woman prays in a church; a young man takes swings in a batting cage. The short vignettes are nondramatic and repetitive: they show people performing mundane, everyday tasks, albeit in different and often unique contexts such as a drag queen trying on her leotards in front of a mirror. The shots are also relatively lengthy, at approximately a minute each, giving the viewer a tactile sense of the activity at hand.

These short but intensive studies of different Cubans attending to the tasks of everyday life strongly foreground the experience of time. In particular, the long takes and mundane activities are strongly suggestive of a phenomenological reality in Cuba—that of waiting and passing time. This is a persistent and difficult fact of life for many Cubans as transportation is often slow and unreliable and problems of supply and availability of resources frequently delay many kinds of

industrial and other economic activity. The result is a more acute awareness of time in its slow unfolding, a fact conveyed by the filmmaker's haptic presentation of time through long takes. In addition to communicating a significant temporal reality of Cuba in the early twenty-first century, the observational attention that the film gives to minor details of Cuban life expresses an honest attempt to look at Cuba beyond the often overdetermined readings of the island presented by the Cuban state media output. By focusing attention on local people decontextual-ized from the broader political and ideological context of the nation, the film captures local particularity and resists an ideological interpretation of Cuba as either a socialist paradise or a socialist wasteland (the Manichaean terms often taken in approaches to Cuba). By doing so, the film focuses attention on both the distinctive characteristics of everyday life in Cuba as well as its universal elements. After all, routine, boredom, work, and temporal delay are not unique to Cuba. The film thus expresses some of the ideals envisioned by Yglesias when he discussed the importance of foreign visions and interpretations of Cuba. The film neither resuscitates old clichés about the country, nor does it focus on famil-iar icons and symbols of the Cuban revolution. Rather, in drawing attention to the minutiae of everyday life in Cuba, the film attempts to convey local reality without the overdetermination of ideology.

Conclusion: Utopia beyond Manichaeism

EICTV, like many other postrevolutionary initiatives, expresses an ambivalent relationship to the Cuban revolutionary ethos that was central in its founding as an institution. Residual revolutionary and socialist impulses that motivated previous generations of Cuban filmmakers such as Tomás Gutierrez Aléa or Julio García Espinosa are evident in many aspects of the training and in the orienta-tion of quite a number of the young filmmakers in the school. For example, this spirit was evident most explicitly in the words of the young indigenous film-maker from Venezuela whose vision of EICTV paralleled her own interests as a social activist. As she mentioned to me, the training she received at the Cuban school will help refine her audiovisual skills and permit her to pursue her project focusing on examining violence in indigenous communities in Venezuela and beyond. However, while this revolutionary orientation persists in residual forms, it has evolved from the dogmatic and antagonistic position that is emblematic of the radical energies of Cuban revolutionary art and film of the 1960s. These ener-gies are evident in the slogans that frame the educational experience at EICTV (on the walls and plaques around the school) but are not necessarily reflected in the film projects and career ambitions of the filmmakers themselves. What seems to have waned in particular is the commitment to nationalism and iden-tifications based on national alliances and antagonisms that were characteristic of the Cold War period in Cuba and other parts of Latin America. In my discus-sions with students at EICTV, there remained palpable commitments to social justice and ethical filmmaking. Yet, these commitments were not described with the same Manichaean contrasts evidenced in Cuban revolutionary discourse and

the words of the school's founders. Rather, in many of the films that have been produced at the school in recent years, these political or ethical commitments are articulated through deep, phenomenological concern for the film subjects at hand. While there are no explicit political positions evident in the films I have discussed here, there is surely a demonstrable care and attention to the place and people in the pro-filmic environment, an ethics of the local and particular instead of the national. It is perhaps in this attention to the phenomenological particularities of the local that the utopian ideas expressed by the school's founders can still be found to exist in EICTV today. While the school's new name has indeed a generic quality that makes it more easily digestible for a globally oriented filmmaking student, it can also be read as a utopian claim for a kind of community that is both post-national and post-ideological. By abandoning the more aggressive and potentially divisive name, The School of Three Worlds, the school has evolved beyond the binary thinking endemic to the Cold War period: north/south, capitalist/socialist, good/evil. Alliances in the current geopolitical order must not be sought in the manner of the Cold War, but, rather, must be forged through new trans-local connections and exchanges. This seems to be at the heart of the ideas proposed by Jorge Yglesias in his call for a kind of filmmaking no longer ruled by the old models of nationalism and continentalism but rather by discrete encounters with local difference through intensive and immersive filmmaking experiences.

Acknowledgments

The research for this chapter was made possible in part by a research grant from CUPE 3908 at Trent University in Peterborough, Canada.

Notes

1. *A Changing Cuba in a Changing World*, New York, March 13–15, 2008, City University of New York.
2. For a broad discussion of the energy and legacy of the "global sixties" see Karen Dubinsky et al., *New World Coming: The Sixties and the Shaping of Global Consciousness* (Toronto: Between the Lines, 2009).
3. Here I am thinking specifically of the Cuban state's collaboration with foreign firms in the increasingly lucrative tourist industry. For further discussion, see Marguerite Rose Jiménez, "The Political Economy of Leisure," in *Reinventing the Revolution: A Contemporary Cuba Reader*, ed. Philip Brenner et al. (Plymouth UK: Rowman & Littlefield, 2008).
4. Julianne Burton, "Democratizing Documentary: Modes of Address in the New Latin American Cinema, 1958–1972," in *The Social Documentary in Latin America*, ed. Julianne Burton (Pittsburgh: University of Pittsburgh Press, 1990).
5. Ann-Marie Stock, *On Location in Cuba: Street Filmmaking During Times of Transition* (Durham NC: University of North Carolina Press, 2009), 39. See also Zuzana Pick, *The New Latin American Cinema: A Continental Project* (Austin: University of Texas, 1993).

6. Stock, *On Location*, 40.
7. See Tomás Gutiérrez Alea, "The Viewer's Dialectic," in *New Latin American Cinema* vol. 1, ed. Michael T. Martin (Detroit: Wayne State University Press, 1997); Julio García Espinosa, "For an Imperfect Cinema," in *Film and Theory*, ed. Robert Stam and Toby Miller (Malden MA: Blackwell, 2000); and Fernando Solanas and Octavio Getino, "Towards a Third Cinema," in *Movies and Methods*, vol. 1, ed. Bill Nichols (Berkeley: University of California Press, 1976).
8. Translation by author.
9. As Anne Marie Stock notes, this quote greeted visitors to EICTV's website in 2009 (*On Location*, 40). In my examination of the website in 2011 and 2012, however, I was not able to find any trace of Espinosa's famous words, a fact that supports my argument concerning the changing politics of the school.
10. Ariana Hernandez-Reguant, "Cuba's Alternative Geographies," *Journal of Latin American Anthropology* 10, no. 2 (2005): 283–284.
11. As Jorge Yglesias noted, approximately 80 percent of the students at the school are from Latin America.
12. Of the approximately 42 students who enter the school every year for the three-year program, roughly four to eight of those students are from Cuba.
13. Jorge Yglesias, Director of the Humanities Program and History of Cinema Professor, EICTV, interview by author, San Antonio de los Baños, Cuba, October 27, 2011.
14. Yglesias mentioned that the approximate tuition for the school was 5000 Euros, considerably lower than the approximately 40,000 USD per year fee to attend the New York Film Academy's documentary filmmaking program.
15. Stock, *On Location*, 77.
16. For a more detailed discussion of mobile cinema exhibition in Cuba see Nicholas Balaisis, "Cuba, Cinema, and the Post-Revolutionary Public Sphere," *Canadian Journal of Film Studies* 19, no. 2 (Fall 2010).
17. Yglesias, interview, October 27, 2011.
18. For a broader discussion of this see Ana Serra, "The Literacy Campaign in the Cuban Revolution and the Transformation of Identity in the Liminal Space of the Sierra," *Journal of Latin American Cultural Studies* 10, no. 1 (2001).
19. Yglesias, Interview, October 27, 2011.
20. Jorge de León, interview by author, San Antonio de los Baños, Cuba, October 27, 2011.
21. "Me fui con la sensación del analphabetizor."
22. See Hernandez-Reguant, "Cuba's Alternative Geographies."
23. Serra, "The Literacy Campaign," 137.
24. Philip Brenner et al., preface to *Reinventing the Revolution: A Contemporary Cuba Reader*, xi.
25. Escuela Internacional de Cine y TV (EICTV), *2011 Official Brochure* (paper document) (San Antonio de los Baños: EICTV, 2011).
26. Boris González, Coordinator of the Humanities Program, EICTV. Interview by author, San Antonio de los Baños, Cuba, October 24, 2011.
27. The 2011 assessment committee consisted of the following people: Orlando Senna (Brazil), Silvie Pierre (France), Jacques Comets (France), Antonio Delgado (Spain), Oliver Laxe (France/Spain), Marielle Nitoslawska (Poland/Canada), Rolf Coulanges (Germany), Paulo Antonio Paranagua (Brazil), Miguel Coyula (Cuba), and Maita Rivera Carbonell (Puerto Rico). Escuela Internacional de Cine y TV (EICTV), *2011 Assessment* (paper document) (San Antonio de los Baños: EICTV, 2011).
28. Jorge Yglesias, interview, October 27, 2011.

29. A number of students I spoke to from Latin America had received grants from their respective countries to attend EICTV, including an indigenous filmmaker from Venezuela and two students from the Dominican Republic.

30. Escuela Internacional de Cine y TV (EICTV), *2011–12 Plan de Estudios, Humanidades* (paper document) (San Antonio de los Baños: EICTV, 2011).

31. González, interview, San Antonio de los Baños, Cuba, October 24, 2011.

32. Havana visual artists René Francisco and Sandra Ceballos expressed similar sentiments. In previous private discussions with Francisco, he mentioned the fact that he was alone among his art school colleagues in remaining in the country, while Ceballos herself has made art installations commenting specifically on the gaping hole that artist emigration has created for the artistic community within Cuba.

33. One of the things I noted at the school that distinguished it from everyday Cuban life was the quality of the cafeteria food, which vastly surpassed other cafeteria food that I had eaten in Cuba.

34. Michael O'Sullivan, "Educated Cuban Youth and the 2010 Economic Reforms: Reinventing the Imagined Revolution," *International Journal of Cuban Studies* 3, no. 4 (2011).

35. For further discussion of these economic reforms in Cuba see Collin Laverty, "Cuba's New Resolve: Economic Reform and its Implications for U.S. policy," *Report, Centre for Democracy in the Americas*, http://www.democracyinamericas.org/cuba/cuba-publications/cubas-new-resolve/.

36. See Alejandro Moreno and Daniel Calingaert, "Change Comes to Cuba: Citizens' Views on Reforms after the Sixth Party Congress," *Freedom House*, http://www.freedomhouse.org/report/special-reports/change-comes-cuba.

37. González, October 24, 2011.

38. Yglesias, October 27, 2011.

39. See Enrique Colina and Daniel Díaz Torres, "Ideology of Melodrama in the Old Latin American Cinema," in *Latin American Filmmakers and the Third Cinema*, ed. Zuzana Pick (Ottawa: Carleton University Film Program, 1978).

Building Film Culture in the Anglophone Caribbean: Film Education at the University of the West Indies

Christopher Meir

Introduction

Despite being home to world-renowned intellectual and artistic traditions, the nations of the Anglophone Caribbean remain woefully behind their peers within the region and in the wider world when it comes to cinema, whether one wants to measure the achievements in this area in industrial or in artistic terms. Despite producing such luminaries as C. L. R. James, Marcus Garvey, and Derek Walcott as well as having the musical traditions of reggae, dancehall, and calypso, among others, the region can claim little besides *The Harder They Come* (dir. Perry Henzell, 1972) that has garnered the international acclaim repeatedly achieved on islands such as Cuba or the other Spanish-speaking islands. Indeed, even the francophone and Dutch-speaking islands, which have spawned such famous films as *Sugar Cane Alley* (dir. Euzhan Palcy, 1983) or *Ava and Gabriel* (dir. Felix de Rooy, 1990), which were made in Martinique and Curacao respectively, dwarf the achievements of the anglophone islands. From an industrial point of view, cinema on the English-speaking islands is also very underdeveloped with few filmmakers being able regularly to produce work from within the region, and few opportunities existing for filmmakers even to obtain stable employment in the audiovisual sector, let alone make their own films. The reasons for this lack of industrial infrastructure are multiple and detailing all of them is beyond the scope of this chapter, except for two problems that have long dogged the region: a lack of technical skills for making films and a general lack of knowledge about the medium itself. Such problems are perhaps inevitable when one considers the

lack of rigorous, thoroughgoing training opportunities for filmmakers in the region. Aside from the odd peripatetic event such as touring workshops or scattered university classes, there have until recently been no substantial, sustained, and long-lasting programs dedicated to educating filmmakers in the region.

This chapter will be concerned with the ways in which one institution—the University of the West Indies (UWI)—has tried to fill the void of film education in the region. As is the case with any university, the programs of education it offers consist of multiyear regimens of coursework and in some cases thesis projects, all of which are governed by the logic of curricula that ideally mold and guide students' artistic and intellectual progression from an incoming student to a graduate. The exact formation of that graduate—which invariably involves striking a balance between emphasizing training in technical skills, industrial savvy, and intellectual awareness of the medium—is something that every university program in the world must debate at some point or another. UWI has been no exception and this chapter will be a close examination of the curricula of the film programs at the UWI, detailing how they attempt to address this balance as well as how they fashion their curricula to meet the specific needs of the region. Before detailing the design of these programs, though, we must first look more closely at the institution itself and film education's place within it.

The UWI and Film Education

The UWI consists of three physical campuses: UWI Mona in Jamaica—the oldest and flagship campus—UWI Cave Hill in Barbados, and UWI St. Augustine in Trinidad and Tobago. In addition to these traditional campuses, there is also a UWI Open Campus that offers continuing education courses throughout the region and delivers the bulk of its degree programs via online technologies. Ostensibly, the campuses are simply different locations of the same university, with each location sharing the same regional mandate and beholden to the larger Caribbean community. In practice, however, they are largely autonomous, self-contained, self-governed universities. Due to the funding of the individual campuses, which largely comes from the governments of the nations in which the different campuses are located, each of the three physical campuses are essentially national universities, with the vast majority of their student populations being citizens of the nations that host the respective campuses. Furthermore, over the course of the last 30 years, each campus has come to duplicate the degree offerings of its counterparts, leaving seemingly little need or incentive for students to travel between islands to study.

These developments have undermined the UWI's original mission to foster a pan-Caribbean intellectual culture that builds bridges between the geographically isolated member nations. Despite this, many of the faculty and administrators in all branches of the UWI remain committed to the ideals of pan-Caribbeanism at the level of education and research (and indeed many of them were educated at UWI during a time that required moving between islands and have thus benefited from the greater cultural understanding that this fostered). This, at least in

terms of film education, has trickled down into curriculum design in significant ways, as we shall see shortly.

Formal education in media and communications began at the UWI in the mid-1970s at the Mona campus where a program in Mass Communications would eventually spawn the Caribbean Institute of Media and Communication (CARIMAC). This institute now offers degrees in media production that emphasize technical skills in television and radio broadcasting within a journalistic framework. CARIMAC also offers courses in mass communication theory, but these (like much of communication studies generally) are concerned with the sociological sides of media rather than the aesthetic and ideological dimensions of specific media texts, as tends to be the focus of Film and Television Studies. Though courses in Film Studies are currently being offered within sections of the campus's Department of Liberal Arts, these courses are not intended to assist in the education of media practitioners, but are instead intended to complement degrees in Literatures in English. UWI Cave Hill began offering a degree in Film in 2007 (though courses in Film Studies were offered slightly earlier) with the launch of a BFA in Creative Arts, which includes courses in film as well as theater and dance, any of which can be studied interchangeably to complete the degree, providing the requisite credits are completed. This program offers a total of 14 film courses to choose from, the majority of which (ten) are production-oriented.

The program at St. Augustine was founded in 2006 and is the only one of the three at the UWI that is concerned exclusively with film per se (from both a theory and a practice point of view) and not with journalism or creative arts generally. As such, it has the most relevance for us here and most of the discussion of curricula that will be found below will focus on this particular program. This program offers BA degrees in Film Production and Film Studies as well as a minor in Film Studies. Course offerings include over 20 film courses, of which approximately half are production-oriented with the rest being film studies courses.

Whatever their unique characteristics may be, all three programs bear important similarities. Discussing these similarities means turning to the regional mandate that unites them, as it is the desire to cater to the specific needs of the anglophone Caribbean that ultimately underpins curricula at all three institutions. To understand these curricula thus means we must first turn to the region itself and the problems that its filmmakers face.

The Anglophone Caribbean: Particularities and Problems

Of the four major language groups that make up the nations of the Caribbean (Spanish, French, English, and Dutch), the anglophone nations comprise the second smallest group in terms of population, with only the Dutch being smaller. While the exact population of the anglophone portion of the region varies depending on the definition of the region being utilized,[1] by any global yardstick the region is sparsely populated, consisting of approximately 17 nations with a total population of less than six million. The nations in the region range from

just under three million in Jamaica to just under five thousand in Montserrat. In terms of economics, the region is largely poor and underdeveloped. Only two nations in the region—the Bahamas and Trinidad and Tobago—meet the World Bank's criteria for "high income nations" (per capita gross national incomes above approximately US$13,000 per year) and most instead fall into the categories of "lower middle income" (under about US$4000 per year) or "upper middle income" (between US$4000 and US$13,000 per year).[2]

Given such a combination of small scale and relative poverty, it is not surprising that the audiovisual industries within the region have been slow to develop. Also hampering the development of the sector has been the dependence of many of the region's nations on one or two major industries, typically either tourism, extraction of raw materials, agriculture, or some combination of these. Though very much present in the branding of different nations—particularly Jamaica and Trinidad and Tobago—cultural industries such as music and carnival have not, until very recently, been a priority for economic development for the governments in the region. The latter have been content to live off the revenues of their respective dominant industries, all but ignoring indigenous artistic and intellectual cultures. This indifference has exposed artists and intellectuals to the harsh logics of the marketplace and driven many—including V. S. Naipaul and Wilson Harris to name just two—to ply their trades outside the region.

Film being more capital intensive than music, painting, or literature has meant that most of the region's talented artists—including Britain-based Trinidadian Horace Ové and Canada-based filmmakers like Clement Virgo and Richard Fung, as well as many others—have had to work from industrial bases either partially or wholly outside the region. While others such as Chris Browne in Jamaica or Yao Ramesar in Trinidad have managed to carve out careers within the region, the industrial conditions have meant that they have faced enormous difficulties in realizing their projects and have had to rely on "day jobs" of various sorts to support their filmmaking ambitions. In some nations, particularly Jamaica and Trinidad and Tobago and to a lesser extent Guyana and Dominica, governments have recently taken a more progressive stance on cultural policy and have established different support mechanisms for filmmakers, including, in some cases, subsidy programs. While these developments are very welcome, they are still too new to have changed the underlying fundamentals of film production in the region, which are heavily dependent on "runaway productions" from larger film economies (particularly the United States and Canada) to provide any kind of reliable, relatively well-paying jobs for local practitioners. When indigenous production does take place it is extremely small scale in nature and often depends on small crews whose members must take on multiple roles in order to complete production.[3] Additional problems are to be found in the commercial climate surrounding filmmaking in the region. Private sector finance has been nearly nonexistent for indigenous filmmaking, and television broadcasters have also been unwilling to support local production of any kind, opting instead to fill most of their timeslots with rebroadcasted foreign content. Similarly, distribution opportunities for Caribbean films have been few and far between, leaving many filmmakers to pursue self-distribution or to form their own companies,[4]

two options that both involve significant outlays of time and expense that could perhaps have been better utilized for making more films.

The nations of the region are also geographically isolated from one another—2,500 kilometers, for example, separating the northernmost nation (Bermuda) from the southernmost (Trinidad and Tobago). Moreover, the nations that are not islands—Belize and Guyana—share no physical borders with other English-speaking states. As detrimental as this geographical reality has been to economic cooperation between the nations of the region, the more insidious problem caused by physical isolation has been the ideological isolationism it has helped to inspire. This geographical context has helped to foster the insularity (and some would argue jingoism) that has plagued the region since decolonization, an insularity that doomed the West Indian Federation in the 1950s[5] and is currently undermining CARICOM—perhaps fatally[6]—and that is behind the fragmenting of the UWI system as well. As we shall see, combating this insularity has been a major goal for curriculum development in film at the UWI, as it has been throughout the university. This is a goal that goes hand in hand with fostering some sort of pride in an identity that is both national and regional, a pride that one hopes can help to counterbalance the ideological forces that drive the "brain drain" (the perennial exodus of skilled labor to more developed countries outside the region), forces that essentially boil down to the postcolonial maxim within the region that holds that "foreign is better." This mindset is reflected in the hostility that Caribbean audiences typically show toward local productions and indeed any production that does not come from Hollywood, or, in the case of nations with large diasporic South Asian populations (e.g. Guyana and Trinidad and Tobago), India. As they do in many parts of the world, films from these two centers dominate Caribbean markets and have created a very limited understanding of the medium among Caribbean audiences, one that for a variety of reasons cannot and should not be replicated by indigenous filmmakers.

A final particularity to be discussed here is the racial makeup of the region. Even if the prohibitive costs of replicating Hollywood or Hindi cinema production values were not an issue, much of the popular cinema in the region is also problematic as a media diet on ideological grounds. Despite the growth in recent years of African-American themed popular cinema, Hollywood films largely present being white—or at least light complexioned—as being beautiful and "normal." Much of Hindi cinema exhibits similar tendencies, with fair-skinned actors such as Shahrukh Khan and Aishwarya Rai dominating the industry. Such racial and colorist politics are very pernicious in the context of the Anglophone Caribbean where the vast majority of the population is of African descent and the largest minority is of South Asian descent.[7] Despite there now being two female prime ministers in the region (in Trinidad and Tobago and Jamaica), the societies are still very conservative and patriarchal in many ways. Such problems are often exacerbated by Hollywood and Hindi cinema, at least that which is imported into the region, which consists largely of special effects–laden action films and low-brow comedies. For these reasons, the cultural politics of race, gender, and cultural imperialism—issues that are seen as passé in some academic circles in

other parts of the world—must remain central to Caribbean critical thought and, as we shall see, are particularly important for film education.

Devising Curricula I: Film Production

Before detailing the curricula of the UWI programs at length, we must first understand the structure of bachelor's degrees at UWI generally. An important facet to appreciate regarding the design and ethos of the UWI generally is that it is an institution born out of the colonial institutions of the British Empire. Both the Mona and the St. Augustine campuses were initially branches of the University of London, and from the British model the UWI adapted the degree course structures that make the typical BA program three years in length with little to no scope for coursework from outside a student's chosen field of study. As the postindependence period has progressed, however, the region has grown away from the former colonial power and toward a new neocolonial power in the United States. The design of BA degrees at the UWI during this period came to be influenced by the US ethos of liberal arts education, which favors a breadth of study for all undergraduate students. The US model favors a four-year degree program, but the UWI chose to incorporate this ethos into a three-year degree structure, creating an unfortunate hybrid degree structure that awkwardly tries to capture the breadth of the US degree within a shorter time frame than the one typical of US institutions. The end result of this combination of approaches to undergraduate education is one in which students are given approximately two full years of study (excluding the year that is dedicated to what are called "Foundation Courses" at the UWI—in academic writing and Caribbean cultural studies—and other general education requirements) to master their chosen fields of study.

Having now explored the challenges that face the region, as well as some of the particularities of the UWI system, we can at last turn to the ways in which film programs at the UWI attempt to address the relevant problems, beginning with the most pressing challenge of them all: size. The realities of scale factor into production education in a number of differing, yet interrelated ways. The first of these pertains to technical training. Curricula in all three programs place emphasis on the technical skills of editing, cinematography, sound, direction, and screenwriting in different ways. All three programs discourage specialization at the BA level and instead offer students the opportunity to study all of these aspects of media production, hoping in the process to create students who are well-rounded enough to be employed in any capacity on a film (or television) set, and preparing them for the possibility that they may be required to act in more than one of these capacities throughout their careers and even on the same project. The St. Augustine Film Production BA takes this ethos the furthest and *requires* students to complete courses in *all* of these technical skills. The program also requires courses in both fiction and documentary filmmaking, seeking to create graduates who are at least conversant with the two most commercially established modes of filmmaking. Even the Film Studies BA requires coursework

in the basics of film production (the first-year course Production Tools) and allows students the option to take courses in production as electives that count toward the major. The idea here is that good critics and theorists must understand at least the rudiments of filmmaking, and that degree holders will also be more employable in the industry itself if such opportunities present themselves.

Given the lack of any kind of industrial apparatus in the region (as well as the implicit accountability to governments who generally view the university in economically instrumental terms), all three programs seek to address the lack of industrial infrastructures for marketing and distribution by dedicating some portion of the curriculum to commercially themed courses. CARIMAC's coursework includes units on advertising, marketing, and entrepreneurship in communications contexts. Cave Hill and St. Augustine have also identified these as key areas. To this end, Cave Hill offers a course solely concerned with production management. St. Augustine, for its part, offers courses in topics such as "The Film Producer"—a course that covers production management, fund-raising, and the legal aspects of filmmaking as well as the creative involvement of the producer in script revision and editing—and "Film Marketing and Distribution." It should be noted that even though all three programs see commercial training as important, this does not necessarily involve placing commercial values ahead of cultural ones, or to put it another way, placing the pursuit of large audiences ahead of making films with artistry and/or social relevance as their primary *raisons d'être*. Instead the assumption is that all *well-made* films—particularly in this post-Fordist age of proliferating distribution outlets—have a potential audience and market somewhere and that it is incumbent on filmmakers to find those audiences.

"Well-made" is of course a very open criterion and discussing what is meant by the term in the context of film education opens up larger questions regarding the values of the UWI film programs. Coursework on commercial topics, and indeed much of the instrumental logic that I have thus far articulated as the rationale for production curricula generally, could perhaps lead one to conclude that the UWI's conception of film education is one that emphasizes craft and formulae over artistry and experimentation, industrial development over personal expression.[8] This is not quite the case, as curricular design is only one part of what determines the type of education an institution offers students. Another vital part consists of the approach taken by instructors in the classroom and the values reflected in lecture contents and the assessment of coursework. Despite the best efforts of the bureaucracy of the university system, such aspects of film education are ultimately determined by the individuals who teach the courses and cannot—and indeed should not—be wholly regulated by the institution. Within this framework, we can see within the UWI programs some interesting and, in the long run, beneficial contrasts in approaches to filmmaking. Industrial development is a major objective, but many courses are taught by filmmakers (such as Yao Ramesar and, until recently, the late Elspeth Kydd at St. Augustine and part-time lecturer Frances-Anne Solomon at Cave Hill) whose individual approaches to the medium tend toward art cinema and the avant-garde, two modes of cinema famous for their antipathy, or at least seeming indifference, to commercial considerations.

But other members of staff—such as cinematographer Franklyn St. Juste at Mona, producer Bruce Paddington, and director Chris Laird at St. Augustine—have tended to work in ways that favor narrative-driven films (with classical techniques deployed in order to foreground narrative clarity) over conspicuous experimentation with style. All of these instructors will teach their individual classes differently and this can only enrich a student's education. Over the course of a three-year degree program, students of all artistic inclinations will in turn find their own developing approaches indulged and challenged. Such diversities are not only healthy from artistic and intellectual points of view, but at a public university they are also a necessity. Whatever the instrumental industrial pressures from other parts of the governments supporting the programs, such institutions are ultimately accountable to the public and must therefore offer as wide a variety of avenues of education as possible in the subjects they teach.

Educating filmmakers often also goes beyond the confines of the university curriculum and it is worth looking more closely at how the UWI programs have tried to facilitate student development through cooperation with other film institutions. In response to the problems of scale and insularity in the region, the program at St. Augustine has sought partnerships with institutions abroad (such as other university programs in the United States, Canada, and, in the future, Haiti and Cuba) as well as some within Trinidad and Tobago. The establishment of the program went hand in hand with the establishment of the Trinidad and Tobago Film Company (TTFC), a government office that runs various support programs for the audiovisual industry, including production subsidies and training initiatives. Trinidad and Tobago being a very small country, some of the people involved in establishing the TTFC were also directly involved in setting up the program at St. Augustine—particularly Bruce Paddington who helped devise both the strategic plan for TTFC and the curricula for the Film BA degrees. This close relationship is also seen at the levels of teaching and research. Three of the four permanent members of staff work for TTFC as consultants, while many of the sessional instructors likewise work with TTFC. Moreover, representatives from the film company regularly contribute lectures and presentations to relevant courses (particularly the industrially oriented ones) and offer guidance to students on ways of accessing funding from the company. Such collaboration allows the institutional infrastructure of the university to support and amplify the peripatetic efforts of TTFC to reach out to local filmmakers. What is more, it has allowed UWI students to gain access to relevant training opportunities along with, in some cases, internship and employment opportunities.

This kind of pooling of resources is vital in a small and cash-strapped environment like the Caribbean and a similar logic underpins the St. Augustine program's collaboration with the Trinidad and Tobago Film Festival (TTFF). Like the Film Company, TTFF was founded at approximately the same time as the Film Program at the St. Augustine campus and its goals and ambitions make for a natural partnership with the university. As Marijck de Valck's chapter in *The Education of the Filmmaker in Europe, Australia, and Asia* points out, film festivals often play a vital role in providing innovative training opportunities for filmmakers,[9] and TTFF is yet another example of this tendency, with workshops on a range of topics

hosted by visiting filmmakers being a regular feature of the festival. By partnering with TTFF, the St. Augustine program has been able to provide space on campus for workshops and screenings as well as monetary support for the festival itself. It has also facilitated student and alumni access to these workshops (often at discounted rates or for no charge at all), and to the "state of the art" training in new technology and working methods that they typically provide.

This partnership with the film festival also offers logical synergies with the St. Augustine program's critical and ideological goals. TTFF seeks to promote Caribbean and Latin American cinema as well as the cinemas of the "heritage cultures" of the region's ethnic groups, a programming philosophy that resonates strongly, as we shall see, with the program's curricular agenda for film studies. As part of the partnership between the two bodies, films from the festival's selection are screened on campus and are typically selected to fit the pedagogical needs of the program, as well as those of other departments on campus. This allows lecturers in the documentary, Caribbean and Latin American, African, and Indian cinema courses, among others, to use the screenings to augment their lesson plans. Similarly, visiting filmmakers regularly become guests in relevant courses. So it is that over the last five years, students living in what has long been an isolated island state have had the opportunity to meet and learn from filmmakers from across the region, the Caribbean diaspora, and, indeed, all corners of the

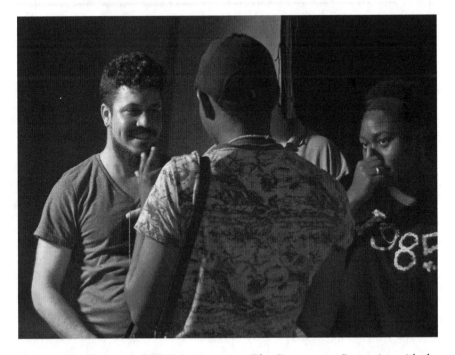

Figure 10.1 Courtesy of UWI, St. Augustine Film Programme, Partnering with the Trinidad and Tobago Film Festival. Jamaican director Storm Saulter (left) meets with UWI, St. Augustine film students.

world. This list includes Jamaican filmmakers Chris Browne and Storm Saulter, screenwriter and novelist Caryl Phillips, Colombian filmmaker Ciro Guerra, Surinamese director Pim de la Parra, Kenyan director Wanuri Kahiu, and famed Indian auteur Adoor Gopalakrishnan, among many others. The collaboration between TTFF and the St. Augustine program is thus one that has made a multi-faceted contribution to the education of Caribbean filmmakers.

Devising Curricula II: Film Studies/Theory and the Development of the Caribbean Filmmaker

As Duncan Petrie has noted, incorporating film studies into film education has, since the 1970s, been an often difficult and controversial enterprise, inasmuch as the discipline has been seen, increasingly so, to be esoteric and out of touch with the needs of filmmakers.[10] UWI has been no exception to this rule and this perception. Given the "creeping anti-intellectualism" that Petrie describes,[11] which is also very much present in the Caribbean, establishing a place for film or media theory within curricula was initially difficult, at least at St. Augustine. Moreover, again in the case of St. Augustine, once that place was established—after considerable internal debate at various levels of the administration of the campus—debates continued over the specific shape that the film studies portion of the curriculum should take, culminating in a significant shift in emphasis. While I discuss this overhaul in some detail below, I first comment on the larger place that film studies currently holds in the curricula of the Cave Hill and St. Augustine programs.

Film studies is integral to both programs and holds great instrumental value for the artistic and intellectual development of the Caribbean filmmaker, two forms of development that are irrevocably linked. To appreciate this, we can return once again to some of the region's problems and particularities, particularly those caused by the dominance of Hollywood and Hindi blockbuster cinema in the typical Caribbean film diet. While the Caribbean may not be alone in this regard—indeed, every film culture in the world faces this problem to some degree or another—the extent of the problem is particularly pronounced in the region. Few spaces exist for the exhibition of anything but the big budget commercial cinema. Mainstream cinemas tend to shun works that do not fit this mold and spaces for any alternative cinemas are limited. In Trinidad and Tobago, for example, the only "art cinema" venues have been art galleries, the UWI campus, or informal and, in the long run, unstable ventures such as Studio Film Club, a weekly repertory screening venue that for a while was hosted by painters Peter Doig and Che Lovelace at their shared studio space on an industrial estate. Examples of such venues in other parts of the region would include the Cave Hill Film Society on the UWI campus in Barbados, or the Sidewalk Café in Georgetown, Guyana, which periodically hosts film events. While these venues constitute an important part of Caribbean film culture, their lack of financial resources to promote and market themselves ultimately mean they draw small—and for the most part, older—crowds. Various national film festivals and

touring events like the European Film Festival and the Travelling Caribbean Film Showcase are increasing in popularity but are still relatively recent innovations.

While there is great hope for these initiatives laying the groundwork for a more cosmopolitan film culture to come in the region, for the time being it is still usually the case that students arrive for their first UWI course in Film without ever having seen a film from Africa, Europe, South America, or even other parts of the Caribbean. Moreover, few will have any experience of documentary beyond those found on American cable channels such as National Geographic or the History Channel, and almost none will have any experience of experimental filmmaking or art cinema. Finally, they will tend to see cinema solely as a vehicle for escapism and light entertainment and fundamentally as something that does not happen in the Caribbean.[12] Such a mindset is inimical to making films that are either commercially or artistically viable in a Caribbean context and both St. Augustine and Cave Hill have turned to film studies to address this problem, though the exact ways in which they do this differ substantially.

Being a program that is rooted in creative arts, Cave Hill actually has two layers of theoretical inquiry that guide the educations of its film students. One of these is film studies and one is general theories of art and of art's place in society and culture. As a "gateway course" into the degree in Creative Arts, all students must take a course entitled "Critical Foundation in the Arts" and film students are then expected also to take "Introduction to Film," a course on textual analysis. At the second-year level, all film students must take a course that combines film history and a survey of different forms of films ("History and Theory of Cinematic Forms"). In this respect, the compulsory courses in Film Studies resemble some of those at St. Augustine, particularly the first-year courses "Introduction to Cinema" and "The History of Narrative Cinema." Besides honing skills of textual analysis, the idea underpinning these courses is to familiarize students with types of cinema that they most likely will not ever have encountered before. The idea is also to give them a sense of what it is that constitutes a "well-made" film when it comes to style and technique as well the unique demands of each kind of cinema studied.

Both programs also use film studies to take on the alienation that Caribbean film audiences have from their own filmmaking traditions. As mentioned previously, the idea of local cinema is often off-putting to Caribbean audiences, to put it mildly, and the perception is by and large that "cinema" is to be equated with Hollywood. To address this problem, both programs offer courses in Caribbean cinema at the second-year level. At Cave Hill this is an elective course, while at St. Augustine the course is compulsory for all majors in Film Production and Film Studies as well as all minors in Film Studies. St. Augustine also provides an elective course at the third-year level offering a more advanced survey of Caribbean and Latin American cinema (a course that the faculty will be making compulsory in the near future) as well as a final-year thesis project in Caribbean cinema that is compulsory for Film Studies majors. All of these courses seek first and foremost to show students that Caribbean cinema does indeed exist and is something that Caribbean filmmakers can look to with pride and for inspiration, even if it must also be recognized that there is room for growth and improvement (figure 10.2).

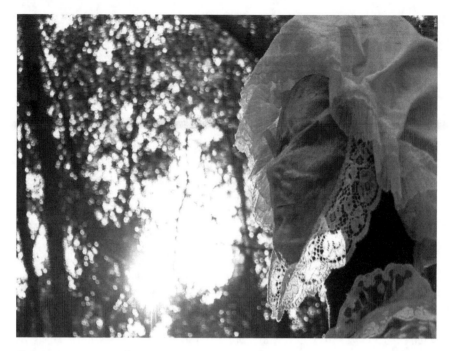

Figure 10.2 Proving that Caribbean cinema exists. A still from Yao Ramesar's *Sistagod*.

Ideally, such courses utilize film historiography to empower potential film-makers, but the courses also seek to get filmmakers to see the ways in which film can reflect upon the realities and shared experiences of the individual nations of the Caribbean as well as the region as a whole. Thus, it is hoped that by seeing a film like *Bim* (dir. Hugh Robertson, 1975), Trinidadian students will be inspired to think critically about race relations in their country as well as the film's sug-gestion that the nation's political class has sought to exploit these tensions for their own gain. It is also hoped that those same students will see in a film like the Martinican classic *Sugar Cane Alley* (dir. Euzhan Palcy, 1983) a common heri-tage with another Caribbean nation, one transcending linguistic difference and geographic distance. In this sense, these courses are another way in which the programs seek to foster the kind of pan-Caribbeanism that is vital to the mission of the UWI and the future of the region as a whole.

These three courses and a third-year course on film history before World War II are the extent of film studies training at Cave Hill and the rest of the curriculum is devoted to technical training and courses in other fields of creative arts.[13] The offerings at St. Augustine, in contrast, are more extensive and more closely syn-chronized with those in film production. Understanding their current arrange-ment and status within the degree plans means discussing an important debate within the department that reflects a substantial change in philosophy for the instrumental value of film studies in the Caribbean. In the initial design of all of the degrees that St. Augustine offers, the Film Studies curriculum foregrounded

aesthetic and narrative experimentation, largely within the European modernist tradition. "Introduction to Cinema" and "Caribbean and Latin American Film I" were compulsory courses, as they are now, but the other compulsory classes were on topics such as narrative theory across a range of media (a course entitled "Film, Literature and Drama"), montage theory focusing particularly on Sergei Eisenstein and his legacy (a course entitled "Early and Silent Cinema and the Rise of the Nation"), and film sound aesthetics (a course entitled "Sound and Visual Dynamics"). Electives in the initial structure of the degrees included courses on film authorship, film history, gender theory, and national cinemas such as those of India and "emergent" national cinemas (the design of which allowed the instructor to choose the cinema or cinemas to be taught).

While these courses have been very valuable to aspiring filmmakers, it became apparent that within a three-year degree course more was needed to diversify students' understanding of the medium in formal, historical, and most importantly, cultural terms. In a region without a culture of watching and understanding films from anywhere besides Hollywood and "Bollywood," more emphasis needed to be placed on film history. The first-year course on the history of narrative cinema was thus made compulsory at the expense of the course on narrative theory, which became an elective. In order better to familiarize students with other modes of cinema besides the fiction film, a course was introduced in documentary history and practice at the second-year level. This course is intended to augment students' understanding of the form while they are also learning to practice that form in their production coursework. This course took the place of the course on montage theory as a compulsory course. Besides synergies with the production curriculum, this shift reflected a desire to make the curriculum more in tune with local needs. Documentary production is a mainstay of regional practice (hence the compulsory production course in this area), and this is reflected in the design of the documentary studies course that includes a module on Caribbean documentary practice, including the works of figures like Sarah Gomez as well as practitioners within the anglophone region.

The new view of Caribbean filmmakers' needs underpinning these changes also led to the decision to make the film sound course an elective. This was done in part to free up time for the wide range of technical courses teaching skills that filmmakers must master (here we are seeing most vividly the adverse impact that the three-year degree has on curricular decisions), but this change was also made to the Film Studies curriculum, which has no such time-consuming technical components. Within the Film Studies BA and Film Studies minor, the compulsory emphasis was shifted from film sound to national cinemas, specifically those of India and Africa, with a new course being introduced on the latter. The decision here was based on the idea that students—particularly those looking to move into careers in film criticism, education, and policy, among other career paths that Film Studies students are best suited for—must have a deeper understanding of the medium from perspectives other than Hollywood and the popular cinema traditions previously discussed (the Indian cinema course in this case focuses on oppositional traditions within Indian cinema as well as the artistically innovative and culturally significant strands of Hindi cinema,

strands that are seldom seen in Caribbean cinemas). Given the racial and cultural makeup of the region, it is also important that Film Studies curricula not place emphasis exclusively on figures like Eisenstein or in the case of the sound course, figures such as Robert Bresson or Walter Murch. Such figures have a lot to offer to Caribbean film students, but given the limitations imposed by the three-year degree system, it is more important that students see ideological and aesthetic alternatives to the largely American and Eurocentric canon of this kind of film theory. Put crudely, the changes reflect the staff's conviction that students' need to know about Julio García Espinosa, Satyajit Ray, and Ousmane Sembene is greater than their need to know about Sergei Eistenstein, Gilles Deleuze, or Michel Chion.[14]

This reasoning also means that a course in East Asian cinemas must be introduced at some point in the near future. It also means that courses in Latin American cinema must be made compulsory for at least Film Studies students, a shift that is made all the more compelling by the geographical proximity between the region and that of South America and the great cultural and commercial potential inherent in cooperation and greater exchange with the nations of that continent.[15] This need not mean an advocacy for a politicized third cinema à la Solanas and Getino or the Cuban filmmakers of the 1960s and 1970s, an approach that Nicholas Balaisis shows, in his contribution to this volume, is ironically no longer in favor in Cuba itself. Instead, it means simply making students aware of what strategies filmmakers in similar situations to those in the Caribbean have adopted and continue to use in connection with the medium. As previously discussed, this is another area in which the St. Augustine program's partnership with the Trinidad and Tobago Film Festival (and its developing partnership with the Travelling Caribbean Film Showcase) helps all involved to realize their missions. Similar events such as the Indian Cine-Club at the St. Augustine campus and the recent Venezuelan Film Festival at Cave Hill show that the respective programs are finding common ground with the diplomatic corps of various nations in their shared desire to foster greater cultural exchange and understanding between nations. Film has long been utilized as a tool for promoting international trade and cooperation by diplomatic missions and this, for the UWI film programs, finds a logical synergy with the traditional goal of liberal arts education to broaden students' cultural horizons.

In attempting to open students' eyes to a larger world and a fuller understanding of the medium, film educators in the Caribbean are performing a crucial task. This is perhaps easy to illustrate at a cultural level—after all, education in the humanities generally places great value on broadening students' cultural horizons—but it is also worth reiterating that such pedagogical outcomes are also instrumental in the development of filmmakers. With a fuller appreciation of the medium and its history comes a greater understanding of and respect for the art and craft of film. With a wider view of filmmaking practices and film cultures from around the world comes a cosmopolitanism that allows for artistic influence and cultural and economic exchange. All of these are vital to the development of film industries in the region, as successful industries must ultimately be built on top of vibrant, cosmopolitan, and engaged film cultures.

Conclusion: Building Critical Mass and Embracing the Digital

Having outlined the development and current state of filmmaker training in the Anglophone Caribbean, I would like to conclude with some thoughts about its future. High on the agenda for the St. Augustine program is the goal of expanding its degree offerings. Both Cave Hill and CARIMAC already offer degrees at the postgraduate level as well as at a diploma level that precedes the BA, these being like their undergraduate programs, based in creative arts and mass communications contexts respectively. With its greater emphasis on filmmaking, the St. Augustine program hopes to help build a critical mass of film practitioners in the region by offering diploma/certificate courses in technical filmmaking skills, MFAs in various aspects of filmmaking, and advanced degrees in Film Studies. MFA degrees will offer the opportunity for Caribbean filmmakers to specialize in aspects of filmmaking such as screenwriting, producing, and/or directing, something that cannot be done in the BA programs as they are currently structured. It is then envisioned that such degree holders will be leading figures in the development of the region's production infrastructures. Degree offerings at the diploma and certificate level would allow for a shorter program of training—primarily encompassing technical skills but also at least a basic course in Film Studies—for practitioners without the time or formal qualifications to matriculate for the BA. By expanding its offerings in this way, the St. Augustine program hopes to help build a critical mass of practitioners with a variety of skills and competencies, a critical mass that can act as a skilled labor pool for an industry and as the bedrock for the kind of film culture that is so desperately needed in the region.

Another area for future development in film education at UWI concerns the need to keep current with developments in digital technology. In terms of production training, all three programs currently offer some sort of training in the use of such technology. CARIMAC offers degree courses specifically in the use of digital media and Cave Hill offers specialized courses in digital filmmaking, while St. Augustine integrates these technologies into all of its production courses. But technology changes very quickly and keeping up will mean that the university will need to provide the resources needed to equip students with the software and hardware needed to meet international standards. Film studies too has a significant role to play in this process as students need much more than 3D or Red cameras to stay abreast of the possibilities that digital technology present for low-budget filmmakers. While some courses currently include works such as *Tarnation* (dir. Jonathan Caouette, 2003) or *Ten* (dir. Abbas Kiarostami, 2002) that have artistically capitalized on low-cost digital technologies, courses dedicated to the critical study of digital cinema must become part of the curricula in all three programs. Films such as *La Casa Muda* (dir. Gustavo Hernández, 2010) in Uruguay and the works of the DV8 Company in South Africa have shown the possibilities that exist for developing world filmmakers to use this technology in artistically interesting and commercially viable ways, and it is vital that Caribbean students are able to learn from their experiments.

Whatever specific direction film education takes at the UWI in the years to come, film and media programs must find ways for film studies and film production to work together productively. To paraphrase the great Brazilian filmmaker Glauber Rocha, to make films that matter students need both ideas in their heads and cameras in their hands. If coursework in film studies and film theory can provide those ideas and production courses can give students the access and know-how to use those cameras, then we can collectively hope to build a truly vibrant film culture in a region that has for too long been without one.

Acknowledgments

The author would like to thank the following faculty members, students and alumni from the UWI film and media programs who assisted in the development of this chapter: Mandisa Pantin, Natasha Callendar, Thomas Jemmerson, Kavita Rajpath, Yao Ramesar, Bruce Paddington, Augustin Hatar, Yvette Rowe, and Francesca Hawkins.

Notes

1. The contentions here revolve around whether or not to count non-island states such as Belize and Guyana, or whether or not to include anglophone island states such as the Bahamas and Bermuda, which are not geographically located in the Caribbean Sea. Further complications arise when the region is discussed through the lens of the supranational body CARICOM, which includes the bulk but not all of the anglophone states as well as Suriname and Haiti, or through member nations in the UWI system, which includes Bermuda and the Bahamas but excludes Guyana. The definition I am using in this chapter counts all 16 UWI member nations as well as Guyana.
2. For statistics on individual nations, see http://data.worldbank.org/indicator/NY.GNP. PCAP.CD. For guidelines for classification, see http://data.worldbank.org/about /country-classifications.
3. A telling example of film production in Trinidad for example was Yao Ramesar's feature film *Sistagod 2* (2010), which featured a crew of two (Ramesar and collaborator Edmund Attong) and a cast of two, lead actor Michael Cherrie and lead actress Crystal Felix.
4. Filmmakers from Perry Henzel (*The Harder They Come*, 1972) to Roger Alexis (*I'm Santana: The Movie*, 2012) have opted for self-distribution, while Frances-Anne Solomon recently helped to create Caribbean Tales Worldwide Distribution.
5. As part of the decolonization process in the Caribbean, the British initially offered the anglophone states Dominion status as a single political entity that encompassed ten "provinces" of Caribbean islands. The West Indian Federation, as it was known, was established in 1958 but fell apart by the early 1960s when Jamaica and then Trinidad and Tobago—the two largest provinces within the Federation—withdrew their support for the joint state and agitated for their own national independence. Britain granted both requests in 1962. The collapse of the Federation is often seen within the region as a triumph of national self-interest over pan-Caribbean unity and one of the most lamentable events in the region's postcolonial history.
6. CARICOM is an intergovernmental organization that seeks to act as a single political entity representing the interests of its member states, which include nearly all the

anglophone states as well as Haiti and Suriname. However, many of its initiatives, including the Caribbean Single Market Economy, have either been undermined or completely thwarted by infighting among member nations. This has meant that the body has achieved very little in the way of tangible, enforceable directives in recent years and a report by the body itself issued this year has predicted the eventual demise of the organization by 2015 due to its inefficacy. See their report on this matter: Richard Stoneman, Justice Duke Pollard and Hugo Inniss Turning, *Around CARICOM: Proposals to Restructure the Secretariat* (Wiltshire: Landell Smith, 2011), http://www .caricom.org/jsp/communications/caricom_online_pubs/Restructuring%20the%20 Secretariat%20-%20Landell%20Mills%20Final%20Report.pdf.

7. Persons of South Asian descent, or "East Indians" as they are known within the region, are actually the largest racial group in Guyana as well as Trinidad and Tobago (where there is nearly as large a population of persons of African descent). There are smaller East Indian populations in St. Vincent and the Grenadines, Belize, and Jamaica. Other large racial groups within the anglophone Caribbean include native peoples (known as "Amerindians" within the region), persons of East Asian descent and persons of European descent.

8. I am indebted to Ben Goldsmith and Tom O'Regan's "Beyond the Modular Film School: Australian Film and Television Schools and their Digital Transitions" for some of this terminology as well as generally drawing attention to the spectrum of types of film education found at film schools. See *The Education of the Filmmaker in Europe, Australia, and Asia*, ed. Mette Hjort (New York: Palgrave Macmillan, 2013).

9. Marijke de Valck, "Sites of Initiation: Film Training Programs at Film Festivals," in *The Education of the Filmmaker in Europe, Australia, and Asia*.

10. Duncan Petrie, "Theory, Practice and the Significance of Film Schools," *Scandia* 76, no. 2 (2010): 40–43.

11. Ibid., 42.

12. It is worth pointing out that at the time of writing, the Caribbean Exams Council (CXC) was developing a syllabus for secondary school education in the "Cinematic Arts," which will be one track of a module dedicated to the Performing Arts. In its most recent draft form, the syllabus seeks to balance theory and practice in ways that mirror the general pedagogical structures of the St. Augustine and Cave Hill BA degrees.

13. It should be noted that a course in African Cinema is offered at Cave Hill through the Literatures in English unit of the Department of Liberal Arts.

14. It is important to reiterate that the old courses have not been removed from our offerings, but have instead been made electives. Moreover, Eisenstein is still taught, albeit in a more limited fashion, in both the "Introduction to Cinema" course as well as "The History of Narrative Cinema."

15. Trinidad and Tobago is only seven miles off the coast of Venezuela at its closest point. Belize and Guyana share borders with Central and South American countries. Despite this, most Caribbean filmgoers have little or no exposure to South American cinema.

Practice-Based Film Education for Children: Teaching and Learning for Creativity, Citizenship, and Participation

Armida de la Garza

The value of practice-based learning, especially in the case of children and young people, has long been acknowledged. It can be traced back to John Dewey (1859–1962),[1] a pioneer in the "learning by doing" and "problem solving" approach that sought to integrate school with society; and to Maria Montessori (1870–1952),[2] who saw independence as the aim of a child's education and realized that to achieve this, the child should take control of at least part of the learning process, with the environment playing a crucial role. And, importantly in Latin America, Paulo Freire (1921–1997) centered his whole model for pedagogy on informed praxis, thereby refusing the split between theory and practice while firmly situating educational activity in the lived experience of participants. The ultimate goal of this pedagogy—initially termed "of the oppressed"[3] and later "of hope"[4]—was to achieve emancipation. Underlying all these approaches is the belief that childhood is a central period of an individual's life, in which the foundations of personality are laid, and that the principles of respect, responsibility, and community are best understood by children through exploration and discovery. Whether we take the view that learning is socially, psychologically, emotionally, or cognitively constructed, practice-based education integrates all these dimensions.[5] Nonetheless, formal education, especially in the realm of film, has often remained subject-centered and teacher-led. It has also tended to have a sharp focus on theory, whether it was aimed at adults or young adults. Only recently has the spread of digital technology, which is affordable and easy to use, made practice-oriented film education for children a real possibility. As a result of such developments, the medium has in various ways been expanded and, indeed, returned to the democratizing potential that Walter Benjamin once thought was inherent in it.

Practice-oriented film education has been hailed for a number of reasons. Among them, as a means of providing tools for self-expression and as a truly motivating factor for learning; as a method that promotes group work and the practice of social and communication skills while also training children in the use of technology; and as a kind of laboratory for experimentation where in-depth learning can take place as children learn not only the codes and conventions of filmmaking, but also how to deconstruct and challenge them when editing, thereby developing their own creative capacities. Production is, after all, "fundamentally about the way creative work acts as a pivot point through which dialectics of 'doing' and 'analysis' merge."[6] But more importantly, there is an argument that with the central role of visual images in our so-called information society, print literacy is no longer enough. Children must now become competent producers, in addition to critical consumers, of audiovisual content if they are to take part in the global public sphere that is arguably emerging as the digital media become pervasive. In sum, practice-oriented film education offers a means of enriching children's lives through aesthetic experiences, and of promoting more integrated communities at the local level, while also raising in them an awareness of what may be called a cosmopolitan experience of childhood.

Whatever commonalities are shared, however, children come from a variety of ethnic, social, and geographical backgrounds, and the benefits and goals of practice-oriented film education can often be elusive. This paper mainly explores how this challenge is being met in *La Matatena A.C.*, a civil association based in Mexico City, founded by Liset Cotera in 1995;[7] reference is also made to two other schools: *Comunicación Comunitaria A.C.*, which roughly translates as Communication for Community, founded by Irma Avila Pietrasanta in 2002, and *Juguemos a Grabar*, meaning *Let's Play We're Making Films*, founded by Sonia Aburto in 2006 in Morelia City, capital of the western state of Michoacán. *La Matatena A.C.*'s remit is the broadest in that it is the institution behind the organization of the International Film Festival for Children that has been taking place in Mexico City every year since 1995, with the organization's workshops covering both film history and appreciation as well as animation.[8] It caters to younger children, 6 to 12 years old, with older children often mentoring younger ones. It has been argued that "peer-mentoring less experienced media makers can…have a profoundly democratic influence on how children see themselves as the social futures."[9] As we will see below, children's experience at *La Matatena A.C.* seems to support this assertion. Learning here is focused on cinema, with aesthetics absolutely central to *La Matatena A.C.*'s teaching concerns and cinephilia indeed key to its cultural milieu.[10] Beyond learning about art, children learn through art. *Comunicación Comunitaria* on the other hand takes a more instrumental approach to the teaching of video production, rather than cinema, with an agenda focused on community-making at the local level. Important aims, in this case, are to empower groups of disadvantaged and vulnerable children between 8 and 13, to preserve cultural identity, and to promote human rights and democratization. The children are slightly older, as they need to be able to read and write and to tell fact from fiction when they join. *Juguemos a Grabar* is conceived within the framework of policies for the development of cultural

industries, as part of a program for urban regeneration around cultural cluster-ing. Clearly concerned with the population of the Michoacán area, *Juguemos a Grabar* dramatizes the tenet that "life is global, living is local,"[11] and focuses on locality—that is, on people's behavior (rather than community, which empha-sizes people's feelings of attachment, as in *Comunicación Comunitaria*).

Below I introduce the background to all three institutions, before providing an overview of the way *Comunicación Comunitaria* and *La Matatena A.C.* run their workshops.

Comunicación Comunitaria

Comunicación Comunitaria was created with the explicit aim of enabling chil-dren to engage critically with the media, to become producers rather than sim-ply consumers of audiovisual material, and this in a project of active citizenship construction that enlisted both family and school. Practice-oriented education is regarded as strategically important in that the assumption is that the more active, critical, and media literate a child is, the freer he or she will become. Culturally relevant material is also deemed essential as racist or classist representations or media representations, in which the ethnic and social backgrounds of the chil-dren are absent, have a negative impact on their self-esteem. Avila believes that while the state in Mexico, and Latin America more generally, has prioritized access to technology as key to the modernization of education, quality content has not been prioritized in the same way.[12] Further, she believes in a producer-led market in which works can eventually find—or perhaps forge—their audiences. Also, since audience development is crucial to the creation of a dynamic, com-petitive, and sustainable film industry, she is aware of the role that film education for children has to play in this regard.

Mostly funded by a variety of local government institutions, *Comunicación Comunitaria* has played a very important role in introducing children to the pres-ervation of cultural heritage, and to issues of identity and memory. A remarkable instance in this regard is its *Manitas Mágicas* ("Magical Little Hands") series of videos, funded by the Fondo Nacional para el Fomento de las Artesanías (FONART), the fund for the support and promotion of local and regional arts and handicrafts, in which children learn documentary making in order to preserve the history, meaning, and production techniques of a number of crafts. Examples include toy-making and the use of forged iron, copper, and clay to craft cutlery and silverware, with the documentaries frequently involving the interviewing of the children's families and other members of the community. In this sense, *Comunicación Comunitaria* follows what might be called a peripatetic approach to teaching, in that they visit the various communities. Also worth mentioning is the introduction the children have received to the life and work of Mexican visual artists. In 2011, two groups of children, all of whom live in the district where one of the museums devoted to painter Frida Kahlo (the Anahuacalli) is located, learned about her work through practice-based film education. The older chil-dren produced a documentary for which they interviewed the museum caretaker

and curator. The younger children produced a two-minute cutout animation that succinctly and pithily manages to convey all key aspects of her life and work while also providing commentary on the meaning and function of visual art.

Built around a drawing by Kahlo entitled "What do I need feet for, if I have wings to fly?" (1953), which she drew shortly after the amputation of her right leg, the video depicts Kahlo in bed, painting a picture of a foot, which then becomes animated, leaps out of the canvas, and leaves the room flying through the window. A voice wondering where it might be going is heard, and then the bed itself becomes animated and Frida in her now-flying bed follows her foot through the window, trying to get it back. Her bed travels above the exhibition of her paintings at the gallery—the children were impressed when they learned she had been taken to the inaugural ceremony in her bed—and then goes into a black "universe" where there are "worlds" (actually circles) of some of the most iconic images in her paintings, such as the world of eyebrows, and the world of monkeys. Throughout her search, whispers can be heard saying "You are free, we are free." She finally finds her foot, floating about, and when she gets hold of it to bring it back to the painting, wings grow out of her back and she is herself able to fly, at which point a voice can be heard declaring "What do I need feet for, if I have wings to fly?" The allegory of Kahlo grappling with all sorts of constraints—including an unfixed identity permanently under construction—and of her painting her way out of pain and toward emancipation is given further detail through the animated foot, which takes the shape of a "miracle." That is, the video features a small metallic devotional object in the shape of a foot, similar to those that the grateful faithful in Mexico place near statues or paintings of saints they believe have granted them a miracle. The video thus achieves an extremely original film/portrait of Kahlo, one in which the emancipatory potential of art is highlighted, both for the artist and for the audience, as the audience here is also constituted as a community of reception, artistically responding to the stimulus provided by the paintings by making their own animated video. Jacques Rancière contends the "emancipated community" is one "of narrators and translators."[13] I would argue the children here have precisely taken that role, "translating" and appropriating the paintings, narrating the Kahlo story in their own visual way through the practice-based education they receive at Comunicación Comunitaria. Beyond being an audience, that is, a community bound by the shared consumption of a cultural background circulated by the media, they are now also bound through the shared production of their own appropriations and reinterpretations of this cultural background. The project, it is clear, enabled the children not only to learn the techniques of animation but also about art, and about their community of belonging.

La Matatena A.C.

Internationalism has been at the heart of La Matatena A.C. from the very beginning. Cotera's idea was born out of a trip to Montreal in 1987, during which she was introduced to the International Centre of Films for Children and Youth (CIFEJ, Centre International de Film pour l'Enfance et la Jeunesse) and, in her

words, fell in love with their project.[14] Also, her aim in the first instance was to widen children's access to cultural diversity in a Latin American environment overwhelmingly dominated by Hollywood, where a film policy for children was all but absent. In this sense, her project was also about laying the foundations for the international festival. Cotera believes that what children all over the world share is their situation of dependence upon the adults around them. She explains: "Unlike the cinema made by adults in which children are addressed for profit, as consumers only—a cinema which I don't deny may also have value as part of the popular culture we all grow up with—I aimed to introduce children to a cinema in which they are protagonists. Camera shots are taken from the perspective of children, and, more importantly, the cinema in question speaks to issues that children face and *can thus be enjoyed by children in other countries* (emphasis mine), for many of the children's concerns, inasmuch as they are dependent on the adults around them, are in fact cross-cultural."[15]

Linked to *La Matatena A.C.*'s festival work is the metaphor of film as travelling or facilitating a kind of journey: not only do the films travel within the countries where they are from, and to other countries, they also open up fictional worlds for viewers. As Marina Stavenhagen, director of the Mexican Film Institute but not directly related to *La Matatena A.C.*, puts it, the aim of the festival is "to allow children's minds and imaginations to feed on images and tales, on stories from abroad, of characters who inhabit other worlds, of animals and stars...images that move them and allow their minds to discover other worlds."[16] In highlighting the chance to explore other worlds that cinema provides as a key reason why cinema is valuable, *La Matatena A.C.* puts internationalism at the heart of the learning experience, while also emphasizing the personal and unique nature of children's engagement with cinema.[17] Also, at the level of infrastructure, running the festival has allowed *La Matatena A.C.* to become a key node in the international network of producers, distributors, and consumers of films for children.

The International Film Festival for Children in Mexico City became the cornerstone on which *La Matatena A.C.*'s practice-oriented film education started. The rationale and phases were as follows: the more films children watch, the more they become conversant with a visual language that they can then draw on and bring into play in their own creations; because of the need to have a qualified jury, consisting entirely of children, workshops focusing on film history and film appreciation were mounted; these were followed by animation and documentary workshops when some of the children took a deeper interest in cinema. Cotera's ultimate aim is to have films made by children featuring prominently in the festival's program. To date, *La Matatena A.C.* has shown 66 feature films from 58 countries and 114 films made by children in their workshops[18] to an audience of 100,000 children.[19] Every year there is a guest workshop leader from one of the institutions participating in the festival. In 2011, when this research took place, this was Joris Van Dael, founder and director of *Kidscam*, a practice-oriented film school for children in Belgium. During his stay in Mexico, Van Dael helped *La Matatena A.C.* run the cutouts animation workshop for street children.

By 2011, 17 editions of the festival had been held, and the workshops were in their twelfth year. *La Matatena A.C.* is clearly beginning to have an impact on

the Mexican film industry.[20] The festival has proven a key way in which new filmmakers working on films for children, especially those working on animation, both get in touch with likeminded colleagues from elsewhere and introduce their work to local audiences. *La Revolución de Juan Escopeta* (*Juan Escopeta's Revolution*; dir. Jorge A. Estrada, 2011) was, for example, presented in a screening attended by the director, followed by a question-and-answer session with the children. In addition, a number of round table discussions take place during the festival itself. For instance, the 2011 edition featured exchanges about what might constitute artistic cinema for children and whether cinema can indeed be regarded as a "total artwork," as well as a comparison between the ways in which the three pioneering film schools for children in Mexico work, as compared with the Belgian *Kidscam*. The discussion was taped and is available for consultation at the Mexican Film Library. Also, with the first cohort of students who took the animation workshop now about to start university, it was good to learn that two of them have chosen media-related careers. The older one was working at the Film Library and was also volunteering every year to help with the organization of the festival, which is put together with a tight budget and largely depends on such voluntary contributions to run. In short, *La Matatena A.C.*'s festival has proven to be a key forum where Mexican cinema for children is nurtured and enjoyed.

The Workshops

Comunicación Comunitaria's and *La Matatena A.C.*'s video production workshops broadly follow the same pattern. *Comunicación Comunitaria*'s workshop is structured around five key topics: violence, gender inequality, consumption, human rights, and cultural identity. As it is not solely devoted to cinema but also to the media more generally, the workshop comprises 15 issue-awareness and critical reflection sessions. Drawing on a constructivist approach, these all start with a question and proceed by way of dialogue, with games, role play, and contests. The aim in using such methods is to make children aware of the crucial role that the media play in constructing, rather than merely reflecting, reality. These sessions are followed by six video production, and three closing sessions, each lasting three hours. At *La Matatena A.C.* there are eight sessions with classes starting at 10 a.m. every day and finishing at 2 p.m., with a break for lunch at 12 p.m. All topics for the videos come from the children themselves, although *La Matatena A.C.* also runs a separate program focused on human rights, in which topics are provided rather than elicited. A healthy lunch is provided on the site.

What follows is a summary of my own experience at the two workshops run by *La Matatena A.C.* in 2011. The first one was aimed at 14 children from a middle- and upper-middle-class background, hereinafter referred to as group A, whose parents each paid 4,000 MXN (equivalent to some US$309.91). These children went to the cinema on a regular basis, and, indeed, a couple of them were from families working in the film or TV industries. Others heard about the workshops at the festival, and in some cases came from far away, supported by their parents

who highly value the development of creativity in their children. They had never met before and were keen to make new friends. They were also thrilled about coming to the workshop or had at least exercised some agency in the course of enrolling in it. The second group, B, comprised ten street children, all girls, in the process of reintegrating into their families. They had rarely, if at all, been to the cinema, and the decision to enroll was made by the institution where they were living at the time, which meant they were already acquainted with each other. The workshop was offered at no cost in their case.[21] The first group worked with a workshop leader and two monitors, both final year pedagogy students working on dissertations on practice-based education for children. The guest workshop leader from Belgium joined them for the second workshop. Each one of these groups posed its own challenges and rewards.

During the first session, to begin with, the children were asked what they expected from the course. "Sharing," "learning," and indeed "experiencing" were some of the most frequently cited expectations. Then they were asked whether they had been to the cinema and, if so, what the film was about. They were introduced to the concept of a story, plot, structure, and characters, and asked to find interesting stories as their homework, by interviewing their friends and families or just creating them themselves. The second half of the session was devoted to the viewing of various short films illustrating a variety of animation techniques. Children were then asked to reflect upon the meaning of the word *animation* (to bring into life), the responsibility it thus brings, and the pride animators feel at "creating a world" (as the workshop leader described it). Some of the short films, all of them selected by the children, were viewed a second time. This time the children were asked to pay attention to scenery construction, especially the materials used.

During the second session the children shared their stories with their classmates, with the workshop leader writing titles down on the blackboard as they went along. Various children from group A had indeed been to the cinema recently and many proposed to remake the stories they had seen, nearly all of them from Disney. This resonates with the argument sometimes made against media production classes that children tend to reproduce the racialized or otherwise stereotyped identities they are familiar with from commercial media, the very representations they were meant to challenge.[22] The counter argument is that "creative practices place youth in conversation with others and with the sedimented social discourses and cultural practices that shape our experiences."[23] Drawing on Mikhail Bakhtin's concept of dialogism, in which our own voices are understood as being formed in and through the voices of others, Elizabeth Soep argues that children "inevitably weave various utterances into their own ... as they prepare their own creative projects."[24] At *La Matatena A.C.* they do this guided by the workshop leader, who explained the value of originality in story-telling. Similarly, Mr. Reyes, the plasticine instructor, played an important role convincing the children that what creativity really means is "to think, improve, and then make anew." Children in group B on the other had not been to the cinema, but had extremely interesting stories to tell, ranging from their own, sometimes heart wrenching experiences that had led them to abandon their families and into street life, to fables or stories about intergenerational communication. These

stories were staged in a shadow play, to make the children aware that such devices lie at the origins of cinema, but also to prompt their reflection on the challenges that telling that particular story in a visual way entails.

At this point, it is worth opening a parenthesis to emphasize the therapeutic, and even healing power that practice-based film education can offer to children from disadvantaged backgrounds. As Rosemary Althouse et al. have observed in their work on story-telling in the education of children, the postmodern climate "values narrative and dialogue,"[25] especially framing and reframing, as strategies that can change the meaning ascribed to events. In other words, children learn that the meaning of events is not fixed and immutable, but depends on how these are understood, and that what might seem like the sad ending of a story might as well become the hopeful beginning of a new story. Visual storytelling, and specifically video making, has proven instrumental in the recovery process of victims of traumatic events. The work of *Vision Machine*, a collective of filmmakers, theorists, and activists based in Canada who use digital media in a therapeutic context, is worth describing in some detail. They employ a method that involves first interviewing a person who has experienced the traumatic event in question, asking him or her to narrate the event, and also to stage it. The interview is then viewed and commented upon, and this is videotaped. It is subsequently shown to participants who tell "the other side" of the story and who also comment on the events, and this second interview and staging is also videotaped. Finally, the footage from both these interviews and staging processes is mixed with footage from news and other sources related to the event, to make up an original, multi-layered piece that presents the event "in an archaeological fashion."

Some of *Vision Machine*'s most important findings so far include the discovery that "genre inflects the memories and imaginaries of those who were [tragedy's] historical actors," since "what happened was itself already staged and scripted."[26] For instance, a killer staged his part as a Kung Fu film. In the words of the researchers, "each screening is a mnemo-technique thriller-trigger, that allows survivors to imaginatively infiltrate the history from which they have been excluded." And they add, "Perhaps it is a first stage towards justice."[27] The implications this has for the possibilities that training in video making holds for giving vulnerable and disadvantaged groups, such as street children, a sense that they can gain back some control over their lives, are thus enormous. But let us now return to the next stage of the workshop under discussion, conducted by *La Matatena A.C.*

During the third session, each story proposed by the children was assessed for strengths and weaknesses in terms of being told with animation. At *Comunicación Comunitaria* there is a choice of techniques, depending on the story, the children, and workshop leader's interests and skills.[28] *La Matatena A.C.* specializes in plasticine animation and cutout. Advice from the workshop leader is that stories with only a few characters, and in which there is a change of sorts, will be easier to make. Having heard the arguments about what makes a particular story more or less suitable for animation, the children voted for the story that best met the requirements—or for their favorite story, regardless. Voting was not compulsory, and it was pretty much a straightforward process in group A, with children raising their hand to vote for any story they liked with no restriction as

to the number of votes they could cast, the story with the most votes winning. Group B had a different dynamic. Three of the older children started an intense lobbying campaign among their fellow classmates, whom they wanted to vote for their story. Thus some of the younger children requested that the voting process take place via secret ballot! Also, a few children were absent for this session and there was some discussion as to whether other children should be allowed to hold two votes, one for themselves and the other for an absent friend. This irregular attendance pattern became the norm in group B, and a source of disruption for the workshop. Eventually it was decided that voting would take place in several rounds, with one story being eliminated each time. With this method, the older girls' story, about a teenager who gets in trouble with her parents on account of the way she dresses, but is able to "escape" with the help of an imaginary friend, a fantastic, colorful dragon, lost very narrowly: by one vote.

With the outcome of the vote decided, the workshop leader then ensured that as many ideas/characters/situations/suggestions from the losing stories as possible were incorporated into the winning one, or that children whose stories got the fewest votes were given decision-making power over the winning story. It is not uncommon for children from disadvantaged backgrounds whose story fails to get votes to lose interest, or to suggest changes such as the main character getting killed or dying early on in the story. In fact, Mimi Orner and others have made the point that self-expression can be a limiting or disempowering act, since "celebrating student voice can backfire, by positing a fully egalitarian environment where none exists."[29] Children are, however, guided throughout the process. It takes a very experienced and caring instructor, such as Ricardo Zentella from *La Matatena A.C.*, to be able to restore their self-esteem while once again getting them involved in the filmmaking. In the 2011 summer workshop, the winning story in group B, proposed by the younger children, was about tolerance and respect. It told the story of a squirrel that other animals in the woods rejected because of her upper-class accent, but whom they learned to like when they knew her better, since sharing life in the woods enabled them to see she was a very kind animal. This is in sharp contrast with the story that had been championed by the older girls, in which the dragon recalled the carnivalesque dimension Bakhtin understood as "an expression of agency, a transgressive challenge" that has historically been important among those with little power.[30] Nevertheless, the girls introduced grotesque and "excessive" characters to the story, such as an eagle that briefly kidnapped the squirrel.

The fourth stage of the workshop typically involves the production of a screenplay and a storyboard. It is, in other words, a matter of translating the sentences that were used to tell the story into images, which are then put together and hung on the classroom's walls, where they remain as a reference for the rest of the production work. Any audio that is envisaged in connection with a given scene is also noted. Children naturally communicate with drawings and the children in both groups were extremely good at the storyboard construction. During an initial stage they simply drew "emotions" and experimented with various colors, before finally illustrating the sentences from the screenplay. There was a general sense of accomplishment by the end of this session.

Figures 11.1 and 11.2 Puppets and scenery made by children at *La Matatena A.C.*

On completion of this stage the next few sessions are devoted to making the scenery and characters that will be needed. These tasks are completed before the actual animation work begins, the animation being done entirely by the children, frame by frame. Scenery for the first story involved the creation of igloos, a sea of raft paper strips, plasticine boats, and penguins. Children worked in small groups, with the workshop leader and the monitors helping as needed and frequently circulating among the tables, where children in group A could already be heard playing, as they used their newly made dolls as characters in other stories of their own, which they invented on the spot to engage their neighbors. The room was teeming with stories. For group B, the story required the making of a wooded area with two rivers and an island, a family of squirrels, two eagles, and other characters. All in all, the children in this group worked in a quieter and more orderly manner, and it took them much longer to finish this phase.

The animation and filming process is extremely hard work, as both activities require considerable patience. Children took turns placing the characters where they should be for each shot, and operating the video camera. The lighting was controlled by the workshop leader who oversaw the whole process. In the meantime, children who were not animating or recording were either still working on scenery production, or playing. The audio was recorded during the last session, mostly with sounds made by the children themselves and library music, and this proved to be a lot of fun.

In 2011, the presence of Joris Van Dael provided a useful counterpoint, enabling La Matatena A.C. to compare workflow and assess the strengths and weaknesses of the methods of instruction of both institutions. A TV actor and theater director, Van Dael founded Kidscam in Belgium in 2003. With the support of the Flemish government, the Kidscam team visits primary and secondary schools to run three day cutout animation workshops, five hours per day. The key differences found between the European school and its Mexican counterparts were related to the use of technology, as the Kidscam workshop relies almost exclusively on computer animation. Also, the extent to which the activities were standardized and systematized was different. Kidscam did not use script comparisons to check for strengths and weaknesses, and there was no shadow play among its activities.[31] Indeed, the Kidscam scripts tend to be very loose, sometimes entailing very little narrative, and with an apparent emphasis instead on playful, ludic experimentations with color and texture. A typical video from Kidscam, De ijsprinses (Ice Princess, 2011), screened during the international festival, shows an ice skater spotted by death, whose scythe cracks the ice so the skater falls into the lake and dies. But as she is trying to keep afloat, death takes a close look at the girl for the first time, falls in love with her and saves her, the video ending with both death and the girl skating together. Van Dael's presence at La Matatena A.C.'s workshop B proved an engaging stimulus for a group of children whose motivation at times lagged, with the Belgian filmmaker clearly enlivening the sessions.

The last stage is of course devoted to editing. When the workshop includes older children, they participate in this stage too, and the workshop leader then

does the final rendering so the video is ready for theatrical exhibition. At *La Matatena A.C.* the video that comes out of the workshop process is shown at a gala event during the closing ceremony of the festival, an enormously thrilling occasion for the children and their families, who are among the audience. In 2011, two of the videos made at *Comunicación Comunitaria* that year were also shown at the festival, to wide acclaim. Children who had taken *La Matatena A.C.*'s film history and film appreciation workshops also had a chance to put their knowledge into practice as members of the jury, inasmuch as they provided a rationale for their awarding choices during the closing ceremony. Most embassies usually send a representative to collect the prizes awarded by the children, and this was also the case in 2011.

Juguemos a Grabar

In between the cinephile cosmopolitanism of *La Matatena A.C.* and the instrumental communitarianism of *Comunicación Comunitaria, Juguemos a Grabar* has carved out a niche of it own. *Juguemos a Grabar* is inscribed within the "cultural industries" paradigm that seeks to maximize the various social and economic benefits that the arts can bring to a locality, especially in terms of social inclusion, the creation of jobs, and urban regeneration through cultural clustering. *Juguemos a Grabar* first started with the support of the state of Michoacán's Ministry of Culture, the state's Institute for the Welfare of Women, and the government of Morelia City. Together these bodies provided 250,000 MXN in total, some USD$19,377.50 at the time of writing. Yet, its founder and director, Sonia Aburto, who is a real entrepreneur, soon mobilized the support of Cinepolis, one of the largest film theater chains in the country. She also secured backing from the Morelia film festival, with its remit of promoting the national cinema, and from public and private museums, notably *Papalote, Museo del Niño* (*The Kite*, Children's Museum). Aburto believes the best way to further the aims and objectives of practice-based film education is "through a partnership between civil society and the private sector,"[32] and she thus seeks to generate as many synergies between film theaters, museums, and film schools as possible.

Juguemos a Grabar aspires to awaken a deep and enduring interest in film and video in children, offering 40-hour modules delivered on Saturdays over a two-year period to children between 8 and 15. The sessions focus on various aspects of video and filmmaking from makeup and costume to acting and cinematography,[33] and enlist the talent and expertise of professional actors, screenwriters, musicians, and other media experts from the state of Michoacán. In this sense, *Juguemos a Grabar* is more vocational in nature than *La Matatena A.C.* or *Comunicación Comunitaria*, since children who finish all courses receive a more thorough technical training over the two-year period—learning from media professionals from various areas of the industry—than do children at the summer or two-week workshops of the other two schools. They are also trained in skills that cater specifically to the job market,

such as interviewing and lighting a scene, skills not developed when learning animation—although both *La Matatena A.C.* and *Comunicación Comunitaria* have some documentary options—and the children targeted are older here. *Juguemos a Grabar* is especially active in the area of fundraising and public relations campaigns. By way of example, the documentary-making marathon organized for Children's Day in 2009 at Morelia's main square, *La Plaza de Armas*, was extremely successful. A call for proposals was launched a month in advance, with the following seven topics: children's rights, the zoo, security at home and at school, disability and children, children say no to drugs, child labor, and culture and education in Michoacán. A total of 48 proposals were received, and four were selected for video making on the day. The marathon lasted for 12 hours. Four editing booths were placed in each corner of the square, as the aim was to have the documentaries ready for outdoor screening there at 8 p.m., making a public event out of the occasion. Prizes provided by sponsors included video cameras, day tickets to popular theme parks and children's museums, as well as guided tours of the film studios. Yet, *Juguemos a Grabar* does not focus exclusively on documentary filmmaking. Their program entitled *Alas y Raíces a los Niños* (Wings and Roots for Children) is, for example, devoted to fiction film. Far more vocational in nature than *La Matatena A.C.* and *Comunicación Comunitaria, Juguemos a Grabar* is starting to fulfill another important function in the landscape of practice-based film education in Mexico: the need to realize the economic potential that cultural industries such as animation and video production can bring to the regions that host and sustain them.

Conclusion

Western thought, relying on dualisms, characterized human beings from early on as split between "body" and "soul" or "spirit," later "mind." Although pre-Socratic in origin, this division was carried forward in Christianity and in secular thought by Cartesian philosophy, the consequence being that the realm of the mind was elevated and equated with divinity, the realm of the body despised. Worse, as a result of the way in which the pursuit of knowledge was later divided into the abstract and formalized realm of the mind, as opposed to the situated and experiential learning that relies on performing an activity or doing, much of the theory has ended up being alienated from practice. In this sense, the urge to do and to feel at the heart of practice-based film education is a welcome development. The promise that this kind of education holds is enormous, for the relevant practices truly make a difference to the lives of the children, their communities, and, eventually, to the various national film industries where these schools operate.

But the schools face an uphill task. To begin with, at the institutional level there is the lack of a cultural policy that properly takes film, and film for children, into account; second, these organizations operate within a now highly precarious economic environment; their work is on a per-project basis and they

Table 11.1 Table Comparing Training Workshops

	Comunicación Comunitaria	*La Matatena A.C.*	*Juguemos a Grabar*	*Kidscam*
Based in	Mexico City	Mexico City	Morelia	Amberes, Belgium
Time devoted to the workshops	6 five-hour sessions (30)	8 four-hour sessions (32)	Choice of several 40-hour modules delivered weekly over a two-year period	3 sessions, 4 hours each (15)
No. of participants	13	14	12	24
Ages	8–13	6–13	8–15	10
Use of Technology	Low. Animation by hand, only editing and rendering with computer	Low. Animation by hand, only editing and rendering with computer	High. Mostly used for documentary making and fiction film	High. All animation done with computers
Activities	Standardized	Standardized, but also case by case response	Standardized, but also case by case response	Fully systematized and standardized
Representative work	*Magical Hands* series. Documentaries on the making of traditional handicrafts	*Ya, no fastidien!* Award-winning animation to raise awareness on global pollution	*The Morelia city centre.* Documentary	Playful, ludic cutout shorts

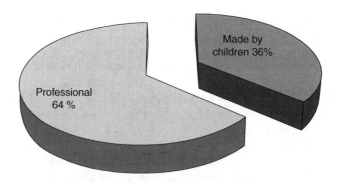

Figure 11.3 International Children's Film Festival, 2011.

are continuously bidding for funds to be able to run their programs; and third, there is the issue of the diverse background of their target population, which often makes the groups extremely challenging to teach. At a more fundamental level, there is also a sense of a very profound crisis, pertaining to both values

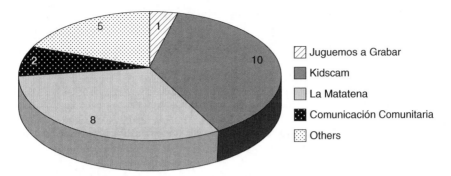

Figure 11.4 Films made by children by school.

and financial matters, in the present context of a so-called flexible accumulation of capital.[34] However, it is precisely the massive nature of the challenges that make their work all the more urgent and necessary. As Maxine Greene puts it:

> Fundamentally, perhaps, I am conscious of the tragic dimension in every human life. Tragedy, however, discloses and challenges; often, it provides images of men and women on the verge. We may have reached a moment in our history when teaching and learning, if they are to happen meaningfully, must happen on the verge. Confronting a void, confronting nothingness, we may be able to empower the young to create and recreate a common world—and, in cherishing it, in renewing it, discover what it signifies to be free.[35]

I contend that in their teaching of practice-based film education, *La Matatena A.C.*, *Comunicación Comunitaria*, and *Juguemos a Grabar* are already training Mexican children in this practice of freedom, at the edge.

Acknowledgments

I am extremely grateful to Liset Cotera and her team at *La Matatena A.C.* This chapter would not have come about without their generous help and support over the research period and beyond. I am similarly grateful to Joris Van Dael, Irma Avila Pietrasanta, Abril Dávila Cabrera, and Sonia Aburto.

Notes

1. John Dewey, *Experience and Education* (New York: Touchstone, 1997).
2. Maria Montessori, *Maria Montessori's Own Handbook: A Guide to her Ideas and Materials* (New York: Random House, 1994).
3. Paulo Freire, *Pedagogy of the Oppressed* (London: Penguin, 1996).
4. Paulo Freire, *Pedagogy of Hope* (London and New York: Continuum, 2004).

5. Colin Beard, *The Experiential Learning Toolkit: Blending Practice with Concepts* (London: Kogan Page, 2010), 4.

6. Michael Hoechsmann and Stuart R. Poyntz, *Media Literacies: A Critical Introduction* (Oxford: Wiley-Blackwell, 2012), 104.

7. *Matatena* is a word in Nahuatl, the language spoken by indigenous inhabitants of central Mexico, meaning "handful of stones." The game involves throwing five small stones or beans onto a flat surface and then trying to pick them up one by one during the time it takes for a small ball also thrown by the participant to bounce back from the table. The aim is to collect all the stones in the shortest possible time, without touching other stones. It is useful to develop children's motor coordination, and much enjoyed even today.

8. By film history I mean the history of cinema, as children use zoetropes, praxinoscopes, and magic lanterns as toys to learn about the origins of the moving image. They also learn some of the history of animation and of Mexican films for children.

9. Hoechsmann and Poyntz, *Media Literacies*, 131.

10. Referring to the historical context of the 1960s in which art cinema was being institutionalized in Europe, Susan Sontag defined cinephilia as a special love that cinema inspired, which evoked a sense of wonder, "born of a conviction that cinema was an art unlike any other" whereby "people took movies into themselves and felt liberated by the experience of surrender to, of being transported by, what was on the screen." Susan Sontag, "The Decay of Cinema," *The New York Times*, February 25, 1996. Others have argued this love is in fact ahistorical, with cinephilia alive and well in the digital age. Jenna Ng, "Love in the Time of Transcultural Fusion," in *Cinephilia: Movies, Love and Memory*, ed. Marijke De Valck and Malte Hagener (Amsterdam: Amsterdam University Press, 2005). The workshops offered at *La Matatena* can certainly be said to be introducing new generations into the practice of love for the cinema.

11. Meryl Aldridge, *Understanding the Local Media* (Maiden Head: Open University Press, 2007), 5.

12. Irma Avila Pietrasanta, *Apantallad@s: Manual de Comunicación en Radio y Video para Niños* (México D.F.: Comunicación Comunitatria, 2011), 14.

13. Jacques Rancière, *The Emancipated Spectator* (London: Verso, 2009), 22.

14. Liset Cotera, interview with, about *La Matatena: Origins, Mission, Perspectives*, by Armida de la Garza, July 20, 2011.

15. Liset Cotera, interview.

16. Marina Stavenhagen, "Oasis de Frescura y Diversidad," *Festival Internacional de Cine para Niños (. . . y no tan niños)* 16 (2011): 3.

17. Indeed Liset Cotera explains how the school name "*La Matatena*" captures this: "Matatena games are highly personal, and unique. Each time a child throws the stones they fall into a different position, and the strategy to pick them up is also different. Cinema is like that too: each film is a unique experience for each one of us, for we all engage with it both collectively and from our own, individual perspective." Liset Cotera, interview.

18. Some of these can be viewed at http://www.lamatatena.org/es/videoteca/animaciones/.

19. Liset Cotera, "Altas Dosis de Cine para Niños," *Toma, Revista Mexicana de Cine* May/June (2010): 73.

20. In 2011 the festival featured 72 films from 21 countries. Among these, 6 were feature films, 3 documentaries, 13 were short films, 23 were short animation films, and 25 were short animation films made by children, 8 at *La Matatena A.C.*, 2 at *Comunicación Comunitaria*, and 1 at *Juguemos a Grabar*. Three venues participated: Cineteca Nacional

(the National Film Library), Chapingo University, and the Instituto Tecnológico de Estudios Superiores de Monterrey, Santa Fe Campus.

21. *La Matatena A.C.*'s work regularly includes children from indigenous and minority communities, street children, and children with disabilities, as well as children from government and private schools in Mexico City and the cities of Cuernavaca and Monterrey.

22. See for instance Mimi Orner, "Interrupting the Calls for Student Voice in Liberatory Education: A Feminist Post-structuralist Perspective," in *Feminisms and Critical Pedagogy*, ed. Carmen Luke and Jennifer Gore (New York: Routledge, 1992).

23. Hoechsmann and Poyntz, *Media Literacies*, 123.

24. Elizabeth Soep, "Beyond Literacy and Voice in Youth Media Education," *McGill Journal of Education* 41, no. 3 (2006): 202.

25. Rosemary Althouse, Margaret H. Johnson, and Sharon T. Mitchell, *The Colours of Learning: Integrating the Visual Arts into the Early Childhood Curriculum* (New York: Columbia University Press, 2003), 9.

26. Michael Uwemedino and Joshua Oppenheimer, "History and Histrionics: Vision Machine's Digital Poetics," in *Fluid Screens, Expanded Cinema*, ed. Janine Marchessault and Susan Lord (Toronto: University of Toronto Press, 2007).

27. Uwemedino and Oppenheimer, "History and Histrionics," 184.

28. These are: cutout, animation using objects, puppets, or plasticine models, collage, pixellation, or fiction film with actors. Both *Comunicación Comunitaria* and *La Matatena A.C.* offer documentary filmmaking for older children.

29. Mimi Orner, "Interrupting the Calls for Student Voice." A far more important concern though has been raised by Sarah Bragg, namely that "the call for youth to develop their own voices can mask a more subtle form of regulation" as young people are asked "to become [a] certain kind of enterprising subjects", the subjects of neoliberalism. Bragg has a point, but this would in my view depend on the social context in which the learning takes place. See Sarah Bragg, "'Student Voice' and Governmentability: The Production of Enterprising Subjects?" *Discourse: Studies in the Cultural Politics of Education* 28, no. 3 (2007): 343.

30. Hoechsmann and Poyntz, *Media Literacies*, 135.

31. Joris Van Dael, interviewed by Armida de la Garza, August 12, 2011.

32. Liliana David, "Corto michoacano, ganador de concurso latinoamericano de cine infantil y juvenil," *La Voz de Michoacán* (2008), 1.

33. The full curriculum comprises: screenwriting, film music, film direction, storyboard, acting, cinematography, editing, make-up, costume, and production.

34. David Harvey, *The Condition of Postmodernity* (Oxford: Blackwell, 1991).

35. Maxine Greene, *The Dialectic of Freedom* (New York: Teachers College, 1988), 22.

12

Audiovisual Educational Practices in Latin America's Peripheries

George Yúdice

Introduction

When I first conceptualized this study, I called it "Community Audiovisual Production." Some of the experiences that I refer to, however, are not necessarily communitarian, although many are. I have chosen the word "peripheries" because it refers not only to marginalized communities, like favelas,[1] on which much of my research focuses, but also to experiences that are not dominant or central in the sense of commanding large-scale resources, venues, contacts, policies (both explicit and implicit), the law, and often coercion. This is the primary sense in which I am using this term, for there is nothing essentially peripheral about the diverse experiences that I will speak about, especially not to the protagonists of these experiences, who reject the idea that they are somehow lesser because they do not inhabit or aspire to the current professional-industrial mainstream. Moreover, these diverse protagonists increasingly have the sense that they form part of an emergent plurality. It could be said that these peripheral practices constitute an emergent field of audiovisual production that challenges and reformulates the dominant field, composed largely of educated, professional middle-class filmmakers and producers who see the narrative feature film as the most valued kind of audiovisual product and the movie house as the appropriate venue for cinematic experience. The field of peripheral audiovisual production, while not neglecting these criteria, nevertheless prioritizes other practices and formats such as collaborative production, documentaries, shorts, activist video, and so on; circulation in community settings, informal markets, public TV, and Internet portals and sites like YouTube and Vimeo, and so on; and education in community workshops, through viewership and discussion in local settings, civic organizations, and cineclub networks, all of which generate new kinds of cinephilia.

What kinds of peripheral experiences am I referring to? In the first place, many of the relevant experiences are collaborative. In some instances they involve the efforts of a new generation of filmmakers who adopt a post-industry practice (I will return later to an explanation of this term), backgrounding the usual division of labor and circulation in the audiovisual sector. Collaboration also takes place in the audiovisual divisions of community organizations in favelas or shanty towns; most of these organizations emerged in the 1990s to promote the rights of subalternized residents, usually through cultural production connected to urban social movements, although as we shall see, there are also rural and indigenous peoples involved in this kind of production. More recently, youth collectives dedicated to artisanal and new technological production and the exhibition and circulation of audiovisual expressions have emerged, and in Brazil they are seeking to reorganize the entire sector, as they have done with music. Many of these collectives are in non-capital cities, at a remove from the Rio-São Paulo axis where the majority of incentives and support for industry and wealth are located. These youth are generally middle class, often turned off by the university and the kind of jobs they are being prepared for, and some have chosen to militate in cultural activism that is also deeply political.

In addition to these two kinds of experiences—those of favela organizations and those of middle-class youth—there is a spectrum of other kinds of peripheral audiovisual organization: indigenous peoples are particularly salient; so are migrant communities that have moved from towns in the interior to large cities where they are often treated like aliens, and use audiovisual means to produce cultural fare that is of interest to them and that no one else is producing for them; and a panoply of "fringe" cinema and video initiatives, such as collectives that make feature films rooted in regional stories, or that parody Hollywood, Bollywood, and Chinese martial arts films, mashed together with local legends and myths. There is also an explosion of music videos for the hundreds of genres throughout the hemisphere; often these music videos relate to the desire to find an audiovisual language that TV and mainstream film do not provide. And finally, many of these activist practitioners and collectives have begun to network, across their considerable differences; I write as a participant observer of such networking experiences. At a recent meeting of 17 cultural networks, many audiovisual collectives such as Grupo Chaski and the Network of Microcines in the Andean countries interacted with and formed synergies with other audiovisual networks as well as other kinds of cultural work.[2] What they all share is a challenge to the prevailing structure of the fields of artistic, cultural, and audiovisual production at all levels: financial, professional, race/class, institutional, technological, aesthetic, reception and so on.

Contextualizing Audiovisual Production in the Peripheries

Peripheral film and video makers are different from two types of professionals. They are not governed by the economy of scarcity that, in the mainstream industry, translates into the pursuit of blockbusters on the international scene.

This context has produced such Latin American professional/commercial filmmakers as Fernando Meirelles (codirector of *Cidade de Deus / City of God*, 2002) or Alejandro González Iñárritu (director of *Amores Perros / Love's a Bitch*, 2000), two of the most cited directors of the post-New Latin American Cinema (NLAC). Paul A. Schroeder Rodríguez offers a useful characterization of this post-NLAC, which he argues has "succeeded in reinserting Latin American cinema into the global cinematic marketplace, by appropriating some of the very conventions that NLAC [i.e., New Latin American Cinema] rejected out of principle, and by redirecting the NLAC's emphasis on societies or extraordinary individuals in upheaval, focusing instead on the micropolitics of emotion... [and recycling] earlier cinematic movements—auteur cinema..., neorealism..., militant NLAC...—into multiple configurations distinct from these movements' historical unfoldings."[3]

The peripheral audiovisual production to which I refer is also different from post-NLAC production in that its directors are not part of the traditional circuit of recipients of subsidies from the state, as was characteristic of Brazilian filmmakers from 1969 on. Nor are peripheral filmmakers and videographers inserted in the market through the fiscal incentive laws legislated in the mid-1990s and 2000s. Given the new conditions for cultural production and circulation, made possible especially by new technologies in the areas of music and the audiovisual, peripheral filmmakers, although short on cash, work in an economy of

Table 12.1 Salient post-NLAC filmmakers of the 2000s

Film Director	Film	Budget ($M)	Box Office ($M)
Alfonso Cuarón (Mexico)	*Y tu mamá también* (2001)	5.0	33.6
	Harry Potter... (2004)	130.0	796.7
	Children of Men (2006)	76.0	70.0
Guillermo del Toro (Mexico)	*Blade II* (2002)	54.0	155.0
	Hellboy (2004)	66.0	99.3
	Pan's Labyrinth (2006)	19.0	83.3
Alejandro González Iñárritu (Mexico)	*Amores Perros* (2000)	2.4	21.0
	21 Grams (2003)	20.0	60.4
	Babel (2006)	25.0	135.3
	Biutiful (2010)	35.0	25.0
Fernando Meirelles (Brazil)	*City of God* (2002)	8.5	30.6
	The Constant Gardener (2005)	25.0	82.5
	Blindness (2008)	25.0	19.6
José Padilha (Brazil)	*Bus 174* (2002)	N/A	0.2
	Tropa de Elite (2007)	6.5	14.7
	Tropa de Elite 2 (2010)	9.5	63.0
Walter Salles (Brazil)	*Central Station* (1998)	2.9	5.6
	Motorcycle Diaries (2008)	N/A	57.6
Fabián Bielinsky (Argentina)	*Nine Queens* (2000)	1.5	12.4

abundance: there is no shortage of production. The challenge, of course, is exhibition and circulation.

The preceding table lists some of the top grossing commercial filmmakers, all part of the post-NLAC generation. Obviously, the highest grossing films were produced or coproduced in the United States. What jumps out immediately, though, is that the most successful filmmakers, in commercial terms, are from Mexico and Brazil, countries with the largest populations in Latin America and two diverse systems of support for commercial film: a market system connected in part to Hollywood production, on the one hand, and a subsidy system on the other. The most successful Argentine film, by Fabián Bielinsky, comes close to Walter Salles's *Central Station* (1998); but Bielinksy, like José Padilha, started out by drawing heavily on government and coproduction subsidies. Parenthetically, although Argentine filmmakers are not as successful commercially as their Mexican and Brazilian peers, it should be noted that Argentina has a vibrant commercial audiovisual sector, which, according to the US National Association of Television Program Executives, positions it as the fourth exporter of television programs in the world.[4] Nonetheless, the main problem with the Argentine subsidy system is that producers are interested in the income they get from the system and are not that concerned about exhibition, save for the required brief stint, usually in off-center cinemas since major cinema chains eschew low-grossing films.[5]

I will not elaborate on the funding for commercial film but will limit my remarks on this issue to the role that television plays in providing employment opportunities and a production chain allowing filmmakers and the small and medium enterprises in which they participate to tap into the various segments of it. These include: production, postproduction, exhibition, special effects, videogames, education, advertising, and crossmedia initiatives. Access to these segments is what enables the relevant production companies to thrive.

A good example is Fernando Meirelles's company 02 Filmes, which produced *City of God* as well as *Cidade dos Homens* (*City of Men*, 2007), the latter as a television program for TV Globo, the largest mass media network in Latin America. Additionally, 02 Filmes is one of the most successful production companies, having produced US films and dozens of commercials for companies in the United States, Europe, and Latin America. From the perspective of Hollywood, 02 Filmes, like all other Latin American production companies, is considered an Indie,[6] although in Latin America it is intimately linked to the most powerful networks. In other words, there are two kinds of Indies: those with connections to the mainstream audiovisual industry, and those that operate in alternative circuits, which I prefer to call film and video from the peripheries since the term Indie comes already loaded.

I have begun by focusing on Meirelles and his production company because they have capitalized on the currently profitable interest in the periphery, witnessed by a spate of films like *City of God*, *Bus 174* (2002), and *Tropa de Elite 1* and *2* (2007; 2010). What is little known, particularly outside of Brazil, is that many community organizations had already developed their own audiovisual productions through their activism in the previous 10 to 15 years. In turn, the violent

and quasi Hollywood-action-styled favela films referred to, have made it possible for favela activists to get a greater foothold in public spheres, for their activist media training and the connections they have achieved over the past 20 years have prepared them to engage in a battle of representations that is also a battle for space, resources, and recognition.

The favelas are not the only periphery in which mainstream filmmakers are interested. Meirelles and his production company have also taken an interest in the indigenous forest reserve of Xingu, with their film *Xingu* (dir. Cao Hamburger, 2011), as their website puts it, "Depict[ing] the work of the Villas Bôas Brothers in their defense of the indigenous population and the environment."[7] I will return to the issue of representations of indigenous peoples in my discussion of film and video made by these people themselves. The point I would like to make here is that decades of indigenous film and video production have already set the stage for this interest, although true to mainstream cinematography, *Xingu* is the story, from an outsider's point of view, of how the white anthropologists "saved" the indigenous people. The narrative structure replicates hundreds or thousands of such well-intentioned yet paternalistic interventions, without the slightest reference to the different worldview belonging to indigenous people, or to how they produce a different gaze.

Nevertheless, the important point is that *Xingu* or the violent favela films generated a vast public discussion through which subalternized peoples—the indigenous communities or favela residents themselves—were able to gain access (along with their own voices, perspectives, and audiovisual languages) to public spheres normally denied to them. This entry into public spheres took place in two ways: on the one hand, through access to mainstream TV, brokered by sympathetic producers and highly regarded and newsworthy activists from the periphery; and on the other hand, through the production and circulation of alternative media within the favelas, indigenous villages, or other peripheral or nonmetropolitan contexts. These two means of access to public spheres—the one mainstream, the other alternative—are not completely separated; they collude or collide through complex negotiations permeated by race, class, education, and social and cultural capital, and through the imbrication of all these factors in parallel fields of cultural production.

The Audiovisual Wing of Social Movements on the Periphery

For example, *City of God* and the spinoff TV show *City of Men* employed young non-professional actors who had been trained by a nongovernmental organization, Cinema Nosso (Our Cinema), which then dedicated itself to working with youth from the favelas and peripheral urban zones in areas such as education, computer skills, and citizenship. Funded by Petrobras—Brazil's semi-public/semi-private oil company, the most important funder of cultural projects in the country, and the tenth largest corporation in the world according to Forbes—Cinema Nosso, over a period of ten years, has offered courses and workshops on all aspects of audiovisual production, including feature films,

shorts, documentaries, and videogames; it has also engaged youth in discussion of audiovisual languages.[8] The work of Cinema Nosso resembles that of more activist NGOs that have been operating in favelas over the past 15 to 20 years. Indeed, one of its leaders, Kátia Lund, was codirector of *City of God*. She also participated in community action media initiatives with groups like Afro Reggae, Central Única das Favelas (CUFA, Central Union of the Favelas), and others that I mention below. In fact, her work with these groups distinguishes her from Meirelles and most mainstream filmmakers,[9] and the difference is symptomatic of the audiovisual contestation, discussed below, that local activists have engaged in with respect to *City of God* and other films that sensationalize the violence in the favelas.

Another initiative, Central da Periferia—created by long-time advocates of the culture of the periphery,[10] anthropologist / TV producer Hermano Vianna and TV host Regina Casé—showcased the creativity and sociability of young people in the favelas of Brazil and, indeed, the rest of the world.[11] They and other sympathizers firmly believe that peripheries are the spawning grounds of innovation; which is why they explore peripheries throughout the world in addition to favelas and other marginal areas in Brazil. The creativity is particularly evident in music, with samba emblematizing representations of national culture in the past, and funk, hip-hop, and sundry vernacular fusions characterizing the cultural diversity of the present. Yet, although Vianna and Casé are steeped in the culture of the peripheries and are well-intentioned collaborators and mediators of the activism of the periphery, they are nevertheless upper-middle-class outsiders.

There are, however, TV programs on mainstream networks that present the perspective of the activist organizations of the favela, such as *Conexões Urbanas* (Urban Connections), created and hosted by José Júnior. The latter is the coordinator of the Cultural Organization Afro Reggae (about which I have written extensively elsewhere),[12] which is the subject of a highly acclaimed documentary, *Favela Rising* (2005).[13] Afro Reggae is a hybrid for-profit and non-profit organization created in the favela of Vigário Geral after an invasion and massacre by the police; its members aim to get young favela residents off the streets and to remove them from the twin problems of narco traffic and police harassment. They do this by involving youth in music and other artistic work, and since its founding as an NGO in 1993, Afro Reggae has continually expanded into a range of other activities, such as providing anti-police-brutality training in various Brazilian cities. Júnior took Afro Reggae's program *Conexões Urbanas* to the mainstream Globo TV network in 2008, building on a number of audiovisual projects that seek to present and transform the world from the perspective of the periphery, and in particular to bring into contact people who are separated by class, race, territory, employment, and so on. In the lead episode, Júnior says *"Conexões Urbanas* is not a TV program, it is the audiovisual wing of the Afro Reggae social movement," and emphasizes issues that are often left out of mainstream audiovisual representations of the peripheries.[14]

Another NGO that works with at-risk youth is Central Única das Favelas (Central Union of the Favelas or CUFA). Like Afro Reggae, it provides education

through workshops. The scope of these includes all of the arts as well as culture more generally (music, theater, the spoken word, and the audiovisual). CUFA's reach is wider, with centers in all 27 states of Brazil, and it even has branches in Argentina, Austria, Bolivia, Chile, Germany, Haiti, Hungary, Italy, Spain, and the United States. CUFA has an Audiovisual Division that provides training in film and video making to favela residents. Two of the founders of CUFA—Celso Athayde, a record producer, and MV Bill,[15] a well known rapper who records with Athayde—have also worked together on several books that present the difficulties of everyday life in the favelas, especially those of youth involved in drug trafficking. Their book *Cabeça de porco*,[16] co-authored with a former secretary of security for Rio de Janeiro and the country as a whole, gathers together interviews with petty drug traffickers in nine Brazilian cities. The idea was to get beyond the violence that is typically shown in the media and instead to provide an inside view of the shattered dreams of those who would prefer to be doing something else, particularly because of the insecurity of the way of life in question. This point is brought home poignantly in another book co-authored by MV Bill and Celso Athayde, *Falcão, Meninos do Tráfico* (Falcon, Drug-Traffic's Children),[17] which is also a documentary film in which they tried to show the human side of the youths who become cannon fodder for narco traffickers.[18] The documentary *Falcão, Meninos do Tráfico* aired in 2006 on the same TV Globo program (*Fantástico*)—in which Central da Periferia appeared.

Both founders of CUFA had originally been involved in Meirelles's *City of God*, but left the project when they realized that the film would spectacularize violence in the favela. Having grown up in City of God, MV Bill was particularly outspoken in claiming that most fellow residents felt disrespected by the representation and that the film did not contribute to the community, particularly with regard to the issue of identifying the complex origins of poverty and violence.[19] Meirelles responded that he was simply registering the violence that had racked the favela and the lack of security, quoting President Luiz Inácio "Lula" da Silva's endorsement of the film. Lula, more specifically, said that the film made him aware of the problems and prompted him to develop policy for dealing with lack of youth employment and the absence of the state in the favelas.[20] As several observers pointed out, part of the reason for MV Bill's discontent had to do with the different scope of access that the periphery has to public spheres and thus to the possibility of representing a given reality: When, where, and by what means? From MV Bill's perspective, these youth were cannon fodder for both narco traffickers and the mainstream media. Moreover, in contrast to 1960s Cinema Novo analysis of the factors that led to the poverty, Mereilles's film never ventured past the spectacle of violence. It was this characteristic of the film that led media critics to invoke Ivana Bentes's sardonic expression "cosmetics of hunger" to characterize contemporary films that slickly transform poverty and violence into a spectacle, in contrast to Glauber Rocha's critical and raw "aesthetics of hunger."[21] The suggestion was that the spectacle contributed to shielding the truth about the origins of narco traffic among power elites outside the favela, "absolv[ing] the act of looking from the actions of that which is being looked at."[22]

Athayde's and MV Bill's response, *Falcão, Meninos do Tráfico*, was also shown on TV Globo, in part because of its newsworthiness and in part because of MV Bill's fame as a rapper and as a cofounder of CUFA. CUFA, along with Afro Reggae and other similar organizations with audiovisual divisions, took part in a significant remake project, *5 x Favela, Agora por Nós Mesmos* (*5 Times Favela, Now by Ourselves*, 2010), based on the original *5 x Favela* (*5 Times Favela*, 1962), which was made by five directors, four of whom became leading exponents of Cinema Novo, the Brazilian name for the revolutionary New Latin American Cinema. As in other NLAC films, the original film was told by a critical voice from outside the favela, a point of view that presumed analytical Marxist truths. Made 48 years after the original, *5 Times Favela, Now by Ourselves* is told by five directors from the favelas, and as stated, from the local organizations where these favela residents were trained in workshops. The project was produced by Carlos Diegues, one of the Cinema Novo directors involved in making the original film, and a person who has led many workshops for favela youth. He himself recognizes the importance of communities' devising their own stories, in technical and narrative terms, and from viewpoints that emerge from lived experience. Moreover, he recognizes that the collaborative forms that these groups have taken mark an important departure from Cinema Novo and NLAC.

Paul Schroeder Rodríguez lays out a useful periodization of NLAC, from the avant-garde revolutionary experimentation of the 1960s to a neobaroque aesthetics that ensued in the later 1970s and 1980s when revolution was written off and more reflexive and allegorical artistic modes became the order of the day. The economic crises of the 1980s took their toll on state funding for film production, and the abrupt implementation of neoliberal restructuring, including the elimination of the state production company Embrafilme in 1990 by the government of President Collor de Mello, brought film production to a virtual standstill. What emerged after Collor's impeachment in 1992 was a new mechanism of public-private arrangements via fiscal incentive policies favoring an industrial film production model and with an emphasis on commercial films that could achieve sizable returns. Within this framework, films had to attract large audiences so as to make investment desirable by corporations interested in a multitudinous reception and to guarantee returns on cultural marketing expenses. Young filmmakers without a track record could not get support for their film projects, even if they had won awards at prestigious festivals for their shorts. From the late 1990s on, Brazilian film re-emerged, as also happened with Mexican and Argentine film, with a number of highly marketable films featuring a slick cinematic language capable of appealing to international audiences: *Central do Brasil* (*Central Station*; dir. Walter Salles, 1998), *City of God, Carandiru* (dir. Hector Babenco, 2003), and *Tropa de Elite* (*The Elite Squad*; dir. José Padilha, 2007), among others. Schroeder Rodríguez catalogues these films as melorealistic, either of the nostalgic kind (characteristic of the 1990s) or of the suspenseful sort (characteristic of the first decade of the twenty-first century). That decade's neoliberal "climate of pragmatic reformism (relative to the second half of the twentieth century) has enabled an imaginary that focuses on a contingent present, rather than on a future utopia, as in the NLAC, or a glossy past, as

Table 12.2 Schroeder Rodríguez's periodization of NLAC and post-NLAC

	Schroeder-Rodríguez's Periodization		
Type of NLAC	Period	Style	Scope
Revolutionary	60s	Marxist neorealism	Nationalist, Third Worldist
Underground, marginal	70s	Grunge avant-gardism	Local, non-territorial
Neobaroque	70s & 80s	Allegorical	Critique of teleological narratives (on nation)
Nostalgic reprise NLAC	90s	Nostalgic melorealism	Popular-international
Hyperrealist reprise NLAC	2000s	Suspenseful melorealism	glocal
Missing in Schroeder Rodríguez's Periodization			
Postindustrial	2000s on	Many styles	Local, collective

in the nostalgic cinema of the 1990s."[23] What Rodríguez misses in his account of contemporary cinema, however, is the dynamism of an activism that is not only challenging cultural institutions and their infrastructure but also undertaking the reinvention of cinema, that is, creating a new paradigm.

Audiovisual Education

The new paradigm, as I indicated at the beginning of this chapter, is postindustrial, eschews the professionalism of commercial audiovisual production, and focuses on a range of peripheral audiovisual experiences involving favela youth, indigenous groups, informal production modes, and young people who are disaffected by commercial venues and university training. I will focus mostly on community audiovisual education, noting that in this age of networking, there is much interaction among the types of experiences just mentioned.

We can see this interaction in the case of CUFA's Audiovisual Division in the favela of City of God.[24] Veteran filmmaker Carlos Diegues recommended the creation of this division precisely so that favela and social movement youth could disseminate their visions of the world in audiovisual languages developed by themselves, and through an exchange with sympathetic professionals and academics. In 2008, CUFA-City of God got funding from Petrobras to sponsor the eighth edition of the audiovisual course as part of the *Ver Favela* (See [or make visible] the Favela) project, in partnership with the School of Communication of the Federal University of Rio de Janeiro. A total of 80 participants studied all aspects of audiovisual history, theory, and production, with the aim of providing audiovisual literacy. The thinking was that such literacy would prepare some participants for the audiovisual market, while also enabling them more generally to devise languages with which to resignify the favela, thereby overcoming stereotypes and invisibility through "subjective mobilization."[25] According to Patrícia Braga, coordinator of the division, production companies like URCA Filmes and TV Zero, as well as television networks like Record and TVE, employed

graduates of the course not so much because of their technical know-how but largely because favela identity and "favelese" were no longer seen as liabilities but as assets in an era of social inclusion.[26] Indeed, Ivana Bentes, director of the School of Communication at the Federal University of Rio de Janeiro, explained that an important aspect of the collaboration between it and CUFA is that the latter, as a successful social movement, has gained a legitimacy that enables it to get grants and resources, to the point where a partnership becomes appealing to the university.[27] Rio's favelas have recently been featured in Globo's most lucrative telenovelas: *Duas Caras, Cheias de Charme, Lado a Lado,* and *Salve Jorge* and community audiovisual makers are making claims not only on the legitimacy of representations but also on who benefits economically.[28] It might be said that academics have just as much to learn and earn from this collaboration as favela residents do. This is what distinguishes this educational experience from that of more professional/academic courses of study.

Another innovative audiovisual educational project is the Escola Livre de Cinema (Free Cinema School or ELC) in Nova Iguaçu, a suburban municipality in the state of Rio de Janeiro. It was founded by Marcus Vinícius Faustini, a dramatist and documentarist, and the author of *Guia Afetivo da Periferia* (Affective Guide to the Periphery).[29] Faustini—himself the son of northeastern migrants who settled in the peripheries and favelas of Rio de Janeiro—created ELC when, as an audiovisual workshop leader, he was invited by the local Secretariat of Education to develop a program consistent with the *Reperiferia* project (Reflecting [on] the Periphery). This project is part of the Bairro Escola (Schooling in the Neighborhood) program, which is designed to transform the neighborhood itself into a learning environment. The project was expanded into a full-blown school in which students get traditional schooling in the morning (from eight to noon) and, after lunch, schooling in all aspects of audiovisual production, from screenplay writing to lighting, props, costume design, camera work, digital editing, and so on. But ELC is not a film school in a conventional sense; it is oriented toward a comprehensive understanding of the surrounding reality. Its founder, Marcus Vinícius Faustini, considers the school as a resource for researching the surrounding reality and reinventing the territory through images.[30] According to the school's website, the aim of its audiovisual training is to "capture images from the territory that reveal [the community's] way of looking and its place in the world through the reception of stimuli of diverse techniques, engagement with visual arts, feuilletons written by writers from the popular classes, literature, photography, image, sound and light editing, and the entire universe of the spoken and written word. In this environment of discovery and experimentation, students construct their imaginaries and make use of digital technologies. They construct, transform and exhibit their universes."[31] To develop these audiovisual narratives, the students explore the city: church halls, clubs, the fire department, and any number of other sites are transformed into locations for research, construction of knowledge, and audiovisual representation.[32] In this way, ELC integrates the life of the city into the students' work, allowing them to devise new audiovisual languages proper to these subjects. At

the time of writing, the program had been in existence for six years, with many of its students having already won awards at film and video festivals.[33]

The Escola Livre de Cinema is one of many nodes in a dense network of audiovisual and cultural organizations throughout Rio de Janeiro and indeed all of Brazil. Each person who works with it further extends that network in many different directions. The school is linked with cineclubs, filmmakers' collectives, a diversity of cultural actors and activists, and funding institutions, such as the semi-public oil company Petrobras. An important partner is the Network of Popular Audiovisual Schools and Workshops, which has its own Festival Audiovisual Visões Periféricas (Audiovisual Festival of Visions from the Periphery). Among other objectives, this festival seeks to examine the use of digital technologies, to engage participants in a profound reflection on and critique of film and video produced in the periphery, to promote debate on the many perspectives from which the periphery is viewed, and even to question the notion of the periphery as a working concept.[34] Another noteworthy project is the Forum of Popular Audiovisual Experiences of the Observatório das Favelas, which also offers critical discussion of audiovisual projects from the peripheries, not just in terms of film but also of the issues that are of utmost importance to the development of these areas. Efforts are made to connect with different peripheries, such as indigenous filmmakers who work with Vídeo nas Aldeias (Video in the Villages), about which more below. CUFA, ELC, Observatório das Favelas, and numerous other community organizations also sponsor cineclubs and film and video festivals, an important feature of community life in many Latin American countries, where participants are exposed to the most varied film and video trends.

In 2010, the Escola Livre de Cinema became a "Point of Culture." The "Points of Culture" program was created in 2005, by then minister of culture, the legendary musician Gilberto Gil, the aim being to strengthen already existing cultural practices throughout Brazil. The practices ranged from more traditional fine arts to vernacular cultures to youth projects, and encompassed cinema, the spoken word, and other modes of expression. The idea was not only to recognize the diversity of cultural practices but also to network them, so that Brazilians would get to know each other. To this end, Gil provided each project with US$30,000 per year and a multimedia kit with broadband access to facilitate the dissemination of its work and communication with other projects. For Gil, incentivizing the diversity of cultures is like a *do-in* acupuncture massage: it removes the blockages to the social body.

This is one of the most celebrated cultural policies ever in Latin America and it is being copied throughout the region. In the case of the ELC, the support provided through the Points of Culture program had the effect of multiplying its contacts with other organizations and individuals involved in audiovisual production. There is a lot of work in the audiovisual area, particularly for the Internet, with all of the organizations mentioned above using video quite profusely. As a Point of Culture, the ELC also participated in the program's Living Culture Lab, which organized an audiovisual seminar as the first step in the

development of the concept, visual identity, navigation, and functions of the lab's platform of creative collaboration on the web.[35]

From Circulation to Participatory Audiovisual Production

Like CUFA's Audiovisual Division, the Escola Livre de Cinema is at the intersection of a number of partnerships. Although many of the ELC's instructors are graduates from previous cohorts, professionals and academics who support its goals are also involved. These include such figures as Cezar Migliorin, professor and director of the Department of Cinema and Video at the Universidade Federal Fluminense (UFF, in the state of Rio de Janeiro), which was founded in 1968 by Cinema Novo pioneer Nelson Pereira dos Santos. Migliorin was brought to the ELC by its founder, Faustini, (who had studied film under him) to teach, supervise, and design curricula for the school. In a recent article Migliorin reflects on what he calls postindustrial cinema.[36] He notes something that I have witnessed in my travels throughout Latin America: people see a lot of film and video in alternative venues, and not just on TV, and much less in movie houses. Many of these postindustrial films circulate through festivals, screenings, DVDs, cineclubs, informal stands, and the web; one is hard put to find them in movie houses or malls. In countries like Peru, 98 percent of music and film is bought in informal markets. This is part of the reality of the economy of abundance to which I referred at the beginning of this chapter. The many ways of maintaining circulation are, thus, not just a technological or mechanical issue but a matter of crucial cultural and political *practices*.

The current abundance contrasts with the violent "aesthetics of hunger" that Brazilian Gláuber Rocha found to be the appropriate revolutionary response to colonialism and imperialism.[37] Yet, it resonates in part with the analogous "imperfect cinema," which, according to Cuban Julio García Espinosa, shunned commercial theaters and circuits and could just as easily be made "with a Mitchell or with an 8mm camera, in a studio or in a guerrilla camp in the middle of the jungle."[38] In both cases, revolutionary cinema was opposed to the technical mastery of Hollywood: García Espinosa began his 1969 manifesto by stating that "perfect cinema—technically and artistically masterful—is almost always reactionary cinema."[39] I have already commented on the post–New Latin American Cinema, which to a significant extent achieved a marriage between commercially oriented Hollywood-style cinema and politically and artistically oriented World Cinema. The new paradigm of peripheral audiovisual production recuperates the political-aesthetic ethos of Cinema Novo, yet exploits all the advantages of the new technologies and new social media without seeking to compete with Hollywood. Film and video makers who are peripheral in a technical or artistic sense can be both masterful and raw.

Young video- and filmmakers have formed collectives and have engaged in a profuse production of new work that was facilitated by two developments: new technologies and cineclubs. The emergence of sophisticated and inexpensive technologies obviously favored not only the production but also the circulation of

this work, as well as new viewing venues and circuits. Indeed, film and video collectives have formed networks that have both physical and virtual meetings and forms of collaboration. The ELC established a working relationship with one such mega network, the audiovisual network of the Circuito Fora do Eixo (Off-Axis Circuit), to produce music videos for the rock bands that circulate through their hundreds of venues (cineclubs, festivals, etc.).[40]

The Fora do Eixo circuit emerged with the goal of transforming the music sector in Brazil. As it grew, so did new platforms for cultural diffusion. Its cineclubs comprise one such platform where a network of collectives works with the most varied kinds of audiovisual material.[41] The circuit's network of cineclubs operates in four areas: communication, production, distribution, and circulation. Each collective has a WebTV for the dissemination of its contents in a weekly program—*Curto Circuito Fora do Eixo* (Fora do Eixo Short Circuit)—that is collectively produced and through which members interface interactively. The circuit also provides live coverage and transmission of events. In addition to institutional and promotional programming, the circuit has created a distributor, DF5, to disseminate shorts and medium and full-length features in a digital format, all of which are made available without charge for noncommercial exhibition.[42] Filmmakers agree to a Creative Commons license in order to be placed in the catalogue on its site on Vimeo. Fora do Eixo encourages each collective to create a cineclub. Moreover, it sponsors workshops in communication, production, distribution, circulation, and intersections with other artistic languages at its regular plenary meetings, with up to 100 or more members of collectives converging at the Fora do Eixo House in São Paulo and hundreds more via skype and other forms of teleconferencing.[43]

The aesthetics of film and video are not simply in the narrative or in the montage, that is, in the content and form of an audiovisual work. A film or video may in itself be an act, a ritual, a form of establishing solidarity.[44] Circulation linked to indigenous video production conveys this other aspect, which is largely missing from mainstream discussions of audiovisual media, as well as from many of the alternative accounts. Jeff Himpele provides a way of understanding how circulation itself can evoke and even participate in the production of indigenous worlds:

> Yet the Bolivian video makers direct our attention outside the box to the media worlds beyond, to the location of videos in social spaces of production or exhibition, and their struggles to produce new cultural possibilities. That is, they direct us to imagine the videos as mobile and mediating elements that may move in and out of a generalizable status as a commodity, but without occluding how filmmakers manage the flows of circulation, to assemble their video works since this process is clearly indexed on the surface of the videotape case itself. What is of value in this regime, then, is the expansion of indigenous worlds via the circulation of their media.[45]

Circulation of video has literally brought indigenous groups into contact with each other, as explained by Vincent Carelli, founder of Vídeo nas Aldeias (Video

in the Villages), an indigenous audiovisual project that began in 1987 in connection with the Centro de Trabalho Indigenista (Center of Indigenous Labor), founded in 1979 to seek alternatives to the Brazilian government's ideology of assimilation. Two of Vídeo nas Aldeia's early works, *A Arca dos Zo'é* (Meeting Ancestors, 1993) and *Eu já fui o seu irmão* (We Gather as a Family, 1993) record the encounter of images of closely related indigenous peoples unknown to each other and "the desire for face-to-face exchange between [them]..., like the Tupi-speaking Waiãpi and Zo'é, or the Parakatêjê and Krahô, both belonging to the Timbira located in Maranhão, Goiás (now Tocantins) and the south of Pará."[46]

Carelli explains that in the first ten years of his work with indigenous communities in the Amazon and surrounding states, they were interested in registering their culture for future generations and in exploring it in the present, as in the case in which they recuperated a nose-piercing ritual that had been abandoned years before. They understood these images as neither representations nor folklore.[47] Video for them is a social practice. These communities requested that Carelli assist them in producing these videos, but as he did not want to insert his own perspective into the work, he limited himself to distributing cameras and demonstrating their mode of operation. The two above-mentioned films correspond to this stage.

In the 1990s, Carelli began to travel to other countries like Bolivia, Mexico, the United States, and Canada, where indigenous audiovisual production was already established or the process of creating training centers or schools well under way. Vídeo nas Aldeias adapted the documentary filmmaking methodology of the Ateliers Varan workshops (Paris) to the collective practice of indigenous communities. Video makers do not work with scripts; they begin by focusing on a character's daily life in the village and go on to assemble the video in a collective setting. With the digital revolution, editing, which is also done through a process of collective feedback, became significantly easier, as did the subsequent diffusion of the work (on YouTube, Vimeo, and a number of other Internet platforms, in addition to television). In an arrangement with the Ministry of Education, Vídeo nas Aldeias distributed 60,000 videos to public schools throughout Brazil as part of the inclusion of indigenous people in the country's heritage.

While the indigenous videos of Vídeo nas Aldeias focus on daily life and rituals, those who produce them do not see them primarily as ethnographies or documentaries. Rather, as indicated above, they understand them as a practice. This is evident in the video-letters they send to nonindigenous communities, seeking to establish exchanges with them. An example of this is *Marangmotxíngmo Mïrang—Das crianças Ikpeng para o mundo* (From the Ikpeng Children to the World), which has won no fewer than seven awards, and where an indigenous response is provided to a video-letter sent from Sierra Maestra in Cuba.[48] In the video, four Ikpeng children speak directly to the viewer, not only showing what their life is like but also engaging in numerous antics and ironic performances that sometimes seem like standup comedy. Another relevant video, which is part of the *Troca de Olhares* (Exchange of Gazes) series, is *Morrinho* (Little Favela). In this documentary video, the indigenous filmmakers Zezinho Yube and Bebito

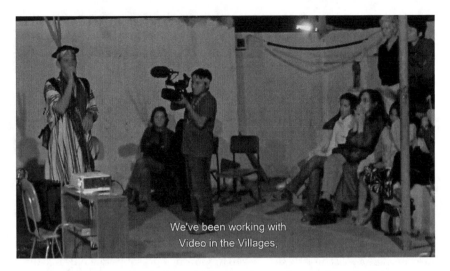

We've been working with
Video in the Villages,

Figure 12.1 Screenshot of *Troca de Olhares/Exchange of Views*, from YouTube.

Pianko chronicle their encounter with the young creators of a scale model favela—"Morrinho"—in the Pereira da Silva community, which serves as the set where the young creators stage performances about life in the neighborhood. The film begins with Zezinho and Bebito flying over the spectacular cityscape of Rio de Janeiro as Zezinho's voice offscreen says: "A lot of people think that indigenous filmmakers only film their culture, but we're also curious about other realities."[49] This and other films are shown in Morrinho in a cineclub setting, reminiscent of the thousands of such venues in Brazil and Latin America.

This kind of circulation is not primarily commercial, or ethnographic, or even meant to serve as a platform for making rights claims, which was largely the purpose served by most NGO films and videos a short generation ago. The Points of Culture program mentioned earlier has a different ethos, which is to facilitate not so much the production but the circulation of the work of local citizens, so that differences that are not available on television or in movie houses become the matter of a different kind of public discourse and entertainment.

There are many such initiatives in contexts other than Brazil. It is worth mentioning the Peruvian cinema collective Grupo Chaski, which was formed in 1982 and grew to over 60 members by the late 1980s. It was inspired by Fernando Birri's Santa Fe documentary school of the 1950s and built on the work of the Bolivian Grupo Ukamau from the 1960s. Chaski works with local people to give them a space where they can tell their stories and also plays a role in shaping consciousness. In contrast to Hollywood-style filmmaking and also to European-style auteur films, the collective rejects the traditional hierarchical structure of filmmaking in favor of a democratic, communitarian, collaborative practice, the process being understood as extending well beyond its immediate product. As one of the early members Oswaldo Carpio stated: "Because we make films from within, we have taken the name of the ancient communicators of the Incan empire—the

Chaskis—a system that worked and that put COMMUNICATION at the service of an entire people."[50] Chaski promotes politically progressive filmmaking by fostering not only production but also distribution and exhibition, and in the process creating a community of film-savvy collaborators and publics.

In 2003, Grupo Chaski stopped working with commercial distributors and set up a chain of micro cinemas, now numbering over 35, in Peru, Bolivia, and Ecuador. They not only exhibit and discuss cinema in settings like those reviewed above, fostering a critical audiovisual literacy, but also use these sites to engage the community in filmmaking projects.[51] The *microcines* are also micro and small enterprises "managed by leaders of the community...capable of working as cultural promoters [who] seek autonomy and sustainability."[52] The founders have made award-winning films—*Gregorio* (dir. Fernando Espinoza and Alejandro Legaspi, 1984), *Juliana* (dir. Fernando Espinoza and Alejandro Legaspi, 1988), *Encuentro de hombrecitos* (Meeting of Little Men; dir. Alejandro Legaspi, 1987), and its follow-up *Sueños lejanos* (Distant Dreams; dir. Alejandro Legaspi, 2007)—and in 2010 they began to sponsor workshops for collective film-making projects analogous to those of the ELC and Vídeo nas Aldeias. According to Stefan Kaspar, one of the founders of Grupo Chaski, the new technologies had already transformed even the poorest citizens into users of a diversity of audio-visual technologies—indeed, the popular classes use video on a daily basis—and the workshops are meant to help develop a vibrant audiovisual culture through the generation of a diversity of cinematic languages.[53]

Conclusion

I have barely scratched the surface of the new plural framework that I call the Audiovisual Paradigm in Latin America's Peripheries. And I have concentrated mostly on Brazil, for the sake of depth and texture. And even in this context I have not done full justice to the phenomenon, for I have not provided an account of the cinema collectives that are not peripheral in the sense of originating in favelas or from the efforts of community organization. Examples of initia-tives warranting attention include Alumbramento, in the northeastern city of Fortaleza in the state of Ceará, which works without public funding or access to an effective market, and the collective Teia, from Minas Gerais. One of Teia's films, *O céu sobre os ombros* (The Sky over His Shoulders), focuses, in documen-tary-like fashion, on the daily life of three unusual characters from this dreary urban landscape. These and numerous other films mentioned by Marcelo Ikeda and Cezar Migliorin are increasingly populating the imaginary of the alternative scene within mainstream cinema.[54]

Other instances of marginal cinema—not part of the peripheral sphere of audiovisual production focused on above—are evident in low-budget parodies, in the *chanchadas* of yesteryear, like the Rambú series (from I to V) that takes place in the Amazon, and in cinematic forms shot in HD by enthusiastic cinephiles.[55] In Ecuador, Miguel Alvear and Christian León chronicle the explosion of local cinematographies that circulate below the radar of the institution of cinema, and

that parallel the variety that has been mentioned in this chapter. This variety overwhelms what might be thought of as formal cinema through powerful informal markets, often without even the advantages of community cineclubs and collective filmmaking workshops.[56] In the *comunas* of the Colombian cities of Cali, Bogotá, and Medellín, one finds video-activist, participatory collectives such as Formato 19K, Mejoda, and Pasolini en Medellín that straddle the parameters of such organizations as CUFA, Afro Reggae, and the territorial focus of the Escola Livre de Cinema. Pretty much everything that I have written about these organizations can be said about the Colombian initiatives: they are participatory, they work with new technologies, they have their own cinephilia, they are disseminated through new social networks, and they explore non-narrative audiovisual languages.[57] Increasingly, all of these initiatives enter into contact with each other and constitute a new kind of multitudinous audiovisual educational practice, at a significant remove from formal cinema schools.

Acknowledgments

I would like to thank the following people for giving me interviews and / or answering my questions. Santiago Alfaro, Roger Bundt, Vincent Carelli, Marcus Faustini, Marcelo Ikeda, Stefan Kaspar, Carlos Eduardo Magalhães, Josinaldo Medeiros, Cezar Migliorin, Alfredo Palacio, Rafael Rolim. Their help was invaluable.

Notes

1. The word *favelas* (Brazil)—like *villas miseria* (Argentina), *pueblos jóvenes* (Perú), *ranchitos* (Venezuela), *tugurios* (Costa Rica), *asentamientos irregulares* (México), *comunas* (Colombia), etc.—is often translated into English as "slums" or "ghettos," thus conveying preconceptions of meanness, squalor, and poverty. In their origins, favelas are informal squatter communities that did not have state-provided services. As these communities press for citizen recognition, many of them acquire such services to some degree. Since the 1960s, in Brazil, favela residents' organizations have struggled for dignified treatment, and since the 1980s movements for citizen rights, this struggle has extended to media representations. In the 1990s, many community-based organizations began to produce their own films and videos. Given this understanding of the term, I am tempted to place it in scare quotes, but the frequency with which I use it makes this strategy impractical.
2. A record of the meeting, Proyecto Rio—Redes, Interacciones y Organización del Sector Cultural en América Latina, March 8–10, 2012, Managua, Nicaragua, is available at http://proyectorio.org/blog/.
3. Paul A. Schroeder Rodríguez, "After New Latin American Cinema," *Cinema Journal* 51, no. 2 (Winter 2012): 108.
4. Punto Panorámico, "Argentina es el 4° exportador mundial de TV," *Punto Panorámico. Noticias del Laboratorio de Industrias Culturales* 5, no. 26 (March 2012), posted March 1, 2012, http://lic.cultura.gov.ar/ppanoramico/pp2601.php (accessed October 29, 2012).

5. For an elaboration of this perverse subsidy syndrome, see Peacock, "La avalancha de estrenos argentinos," Micropsia Blog, entry posted October 30, 2012, http://micropsia.otroscines.com/2012/10/la-avalancha-de-estrenos-argentinos/ (accessed December 9, 2012).

6. Marcelo Cajueiro, "Brazil hosts Yank shoot," *Variety*, October 17–23, 2005, 19.

7. www.o2filmes/longas (accessed May 5, 2012).

8. Nosso Cinema, "Nossa História," no posting date, http://s3images.coroflot.com/user_files/individual_files/267689_3iRY3__uAM1rbYFuJwjra5nUa.pdf (accessed December 28, 2012).

9. The differences between Lund and Meirelles increased when she sued him and the production company for greater recognition in the credits, given that she had been given a minimal and secondary acknowledgment. Daniel Solyszko, "Sucesso de 'Cidade de Deus' gerou disputa de autoria entre os diretores do filme," UOL, August 30, 2012, http://cinema.uol.com.br/ultnot/2012/08/30/sucesso-de-cidade-de-deus-gerou-disputa-de-autoria-entre-os-diretores-do-filme.jhtm (accessed October 31, 2012).

10. The name of this show both refers to CUFA and creates an oxymoronic play of words between the notion of centrality and peripherality. After all, this show about peripheries appears on the most "central" of TV networks.

11. See *Central da Periferia: Minha Periferia é o Mundo*, DVD, produced by Estevão Ciavatta for Rede Globo TV (Rio de Janeiro: Som Livre, 2006). Available with English subtitles at: http://www.youtube.com/watch?v=hJ78j-JKS_4 (accessed on December 9, 2012).

12. See, for example, George Yúdice, "Parlaying Culture into Social Justice," in *The Expediency of Culture: Uses of Culture in the Global Era* (Durham: Duke University Press, 2003).

13. In my view, *Favela Rising* is an overly romanticized filmic representation of this organization's activism, in particular its recourse to the personification of a range of forces in the person of one member of the group.

14. *Afro Reggae Programa de TV, Conexões Urbanas*, June 2, 2008, video clip, Youtube, http://www.youtube.com/watch?v=0ISLJ1zMy50 (accessed December 8, 2012).

15. The "MV" in MV Bill's name stands for *mensageiro da verdade* (messenger of truth).

16. In local slang, *Cabeça de Porco* (Pig's Head), means a tenement building or problems without solution, confusion.

17. *Falcão* or falcon, is the name given to look-outs who alert the drug sellers that the police are entering the favela.

18. You can see the first 9:45 minutes with English subtitles at: http://www.youtube.com/watch?v=XeRVGSLvgnM. The entire documentary is available in Portuguese at http://www.youtube.com/watch?v=w6PWF1u3rhc (accessed December 8, 2012).

19. CliqueMusica, "MV Bill e a polêmica com *Cidade de Deus*," UOL, January 22, 2003, http://cliquemusic.uol.com.br/materias/ver/mv-bill-e-a-polemica-com-i-cidade-de-deus -i- (accessed November 4, 2012).

20. Cinema, "Fernando Meirelles rebate críticas de MV Bill contra *Cidade de Deus*," Cinema, January 23, 2003, http://www.terra.com.br/cinema/noticias/2003/01/24/003.htm (accessed November 4, 2012).

21. Cléber Eduardo, "Cosmética da fome," *Época*, August 26, 2002, http://revistaepoca.globo.com/Epoca/0,6993,EPT373958–1661,00.html (accessed November 4, 2012).

22. Felicia Chan and Valentina Vitali, "Revisiting the 'Realism' of the Cosmetics of Hunger: *Cidade de Deus* and *Ônibus 174*," *New Cinemas: Journal of Contemporary Film* 8, no. 1 (2010): 22.

23. Schroeder, "After New Latin American Cinema," 111–112.

24. City of God is not a favela technically, but a housing project on the periphery of Rio de Janeiro to which residents from various bulldozed favelas in the heart of the city were relocated.

25. Antonia Gama Cardoso de Oliveira Costa, "'Fazendo do nosso jeito': o audiovisual a serviço da 'ressignificação da favela'" (MA Thesis, Pontifícia Universidade Católica, Rio de Janeiro, 2009), 16, http://www.dominiopublico.gov.br/download/texto/cp115625 .pdf (accessed December 8, 2012).

26. Costa, "'Fazendo do nosso jeito,'" 98.

27. Ibid., 77.

28. Marcus Vinícius Faustini, who is featured in the next section of this essay, sees the audiovisual and larger cultural sphere as a site of struggle in which the mainstream seeks to extract innovation from the periphery, with those situated on it increasingly capable of demanding recognition for what they create. See Marcus Vinícius Faustini, "Mobilidade + Juventude" (Mobility + Youth), videoclip, YouTube, http://www.youtube.com/watch?v=6fJ4sm8jsmM (accessed on December 9, 2012).

29. Marcus Vinícius Faustini, *Guia Afetivo da Periferia* (Rio de Janeiro: Aeroplano, 2009). Available for download at: http://www.hotsitespetrobras.com.br/cultura/upload /project_reading/0_Miolo_completo_Guia-Afetivo-Periferia-Miolo-6_online.pdf (accessed on December 9, 2012).

30. See Escola Livre de Cinema, *Escola Livre de Cinema 2011: 5 Anos Inventando o Território com Imagens* (Nova Iguaçu, RJ, in press [provided by Marcus Vinícius Faustini]). You can see how the process works in *Bastidores Iguaçu de Massinha* (2007), a "making of" video of one of the school's animated films about a fictional neighborhood hero named Iguaçu. The "making of" can be seen at http://www. youtube.com/watch?v=TtXO0EtIWHI, and the film itself—*Iguaçu de Massinha* (2007)—is at: http://www.youtube.com/watch?v=BGX-9tOHXNc (accessed on December 9, 2012).

31. http://escolalivredecinema.blogspot.com/ (accessed November 4, 2012).

32. See the school's *Território Periférico* and *Fragmentos de uma trajetória*, two shorts based on Faustini's *Guia Afetivo da Periferia*, the theme of which is precisely the creativity that emerges from the encounter with the city's neighborhoods and people. Respectively http://www.youtube.com/watch?v=MjVzVPU_bo0 and https://www .youtube.com/watch?v=oyJXBGQooWA (accessed on December 9, 2012).

33. See "Escola Livre de Cinema—Nova Iguaçu (RJ). *Sábados Azuis*," directed by Rodrigo Hinrichsen for *Sábados Azuis: Histórias de um Brasil que dá certo*, TV Brasil, 2011, http://www.youtube.com/watch?v=ZlLke5Ohd-E&feature=related (accessed November 4, 2012).

34. Visões Periféricas, http://www.visoesperifericas.org.br/2012/o_festival.html (accessed November 4, 2012).

35. Laboratório Cultura Viva, www.cultura.gov.br/culturaviva/seminario-sobre-audio visual-para-pontos-de-cultura/ (accessed November 4, 2012).

36. Cezar Migliorin, "Por um cinema pós-industrial: Notas para um debate," *Revista Cinética,* February (2011), http://www.revistacinetica.com.br/cinemaposindustrial .htm (accessed on May 21, 2012).

37. Gláuber Rocha, "An Esthetic of Hunger" [1965], in *New Latin American Cinema*, vol. 1, ed. Michael T. Martin (Detroit: Wayne State University Press, 1997), 60.

38. Julio García Espinosa, "For an Imperfect Cinema," in *New Latin American Cinema*, vol. 1, ed. Michael T. Martin (Detroit: Wayne State University Press, 1997), 82.

39. Ibid., 71.

40. An example is the ELC's videoclip *Otro* for the band Macaco Bong, directed by Anderson Barnabé and Cristiane Branz. It was part of four music videos for YouTube produced between May and December, 2011. This and the other videos are available on Fora do Eixo's distributor, DF5, on vimeo, http://vimeo.com/df5. You can view *Macaco Bong—Otro* at http://vimeo.com/35024177 (accessed on December 9, 2012).

41. Fora do Eixo Cineclubs, http://foradoeixo.org.br/clubedecinema/quem-somos (accessed on December 9, 2012).

42. DF5, http://df5.tnb.art.br/ (accessed December 9, 2012).

43. Fora do Eixo is increasingly criticized for taking advantage of the bands and artists who enter their network, for they are often not paid. Many venues will no longer work with them, alleging that they ride roughshod over them, putting their logo on events produced locally, thus acting like a holding company that assumes control. As they grow, they establish close relations with politicians and organizations that benefit politically from the visibility and large number of members in the network that they can deliver. They have sought to portray themselves as a Brazilian Occupy movement, albeit one with strong connections to corporations and political interests. See Regis Argüelles, "O pós-rancor e o velho Estado: uma crítica amorosa à política do Fora do Eixo," *Passa Palavra*, February 4, 2012, http://passapalavra.info/?p=51886 (accessed December 9, 2012) and Shannon Garland, "'The Space, the Gear, and Two Big Cans of Beer': Fora do Eixo and the Debate over Circulation, Remuneration, and Aesthetics in the Brazilian Alternative Market," *Journal of Popular Music Studies* 24, no. 4 (2012).

44. Fernando Solanas and Octavio Getino, exponents of the revolutionary Latin American or third cinema, had spoken of a "film act," although the current practice is hardly imagined as a guerrilla's "gun that can shoot 24 frames per second." See Fernando Solanas and Octavio Getino, "Towards a Third Cinema: Notes and Experiences for the Development of a Cinema of Liberation in the Third World," in *New Latin American Cinema*, vol. 1, ed. Michael T. Martin (Detroit: Wayne State University Press, 1997), 56, 53.

45. Jeff D. Himpele, *Circuits of Culture: Media, Politics and Indigenous Identity in the Andes* (Minneapolis: University of Minnesota Press, 2008), 207.

46. Vincent Carelli, "Another look, a new image," in *Vídeo nas Aldeias 25 anos: 1986–2011*, ed. Ana Carvalho Ziller Araújo, trans. David Radgers (Olinda, PE: Vídeo nas Aldeias, 2011), 198. The two videos mentioned above are included, together with another eight videos, in the two DVDs that accompany the book.

47. Personal communication with Vincent Carelli, São Paulo, December 14, 2010. The report on Carelli's work with Vídeo nas Aldeias in this and the next paragraph is based on this unpublished interview.

48. Karané, Kumaré and Natuyu Yuwipo Txicão, *From the Ikpeng Children-PREVIEW*, videoclip, YouTube, http://www.youtube.com/watch?v=3TOirYOJEt4 (accessed December 9, 2012). The list of film festival awards can be seen on the Vídeo nas Aldeias site at http://www.videonasaldeias.org.br/2009/video.php?c=28 (accessed December 9, 2012).

49. Zezinho Yube and Bebito Pianko, *Troca de Olhares / Exchange of Views* (Hunikui/Ashaninka) (2009), videoclip, YouTube, https://www.youtube.com/watch?v=lRooMqomCJ0 (accessed on December 9, 2012).

50. Oswaldo Carpio, "Cine comunicación y cultura: La experiencia del Grupo Chaski," unpublished (1990), cited in Sophia McLennan, "The Theory and Practice of the Peruvian Grupo Chaski," *Jump Cut* 50 (2008). Available online: http://www.ejumpcut.org/archive/jc50.2008/Chaski/index.html (accessed December 9, 2012).

51. Stefan Kaspar, personal communication, Managua, Meeting of Proyecto Rio, March 8, 2012.
52. Miriam Ross, "Grupo Chaski's Microcines: Engaging the Spectator," *eSharp* 11 (2008): 14, http://www.gla.ac.uk/media/media_81277_en.pdf (accessed on December 9, 2012).
53. Stefan Kaspar, personal communication, Managua, Meeting of Proyecto Rio, March 8, 2012.
54. Marcelo Ikeda, "O 'novíssimo cinema brasileiro': sinais de uma renovação," *Cinémas d'Amérique Latine*, 20 (2012); Cezar Migliorin,"Por um cinema pós-industrial."
55. Bernadette Lyra and Gelson Santana, "Um breve passo pelas bordas do cinema brasileiro," *Revista Filme Cultura*, special issue on *Febre de Cinema*, 53 (2011), http://www.filmecultura.org.br/edicoes/53/pdfs/edicao53_completa.pdf (accessed December 28, 2012).
56. Miguel Alvear and Christian León, *Ecuador bajo tierra: videografías en circulación paralela* (Quito: Editorial Ochoymedio, 2009), http://issuu.com/wchicha/docs/110210_ebt_digital (accessed on December 9, 2012).
57. María José Román, "Mirar la mirada: para disfrutar el audiovisual alternativo y comunitario," *Folios 21 & 22* (2009). http://aprendeenlinea.udea.edu.co/revistas/index.php/folios/article/viewFile/6438/5908 (accessed December 9, 2012).

Notes on Contributors

Alia Arasoughly is director general of Shashat, a women's cinema NGO in Palestine, and curator of its annual "Women's Film Festival in Palestine," the longest running women's film festival in the Arab world. She is also a filmmaker and her directing credits include *Ba`d As-Sama' Al-Akhirah* (*After the Last Sky*, 55 minutes), *The Clothesline* (14 minutes), and *Hay mish Eishi* (*This is not Living*, 45 minutes), which has been translated into five languages and shown at over 100 international film festivals. Alia has worked as an expert trainer and development professional in the area of media and gender on major projects for international organizations such as UNDP, UNFPA, and UNIFEM. She has been responsible for intensive training/production programs for young women filmmakers in the West Bank and Gaza Strip. In 1996 she co-organized and co-curated, with the Film Society of Lincoln Center, the landmark five-week-long festival, Centennial of Arab Cinema. She also co-organized the First Retreat between Arab women filmmakers and Arab critics in Casablanca, Morocco, in 1997. Alia has taught and lectured internationally on issues of postcolonialism, gender, and national identity in Arab cinemas. She has received prestigious academic fellowships from the Fulbright Program, the Andrew W. Mellon Foundation, and the Ford Foundation.

Nicholas Balaisis is lecturer in Cultural Studies at Trent University in Peterborough, Canada. He recently completed a PhD in Communication and Culture at York University, Toronto, writing a dissertation on cinema, spectatorship, and the Cuban public sphere. His research interests include globalization and the transnational flow of images; media and the reshaping of urban space; melodrama; film and the public sphere; and mobile media. In connection with the latter, he has written about the history of mobile cinema exhibition in Cuba and plans a comparative study of mobile cinema in rural China. Nicholas serves on the Board of Directors and Programming Committee of the Regent Park Film Festival, a free multicultural film festival serving the residents of the Regent Park neighborhood in Toronto, the oldest and largest public housing development in Canada. He is also co-investigator of the Visible City Project + Archive at York University and has published journal articles in *Cineaction*, *Public*, and *Canadian Journal of Film Studies*.

Anton Basson holds a cum laude MA in Literature from the University of the Witwatersrand in Johannesburg. He is the head of Curriculum Development

at the South African School of Motion Picture Medium and Live Performance (AFDA). A playwright, poet, lyricist, and short story writer, he taught linguistics and narrative at a number of universities in Johannesburg before joining AFDA as lecturer in Scriptwriting and in various leadership capacities.

Gerda Dullaart chairs the Academic Standards Council at the AFDA film school in Johannesburg and Cape Town and lectures on Film Narrative and on Research Methodology. Gerda worked in journalism, copywriting, and script doctoring before joining AFDA in 2003. She wrote her PhD thesis on curriculum objectives for skills and attitudes useful to BA graduates pursuing film and media careers.

Armida de la Garza is associate professor in Communication and Media at Xi'an Jiaotong-Liverpool University. She is also co-editor of the *Transnational Cinemas* journal (Bristol: Intellect). As a researcher, she is interested in film and its relation to cultural identity, especially national identity, and in audience reception. She has published essays on the links between documentary and diaspora (in Miriam Haddu and Joanna Page, *Visual Synergies: Fiction and Documentary Filmmaking in Latin America*, Palgrave, 2009) and realism in Latin American cinema (in Lúcia Nagib and Cecília Mello, *Realism in the Audiovisual Media*, Palgrave, 2009). She is currently working on a collaborative research project entitled *Transnational Cinema in Globalising Societies: Asia and Latin America*. The focus is on those films that are produced for the global market but still sold as national productions, and on the ways in which audiences engage with them in their countries of origin to make sense of their identity.

Mette Hjort is associate vice president and chair professor of Visual Studies at Lingnan University, where she is also director of the Centre for Cinema Studies. She is affiliate professor of Scandinavian Studies at the University of Washington, Seattle, and adjunct professor at the Centre for Modern European Studies, University of Copenhagen. She is the author of *The Strategy of Letters* (Harvard University Press, 1993), *Small Nation, Global Cinema* (University of Minnesota Press, 2005), *Stanley Kwan's "Center Stage"* (Hong Kong University Press, 2006), and *Lone Scherfig's "Italian for Beginners"* (University of Washington Press, 2010). She is the editor or co-editor of a number of books, including, most recently, *Film and Risk* (Wayne State University Press, 2012), and *Creativity and Academic Activism: Instituting Cultural Studies* (with Meaghan Morris; Hong Kong University Press, 2012). A third volume in a series of interview books with Danish directors is forthcoming as *Danish Directors 3: Dialogues on the New Danish Documentary Cinema* (with Ib Bondebjerg and Eva Novrup Redvall; Intellect, 2013). Mette Hjort is foundation fellow of the Hong Kong Academy of the Humanities. She co-edits the Nordic Film Classics Series with Peter Schepelern for the University of Washington Press and Museum Tusculanum.

Scott MacKenzie is author of *Screening Québec: Québécois Moving Images, National Identity and the Public Sphere* (Manchester University Press, 2004) and *Guy Debord* for the French Filmmakers Series (Manchester University Press, forthcoming). He is also co-editor of *Cinema and Nation* (with Mette Hjort; Routledge, 2000), *Purity and Provocation: Dogma 95* (with Mette Hjort;

BFI, 2003) and *The Perils of Pedagogy: The Films and Videos of John Greyson* (with Brenda Longfellow and Thomas Waugh; McGill-Queens University Press, forthcoming). He is co-investigator of the Visible City Project + Archive at York University and has published in such journals as *Cineaction, Public, Canadian Journal of Film Studies,* and *Screen.*

Christopher Meir is lecturer in Film at the University of the West Indies, St. Augustine in Trinidad and Tobago, where he has been teaching since 2008. He completed a PhD project at the University of Warwick on the production and international circulation of Scottish cinema. He is currently preparing a manuscript based on his doctoral thesis for Manchester University Press and working on a comparative study of the film industries of the nations of the Commonwealth.

Toby Miller is professor of Cultural Industries in the Centre for Cultural Policy and Management at the City University of London. He is the author of numerous books, including *The Well-Tempered Self: Citizenship, Culture, and the Postmodern Subject* (The Johns Hopkins University Press, 1993), *Contemporary Australian Television* (with Stuart Cunningham; University of New South Wales Press, 1994), *The Avengers* (BFI, 1997/Indiana University Press, 1998), *Technologies of Truth: Cultural Citizenship and the Popular Media* (University of Minnesota Press, 1998), *Popular Culture & Everyday Life* (with Alec McHoul; Sage, 1998), *Global Hollywood* (with Nitin Govil, John McMurria, and Richard Maxwell; BFI/University of California Press, 2001) and *Cultural Policy* (with George Yúdice; Sage, 2002). His edited or co-edited books include *SportCult* (with Randy Martin; University of Minnesota Press, 1999), *A Companion to Film Theory* (with Robert Stam; Blackwell, 1999), *Film and Theory: An Anthology* (with Robert Stam; Blackwell, 2000), *A Companion to Cultural Studies* (Blackwell, 2001). His most recent books are *Greening the Media* (Oxford University Press, 2012), with Richard Maxwell, and *Blow Up the Humanities* (Temple University Press, 2012). His work can be followed at tobymiller.org.

Hamid Naficy is the John Evans Professor of Communication, teaching screen cultures courses in the Department of Radio, Television, and Film, at Northwestern University. His areas of research and teaching include documentary and ethnographic films; cultural studies of diaspora, exile, and postcolonial cinemas and media; and Iranian and Middle Eastern cinemas. He has published extensively on these and related topics. His English language books are: *Iran Media Index* (Greenwood Press, 1984), *The Making of Exile Cultures: Iranian Television in Los Angeles* (University of Minnesota Press, 1993), *An Accented Cinema: Exilic and Diasporic Filmmaking* (Princeton University Press, 2001), *Home, Exile, Homeland: Film, Media, and the Politics of Place* (edited, Routledge, 1998), *Otherness and the Media: the Ethnography of the Imagined and the Imaged* (co-edited, Harwood Academic, 1993), and, most recently, the four-volume project entitled *A Social History of a Century of Iranian Cinema* (Duke University Press, 2011–2012). He has also published extensively in Persian, including a two-volume book on the theory and history of documentary cinema, *Film-e Mostanad* (*Entesharate-e Daneshgah-eAzad-e Iran, 1978*). He has lectured widely internationally and his

works have been cited and reprinted extensively and translated into many languages, including French, German, Turkish, Italian, and Persian.

Osakue Stevenson Omoera is lecturer at the Department of Theatre and Media Arts at Ambrose Alli University, Ekpoma, Edo State, Nigeria, where he currently coordinates the Students' Industrial Work Experience Scheme. He is an exponent of the Benin video film aspect of Nollywood studies and has abiding academic interests in Media Sociology, Nollywood/Benin Video Film, Theater for Development, and African Cultural and Performance Studies.

Rod Stoneman is director of the Huston School of Film & Digital Media at the National University of Ireland, Galway. He was chief executive of Bord Scannán na hÉireann / The Irish Film Board until September 2003 and previously deputy commissioning editor in the Independent Film and Video Department at Channel 4 Television. He has made a number of documentaries including *Ireland: The Silent Voices* (1983), *Italy: the Image Business* (1984), *12,000 Years of Blindness* (2007), and *The Spindle: How Life Works* (2009), and has written extensively on film and television. He is the author of *Chávez: The Revolution Will Not Be Televised: A Case Study of Politics and the Media* (Wallflower, 2008) and *Seeing is Believing: The Politics of the Visual* (Black Dog Publishing, 2013). He is the co-editor, with Seán Crosson, of *The Quiet Man...and Beyond: Reflections on a Classic Film, John Ford and Ireland* (Liffey Press, 2009) and of *Scottish Cinema Now*, with Jonathan Murray and Fidelma Farley (Cambridge Scholars Publishing, 2009).

Keyan Tomaselli is senior professor and director in the Centre for Communication, Media and Society, University of KwaZulu-Natal, Durban. He is co-editor of *Journal of African Cinemas*, editor of *Critical Arts: A Journal for Cultural Studies*, and author of *Encountering Modernity: 20th Century South African Cinemas* (Rozenberg, 2006) and *The Cinema of Apartheid: Race and Class in South African Film* (Routledge, 1989). He has produced numerous videos screened on South African television and is a member of the AFDA MFA Advisory Board and a corresponding member of CILECT. Tomaselli co-wrote the *Film Development Strategy—the White Paper on Film* (1996). He served as the chair of the SA Film and TV Technicians Association in the late 1970s and early 1980s. He has taught cinema studies at three South African and at two US universities.

George Yúdice is professor of Modern Languages and Literatures, and Latin American Studies, at the University of Miami. His research interests include new aesthetic phenomena in the digital age; globalization and transnational processes; the role of intellectuals, artists, and activists in national and transnational institutions; contemporary Central America; and cultural policy. In connection with the latter, he has formed the Miami Observatory on Communication and Creative Industries, which brings together researchers from UM and FIU (Florida International University). He is the author of *Vicente Huidobro y la motivación del lenguaje poético* (Galerna, 1977); *Cultural Policy*, co-authored with Toby Miller (Sage, 2002), in Spanish, *Política Cultural* (Gedisa, 2004); *El recurso de la cultura* (Gedisa, 2003), in English *The Expediency of Culture* (Duke University

Press, 2004), and Portuguese *A Conveniência da Cultura* (Editora da UFMG); *Nuevas tecnologías, música y experiencia* (Gedisa, 2007), and *Culturas emergentes en el mundo hispano de Estados Unidos* (Fundación Alternativas, 2009). He has in progress *Culture and Value: Essays on Latin American Literarature and Culture* and *Cultura y política cultural en América Central: 1990 a 2012* (Editorial de la Universidad de Costa Rica). He is also co-editor (with Jean Franco and Juan Flores) of *On Edge: The Crisis of Contemporary Latin American Culture* (University of Minnesota Press, 1992).

Bibliography

"A Conversation with Patricia Meyer about Producing, Screenwriting, Women of Brewster Place, Oprah." *culturalstudies.* http://culturalstudies.podbean.com /2011/05/01/a-conversation-with-patricia-meyer-about-producing-screenwriting-women-of-brewster-place-oprah/ (accessed December 6, 2012).

Aad, Serena Abi. "Thinking Outside the Box." In *Viewpoints Special Edition—State of the Arts Volume VI. Creative Arab Women*, 33–34. Washington, DC: The Middle East Institute, 2010.

Abani, C., O. Igbuzor, and J. Moru. "Attaining the Millennium Development Goals in Nigeria: Indicative Progress and a Call for Action." In *Another Nigeria is Possible: Proceedings of the First Nigerian Social Forum*, edited by J. Moru, 1–13. Abuja: Nigerian Social Forum, 2005.

Abu Maalla, Said, Rima Nazzal, and Alia Arasoughly, eds. *Eye on Palestinian Women's Cinema*. Ramallah: Shashat, 2013.

Ademiluyi, I. A. and O. A. Dina. "The Millennium Development Goals and the Sustainable Future for Nigeria's Urban Environment: A Railway Strategy." *Journal of Human Ecology* 33, no. 3 (2011): 203–209.

Afro Reggae Programa de TV, Conexões Urbanas, June 2, 2008. Video clip, YouTube. http://www.youtube.com/watch?v=0ISLJ1zMy50 (accessed December 9, 2012).

Agheyisi, Rebecca N. *An Edo-English Dictionary*. Benin City: Ethiope Publishing Corporation, 1986.

Ajibade, Babson. "From Lagos to Douala: The Video Film and its Spaces of Seeing." *Postcolonial Text* 3, no. 2 (2007): 1–14. http://postcolonial.org/index.php/pct/article /view/524/418 (accessed January 7, 2012).

Aldridge, Meryl. *Understanding the Local Media*. Maiden Head, Berkshire: Open University Press, 2007.

Alea, Tomás Gutiérrez. "The Viewer's Dialectic." In *New Latin American Cinema Volume One*, edited by Michael T. Martin, 108–131. Detroit: Wayne State University Press, 1997.

Allen, Linn. *"Schools Fear Waning Interest in Study Abroad." Chicago Tribune November 1 (2001)*: 2c1. http://search.proquest.com/docview/419470517/13A89FADC0676CF69E9 /16?accountid =12861 (accessed December 4, 2012).

Althouse, Rosemary, Margaret H. Johnson, and Sharon T. Mitchell. *The Colours of Learning: Integrating the Visual Arts into the Early Childhood Curriculum*. New York: Teacher's College Press, Columbia University, 2003.

Alvear, Miguel and Christian León. *Ecuador bajo tierra: videografías en circulación paralela*. Quito: Editorial Ochoymedio, 2009. http://issuu.com/wchicha/docs/110210 _ebt_digital (accessed December 9, 2012).

Andersen, Robin. "Bush's Fantasy Budget and the Military/Entertainment Complex." *PRWatch*, February 12, 2007. prwatch.org/node/5742 (accessed December 11, 2012).

Anderson, Benedict. *Imagined Communities: Reflections on the Origin and Spread of Nationalism* (new edition). New York: Verso, 2006.

Anderson, John. "The 'Invisible Art': A Woman's Touch Behind the Scenes." *New York Times*, May 27, 2012.

Anderson, Peter. "The Tiakeni Report: The Maker and the Problem of Method in Documentary Video Production." *Critical Arts* 4, no. 1 (1985): 1–79.

Appelo, Tim. "The 25 Best Film School Rankings." *Hollywood Reporter*, July 27, 2011. http://www.hollywoodreporter.com/news/25-best-film-schools-rankings-215714 (accessed December 6, 2012).

Arasoughly, Alia and Dalia Taha, eds, *Palestinian Women Filmmakers—Strategies of Re-presentation and Conditions of Production*. Ramallah: Shashat, 2013.

Argüelles, Regis. "O pós-rancor e o velho Estado: uma crítica amorosa à política do Fora do Eixo," *Passa Palavra*, February 4, 2012. http://passapalavra.info/?p=51886 (accessed December 9, 2012).

Astruc, Alexandre. "The Birth of a New Avant-Garde: *La caméra-stylo*." In *The New Wave: Critical Landmarks*, edited by Peter Graham, 17–23. London: Secker and Warburg, 1968.

Atchison, Mary, Sarah Pollock, Ern Reeders, and Janine Rizzetti. *Guide to Work-Integrated Learning*. Melbourne: RMIT, 1999.

Avila Pietrasanta, Irma. *Apantallad@s: Manual de Educación para los Medios y Derechos de la Comunicación en Radio y Video para Niños*. Mexico: Comunicación Comunitaria, 2011.

Balaisis, Nicholas. "Cuba, Cinema, and the Post-Revolutionary Public Sphere." *Canadian Journal of Film Studies* 19, no. 2 (2010): 26–42.

Ballantyne, Tammy, Angélique Saverino, Xoliswa Sithole, Florence Mukanga and Mike van Graan, compilers. *Arterial Network Arts and Culture Information Directory 2011*. Cape Town: Arterial Network, 2011. http://www.arterialnetwork.org/uploads/2011/09 /Arterial_Network_Directory_2011_(1).pdf (accessed January 7, 2012).

Banks, Miranda and Ellen Seiter. "Spoilers at the Digital Utopia Party: The WGA and Students Now." *Flow* 7, no. 4 (December 7, 2007). http://flowtv.org/2007/12/spoilers-at -the-digital-utopia-party-the-wga-and-students-now/ (accessed December 7, 2012).

Bar, François, with Caroline Simard. "From Hierarchies to Network Firms." In *The Handbook of New Media: Updated Students Edition*, edited by Leah Lievrouw and Sonia Livingstone, 350–63. Thousand Oaks: Sage, 2006.

Barthes, Roland. *Camera Lucida*. New York: Hill and Wang, 1981.

Beard, Colin. *The Experiential Learning Toolkit: Blending Practice with Concepts*. London: Kogan Page, 2010.

Bell, Daniel. "The Future World Disorder: The Structural Context of Crises." *Foreign Policy* 27 (1977): 109–35.

Benjamin, Walter. "Theses on the Philosophy of History." In *Illuminations: Essays and Reflections*, edited by Hannah Arendt, translated by Harry Zohn, 249–255. New York: Schocken, 1969.

Berlin, Isaiah. "Two Concepts of Freedom." In *Liberty: Incorporating Four Essays on Liberty*, edited by Henry Hardy, 166–217. Oxford: Oxford University Press, 2002.

Berrett, Dan. "Humanities, for Sake of Humanity." *Inside Higher Ed*, March 30, 2011. http://www.insidehighered.com/news/2011/03/30/scholars_seek_to_craft_argument _for_urgency_of_the_humanities_in_higher_education (accessed December 7, 2012).

Biggs, John. *Teaching for Quality Learning at University: What the Student Does?* Buckingham, UK: Open University Press and Society for Research into Education, 1999.

Blignaut, Johan and Martin Botha, eds. *Movies—Moguls—Mavericks: South African Cinema, 1979–1991.* Cape Town: Showdata, 1992.

Block, Bruce. *The Visual Story.* Oxford: Focal Press, 2008.

Bobker, Lee R. *Elements of Film.* New York: Harcourt Brace and World, 1969.

Boorman, John, Fraser MacDonald and Walter Donahue, eds. *Projections 12: Film-makers on Film Schools.* London: Faber and Faber, 2002.

Botha, Martin P. "New Directing Voices in South African Cinema." *Kinema.* http://www.kinema.uwaterloo.ca/article.php?id=58&feature#ViewNotes_17 (accessed December 17, 2012).

———. "The Song Remains the Same: The Struggle for a South African Film Audience, 1960–2005." *CILECT News,* 43 (December 2005): 17–24.

———. *South African Cinema, 1986–2010.* Bristol, UK: Intellect Books, 2012.

Bragg, Sarah. "'Student Voice' and Governmentality: The Production of Enterprising Subjects?" *Discourse: Studies in the Cultural Politics of Education* 28, no. 3 (2007): 343–358.

Bray, Mark and Steve Packer. *Education in Small States: Concepts, Challenges, and Strategies.* Oxford, England and New York: Pergamon Press, 1993.

Breleur, Ernest, Patrick Chamoiseau, Serge Domi, Gérard Delver, Edouard Glissant, Guillaume Pigeard de Gurbert, Olivier Portecop, Olivier Pulvar and Jean-Claude William. "Plea for Products of High Necessity." Originally published in *Le Monde,* February 16, 2009. Available from *L'Humanité in English.* http://www.humaniteinenglish.com/spip.php?article1163 (accessed December 18, 2012).

Brennan, John and Brenda Little. *A Review of Work Based Learning in Higher Education.* Sheffield: Department for Education and Employment, Great Britain, 1996.

Brenner, Philip, Marguerite Rose Jiménez, John M. Kirk, and William M. LeoGrande, eds. *Reinventing the Revolution: A Contemporary Cuba Reader.* Plymouth UK: Rowman and Littlefield, 2008.

Bro, Arne. "Exchange Program for Documentary Film Makers from Iran / Syria / Lebanon / Egypt / Libya / Tunisia / Morocco / Denmark – Investigating: One (Wo)man / One Camera / One Voice." Copenhagen: The National Film School of Denmark, 2012.

Bro, Arne, Karin P. Worsøe, and Max Kestner. "Destination Beirut: One Woman / One Camera / One Sound." Copenhagen: The National Film School of Denmark, 2010.

Bro, Arne, Karin P. Worsøe, and Helle Pagter. "Destination Beirut: One Woman / One Camera / One Sound." Copenhagen: The National Film School of Denmark, 2009.

Bro, Arne, Mette-Ann Schepelern, and Louise Kjær. "Moderne sprog i Mellemøsten / Unge kunstnere i Den Arabiske Verden." (Modern Languages in the Middle East / Young Artists in The Arab World). Copenhagen: The National Film School of Denmark, 2006.

Bro, Arne and Mette-Ann Schepelern. "Moderne sprog i Mellemøsten / Unge kunstnere i Den Arabiske Verden." (Modern Languages in the Middle East / Young Artists in The Arab World). Copenhagen: The National Film School of Denmark, 2008.

Brzezinski, Zbigniew. *Between Two Ages: America's Role in the Technotronic Era.* New York: Viking Press, 1969.

Burch, Noël. *Theory of Film Practice.* London: Secker and Warburg, 1973.

Burston, Jonathan. "War and the Entertainment Industries: New Research Priorities in an Era of Cyber-Patriotism." In *War and the Media: Reporting Conflict 24/7,* edited by Daya Kishan Thussu and Des Freedman, 163–175. London: Sage Publications, 2003.

Burton, Julianne. "Democratizing Documentary: Modes of Address in the New Latin American Cinema, 1958–1972." In *The Social Documentary in Latin America,* edited by Julianne Burton, 77–86. Pittsburgh: University of Pittsburgh Press, 1990.

Cajueiro, Marcelo. "Brazil hosts Yank shoot." *Variety*, October 17–23, 2005, 19.

Campbell, Clayton. "Creative Communities and Emerging Networks." In *Cultural Expression, Creativity & Innovation*, edited by Helmut Anheier and Yudhishthir Raj Isar, 188–198. London: Sage Publications Ltd., 2010.

Camre, Henning. "Preface." DVD set entitled *Arab Institute for Film*. n.d.

Canclini, Néstor García. *Diferentes, desiguales y desconectados: Mapas de la interculturalidad*. Barcelona: Editorial Gedisa, 2004.

Carelli, Vincent. "Another Look, a New Image." In *Vídeo nas Aldeias 25 anos: 1986–2011*, edited by Ana Carvalho Ziller Araújo, translated by David Radgers, 197–200. Olinda, PE, Brazil: Vídeo nas Aldeias, 2011.

Carpio, Oswaldo. "Cine Comunicación y Cultura: La experiencia del Grupo Chaski." Unpublished (1990). Cited in Sophia McLennan, "The Theory and Practice of the Peruvian Grupo Chaski." *Jump Cut* 50 (2008). http://www.ejumpcut.org/archive /jc50.2008/Chaski/index.html (accessed December 9, 2012).

Castoriadis, Cornelius. *The Imaginary Institution of Society*. Cambridge: Polity Press, 1987.

Central da Periferia: Minha Periferia é o Mundo. DVD. Produced by Estevão Ciavatta for Rede Globo TV. Rio de Janeiro: Som Livre, 2006. Available with English subtitles at: http://www.youtube.com/watch?v=hJ78j-JKS_4 (accessed December 9, 2012).

Centre for Cinema Studies. Lingnan University. http://www.ln.edu.hk/ccs/

Centre for World Indigenous Studies. *International Day of the World's Indigenous Peoples—Celebrating Indigenous Filmmaking*. New York: United Nations, 2010. http:// www.un.org/en/events/indigenousday/ (accessed December 20, 2012).

Centre International de Liaison des Ecoles de Cinéma et de Télévision. "The AFDA Master of Fine Arts, Johannesburg." *CILECT News* 43 (December 2005): 14–16.

Chan, Felicia and Valentina Vitali. "Revisiting the 'Realism' of the Cosmetics of Hunger: *Cidade de Deus* and *Ônibus 174*." *New Cinemas: Journal of Contemporary Film* 8, no. 1 (2010): 15–30.

Chartier, Roger. "Aprender a leer, leer para aprender." *Nuevo Mundo / Mundos Nuevos*, February 1, 2010. http://nuevomundo.revues.org/58621 (accessed December 7, 2012).

Chmielewski, Dawn C. "Poptent's Amateurs Sell Cheap Commercials to Big Brands." *Los Angeles Times*, May 8, 2012. http://articles.latimes.com/2012/may/08/business /la-fi-ct-poptent-20120508 (accessed December 7, 2012).

Cieply, Michael. "A Film School's New Look is Historic." *New York Times*, February 9, 2009.

———. "For Film Graduates, an Altered Job Picture." *New York Times*, July 4, 2011.

CILECT Conference 2011. Exploring the Future of Film and Media Education. http:// cilect.org/posts/view/114.

CILECT. The International Association of Film and TV Schools. http://cilect.org/.

Cinema. "Fernando Meirelles rebate críticas de MV Bill contra *Cidade de Deus*." Cinema, January 23, 2003. http://www.terra.com.br/cinema/noticias/2003/01/24/003.htm (accessed November 4, 2012).

Citron, Michelle and Ellen Seiter. "The Woman with the Movie Camera." *Jump Cut: A Review of Contemporary Media* 26 (1981): 61–62.

Cizek, Katerina and Liz Miller, "Filmmaker-in Residence: The Digital Grandchild of Challenge for Change." In *Challenge for Change: Activist Documentary at the National Film Board*, edited by Thomas Waugh, Michael Brenan Baker, and Ezra Winton, 427–442. Montreal: McGill-Queen's University Press, 2010.

CliqueMusica. "MV Bill e a polêmica com *Cidade de Deus*." UOL, January 22, 2003. http://cliquemusic.uol.com.br/materias/ver/mv-bill-e-a-polemica-com-i-cidade-de-deus-i- (accessed November 4, 2012).

Cohen, Jodi. "Northwestern Expanding to Mideast." *Chicago Tribune* (November 8, 2007). http://articles.chicagotribune.com/2007-11-08/news/0711070611_1_middle-east-al-jazeera-journalism (accessed December 7, 2012).

Cohen, Patricia. "In Tough Times, the Humanities Must Justify their Worth." *New York Times*, February 24, 2009. http://www.nytimes.com/2009/02/25/books/25human.html (accessed December 6, 2012).

Colina, Enrique and Daniel Diaz Torres. "Ideology of Melodrama in the Old Latin American Cinema." In *Latin American Filmmakers and the Third Cinema*, edited by Zuzana Pick, 46–69. Ottawa: Carleton University Film Program, 1978.

Comunicación Comunitaria. http://www.comunicacioncomunitaria.org/ (accessed May 20, 2012).

Costa, Antonia Gama Cardoso de Oliveira. "'Fazendo do nosso jeito': o audiovisual a serviço da 'ressignificação da favela'." MA Thesis, Pontifícia Universidade Católica, Rio de Janeiro, 2009. http://www.dominiopublico.gov.br/download/texto/cp115625.pdf (accessed December 8, 2012).

Cotera, Liset. Interview by Armida de la Garza, about *La Matatena*: Origins, Mission, Perspectives, July 20, 2011.

Cotera, Liset. "Altas Dosis de Cine para Niños." *Toma, Revista Mexicana de Cine* (Paso de Gato), May-June (2010): 72–73.

Crawford, Lawrence. "Viktor Shklovskij: Différance in Defamiliarization." *Comparative Literature* 36 (1984): 209–219.

Danish Center for Culture and Development (DCCD). "Danfaso Culture and Development Programme for Burkina Faso, 2011–2013." http://www.cku.dk/wp-content/uploads/DANFASO-Culture-and-Development-Programme-for-Burkina-Faso.pdf.

Danish Film Institute (FILMupdate). "Filmskolens TV-uddannelse fylder 20 aar" (The Film School's TV program is 20 Years Old). www.dfi.dk/Nyheder/FILMupdate/2012/november/Filmskolens-TV-Uddanelse- (accessed November 27, 2012).

David, Liliana. "Corto michoacano, ganador de concurso latinoamericano de cine infantil y juvenil." *La Voz de Michoacán*, 2008.

Davids, Alex. "Film as Art at UCT." *The SAFTTA Journal* 1, no. 2 (1980): 24–27.

de Beauvoir, Simone. *The Second Sex*, translated by Constance Borde and Sheila Malovany-Chevalier. New York: Vintage Books, 2011.

de Sola Pool, Ithiel. *Technologies of Freedom*. Cambridge, MA: Harvard University Press, 1983.

de Valck, Marijke. "Drowning in Popcorn at the International Film Festival Rotterdam? The Festival as Multiplex Cinephilia." In *Cinephilia: Movies, Love and Memory*, edited by Marijke de Valck and Malte Hagener, 97–109. Amsterdam: Amsterdam University Press, 2005.

———. "Sites of Initiation: Film Training Programs at Film Festivals." In *The Education of the Filmmaker in Europe, Australia, and Asia*, edited by Mette Hjort, 127–145. New York: Palgrave Macmillan, 2013.

Deck, Andy. "No Quarter: Demilitarizing the Playground." Art Context (2004). http://artcontext.org/crit/essays/noQuarter (accessed December 7, 2012).

DeLillo, Don. *White Noise*. London: Picador, 1986.

Delson, Jennifer. "$2-Million Gift to UC Irvine Will Fund Center for Persian Studies and Culture." *Los Angeles Times* (April 22, 2005): B8.

Desrochers, Donna M., Colleen M. Lenihan, and Jane V. Wellman. *Trends in College Spending 1998–2008: Where Does the Money Come From? Where Does It Go?* Washington, DC: Delta Cost Project / Lumina Foundation for Education, 2010.

Dewey, John. *Experience and Education.* New York: Macmillan, 1938.

———. *Experience and Education.* New York: Touchstone, [1938] 1997.

Diallo, Siradiou. "African Cinema is Not a Cinema of Folklore." In *Ousmane Sembene: Interviews,* edited by Annette Busch and Max Annas, 52–62. Jackson, MS: University of Mississippi, 2008.

DOX:LAB. "Filmmaker Rania M. Tawfik, Denmark" (2011 / 2012). http://www.cphdox.dk/doxlab/dir.lasso?n=52 (accessed June 30, 2012).

du Plooy, Gertruida and Pieter J. Fourie. "Film and Television Training at the Dept. of Communication at UNISA." *The SAFTTA Journal* 1, no. 2 (1980): 20–23.

Dubinsky, Karen, Catherine Krull, Susan Lord, Sean Mills, and Scott Rutherford, eds. *New World Coming: The Sixties and the Shaping of Global Consciousness.* Toronto: Between the Lines, 2009.

Dyer-Witheford, Nick and Greig S. de Peuter. *Games of Empire: Global Capitalism and Video Games.* Minneapolis: University of Minnesota Press, 2009.

Dynamics of World Cinema project. http://www.st-andrews.ac.uk/worldcinema/.

Early, Gerald. "The Humanities & Social Change." *Daedalus* 138, no. 1 (2009): 52–57.

Edgar, Tom and Karin Kelly. *Film School Confidential: Get In. Make It Out Alive.* New York: Perigee, 1997.

Eduardo, Cléber. "Cosmética da fome." *Época,* August 26, 2002. http://revistaepoca.globo.com/Epoca/0,6993,EPT373958-1661,00.html (accessed November 4, 2012).

Egharevba, Jacob U. *A Short History of Benin.* Benin City: Fortune and Temperance Publishing Company, 2005.

Ekwuazi, Hyginus. "Nigerian Literature and the Development of the Nigerian Film Industry." *Ijota: Ibadan Journal of Theatre Arts* 1, no. 1 (2007): 130–139.

———. "Perspectives on the Nigerian Motion Picture Industry." In *Making the Transition from Video to Celluloid,* edited by Ekwuazi Hyginus, Mercy Sokomba, and Onyero Mgbejume, 3–11. Jos: National Film Institute, 2001.

El Ouargui, Najat. "Cultural Creativity: Catalyst for Social Development." In *Viewpoints Special Edition—State of the Arts Volume VI: Creative Arab Women,* 26–27. Washington, DC: The Middle East Institute, 2010.

Ellin, Abby. "Failure is Not an Option." *New York Times,* April 13, 2012.

El-Nawawy, Mohammed and Adel Iskandar. *Al-Jazeera: How the Free Arab News Network Scooped the World and Changed the Middle East.* Cambridge, MA: Basic Books, 2002.

Elster, Jon. *Ulysses Unbound: Studies in Rationality, Precommitment, and Constraints.* Cambridge: Cambridge University Press, 2000.

Emielu, Austin. "Music and National Development: A Reflection on Academic and 'Street' Musicianship in Nigeria." *The Performer: Ilorin Journal of the Performing Arts* 10 (2008): 95–107.

Enegho, Felix E. "Philosophy as a Tool for Sustainable Development in Nigeria." *Enwisdomization Journal* 4, no. 3 (2010): 1–13.

Escola Livre de Cinema. "Bastidores Iguaçu de Massinha" (2007). Videoclip, YouTube. http://www.youtube.com/watch?v=TtXO0EtIWHI (accessed December 9, 2012).

———. "Fragmentos de uma trajetória" (2010). Videoclip, YouTube. https://www.youtube.com/watch?v=oyJXBGQooWA (accessed December 9, 2012).

———. "Iguaçu de Massinha" (2007). Videoclip, YouTube. http://www.youtube.com/watch?v=BGX-9tOHXNc (accessed on December 9, 2012).

———. "Território Periférico" (2010). Videoclip, YouTube. http://www.youtube.com /watch?v=MjVzVPU_bo0 (accessed December 9, 2012).

———. *Escola Livre de Cinema 2011: 5 Anos Inventando o Território com Imagens.* Nova Iguaçu, RJ, in press.

"Escola Livre de Cinema—Nova Iguaçu (RJ); Sábados Azuis." Directed by Rodrigo Hinrichsen for "Sábados Azuis: Histórias de um Brasil que dá certo," TV Brasil, 2011. Videoclip, YouTube. http://www.youtube.com/watch?v=ZlLke5Ohd-E&feature=relat ed (accessed November 4, 2012).

Escuela Internacional de Cine y TV (EICTV). *2011 Assessment* (paper document). San Antonio de los Baños: EICTV, 2011.

———. *2011 Official Brochure* (paper document). San Antonio de los Baños: EICTV, 2011.

———. *2011–12 Plan de Estudios, Humanidades* (paper document). San Antonio de los Baños: EICTV, 2011.

Espinosa, Julio Garcia. "For an Imperfect Cinema." In *Film and Theory*, edited by Robert Stam and Toby Miller, 287–297. Malden, MA: Blackwell, 2000.

Fafunwa, Babs F. *History of Education in Nigeria.* Ibadan: NPS Educational Publishers, 2002.

Faustini, Marcus Vinícius. "Mobilidade + Juventude." Videoclip, YouTube. http://www. youtube.com/watch?v=6fJ4sm8jsmM (accessed December 9, 2012).

———. *Guia Afetivo da Periferia.* Rio de Janeiro: Aeroplano, 2009. http://www .hotsitespetrobras.com.br/cultura/upload/project_reading/0_Miolo_completo_Guia -Afetivo-Periferia-Miolo-6_online.pdf (accessed December 9, 2012).

Filiu, Jean-Pierre. *The Arab Revolution.* London: C. Hurst and Co., 2011.

Fithian, John. "CinemaCon State of the Industry." Speech given at the CinemaCon 2012, Las Vegas, NV, US, April 24, 2012. http://www.natoonline.org/pdfs/JF%20Speech%20 -%20CinemaCon%202012%20-%20Distribution%20Version.pdf (accessed December 6, 2012).

Fourie, Pieter J. *Aspects of Film and Television Communication.* Cape Town: Juta, 1998.

Freire, Paulo. *Pedagogy of Hope.* London and New York: Continuum, 2004.

———. *Pedagogy of the Opressed*, translated by Myra Bergman Ramos. London: Penguin, 1996.

Frow, John. "Cultural Studies and the Neoliberal Imagination." *Yale Journal of Criticism* 12, no. 2 (1999): 424–430.

Galal, Hala. "Creativity in Disclosing Injustice." In *Viewpoints Special Edition—State of the Arts Volume VI: Creative Arab Women*, 35–36. Washington, DC: The Middle East Institute, 2010.

García Espinosa, Julio. "For an Imperfect Cinema." In *New Latin American Cinema*, vol. 1, edited by Michael T. Martin, 71–82. Detroit: Wayne State University Press, 1997.

Garland, Shannon. "'The Space, the Gear, and Two Big Cans of Beer': Fora do Eixo and the Debate over Circulation, Remuneration, and Aesthetics in the Brazilian Alternative Market." *Journal of Popular Music Studies* 24, no. 4 (2012): 509–531.

Gehman, Chris. "The Independent Imaging Retreat: Program Notes for the Hanover Civic Centre." Phil Hoffman website, September 20, 2003. http://philiphoffman.ca/ film/publications/Film%20Farm%20folder/The%20Independent%20Imaging%20 Retreat.htm (accessed June 26 2012).

George Mason University. "Ras Al-Khaimah Campus in the United Arab Emirates." George Mason University. http://rak.gmu.edu/ (accessed December 5, 2012).

Gibson, James. "The Theory of Affordances." In *Perceiving, Acting, and Knowing: Toward an Ecological Psycholgy*, edited by Robert Shaw and John Bransford, 67–82. Hillsdale, NJ: Lawrence Erlbaum Associates, 1977.

Ginsberg, Allen. "Spontaneous," *Public* 20 (2000): 56.

Godard, Jean-Luc. *Histoire(s) du Cinema* 3a, film. Switzerland, 1988–1998.

Goldsmith, Ben and Tom O' Regan. "Beyond the Modular Film School: Australian Film and Television Schools and their Digital Transitions." In *The Education of the Filmmaker in Europe, Australia, and Asia*, edited by Mette Hjort, 149–169. New York: Palgrave Macmillan, 2013.

Granovetter, Mark S. "The Strength of Weak Ties." *American Journal of Sociology* 78, no. 6 (1973): 1360–1380.

Greene, Maxine. *The Dialectic of Freedom*. New York: Teachers College, 1988.

Grove, Johann. "First National Student and Video Festival: Two Views. View One: Theory or Practice." *Critical Arts* 2, no.2 (1981): 77–80.

Halbfinger, David M. "Pentagon's New Goal: Put Science Into Scripts." *New York Times*, August 4, 2005. http://www.nytimes.com/2005/08/04/movies/04flyb.html ?pagewanted=print (accessed December 7, 2012).

Harmon, Amy. "More Than Just a Game, but How Close to Reality?" *New York Times*, April 3, 2003.

Harvey, David. *The Condition of Postmodernity*. Oxford: Blackwell, 1991.

Hayman, Graham. "Television in Journalism: problems, aims and solutions." *The SAFTTA Journal* 1, no. 2 (1980): 15–19.

Haynes, Jonathan. "'Nollywood': What's in a Name?" *Film International* 5, no. 4 (2007): 106–108.

———. "A Literature Review: Nigerian and Ghanaian Videos." *Journal of African Cultural Studies* 22, no. 1 (2010): 105–120.

———. "Introduction." In *Nigerian Video Films* (revised and expanded edition), edited by Haynes Jonathan, 1–36. Athens, OH: Ohio University Centre for International Studies, 2000.

———. "Video Boom: Nigeria and Ghana." *Post Colonial Text* 3, no. 2 (2007): 1–10. http://postcolonial.org/index.php/pct/article/view/522/422 (accessed December 14, 2011).

Hénaut, Dorothy. "The 'Challenge for Change / Société nouvelle Experience.'" In *Video the Changing World*, edited by Alain Ambrosi and Nancy Thede, 48–53. Montreal: Black Rose, 1991.

Henderson, Lisa Helen. "Cinematic Competence and Directorial Persona in Film School: A Study of Socialization and Cultural Production." Dissertations Available from ProQuest. Paper AAI9026571 (January 1, 1990). http://repository.upenn.edu/dissertations/AAI9026571 (accessed December 6, 2012).

Henderson, Lisa. "Directorial Intention and Persona in Film School." In *On the Margins of Art Worlds*, edited by Larry Gross, 149–66. Boulder: Westview Press, 1995.

Hennigan, W. J. "Computer Simulation is a Growing Reality for Instruction." *Los Angeles Times,* November 2, 2010. http://articles.latimes.com/2010/nov/02/business /la-fi-virtual-reality-20101102.

Henwood, Doug. "I'm Borrowing My Way Through College." *Left Business Observer*, 125, February 2010. http://leftbusinessobserver.com/College.html (accessed December 7, 2012).

Hernandez-Reguant, Ariana. "Cuba's Alternative Geographies." *Journal of Latin American Anthropology* 10, no. 2 (2005): 275–313.

Himpele, Jeff D. *Circuits of Culture: Media, Politics and Indigenous Identity in the Andes*. Minneapolis: University of Minnesota Press, 2008.

Hjort, Mette. "Affinitive and Milieu-Building Transnationalism: The Advance Party Project." In *Cinema at the Periphery*, edited by Dina Iordanova, David Martin-Jones, and Belén Vidal, 46–66. Detroit: Wayne State University Press, 2010.

———. "Denmark." In *The Cinema of Small Nations*, edited by Mette Hjort and Duncan Petrie, 23–42. Indianapolis and Edinburgh: Indiana University Press and Edinburgh University Press, 2007.

———. "On the Plurality of Cinematic Transnationalism." In *World Cinemas, Transnational Perspectives*, edited by Nataša Durovicová and Kathleen Newman, 12–33. London and New York: Routledge, 2010.

———. "The Film Phenomenon and How Risk Pervades It." In *Film and Risk*, edited by Mette Hjort, 1–30. Detroit: Wayne State University Press, 2012.

———. *Lone Scherfig's "Italian for Beginners."* Washington, Seattle, and Copenhagen: University of Washington Press and Museum Tusculanum, 2010.

———. *Small Nation, Global Cinema*. Minneapolis: University of Minnesota Press, 2005.

Hjort, Mette and Duncan Petrie. "Introduction." In *The Cinema of Small Nations*, edited by Mette Hjort and Duncan Petrie, 1–20. Indianapolis and Edinburgh: University of Indiana Press and Edinburgh University Press, 2007.

Hjort, Mette, Eva Jørholt and Eva Novrup Redvall, eds. *The Danish Directors 2: Dialogues on the New Danish Fiction Cinema*. Bristol: Intellect Press, 2010.

Hjort, Mette and Ib Bondebjerg, eds. *The Danish Directors: Dialogues on a Contemporary National Cinema*. Bristol: Intellect Press, 2001.

Hjort, Mette, Ib Bondebjerg and Eva Novrup Redvall, eds. *The Danish Directors 3: Dialogues on the New Danish Documentary Cinema*. Bristol: Intellect Press, 2013.

Hjort, Mette and Scott MacKenzie, eds. *Purity and Provocation: Dogme 95*. London: BFI, 2003.

Hodgson, An. "Special Report: Income Inequality Rising Across the Globe." *Euromonitor International*. http://blog.euromonitor.com/2012/03/special-report-income-inequality-rising-across-the-globe.html (downloaded July 13, 2012).

Hoechsmann, Michael and Stuart R. Poyntz. *Media Literacies: A Critical Introduction*. Oxford: Wiley-Blackwell, 2012.

Hoffman, Philip. "Film Farm Notes 2012." Photocopy provided by the artist.

———. "Our Mandate," Phil Hoffman website. http://philiphoffman.ca/filmfarm/purpose.htm (accessed June 26, 2012).

Hoggart, Richard. *Speaking to Each Other Volume One: About Society*. Harmondsworth: Penguin, 1973.

Holmes, Garth. *Motivating a Learning Approach for Tertiary Level Students to Originate Market Related Aesthetic Choices in their Design Concepts and Products*. Unpublished Master's dissertation: University of Cape Town, 2011.

Horn, John. "Reel China: Land of Cinematic Opportunity." *Los Angeles Times*, October 2, 2011. http://articles.latimes.com/2011/oct/02/entertainment/la-ca-china-film-students-20111002 (accessed December 7, 2012).

Hroch, Miroslav. *The Social Preconditions of National Revival in Europe: A Comparative Analysis of the Social Composition of Patriotic Groups among the Smaller European Nations*. Cambridge: Cambridge University Press, 1985.

Hunter, Ian. "Providence and Profit: Speculations in the Genre Market." *Southern Review* 22, no. 3 (1988): 211–223.

Igbuzor, Otive. "The Millennium Development Goals: Can Nigeria Meet the Goals in 2015." Paper presented at a symposium on Millennium Development Goals and Nigeria: Issues, Challenges and Prospects, organized by the Institute of Chartered Accountants of Nigeria (ICAN), Abuja, Nigeria, July 27, 2006.

Ikeda, Marcelo. "O 'novíssimo cinema brasileiro': sinais de uma renovação." *Cinémas d'Amérique Latine* 20 (2012): 136–149.

Institute of International Education. "Open Doors 2011: International Student Enrollment Increased by 5 Percent in 2010 / 11," *Open Doors*, November 14, 2011. http://www.iie. org/en/Who-We-Are/News-and-Events/Press-Center/Press-Releases/2011/2011–11–14-Open-Doors-International-Students (accessed December 6, 2012).

———. "Top 25 Institutions Hosting International Students, 2011 / 12." Open Doors Report on International Educational Exchange. http://www.iie.org/Research-and -Publications/Open-Doors/Data/International-Students/Leading-Institutions/2011–12 (accessed December 4, 2012).

———. "Top 25 Places of Origin of International Students, 2010/11–2011/12." Open Doors Report on International Educational Exchange. http://www.iie.org/Research -and-Publications/Open-Doors/Data/International-Students/Leading-Places-of -Origin/2010–12 (accessed December 4, 2012).

International Media Support (IMS). "About." http://www.i-m-s.dk/about/ (accessed December 17, 2012).

———. "Annual report 2008." http://www.i-m-s.dk/publication/ims-annual-report-2008/ (accessed December 17, 2012).

———."What We Do." http://www.i-m-s.dk/files/publications/1609%20AboutIMS.final _web.pdf (accessed December 17, 2012).

International Office, Northwestern University. "International Student Population—A Statistical Report by the International Office – Fall 2011." http://www.google.com/url? sa=t&rct=j&q=&esrc=s&source=web&cd=1&cad=rja&ved=0CC4QFjAA&url=http% 3A%2F%2Fwww.northwestern.edu%2Finternational%2Fabout%2FINTLStudentStati stics_Fall_2011.pdf&ei=zBqtUMn0M7KvygHdpIEY&usg=AFQjCNEstnoUmb9ZgR QBdefeg9SoCSNOfw (accessed December 4, 2012).

Iroegbu, Patrick E. "Active Poverty as Elusive Culture in an African Political Environment: Implications for the Vulnerable Population in Nigeria." *Enwisdomization Journal* 4, no. 3 (2010): 47–70.

"Isn't It Strange that 'World' means Everything Outside the West?" An interview with Rod Stoneman. In *De-Westernising Film Studies*, edited by Will Higbee and Saer Maty Ba, 209–221. London: Routledge, 2012.

Jaafar, Ali. "Abu Dhabi to Open Film School." *Variety*, July 6, 2007. http://www.variety .com/article/VR1117968152?refCatId=2523 (accessed December 5, 2012).

Jahad, Shirley. "USC-Affiliated School Graduates Filmmakers from Mideast and North Africa." KPCC Radio (May 23, 2011). http://www.scpr.org/news/2011/05/23/26849 /usc-affiliated-school-graduates-filmmakers-mideast/ (accessed December 5, 2012).

James, David. "Letter to Paul Arthur (Letter with Footnotes)." *Moving Image Review & Art Journal* 1, no. 1 (2012): 27–35.

Jiménez, Marguerite Rose. "The Political Economy of Leisure." In *Reinventing the Revolution: A Contemporary Cuba Reader*, edited by Philip Brenner, Marguerite Rose Jiménez, John M. Kirk, and William M. LeoGrande, 146–155. Plymouth UK: Rowman and Littlefield, 2008.

Jiyankhodjaev, Kamol. "The Case of Central Asia: Non-formal Skills Training as a Tool to Combat Poverty and Unemployment." *Adult Education and Development* 77 (2011): 157–170.

Jowitt, Harold. *Principles of Education for African Teachers*. London: Longman and Green, 1958.

Kambhampati, Uma S. *Development and the Developing World*. New York: Blackwell Publishing Inc., 2004.

Kapuscinski, Ryszard. *The Other.* London: Verso, 2008.

Karam, Danah. "Western Programs Reach Out to Region." *Variety* (June 9, 2010). http://www.variety.com/article/VR1118023627 (accessed December 5, 2012).

Kayode, Jimi and Raheemat Adeniran. "Nigerian Newspaper Coverage of the Millennium Development Goals: The Role of the Media." *Itupale Online Journal of African Studies* IV (2012): 1–17.

Koc, Aysegul. "Hand-Made (in the Digital Age): An Interview with Phil Hoffman." March, 2002. Phil Hoffman website. http://philiphoffman.ca/film/publications/Philip%20Hoffman%20interviews/interview%20march%202002.htm (accessed June 26, 2012).

Krieger, Zvika. "Academic Building Boom Transforms the Persian Gulf." *The Chronicle of Higher Education* (March 28, 2008): A26–29.

Kundnani, Arun. "Wired for War: Military Technology and the Politics of Fear." *Race & Class* 46, no. 1 (2004): 116–125.

Kurlansky, Mervyn and Jon Naar, text by Norman Mailer. *Watching My Name Go By.* London: Mathews Miller Dunbar, 1974.

Latour, Bruno. *We Have Never Been Modern*, translated by Catherine Porter. Cambridge, MA: Harvard University Press, 1993.

Laverty, Collin. "Cuba's New Resolve: Economic Reform and its Implications for U.S. Policy." *Centre for Democracy in the Americas*; http://www.democracyinamericas.org/cuba/cuba-publications/cubas-new-resolve/ (accessed December 11, 2012).

Lawal-Osula, O. S. B. *Edo-Benin Grassroots Voice.* Benin City: Arala Osula Press, 2005.

Lenoir, Timothy. "Programming Theaters of War: Gamemakers as Soldiers." In *Bombs and Bandwidth: The Emerging Relationship Between Information Technology and Security*, edited by Robert Latham, 175–198. New York: New Press, 2003.

Lippmann, Walter. *The Good Society.* New York: Grosset and Dunlap, 1943.

Lyra, Bernadette and Gelson Santana. "Um breve passo pelas bordas do cinema brasileiro." *Revista Filme Cultura*, special issue on *Febre de Cinema* 53 (2011): 28–32.

Macedonia, Mike. "Games, Simulation, and the Military Education Dilemma." In *The Internet and the University: 2001 Forum*, 157–167. Boulder: Educause, 2002.

Macherey, Pierre. "Culture and Politics: Interview with Pierre Macherey." Translated and edited by Colin Mercer and Jean Radford. *Red Letters* 5 (1977): 3–9.

———. "The Literary Thing." Translated by Audrey Wasser. *diacritics* 37, no. 4 (2007): 21–30.

Machlup, Fritz. "Can There Be Too Much Research?" *Science* 128, no. 335 (1958): 1320–1325.

———. *The Production and Distribution of Knowledge in the United States.* Princeton: Princeton University Press, 1962.

MacKenzie, Scott. "Société nouvelle: The Challenge for Change in the Alternative Public Sphere." In *Challenge for Change: Activist Documentary at the National Film Board*, edited by Thomas Waugh, Michael Brenan Baker, and Ezra Winton, 325–336. Montreal: McGill-Queen's University Press, 2010.

———. *Screening Québec: Québécois Moving Images, National Identity and the Public Sphere.* Manchester: Manchester University Press, 2004.

Mander, Jerry. *Four Arguments for the Elimination of Television.* London: The Harvester Press, 1980.

Marchessault, Janine. "Amateur Video and the Challenge for Change." In *Challenge for Change: Activist Documentary at the National Film Board*, edited by Thomas Waugh, Michael Brenan Baker and Ezra Winton, 354–365. Montreal: McGill-Queen's University Press, 2010.

———. "Women, Nature and Chemistry: Hand-Processed Films from Film Farm." In *LUX: A Decade of Artists' Film and Video*, edited by Steve Reinke and Tom Taylor, 135–149. Toronto: YYZ / Pleasuredome, 2006.

Marcus, George. "Ethnography in / of the World System: The Emergence of Multi-Sited Ethnography." *Annual Review of Anthropology* 24 (1995): 95–117.

Martin, Andrew and Andrew W. Lehren. "A Generation Hobbled by College Debt." *New York Times,* May 13, 2012.

Maxwell, Richard and Toby Miller. "Film and the Environment: Risk Off-screen." In *Film and Risk*, edited by Mette Hjort, 271–289. Detroit: Wayne State University Press, 2012.

Mbeki, Moeletsi. *Architects of Poverty.* Johannesburg: Picador, 2009.

Mboti, Nyasha. "ReaGilè in South Africa's Townships: Tracing the design and development of a 'small' idea for life-size community upliftment." *Commonwealth Journal of Youth and Development* (forthcoming).

McChesney, Robert W. "My Media Studies: Thoughts from Robert W. McChesney." *Television & New Media* 10, no. 1 (2009): 108–109.

McCormack, Eugene. "Number of Foreign Students Bounces Back to Near-Record High." *Chronicle of Higher Education* 54, no. 12 (November 16, 2007). http://chronicle.com /article/Number-of-Foreign-Students/35582 (accessed December 4, 2012).

McHoul, Alec and Tom O' Regan. "Towards a Paralogics of Textual Technologies: Batman, Glasnost and Relativism in Cultural Studies." *Southern Review* 25, no. 1 (1992): 5–26.

McLennan, Sophia. "The Theory and Practice of the Peruvian Grupo Chaski." *Jump Cut* 50 (2008). http://www.ejumpcut.org/archive/jc50.2008/Chaski/index.html (accessed December 9, 2012).

McSorley, Tom. "Interview: Phil Hoffman." In *Rivers in Time: The Films of Philip Hoffman*, edited by Tom McSorley, 40–47. Ottawa: Canadian Film Institute, 2008.

Medina, Jennifer. "Like Ivies, Berkeley Adds Aid to Draw Middle-Class Students," *The New York Times* (December 14, 2011). http://www.nytimes.com/2011/12/15/education /berkeley-increasing-aid-to-middle-class-students.html?_r=0 (accessed December 4, 2011).

Meleiro, Alessandra. "Nigerian and Ghanaian Film Industry: Creative Capacities of Developing Countries." *Revista de Economía Política de las Technologías de la Información y Comunicación* XI, no. 3 (2009): 1–7.

Migliorin, Cezar. "Por um cinema pós-industrial: Notas para um debate." *Revista Cinética*, February (2011). http://www.revistacinetica.com.br/cinemaposindustrial. htm (accessed May 21, 2012).

Miller, Toby. "Not Every Film School Graduate Ends Up a Scorsese." *The Australian*, May 16, 2012. http://www.theaustralian.com.au/higher-education/opinion/not-every-film -school-graduate-ends-up-a-scorsese/story-e6frgcko-1226356719938 (accessed June 26, 2012).

———. "Occupy Movement Takes On Behemoth of Student Debt." *The Australian*, November 30, 2011. http://www.theaustralian.com.au/higher-education/opinion/occupy -movement-takes-on-behemoth-of-student-debt/story-e6frgcko-1226209499684 (accessed December 7, 2012).

———. *Cultural Citizenship: Cosmopolitanism, Consumerism, and Television in a Neoliberal Age.* Philadelphia: Temple University Press, 2007.

Miller, Toby and George Yúdice. *Cultural Policy.* London: Sage Publication Ltd., 2002.

Mills, Andrew. "New York U.'s Abu Dhabi Campus to Start With Academically Elite Class." *The Chronicle of Higher Education* (June 21, 2010). http://chronicle.com /article/New-York-Us-Abu-Dhabi-Campus/66005/ (accessed December 5, 2012).

Ministry of Foreign Affairs of Denmark. "Activities." http://um.dk/en/danida-en /activities/ (accessed December 17, 2012).

Montessori, Maria. *Maria Montessori's Own Handbook: A Guide to Her Ideas and Materials*. New York: Random House, 1994.

Moreno, Alejandro and Daniel Calingaert. "Change Comes to Cuba: Citizens' Views on Reforms after the Sixth Party Congress." *Freedom House*. http://www.freedomhouse .org/report/special-reports/change-comes-cuba (accessed October 21, 2011).

Morris, Meaghan and Mette Hjort, eds. *Creativity and Academic Activism*. Durham and Hong Kong: Duke University Press and Hong Kong University Press, 2012.

———. "Introduction: Instituting Cultural Studies." In *Creativity and Academic Activism: Instituting Cultural Studies*, edited by Meaghan Morris and Mette Hjort, 1–20. Durham and Hong Kong: Duke University Press and Hong Kong University Press, 2012.

Morton, Cara. "Films and Fairy Dust." In *Landscape with Shipwreck: First Person Cinema and the Films of Philip Hoffman*, edited by Karyn Sandlos and Mike Hoolboom, 155–159. Toronto: Insomniac Press / Images Festival, 2001.

Muecke, Stephen. "Cultural Science? The Ecological Critique of Modernity and the Conceptual Habitat of the Humanities." *Cultural Studies* 23, no. 3 (2009): 404–416.

Mulvey, Laura. "Then and Now, Cinema as History." In *The New Brazilian Cinema*, edited by Lúcia Nagib, 261–269. London: IB Tauris, 2003.

Nader, Laura. "Up the Anthropologist—Perspectives Gained from Studying Up." In *Reinventing Anthropology*, edited by Dell H. Hymes, 284–311. New York: Pantheon Books, 1972.

Naficy, Hamid. *A Social History of Iranian Cinema. Volume 4: The Globalizing Era (1984–2010)*. Durham: Duke University Press, 2012.

National Economic Empowerment and Development Strategy (NEEDS). *National Economic Empowerment and Development Strategy Report*. Abuja: National Planning Commission, 2004.

National Film School of Denmark. Review document, "Bilag [Appendix] 10.1" (2008).

———. Review document, "Bilag [Appendix] 13.1" (2008).

Negri, Antonio. *Goodbye Mister Socialism*. Translated by Paola Bertilotti. Paris: Seuil, 2007.

NESG. *17th Nigerian Economic Summit*. Abuja: NESG, 2011.

Newfield, Christopher. "Ending the Budget Wars: Funding the Humanities during a Crisis in Higher Education." *Profession 2009* (2009): 270–284.

———. "Public Universities at Risk: 7 Damaging Myths." *Chronicle of Higher Education*, October 31, 2008, A128.

Newman, M. E. J. *Networks: An Introduction*. Oxford: Oxford University Press, 2010.

Newsome, Bruce and Matthew B. Lewis. "Rewarding the Cowboy, Punishing the Sniper: The Training Efficacy of Computer-Based Urban Combat Training Environments." *Defence Studies* 11, no. 1 (2011): 120–144.

Ng, Jenna. "Love in the Time of Transcultural Fusion." In *Cinephilia: Movies, Love and Memory*, edited by Marijke De Valck and Malte Hagener, 65–79. Amsterdam: Amsterdam University Press, 2005.

Ni Zhen. *Memoirs from the Beijing Film Academy: The Genesis of China's Fifth Generation*. Durham: Duke University Press, 2001.

NMA.TV, "James Franco's NYU professor fired for giving bad grade?" NMA.TV, December 20, 2011. http://www.nma.tv/james-francos-nyu-professor-fired-giving-actor-bad-grade/ (accessed December 6, 2012).

Northwestern University in Qatar. "Young Qatari Carries on the Family Media Tradition." Northwestern University in Qatar (May 7, 2012). http://qatar-news.northwestern.edu /family-tradition/ (accessed December 5, 2012).

Nosso Cinema. "Nossa História." [n.d.] http://s3images.coroflot.com/user_files/individ-ual_files/267689_3iRY3__uAM1rbYFuJwjra5nUa.pdf (accessed December 28, 2012).

Novrup Redvall, Eva. "Teaching Screenwriting to the Storytelling Blind—The Meeting of the Auteur and the Screenwriting Tradition at The National Film School of Denmark." *Journal of Screenwriting* 1 (2010): 59–81.

Nwabuoku, Emeka T. "Cultural Dissonance and Tenacity: The Aniocha Paradigm." In *Theatre Arts Studies: A Book of Reading*, edited by Adelugba Dapo and Marcel A. Okhakhu, 95–104. Benin City: Amfitop Books, 2001.

NYU Abu Dhabi University and College in UAE, New York University. http://nyuad.nyu.edu/about/index.html (accessed December 17, 2012).

O'Sullivan, Michael. "Educated Cuban Youth and the 2010 Economic Reforms: Reinventing the Imagined Revolution." *International Journal of Cuban Studies* 3, no. 4 (2011): 321–346.

Office of Development Communications, Princeton University. "$10 million gift establishes Mossavar-Rahmani Center for Iran and Persian Gulf Studies." *News at Princeton* (November 16, 2012). http://www.princeton.edu/main/news/archive/S35/30/15O69/index.xml?section=topstories (accessed December 4, 2012).

Ogunsuyi, Stephen A. *African Theatre Aesthetics and Television Drama in Nigeria*. Abuja: Roots Books and Journals, 2007.

Olson, Scott Robert. *Hollywood Planet, Global Media and the Competitive Advantage of Narrative Transparency*. London: Lawrence Erlbaum Associates, 1999.

Omoera, Osakue S. "A Taxonomic Analysis of the Benin Video Film." *Ijota: Ibadan Journal of Theater Arts* 2–4 (2008): 39–55.

———. "An Assessment of the Economics of the Benin Language Film in Nigeria." *Quarterly Review of Film and Video* 31, no. 5 (forthcoming).

———. "Benin Visual Literature and the Frontiers of Nollywood." *International Journal of Multi-Disciplinary Scholarship (Special Issue—Motion Picture in Nigeria)* 3–5 (2008): 234–248.

———. "Reinventing Igbabonelimhin: An Icono-Cultural Emblem of the Esan."*Journal of the Nigerian Association for Semiotic Studies* 2 (2011): 49–63.

Omole, Wale. "Nigeria at 50 Searching for Gold with a Corroded Pathfinder." *The Constitution: A Journal of Constitutional Development* 10, no. 3 (2010): 1–7.

———. "Rethinking Tertiary Education Financing in Nigeria." *The Constitution: A Journal of Constitutional Development* 11, no. 3 (2011): 66–76.

Onuoha, Freedom C. "Religious Violence and the Quest for Democratic Consolidation in Nigeria: 1999–2009." *The Constitution: A Journal of Constitutional Development* 11, no. 3 (2011): 8–35.

———. "Yet Unanswered? The Youth and Gender Questions in a Decade of Democratic Governance in Nigeria." In *A Decade of Redemocratisation in Nigeria: 1999–2009*, edited by O. S. Ilufoye, O. A. Olutayo, and J. Amzat, 173–181. Ibadan: Department of Political Science, 2009.

———. "Youth Unemployment and Poverty: Connections and Concerns for National Development." *International Journal of Modern Political Economy* 1, no. 1 (2010): 115–136.

Orner, Mimi. "Interrupting the Calls for Student Voice in Liberatory Education: A Feminist Post-structuralist Perspective". In *Feminisms and Critical Pedagogy*, edited by Carmen Luke and Jennifer Gore, 15–25. New York: Routledge, 1992.

Osahon, Naiwu. "The Correct History of Edo." http://www.edo-nation.net/naiwu1.htm (accessed December 20, 2012).

Passchier, Bata. "EVAM: Entertainment Value Assessment Matrix." *CILECT News* (2007): 71–87.

———. "The Learning Programme." Unpublished presentation to CILECT Conference, Cape Town, May 1, 2012.

———. *The Biology of Narrative*. Unpublished presentation at the Helsinki Narrative Conference, 2009.

Peacock. "La avalancha de estrenos argentinos." Micropsia Blog, entry posted October 30, 2012. http://micropsia.otroscines.com/2012/10/la-avalancha-de-estrenos-argentinos/ (accessed December 9, 2012).

Petrie, Duncan. "Creative Industries and Skills: Film Education and Training in the Era of New Labour." *Journal of British Cinema and Television* 9 (2012): 357–376.

———. "Theory, Practice and the Significance of Film Schools." *Scandia* 76, no. 2 (2010): 31–46.

———. "Theory/Practice and the British Film Conservatoire." *Journal of Media Practice* 12 (2011): 125–138.

Pew Research Center. "Marrying Out: One-in-Seven New U.S. Marriages is Interracial or Interethnic." Pew Research Center Publications, June 4, 2010. http://pewresearch.org/pubs/1616/american-marriage-interracial-interethnic (accessed December 7, 2012).

Philipsen, Heidi. "Dansk films nye bølge" ("Danish film's new wave"). PhD diss., University of Southern Denmark, 2005.

Pick, Zuzana. *The New Latin American Cinema: A Continental Project*. Austin: University of Texas, 1993.

Postrel, Virginia. "The Pleasures of Persuasion." *Wall Street Journal*, August 2, 1999.

———. "A Power to Persuade." *Weekly Standard*, May 29, 2010. http://www.weeklystandard.com/articles/power-persuade?page=1 (accessed December 6, 2012).

Price Waterhouse Coopers. *Global Entertainment and Media Outlook: 2006–2010*. New York: PWC, 2006.

Prinsloo, Jeanne and Costas Criticos, eds. *Media Matters in South Africa*. Durban: Education resource centre, University of KwaZulu-Natal, 1991.

Proctor, Jennifer, River E. Branch, and Kyja Krisjansson-Nelson. "Woman with the Movie Camera Redux: Revisiting the Position of Women in the Production Classroom." *Jump Cut: A Review of Contemporary Cinema* 53 (2011). http://www.ejumpcut.org/archive/jc53.2011/womenProdnClass/index.html (accessed December 6, 2012).

Punto Panorámico. "Argentina es el 4° exportador mundial de TV." *Punto Panorámico. Noticias del Laboratorio de Industrias Culturales* 5, no. 26 (March 2012). Posted March 1, 2012. http://lic.cultura.gov.ar/ppanoramico/pp2601.php (accessed October 29, 2012).

Pynchon, Thomas. "Is it O.K. to be a Luddite?" *New York Times Book Review*, October 28, 1984.

Rancière, Jacques. *The Emancipated Spectator*. London: Verso, 2009.

Reagan, Ronald. "The Creative Society." Speech at the University of Southern California, US, April 19, 1966. http://www.freerepublic.com/focus/news/742041/posts (accessed December 6, 2012).

Reble, Jürgen. "Chemistry and the Alchemy of Color." *Millennium Film Journal* 30/31 (1997): 12–17.

Ritzer, George and Nathan Jurgenson. "Production, Consumption, Prosumption: The Nature of Capitalism in the Age of the Digital 'Prosumer.'" *Journal of Consumer Culture* 10, no. 1 (2010): 13–36.

Roberts, Jay W. *Beyond Learning by Doing: Theoretical Currents in Experiential Education*. London: Routledge, 2010.

Rocha, Gláuber. "An Esthetic of Hunger" [1965]. In *New Latin American Cinema*, vol. 1, edited by Michael T. Martin, 59–61. Detroit: Wayne State University Press, 1997.

Román, María José. "Mirar la mirada: para disfrutar el audiovisual alternativo y comunitario." *Folios* 21 and 22 (2009): 141–164. http://aprendeenlinea.udea.edu.co/revistas/index.php/folios/article/viewFile/6438/5908 (accessed on December 9, 2012).

Ross, Andrew. "Global U." *Inside Higher Education* (February 15, 2008). http://www.insidehighered.com/views/2008/02/15/ross (accessed December 4, 2012).

Ross, Miriam. "Grupo Chaski's Microcines: Engaging the Spectator." *eSharp* 11 (2008): 1–21. http://www.gla.ac.uk/media/media_81277_en.pdf (accessed December 9, 2012).

Said, Edward. *Culture and Colonialism*. London: Chatto and Windus, 1993.

———. *Orientalism*. London: Routledge and Kegan Paul, 1978.

Salil, Shetty. "Millennium Declaration and Development Goals: Opportunities for Human Rights." *International Journal on Human Rights* 2, no. 2 (2005): 65–73.

Samuel Jordan Center for Persian Studies and Culture. "Dr. Fariborz Maseeh," Samuel Jordan Center for Persian Studies and Culture, University of California, Irvine. http://www.humanities.uci.edu/persianstudies/about/founder.php (accessed December 4, 2012).

Saul, Gerald. *Fragile Harvest: Films from Phil Hoffman and His Film Farm*. Regina: Saskatchewan Filmpool, 2011. http://www.nmsl.uregina.ca/saul/documents/fragile-harvestprogramnotes.pdf (accessed June 26, 2012).

School of Languages, Literatures, and Culture, University of Maryland. "About Roshan Center for Persian Studies." University of Maryland. http://sllc.umd.edu/persian/about (accessed December 4, 2012).

Schram, Jamie and Frank Rosario. "Professor Claims NYU Fired Him After He Gave James Franco a 'D'." *New York Post*, December 19, 2011. http://www.nypost.com/p/news/local/manhattan/the_franco_cut_kIRVk4WuVdydz59WZ4I5tL (accessed December 6, 2012).

Schroeder Rodríguez, Paul A. "After New Latin American Cinema." *Cinema Journal* 51, no. 2 (Winter 2012): 87–112.

Scott, Mathew. "The View Finder." *South China Morning Post*, November 4, 2012, The Review section.

Screen Institute Beirut (SIB). http://www.screeninstitutebeirut.org/donors.html (accessed December 17, 2012).

Seiter, Ellen. "On Cable, Tech Gods, and the Hidden Costs of DIY Filmmaking: Thoughts on 'The Woman with the Movie Camera.'" *Jump Cut: A Review of Contemporary Cinema* 53 (2011). http://www.ejumpcut.org/archive/jc53.2011/seiterProdnTeach/index.html (accessed December 6, 2012).

Serra, Ana. "The Literacy Campaign in the Cuban Revolution and the Transformation of Identity in the Liminal Space of the Sierra." *Journal of Latin American Cultural Studies* 10, no. 1 (2001): 131–141.

Shaheen, Jack G. *Reel Bad Arabs: How Hollywood Vilifies a People*. Northampton, MA: Olive Branch Press, 2009.

Shashat website. www.shashat.org (accessed December 17, 2012).

Sherwell, Peter. "President Hugo Chavez's revolution in Venezuela limits singing in shower." *The Sunday Telegraph*, November 29, 2009.

Silver, David and Alice Marwick. "Internet Studies in Times of Terror." In *Critical Cyberculture Studies*, edited by David Silver and Adrienne Massanari, 47–54. New York: New York University Press, 2006.

Singh, Vir. "Universities Withstand Dubai's Financial Crisis." *The New York Times* (September 19, 2010). http://www.nytimes.com/2010/09/20/business/global/20iht -educSide20.html?_r=0 (accessed December 5, 2012).

Snow, Charles P. *The Two Cultures and a Second Look: An Expanded Version of the Two Cultures and the Scientific Revolution*. Cambridge: Cambridge University Press, 1987.

Soep, Elizabeth. "Beyond Literacy and Voice in Youth Media Education." *McGill Journal of Education* 41, no. 3 (2006): 197–213.

Solanas, Fernando and Octavio Getino. "Towards a Third Cinema." In *Movies and Methods*, vol. 1, edited by Bill Nichols, 44–64. Berkeley: University of California Press, 1976.

———. "Towards a Third Cinema: Notes and Experiences for the Development of a Cinema of Liberation in the Third World." In *New Latin American Cinema*, vol. 1, edited by Michael T. Martin, 33–58. Detroit: Wayne State University Press, 1997.

Solyszko, Daniel. "Sucesso de 'Cidade de Deus' gerou disputa de autoria entre os diretores do filme." UOL, August 30, 2012. http://cinema.uol.com.br/ultnot/2012/08/30 /sucesso-de-cidade-de-deus-gerou-disputa-de-autoria-entre-os-diretores-do-filme. jhtm (accessed October 31, 2012).

Sontag, Susan. "The Decay of Cinema." *The New York Times*, February 25, 1996.

South African History Online. "What are the Challenges that Face the South African Film industry?" *South African History Online* (n.d.). http://www.sahistory.org.za /what-are-challenges-face-south-african-film-industry (accessed June 28, 2012).

Spivak, Gayatri Chakravorty. "The Rani of Simur." In *Europe and its Others*, vol. 1, edited by Francis Barker et al., 128–51. Colchester: University of Essex, 1985.

Staff of The Academy of Television Arts and Sciences Foundation and the Staff of The Princeton Review. *Television, Film, and Digital Media Programs: 556 Outstanding Programs at Top Colleges and Universities across the Nation*. New York: Random House, 2007.

Staff writer. "NU-Q Faculty Members Discuss Teaching in Qatar." *Time Out*, March 28, 2010: 4. (*Time Out* is the *Gulf Times*' magazine).

Stallabrass, Julian. *Gargantua*. London: Verso, 1996.

Standish, Barry and Antony Boting. *A Strategic Economic Analysis of the Cape Town and Western Cape Film Industry*. Unpublished report for Cape Film Commission by Strategic Economic Solutions cc, 2007.

STANLIB. "SA unemployment rate back above 25% in Q1 2012. Labour force rose by 207 000 in Q1 2012, but employment fell by 75 000." STANLIB. http://www.stanlib .com/EconomicFocus/Pages/SAunemploymentrateQ12012.aspx (downloaded July 13, 2012).

Stavenhagen, Marina. "Oasis de Frescura y Diversidad." *16 Festival Internacional de Cine para Niños (. . . y no tan niños)*. Mexico City, August 9–14, 2011.

Stock, Ann-Marie. *On Location in Cuba: Street Filmmaking During Times of Transition*. Durham: University of North Carolina Press, 2009.

Stockwell, Stephen and Adam Muir. "The Military-Entertainment Complex: A New Facet of Information Warfare." *Fibreculture* 1 (2003). journal.fibreculture.org/issue1 /issue1_stockwellmuir.html (accessed December 11, 2012).

Stoneman, Richard, Justice Duke Pollard and Hugo Inniss. *Turning Around CARICOM: Proposals to Restructure the Secretariat*. Wiltshire: Landell Smith, 2011. http://www .caricom.org/jsp/communications/caricom_online_pubs/Restructuring%20the%20 Secretariat%20-%20Landell%20Mills%20Final%20Report.pdf (accessed December 14, 2012).

Stoneman, Rod. "African Cinema: Addressee Unknown." *Vertigo* Summer / Autumn (1993): 19–23. Republished as "South / South Axis: For a Cinema Built By, With and For Africans," in *African Experiences of Cinema*, edited by Imruh Bakari and Mbye Cham, 175–180. London: BFI, 1996.

———. "Sins of Commission." *Screen* 33, no. 2 (1992): 127–144. Republished in *Rogue Reels, Oppositional Film in Britain, 1945–90*, edited by Margaret Dickinson, 174–187. London: BFI, 1999.

———. "The Ever Bizarre Rules of British Journalism." http://www.irishleftreview. org/2010/01/12/everbizarre-rules-british-journalism/ (accessed Jan 8, 2013).

———. "Under the Shadow of Hollywood: the Industrial Versus the Artisanal." *The Irish Review* 24 (1999): 96–103. Republished in *Kinema* 13 (2000): 47–56.

Tamuno, Tekena N. *Oil Wars in the Niger Delta 1849–2009*. Ibadan: Stirling-Horden Publishers Ltd., 2011.

Teer-Tomaselli, Ruth. "Transforming State Owned Enterprises in the Global Age: Lessons from Broadcasting and Telecommunications in South Africa." *Critical Arts* 18, no. 1 (2004): 7–41.

The Film Festival Research Network; http://www.filmfestivalresearch.org/.

The Project on Student Debt. "Student Debt and the Class of 2010." The Project on Student Debt, 2011. http://projectonstudentdebt.org/files/pub/classof2010.pdf (accessed December 7, 2012).

Thielman, Sam. "YouTube Commits $200 Million in Marketing Support to Channels." *AdWeek*, May 3, 2012. http://www.adweek.com/news/technology/youtube-commits-200-million-marketing-support-channels-140007 (accessed December 7, 2012).

Toffler, Alvin. *Previews and Premises*. New York: William Morrow, 1983.

Tomaselli, Keyan G. "Bashed by Booms: The 2008 Bafundi Film and TV Festival." *Journal of African Cinemas* 1, no. 1 (2009): 122–128.

———. *The Cinema of Apartheid*. Chicago: Lake View Press, 1988.

———. "Communicating with the Administrators: The Bedeviled State of Film and Television Courses in South African Universities." *Perspectives in Education* 9, no. 1 (1986): 48–56.

———. *Encountering Modernity: 20th Century South African Cinemas*. Amsterdam: Rozenberg, 2007.

———. "Film Schools – their relevance for the industry." *The SAFTTA Journal* 1, no. 2 (1980): v–viii.

———. "The Teaching of Film and Television Production in a Third World Context: The Case of South Africa." *Journal of the University Film and Video Association* 34, no. 4 (1982): 3–12.

Tomaselli, Keyan G. and Arnold Shepperson. "Gearing up the Humanities for the Digital Era." *Perspectives in Education* 21, no. 2 (2003): 31–46.

Tomaselli, Keyan G. and Graham Hayman, eds. *Perspectives on the Teaching of Film and Television Production*. Grahamstown: Dept of Journalism and Media Studies, Rhodes University, 1984.

Tomaselli, Keyan G., Jonathan Dockney, and Sarah Dawson. "Bumping into Reality, Brutal Realism and Bafundi 2009: Some Thoughts on a Student Film Festival," *Journal of African Cinemas* 1, no. 2 (2009): 225–234.

Tomaselli, Ruth E., Keyan G. Tomaselli, and Juhan Muller, eds. *Broadcasting in South Africa*. London: James Currey, 1989.

Turse, Nick. *The Complex: How the Military Invades Our Everyday Lives*. New York: Metropolitan Books, 2008.

Txicão, Natuyu Yuwipo, Kumaré Txicao and Karané Txicao. *"From the Ikpeng Children-PREVIEW"* (2001). Videoclip, YouTube. http://www.youtube.com/watch?v=3TOirYOJEt4 (accessed December 9, 2012).

Ugor, Paul U. "Youth Culture and the Struggle for Social Space: The Nigerian Video Films." PhD Diss., University of Alberta, 2009.

Umobuarie, Joy O. "Empowering the Youth through Weaving." *Emotan: A Journal of the Arts* 4 (2010): 139–143.

Umokoro, Matthew. *The Performing Artist in Academia*. Ibadan: Caltop Publications, 2000.

UNCTAD. *Integrating Developing Countries' SMEs into Global Value Chains*. New York and Geneva: United Nations, 2010.

UNDP. *Human Development Index and its Components*. New York: United Nations, 2010. http://hdr.undp.org/en/media/HDR_2010_EN_Table1_reprint.pdf (accessed January 10, 2012).

———. *Millennium Development Goals: A Compact among Nations to End Human Poverty.* New York: Oxford University Press, 2003.

UNESCO Institute for Statistics. "Analysis of the UIS International Survey of Feature Film Statistics: Nollywood Rivals Bollywood in Film / Video Production." Paris: UNESCO, 2010. http://www.uis.unesco.org/FactSheets/Documents/Infosheet_No1 _cinema_EN.pdfI (accessed December 19, 2012).

UNESCO. "Convention on the Protection and Promotion of the Diversity of Cultural Expressions." http://portal.unesco.org/en/ev.php-URL_ID=31038&URL_DO=DO_ TOPIC&URL_SECTION=201.html (accessed September 9, 2012).

———. *Youth in the 1980s*. Paris: UNESCO Press, 1981.

UNHD. *Least Livable Countries of the World—United Nations Human Development Report*. New York: United Nations, 2006.

United Nations. *The Globalization of Youth in the 1990s: Trends and Prospects*. New York: United Nations, 1993.

United States Census Bureau. *Overview of Race and Hispanic Origin: 2010* (March 2011). http://www.census.gov/prod/cen2010/briefs/c2010br-02.pdf (accessed December 7, 2012).

USC Institute for Creative Technologies, "USC Institute for Creative Technologies Receives $135 Million Contract Extension From U.S. Army," September 1, 2011. http://ict .usc.edu/news/usc-institute-for-creative-technologies-receives-135-million-contract -extension-from-u-s-army/ (accessed December 7, 2012).

Utomi, Pat. "Kongi is a Spirit." *The Punch*, Nigeria, May 23, 2012.

Uwemedino, Michael and Joshua Oppenheimer. "History and Histrionics: Vision Machine's Digital Poetics." In *Fluid Screens, Expanded Cinema*, edited by Janine Marchessault and Susan Lord, 177–191. Toronto: University of Toronto Press, 2007.

Van Dael, Joris. Interview by Armida de la Garza, about *Kidscam*, August 12, 2011.

van der Merwe, Fanie and CH Theunissen. "Film Production at the Pretoria Technikon." *The SAFTTA Journal* 1, no. 2 (1980): 1–5. (In Afrikaans).

Van Ness, Elizabeth. "Is a Cinema Studies Degree the New M.B.A.?" *New York Times*, March 6, 2005. http://www.nytimes.com/2005/03/06/movies/06vann.html?_r=1 &pagewanted=2 (accessed December 6, 2012).

Van Nierop, Leon. *Movies Made Easy: A Practical Guide to Film Analysis*. Pretoria: Van Schaik, 2008.

Van Nierop, Leon, Norman Galloway, and Tascoe Luc de Reuck. *Seeing Sense on Film Analysis*. Pretoria: Van Schaik, 1998.

Van Zyl, John. "Beyond Film and Television Studies: Which Jobs for Whom?" In *Perspectives on the Teaching of Film and Television Production*, edited by Keyan G. Tomaselli and Graham Hayman. Grahamstown: Dept. of Journalism and Media Studies, Rhodes University, 1984.

———. *Image Wise: Competence in Visual Literacy.* Sandton: Hodder and Staughton, 1987.

wa Micheni, Mwenda. "African Filmmakers Meet in Nairobi to Count Blessings and Plot." *African Review*, February 14. Nairobi: Nation Media Group, 2011. http://www.afri careview.com/Arts+and+Culture/Africa+got+a+reason+to+celebrate/-/979194/1107332 /-/xdo84xz/-/ (accessed February 16, 2011).

Wallas, Graham. *The Great Society: A Psychological Analysis.* Lincoln: University of Nebraska Press, 1967.

Wilby, Peter. "I Sued and Won." *New Statesman*, August 20, 2009. http://www.news tatesman.com/uk-politics/2009/08/soft-media-services-britain (accessed December 6, 2012).

Wilson, Jamie. "US Military Sends Scientists to Film School." *Guardian*, August 4, 2005. http://www.guardian.co.uk/world/2005/aug/05/usa.film (accessed December 7, 2012).

Winberg, Christine, Penelope Engel-Hills, James Garraway, and Cecila Jacobs. *Work-Integrated Learning: Good Practice Guide.* Pretoria: Council on Higher Education, South Africa: HE Monitor, no.12, August 2011.

Winston, Brian. *Technologies of Seeing.* London: BFI, 1996.

Yube, Zezinho and Bebito Pianko. "*Troca de Olhares / Exchange of Views* (Hunikui / Ashaninka)." Videoclip, YouTube. https://www.youtube.com/watch?v=lRooMqomCJ0 (accessed December 9, 2012).

Yúdice, George. "Parlaying Culture into Social Justice." In *The Expediency of Culture: Uses of Culture in the Global Era*, 133–159. Durham: Duke University Press, 2003.

Yumkella, Kandeh K. "The Bank of Industry 10th Anniversary Lecture." Paper presented at the tenth anniversary of Bank of Industry of Nigeria, Ibadan, Nigeria, December 16, 2011.

Zajc, Melita. "Nigerian Video Film Cultures." *Anthropological Notebooks* 15, no. 1 (2009): 65–85.

Žižek, Slavoj. "Return of the Natives." *New Statesman*, March 4, 2010. http://www .newstatesman.com/film/2010/03/avatar-reality-love-couple-sex (accessed June 29, 2012).

Index

Aad, Serena Abi, 135, 146

A Arca dos Zo'é (Meeting Ancestors, 1993), 252

Abaq al-Thalal (*A Scent of a Shadow*; dir. Ali Ali Hafiz, 2009), 92

Above the Ground, Beneath the Sky (dir. Simon Lering Wilmont, 2008), 139

Abu Dhabi Authority for Culture and Heritage, and The New York Film Academy, 87

Abu Dhabi Film Commission, 87

Aburto, Sonia, 222
 see also Juguemos a Grabar

Abusharif, Ibrahim, on teaching at NU-Q, 92

actor-network theory, 163

Adesuwa (dir. Lancelot Imasuen, 2012), 45

Advance Party Project, 13

affinities, transnational, and small nations, 11–14

affinitive transnationalism, 13, 128

affordances, 126, 129, 137, 139, 141, 143, 146

Afolayan, Kunle, 47

Africa International Film Festival, 14

African media production, as outside the rubric of Western film training, 41

Afro Reggae, 244

agit prop, 68

Akin, Fatih, 91

Akindele, Funke, 47

Akpola Films, 50

Al-Aqsa University, Gaza, and Shashat, 113

Al Arabyia, 61

Alasti, Ahmad, 135, 137

Alas y Raíces a los Niños (Wings and Roots for Children), and Juguemos a Grabar, 233

Albana, Maya, 139

Ali, Hafiz Ali, 92

Al Jazeera Arabic newsroom, and Jassim Al-Rumaihi, 96

Al Jazeera International Documentary Film Festival, 130

All Fall Down (dir. Philip Hoffman, 2009), 173

Along the Way (dir. Sine Skibsholt, 2010), 143, 144

Alqam, Hani, 140–1

Al-Quds 2009 Capital of Arab Culture Fund, 118

Al-Quds University, and Shashat, 113, 114, 115, 116

Aly, Doa, 134

Amata, Fred, 47, 52

Amata, Jeta, 47

Amazing Grace (dir. Jeta Amata, 2006), 47

Ambo, Phie, on "de-film-schoolification," 5

American University in Dubai, Mohammed Bin Rashid School for Communication, 87

Amores Perros (*Love's a Bitch*; dir. Alejandro González Iñárritu, 2000), 241

anecdotes, suggestive, from the field of practice, 1–2

anglophone Caribbean, particularities and problems, 205–8

Anih, Tony, and Africa Movie Academy Awards (AMAA), 49

An-Najah National University, Nablus, and Media Center funded by Kuwaiti Fund, Shashat, 104, 113, 114, 116, 118

Annual Student Academy Awards, 33rd, and AFDA, 32

apartheid, and the end of, implications for film training in South Africa, 25, 26, 27, 28, 34, 35

Apocalypse Now (dir. Francis Ford Coppola, USA, 1979), 66, 67

Aqareb Al-Saah (*Clockwise*; dir. Khalifa Almuraikhi, 2010), 93

Arab American University, Jenin, and Shashat, 113, 114

Arab Comes to Town, An (2008), and collaboration between Ahmad Ghossein and Georg Larsen, 133

Arab Fund for Arts and Culture (AFAC), 118

Arab Institute of Film (AIF), 126, 127, 132, 134

Aram Bash va ta Hatf Beshmar (*Be Calm and Count to Seven*; dir. Ramin Lavafipour, 2008), 92

Aramotu (dir. Niji Akanni, 2011), 47

Arasoughly, Alia, and Shashat, 10, 19, 126

Arinze, Segun, 52

Artistic setup
 equal encounter with another creative being, and NFSD, in the Middle East, 138–42
 one voice, 144–7
 in principle, no money, 142–4

Astruc, Alexandre, 172

Ateliers Varan workshops, and Video in the Villages, 252

Athayde, Celso, founder of CUFA, 245

audiovisual education, in the peripheries, 247–50

audiovisual production in the peripheries, contextualizing of, 240–3

Australian Film, Television and Radio School, The (AFTRS), 8

Ava and Gabriel (dir. Felix de Rooy, 1990), 203

Avatar (dir. James Cameron, 2009), 62

Azari, Shoja, 92

Azugbene, Loveth OKH, 50

Bader (dir. Sara Al-Saadi, Latifa Abdulla Al Darwish, and Maaria Assami), 95

Bairro Escola (Schooling in the Neighborhood) program, 248

Ballard, Daniel, director general, Paris-Sorbonne University in Abu Dhabi, 85

Bamigboye, Mike, 47

Bank of Industry (BOI), 52

Bartas, Šarūnas, as anti-institutional activist, 16

Beach, The (dir. Danny Boyle), 2

Beauvoir, Simone de, 1

Behind the Walls (dir. Zainab Sultan, Amit Chowdhury, and Nazneen Zahan), 95

Beijing Film Academy (BFA), 10, 15, 153, 161

Beirut DC, 134, 135

Benin city, and film production, 50

Benin video film, 40, 42, 44, 45, 46, 49, 50, 52, 53, 54

Benjamin, Walter, and democratizing potential of the film medium, 221

Berrie, Gillian, and Sigma Films, 13

Bethlehem University, and Shashat, 113

Beyond Borders, training program, 64

Bier, Susanne, 130

Big Fish, 27

Bim (dir. Hugh Robertson, 1975), 214

Birri, Fernando, and Santa Fe documentary school, 253

Birzeit University, and Shashat, 114, 115

Björk, and *The Video Diary of Ricardo Lopez* (dir. Sami Saif, 2000), 1

Black Gold: Struggle for the Niger Delta (dir. Jeta Amata, 2011), 47

Blackhawk Down (dir. Ridley Scott, USA, 2001), 67

Bollywood, and distribution, 60

Bologna Accord, 4

Born into Brothels (dir. Zana Briski and Ross Kauffman, 2004), 63

Bouchoucha, Dora, 63–4

Boyd, Don, 14

Braester, Yomi, on practice-based film education, People's Republic of China, 10, 12

Brains of Empowerment (dir. Amna Al-Khalaf), 95

branch campuses
 benefits arising from, 85
 brand, globalization of, 83, 85, 126
 embraced by Arab and Muslim women, 86, 90
 global network paradigm, 125
 Hamid Naficy's involvement in development of, 7
 problematizing of neocolonial formulation of, 94

transferring/transplanting of, to global
 south, 83–6
branch universities, western, and economic
 and political fluctuations, 86
Bresson, Robert, 68, 175, 216
Brin, Sergey, Google cofounder, 82
Bro, Arne, 126, 128
 Roos prize, 131, 135, 137, 143, 145, 146
 see also National Film School of
 Denmark
Browne, Chris, 212
Buainaine, Abdullah, 93
Burch, Noël, 68, 71
Bus 174 (2002), 242

Caméra-etc, 3
 see also Jean-Luc Slock
Cameron, James, director of Titanic, 62
Camre, Henning, 16, 126, 131
Caochangdi Station, 10
Captifs d'amour (directed by John
 Greyson, 2011), 173
Carelli, Vincent, founder of Video in the
 Villages, 251–2
Caribbean Institute of Media and
 Communication (CARIMAC), 205,
 209, 217
Caribbean region, racial makeup
 of, 207
CARICOM, undermining of, 207
Cartoon Crisis, 132
Casa Muda, La (dir. Gustavo Hernández,
 2010), 217
Casé, Regina, 244
Castro, Fidel, 187, 195
Castro, Raoul, 185, 195
Cave Hill Film Society, on UWI campus
 in Barbados, 212
Center for Kultur og Udvikling / CKU
 (Danish Center for Culture and
 Development/DCCD), 9
Central da Periferia, 244
Central do Brasil (Central Station; dir.
 Walter Salles, 1998), 246
Central Única das Favelas / Central Union
 of Slums, 7, 244–6
Centre for Cinema Studies, Lingnan
 University, goals of, 18–19
Centro de Trabalho Indigenista (Center of
 Indigenous Labor), 252

Chaabane, Lina, 64
Challenge for Change, 169
 see also National Film Board of
 Canada
Chanan, Michael, 187
Channel 4, 10, 72
 Africa on Africa, 69
 Cinema of Three Continents, 60, 73–4
 coproduction funds, 72
 direct speech, 65, 69
 People to People, 60
 South, 60
 Vietnam Cinema, programming of,
 65–7
Chan Yuk-Shee, xiii, 18
Chávez, Hugo, 62
Che Guevara, 187
Chen Kaige, director of The Promise, 2
Chen, Steven, YouTube co-founder, 83
Cidade de Deus (City of God, 2002), 242,
 243, 245, 246, 247
Cidade dos Homens (City of Men, 2007),
 242, 243
Cinélink, 3, 14
Cinema Nosso (Our Cinema), 243–4
 see also Kátia Lund
Cinema Novo, 246
Cinémobile, 3
Cinomade, 14
Circuito Fora do Eixo (Off-Axis Circuit),
 251
 Curto Circuito Fora do Eixo (Fora do
 Eixo Short Circuit), 251
City of God, Carandiru (dir. Hector
 Babenco, 2003), 246
CityVarsity, 27
Cizek, Katerina, and NFB's Filmmaker-in-
 Residence programme, 170
cognitariat, the, 159, 160, 161
Collateral Murder, released by
 Wikileaks, 67
colonial era, and misperceptions of
 southern cultures, 60
color film, history of development
 of, 65
Columbia University, and international
 students, 82
Community Video Education Trust, and
 community video production, in
 South Africa, 27

Comunicación Communitaria, 223–4
 workshops, 226–32
 see also Irma Avila Pietrasanta, and
 practice-based film education, for
 children, in Mexico
Conexões Urbanas (Urban Connections),
 created and hosted by José Júnior, 244
Copenhagen Film and Photo School
 Rampen, 12
Coppola, Francis Ford, 187
cosmetics of hunger, in contrast with
 aesthetics of hunger, 245
Cotera, Liset, 222, 224, 225
 see also La Matatena
CPH:DOX, 126
 DOX:LAB, 126
creativity, under constraint, 6, 12
crisis, "Boko Haram," in northern
 Nigeria, 48
Cuba, in transition, 185–6
Cuban and New Latin American
 Left, 186
cultural industry, and modes of
 representation, 59
cybercrime ("Yahoo Yahoo"), 40

Damijo, Richard Mofe, 52
Danfaso Culture and Development
 Programme for Burkina Faso, 9
Danish Broadcasting Corporation (DR),
 132
Danish Centre for Culture and
 Development (DCCD), 131–2
Danish International Development
 Agency (DANIDA), 100, 131
Danish Ministry of Foreign Affairs, and
 "Arab Initiative," 135
Dansereau, Fernand, and Challenge for
 Change, 170
Dar Al-Kalima College, and Shashat, 113,
 115
Dead Birds (dir. Robert Gardner, 1964), 91
Debord, Guy, 68, 180
Del-York International, and the New York
 Film Academy, in Lagos, Nigeria, 46
Dencik, Daniel, 135
Den tid vi har (The Time We Have; dir.
 Mira Jargil, 2011), 130
Deren, Maya, 68, 175
development, problem of, in Nigeria, 40

Devenish, Ross, critical films of, 26
Dewey, John, 33, 221
Diegues, Carlos, 246, 247
digital cinema, and Nigeria, 54
directors, male, and cutting of female
 actors' bodies, 156
Direct Service TV (DStv), South Africa's
 role in provision of, 27
disenfranchised groups, teaching of video
 production to, in Canada, 169
 see also National Film Board of Canada
Doha Tribeca Film Festival, and "Made in
 Qatar" series, 95
Doha Tribeca Film Institute, 94
Dolls—A Woman from Damascus (dir.
 Diana El-Jeiroudi, 2007), 133
Dox Box festival, Syria, 126, 132, 133
Dziga Vertov Group, 100

Ebuwa 1 & 2 (dir. Lancelot Imasuen,
 2009), 45
École supérieure d'études
 cinématographiques (ESEC), and
 Gaston Kaboré, 4
economy, nonformal or informal sector
 of, 41
Education, An (dir. Lone Scherfig), 1
Education City, Doha, Qatar, 90, 96
 Science and Technology Park, 86
Education of the Filmmaker Project
 (EOFP), goals of, 17–18
 practitioner-scholars, 6, 19
 team, 19–20
Eghianruwa, Johnbull, 50
EICTV
 every world, 192–6
 new vistas onto Cuba, 197
 rural immersion and experiential
 filmmaking in the Sierra Maestra,
 188–92
 as school of three worlds, 186–8
 shift away from older paradigm of
 Third Cinema and nationalism, 197
 Television Serrana, 189
 utopia beyond Manichaeism, 198–9
Eisenstein, Sergei, 68, 195, 215, 216
Ejiro, Chico, 47, 52
Ejiro, Zeb, 47, 52
El Chidiac, Anthony, 137, 142, 145, 146–7
elites, political, in the Middle East, 125

El Jeiroudi, Diana, 132–3, 134
El Ouargui, Najat, and C:ntact, Betty Nansen Theater, 132
El Raheb, Eliane, 135
El-Zubaidi, Qais, 100
Embrafilme, elimination of, 246
Encuentro de hombrecitos (Meeting of Little Men; dir. Alejandro Legaspi, 1987), 254
entrepreneurship, and need for self-reliance skills, in South Africa, 35
Equal Men (dir. Anthony El Chidiac, 2010), 146–7
Escola Livre de Cinema / Free Cinema School, 248–51, 255
see also Point of Culture
Escuela Internacional de Cine y TV, Cuba, 8, 185–99
Eternal Night, The (dir. Rania Tawfik), Silver New Horizon Award, Al Jazeera International Documentary Festival, 130
Eu já fui o seu irmão (We Gather as a Family, 1993), 252
European Audiovisual Entrepreneurs (EAVE), 63
see also film workshops
Eurocentric canon, alternatives to, in the Caribbean, 216
European Documentary Network (EDN), 133
European Film College, Ebeltoft, 12

Falcão, Meninos do Tráfico, as response to *City of God* by Meirelles, 246
Falcon, a Revolution, A (dir. Jassim Al-Rumaihi and Rezwan Islam), 95, 96
Faustini, Marcus Vinícius, founder of Escola Livre de Cinema, 248
Favela Rising (2005), 244
FESPACO, 3, 9, 13, 14, 68
Imagine newsreel 3, 3
newsreel workshops, 13, 14, 68
Field, Syd, scripting models, as compared with Philip Hoffman's approach, 174
Figurine: Araromire, The (directed by Kunle Afolayan, 2012), 47
Film and Broadcast Academy (FABA), in Ozoro, Nigeria, 45

film education
ecology of, 8, 10, 11
history of, in Canada, 169
history of, in South Africa, 25–8
knowledge transfer, in Nigeria, 42
models of, 9, 10, 14, 15, 16, 32, 33, 171, 181
Nigeria, 45–7
specialist crafts, and empowerment of Nigerian youth, 53
systematic study of, 15
University of the West Indies, 204–5
values, xiv, 7, 8, 9, 14, 16, 18, 19, 25, 28, 51, 130, 131, 209, 234
why bother?, 171–2
Film Festival Research Network (FFRN), 17
see also Skadi Loist, Marijke de Valck
filmic creativity and output, students', at NU-Q, 94–7
film industry, in South Africa, 25, 26 , 27, 28, 29, 31, 32, 33, 36
filmmaking, ecologically destructive, 3
film schools
EICTV, Cuba, 186–99
graduates of American, and work, 158–61
history of conservatoire-style, 14
Pentagon, 160, 161
positive images of violent technocracy, 160
private, in South Africa, 25, 27, 34
privately owned, in Nigeria, 45
state-owned enterprises (SOEs), in South Africa, 35
Super 16, as alternative to conservatoire-style, 12, 13
transformation, required to counter sexism, militarism, and exploitation, in the United States, 162–4
tuition, at American, 161–2
United States, 15, 84, 88, 89, 107, 153–64
Film Studies, and institutional turn, 16–17
film training
absence of well developed system of, in Malta, 8
Arab television stations, 99
artisanal centers, in Nigeria, 46, 50
Australian Film, Television and Radio School (AFTRS), 8

film training—*Continued*
 Beijing Film Academy (BFA), 10, 153,
 161
 Big Fish, 27
 branch campus initiatives, 81–97
 Caochangdi Station, 10
 CityVarsity, 27
 collaboration, between Napier
 University and Edinburgh College of
 Art, 10
 film festivals, 29, 33, 95, 105, 107, 108,
 210
 global monoculture, 59
 Gothenburg region, Sweden, 10
 Griffith Film School, 8
 history of, in Palestine, 104–7
 Hong Kong International Film Festival
 (HKIFF) Society's Jockey Club Cine
 Academy, 12
 Hong Kong Television Broadcasts
 Limited (HKTVB), 12
 Imagine, 3, 9, 10, 13, 14, 68
 Independent Imaging Retreat (or Film
 Farm), 169–82
 informal communities of filmmakers,
 in Japan, 8
 informal, in Nigeria, 49
 ISIS (Institut Supérieur de l'Image et du
 Son), Burkina Faso, 9
 lack of gender sensitivity, in Palestine,
 114
 Li Xianting Film School, 10
 London Film School, 13, 14, 15
 Matatena, La, 224–6
 Media Lab, Jadavpur University,
 Calcutta, 9
 National Board for Technical Education
 (NBTE), in Nigeria, 45
 National Film School of Denmark, 1, 5,
 8, 12, 13, 125–47
 New York Film Academy Abu Dhabi
 (NYFA), 87
 New York University (NYU), 82, 83, 86,
 88, 125, 153
 Nigeria, 39–54
 Northwestern University, Qatar, 7,
 81–97
 notion of value added, 52
 Open Window, 27
 power relations, 59

 Pretoria Technikon Film School, 26
 public interest, 154
 Red Sea Institute of Cinematic Arts
 (RSICA), 87, 88, 118, 121
 resistance, 116, 120, 179
 rules, 13, 126, 128, 129, 138, 141, 143,
 145
 scale, 47, 59, 63, 126, 130, 206, 208,
 210
 scholarships, 99, 116, 194
 School of Motion Picture Medium and
 Live Performance in Cape Town,
 The, South Africa (AFDA), 25–36
 Shashat, Palestine, 99–123
 socialization of boys, in Palestine,
 113–14
 transnational, 8, 10, 13, 18, 47, 126, 127,
 128, 129, 131, 187
 University of Cape Town, 27
 University of California Los Angeles
 (UCLA), 153
 University of Southern California
 (USC), 71, 82, 88, 125, 153
 values, xiv, 7, 8, 9, 14, 16, 18, 19, 25, 28,
 51, 130, 131, 209, 234
Film and TV Academy of the Performing
 Arts (FAMU), 5
Film Workshop, Copenhagen, 12
film workshops
 capacity creation, 63–5
 filmmakers from the south, 59
 indigenous forms, 64
 Shashat, 101–2, 103–4, 111–23
 timespan, 71
 see also European Audiovisual
 Entrepreneurs (EAVE), Med Film
 Development, Med Film Factory
Final Cut Productions, 127, 133
5 Films from the Middle East (The
 National Film School of Denmark /
 IMS, 2008), 127
5 Spells (dir. Helen Hill, 2000), 173
5 x Favela, Agora por Nós Mesmos (5
 Times Favela, Now by Ourselves,
 2010), remake of *5 x Favela* (*5 Times
 Favela*, 1962), 246
Fondo Nacional para el Fomento de las
 Artesanías (FONART), 223
Forgan, Liz, as head of Factual
 Programmes, Channel 4, 65

Forget, Robert, and Challenge for Change, in Canada, 170

Franco, James, "D" grade at NYU, 155
dismissal of José Angel Santana, 155

Freire, Paulo, 221
see also pedagogy of hope and pedagogy of the oppressed

From Palestine with Love (dir. Mahasen Nasser-Eldin and Camilla Magid, 2010), and DOX:LAB, 126

Fugard, Athol, critical films of, 26

fuji, as a musical form, 41

Full Spectrum Warrior, as military recruitment tool, and Saddam Hussein Abd al-Majid al-Tikriti, 160
University of Southern California, 160

Fung, Richard, working from industrial bases outside the Caribbean, 206

Gadjigo, Samba, see The Making of Moolaadé, 3

Galal, Hala, 134, 147

Garvey, Marcus, 203

Gegen die Wand (Head On; dir. Fatih Akin, 2004), 91

Gehman, Chris, on the Independent Imaging Retreat, 176

George Mason University, closing of Ras Al-Khaimah campus, United Arab Emirates, 86

Ghazil—The Story of Rashed & Jawajer (dir. Sarah Al-Derham), 95

Gibson, Ben, as director of London Film School, 13

gift culture, 13, 138

Gini coefficient, and South Africa, 35

Girls and the Sea (dir. Taghreed El-Azza), 120

Givanni, June, 14

global south, and factual genres, 60

global universities, small and large universities vying for status as, 83

Glover, Danny, 187

Godard, Jean-Luc, 65, 67, 68, 72, 100, 172

Goethe Institute Ramallah, 116

Gomez, Sarah, 215

Gopalakrishnan, Adoor, 212

Gorin, Jean-Pierre, 100

Göteborg International Film Festival, and Shashat, 116

Grace (dir. Mira Jargil, 2010), 47, 130

graduates, of film school, and porn movies, 158

Great Events Organizers (Nig) Limited, 50

Green Berets, The (dir. John Wayne and Ray Kellogg, USA, 1968), 66

Gregorio (directed by Fernando Espinoza and Alejandro Legaspi, 1984), 254

Griffith Film School, 8

Grupo Chaski, 253–4

Grupo Ukamau, 253

Guerra, Ciro, 212

Gulf Cooperation Council countries (CCC), investment in for-profit knowledge villages and education malls, 84

Gyorki Film Studio, and Ousmane Sembène, 4

Haarløv Johnsen, Ditte, 139, 140, 141

Hajjar, Rafiq, 100

Hamouri, Omaima, and Shashat, 121

Harder They Come, The (dir. Perry Henzel, 1972), 203

Hassaan, Ethar, 95, 96

Hawal, Qassem, 100

Hebron University, and Shashat, 113, 115, 116

Hénaut, Dorothy, and Challenge for Change, in Canada, 170

higher education
American and European, internationalization of, and Middle East, 81
future of, in South Africa, 34–6
learning outcomes and skills as goal, 171

Hindi cinema, in the Caribbean, 207

Hoffman, Philip, and Independent Imaging Retreat (aka Film Farm), 7, 169–82

Hollywood-Mosfilm, Jean-Luc Godard on, 172

Hollywood movies, and Arabs, 87

Hollywood technicians, and color consciousness, 65

Holmquist, PeA, 115

Hong Kong International Film Festival (HKIFF) Society, and Jockey Club Cine Academy, 12

Hong Kong Television Broadcasts Limited (HKTVB), 12
Hopland, Anita, 133, 136
Horanyi, Nicole, 140
Hroch, Miroslav, 11
Huillet, Danièle, 68
Huston School of Film & Digital Media in Galway, Ireland, 3
see also Rod Stoneman

Ikoka 1, 2 & 3 (dir. Peddie Okao, 2003), 45
Ikuemitin (dir. Lancelot Imasuen, 2007), 47
Illinois Institute of Technology, and worries about international students after 9/11, 82
Imagine, 3, 9, 10, 13, 14, 68
see also Gaston Kaboré
Imasuen, Lancelot, 45, 47, 50
imperfect cinema, 250
Iñárritu, Alejandro González, 241
Independent Imaging Retreat (aka Film Farm), 169–82
artisanal filmmaking, 179
experimental writing workshop, or Book Farm, 180–1
globalized, 180–1
International School of Film and Television (EICTV), Cuba, 181
manifesto, 173–4
material process, celebration of, 178
process cinema, 174–6
program adapted for children, 181
techno-fetishism, liberation from, 177
women, 177
workshop, 174–6
Indiana Jones and the Last Crusade (dir. Steven Spielberg, 1989), 87
Indian Cine-Club, St. Augustine campus, UWI, 216
Indignado movement, 76
institutions, non-local, in the Middle East, 125
International Academic City, in Dubai, 84
International Association of Film and TV Schools (CILECT), 5
AFDA, 8, 29
Australian members of, 8
conference on values, 5

Department of Film, Television, and Media Studies' Screen Production Program at University of Auckland, 6
Escuela Internacional de Cine y TV, Cuba, 8
ISIS, Burkina Faso, 9
membership, 5
National Film School of Denmark, 8
International Centre of Films for Children and Youth (CIFEJ, Centre International de Film pour l'Enfance et la Jeunesse), 224–5
International Day of the World's Indigenous Peoples (IDWIP), 50
internationalization, recruiting of foreign students, as compared with campus transplantation, 81
International Media Support (IMS), 133, 134, 135, 136, 137
International Monetary Fund, 3
international relations, the imposition from elsewhere, 59–63
international students, contribution to the American economy, 82
Intifada, first, 105
Iordanova, Dina, and "Dynamics of World Cinema," 17
Iranian studies, and philanthropy, 83
ISIS (Institut Supérieur de l'Image et du Son), Burkina Faso, 9
Islamic Museum of Art, Doha, Qatar, and I.M. Pei, 94
Islamic University, in Gaza, and Shashat, 113
Isong, Emem, 47
Italian for Beginners (dir. Lone Scherfig), 1
It Was Better Tomorrow (dir. Hinde Boujemaa, Tunisia, 2012), 64

Jacir, Annemarie, 92
Jalal, Naissam, 139
James, C.L.R., 203
Jia Zhangke, as dean of the Busan International Film Festival's Asian Film Academy (AFA), 2
mentoring, through Xstream Pictures, 2
Jockey Club Cine Academy (JCCA), Hong Kong, 12
Johnson, Mercy, 47

Juguemos a Grabar, 232–3
 see also Sonia Aburto, and practice-
 based film education, for children, in
 Mexico
juju, as a musical form, 41
Juliana (dir. Grupo Fernando Espinoza
 and Alejandro Legaspi, 1988), 254
Jumbo, Uche, 47
Just Forbidden (dir. Fadya Salah-Aldeen),
 121

Kaboré, Gaston, v, 3, 4, 9, 13, 68, 69, 75
 see also Imagine
Kahiu, Wanuri, 212
Kahlo, Frida, 223–4
Karim, Jawed, YouTube cofounder, 83
Kestner, Max, 128, 131, 135
Khan, Shahrukh, 207
Kidscam, 225, 226, 231
Kilani, Liali, and Shashat, 118
Killing My Art (dir. Nicole Horanyi, 2006),
 140–1
Kiss My Pain Away (dir. Rania Tawfik),
 and "Destination Beirut," 130
Kluge, Alexander, 68
knowledge, anglophone conceptions of, as
 institutionally widespread, 64
knowledge industry, investment in, in
 Qatar, 84
Kpakpakpa, Benin videographers and
 philosophy of production, 50
Krogh, Mikala, 131

labor, contingent, as way of life, 159
Lancewealth Images, 47
Landrían, Nicolás Guillén, 191
La Niña Mala (The Bad Girl, 2012), 191
Last of the High Kings (dir. David Keating,
 Ireland, 1996), 74
Lavafipour, Ramin, 92
Lebanese Academy of Fine Arts (ALBA),
 137
Lebanese American University,
 Communication Arts at, 143
Legemah, Osagie, 50
LeGrice, Malcolm, 68
Leila, 4
 see also Imagine, Golda Sellam, and
 Jean-Luc Slock
Lemmon, Jack, 63

León, Jorge de, on EICTV's rural
 immersion program, 190–1
Lering Wilmont, Simon, 139
Leth, Jørgen, 16
Leung Ping-kwan, 19
liberty
 negative conception of, 143
 positive conception of, 142–3
Lift Above Poverty Organization
 (LAPO), 52
Light Breeze, A (dir. Rania Tawfik),
 winner of Best Short Film Award,
 Gulf Student Short Competition in
 Dubai, 130
Little Stones (dir. Tamara Stepanyan,
 2010), 143
Linna, Olavi, 134
Li Xianting Film School, 10
local government areas (LGAs), in Benin,
 Nigeria, 43
Loin du Vietnam (*Far From Vietnam*;
 dir. Jean-Luc Godard, William Klein,
 Claude Lelouch, Chris Marker,
 Alain Resnais, and Agnes Varda,
 1967), 67
Loist, Skadi, and Film Festival Research
 Network (FFRN), 17
London Film School, 13, 14, 15
Lotfi, Nabiha, 100
Lucas, George, and University of Southern
 California (USC), 155
Lund, Kátia, 244
 see also Cinema Nosso
Lynch, David, 175
Lyric Revolt, and NU-Q students Ashlene
 Ramadan, Rana Khaled, Melanie
 Fridgant, and Shannon Farhoud, 95

Machlup, Fritz, typologies of
 postindustrial work, 157
Maher, Ali, 134, 140
Mainframe Productions, 47
Makavejev, Dušan, 68
Making of Moolaadé, The, 3
 see also Samba Gadjigo
*Manar and the Children in the House
 with a Hole in the Roof* (dir. Malina
 Terkelsen, 2008), 136, 143
Manitas Mágicas ("Magical Little
 Hands"), 223

Marangmotxíngmo Mïrang—Das crianças Ikpeng para o mundo (From the Ikpeng Children to the World), 252
Marchessault, Janine, 177, 178, 180
 see also Independent Imaging Retreat
Matatena, La, 222, 224–6
 workshops, 226–32
 see also Liset Cotera, and practice-based film education, for children, in Mexico
Mathieu, Chris, 15
Maurer, Monica, 100
Med Film Development, 63, 70, 76
Med Film Factory, 64, 70, 75, 76
media training, in Palestine, and international organizations, 100
Meirelles, Fernando, 241
Mekas, Jonas, as anti-institutional activist, 16
Michel (dir. Anita Hopland, 2010), 136
Michigan State University, and financial crisis in Dubai, 86
Middle East Film Festival, Abu Dhabi, 87
Middle East Project, National Film School of Denmark's, phases of, 127–38
Midland Entertainment Centre Nigeria Limited, 50
Migliorin, Cezar, and Escola Livre de Cinema, 250
Millennium Development Goals, 39, 40, 54
Ministry of Culture, Arts, and Heritage, Qatar, 93
Missing (dir. Costa Gavras, USA, 1982), 63
M-Net, growth of, in South Africa, 26
modes of education, alternative, in Canada, 171
 centrality of "process," 171
Montessori, Maria, 221
Moolaadé (dir. Ousmane Sembène), 3
Moonlight Video Centre, 50
Mount Zion Productions, 47
Mourad, Selim, 137
Movement for the Actualization of the Sovereign State of Biafra (MASSOB), 48
Mulvad, Eva, 126
Mulvey, Laura, 68
Murch, Walter, 216
MV Bill, founder of CUFA, 245

Naficy, Hamid, and NU-Q service visit to Tanzania, 93
Nasser-Eldin, Mahasen, and Shashat, 126
National Directorate of Employment (NDE), 52
National Film Board/Office national du film (NFB/ONF), 169–70
 "Filmmaker-in-Residence" programme, 170
 see also disenfranchised groups, teaching of video production to, in Canada, and Challenge for Change
National Film Institute (NFI), as training arm of Nigerian Film Corporation (NFC), 45
National Film School of Denmark (NFSD), 126
 Danish Ministry of Cultural Affairs, 129
 Documentary & TV Department, 126, 127, 128, 130, 131, 134
 Middle East Project, 127–38
 see also Arne Bro
National Film and Video Foundation, and white paper, in South Africa, 34
National Poverty Eradication Program (NAPEP), 52
Nelson Films Nigeria Limited, 50
neoliberal colonial paradigm, and global U phenomenon, 85
Nesgaard, Poul, 128, 130
 see also National Film School of Denmark
Neshat, Shirin, 92
Network of Microcines, 240
Network of Popular Audiovisual Schools and Workshops, 249
 Festival Audiovisual Visões Periféricas (Audiovisual Festival of Visions from the Periphery), 249
networks
 affinitive, 138
 already actual, 136–7
 emergence of, at meta-level, 134
 known, 137
 potential, 137
 yet to be identified, 137
New Latin American Cinema (NLAC), as compared with post-NLAC, 241

New York Film Academy Abu Dhabi
 (NYFA), 87
New York University, and global network
 university, 125
 as "Global U," 83
 international students, 83
 NYU Abu Dhabi, 83, 85, 88
 tuition, 161
NGOs, international, role of, in Palestine,
 100–1
Nigerian Film Corporation (NFC), 45
Niji, Akanni, 47
Ninety-Nine Entertainment Centre
 Nigeria Limited, 50
no budget concept, 138, 142
Nollywood
 accomplished practitioners, 52
 apprenticeship, 46
 Benin language film subsector, 45, 50
 boost for, 53
 informal training, 42, 47
Northwestern University
 international students, 82
 third campus in Doha, Qatar, 81
Northwestern University Qatar (NU-Q),
 89–90
 challenges of teaching at, 90–4
 Oh Snap!, 95
 NU-Q Film Society, 94
 Society of Professional Journalists, 95
 students' response to Arab Spring, 95–6
Notes on Love in Copenhagen (dir. Rania
 Rafei, 2009), 137
Nyrabia, Orwa, 132, 134

Observatório das Favelas, Forum of
 Popular Audiovisual Experiences,
 249
Occupy movement, 76
Ociel del Toa (Ociel from Toa; dir. Nicolás
 Guillén Landrían 1965), 191
Odua People's Congress (OPC), 48
Okao, Peddie, and Prolens Movies Nigeria
 Limited, 49
O'Keefe, Barbara, on transplantation
 of the Northwestern campus to
 Doha, 86
Omidyar, Pierre, eBay founder, 82
Omoregie, Eunice, 45, 50
127 Hours (dir. Danny Boyle, 2010), 155

One Woman Army (dir. Maya Albana,
 2006), 139
Opa Williams Productions, 47
Open Window, 27
Opstrup, Mikael, 127, 133
Osagie Mega Plaza Nigeria Limited, 50
Oskouei, Mehrdad, 135
Oslo Accords, and Palestine, 100, 105, 106
Ouoba, Daphne (Cinomade), 14
Ouoba, Motandi, 9
Ové, Horace, working from industrial
 base outside the Caribbean, 206
Oziengbe, Ozin (aka Erhietio Sole Sole),
 45, 50
Ozin Oziengbe Films, 50

Pagter, Helle, 128, 135, 145
Painting My Secret (dir. Ditte Haarløv
 Johnsen, 2006), 139–41
Palestine Broadcasting Corporation, 100
Palestine Cinema Institute, as Palestine
 Liberation Organization's Fatah-
 operated cinema body, 100
Palestinian communities, fragmentation
 of, 101
Palestinian film education, as compared
 with film education for Palestinians, 99
Palestinian National Authority, formation
 of, 99, 105, 106
Palestinian Revolutionary Cinema Period,
 in Lebanon (1968–1982), 99
Pang Ho-cheung, and The Renaissance
 Foundation, 2
Papalote, Museo del Niño (The Kite,
 Children's Museum), 232
Parra, Pim de la, 212
PAS 4 satellite, launch of, in South
 Africa, 26
Passchier, Bata, CEO, AFDA, 28, 30, 31, 32
pedagogy of hope, 221
 see also Paulo Freire
pedagogy of the oppressed, 221
 see also Paulo Freire
Pencil's Film and Television Institute
 (PEFTI), in Lagos, Nigeria, 45
peripheral audiovisual organization, 240
 favela organizations, 240
 indigenous peoples, 240
 middle-class youth, 240
 migrant communities, 240

peripheral audiovisual production
 different from post-NLAC, 241
 field of, 239–55
peripheries, definition of, 239
Persepolis, graphic novel by Marjane
 Satrapi, and Qatari customs
 officers, 93
Persian Gulf states, popularity of film and
 media schools, 87
Petrobras, funding of Cinema Nosso,
 243–4
Philips, Caryl, 212
Philipsen, Heidi, 14, 15, 16
Philp, Katrine, 133, 136, 139
Phi Phi Islands National Park in
 Thailand, 2
 see also *The Beach*
Pictures Communications, 47, 50
Pietrasanta, Irma Avila, 222
 see also Comunicación Communitaria
Pioneers Production, Jordan, 134
Platoon (dir. Oliver Stone, USA,
 1986), 66
Plea for Products of High Necessity, 76
Point of Culture program, and Gilberto
 Gil, 249
 see also Escola Livre de Cinema
political developments, post-Oslo, in
 Palestine, 101
popular arts paradigm, African, 41
Popular Front for the Liberation of
 Palestine, 100
post-New Latin American Cinema, 241
 see also Fernando Meirelles and
 Alejandro González Iñárritu
poverty, in Nigeria
 alleviation/reducation of, 39–40, 42, 47
 small and medium sized enterprises
 (SMEs), 39
practice-based film education
 for children, in Mexico, 221–35
 sites, types, and systems, 7–11
practitioner's agency, 6, 15, 127, 128
Praise (dir. Barbara Sternberg, 2005), 173
President Collor de Mello, 246
President Luiz Inácio "Lula" da Silva,
 endorsement of *City of God*, 245
Pretoria Technikon Film School,
 and whites only policy, in South
 Africa, 26

Prince Abdullah of Jordan (King
 Abdullah II), and Red Sea Institute of
 Cinematic Arts (RSICA), 87
ProAction Film, Damascus, 132, 134
Project Nigeria, 40
Prolens Movies, 47, 49, 50
Promise, The, and killing of trees in
 gardens of Yuanmingyuan, 2
 see also Chen Kaigke

Qatar Foundation for Education, Science
 and Community Development,
 funding of programs from Cornell
 University, Georgetown, Carnegie
 Mellon, Texas A & M, Virginia
 Commonwealth, Northwestern, 84

Rai, Aishwarya, 207
Rafei, Rania, 137, 145
Rainbow Theatre Troupe, 50
Rautenbach, Jans, 26
Ray, Satyajit, 9, 216
Reagan, Ronald, and creative society, 157
Reble, Jürgen, 175
Red Sea Institute of Cinematic Arts
 (RSICA), 87, 88, 118, 121, 125
 see also Steven Spielberg and University
 of Southern California
Redvall, Eva Novrup, 15
Renaissance Foundation, 2
 see also Jia Zhangke
Research-One schools, 153
La Revolución de Juan Escopeta (*Juan
 Escopeta's Revolution*; dir. Jorge A.
 Estrada, 2011), 226
Robbe-Grillet, Alain, 175
Roos, Jørgen, and prize, 131, 145
 see also Arne Bro
Roshan Center for Persian Studies,
 University of Maryland, 83
Royal Film Commission, Jordan, 64, 71,
 87, 134, 140
Rukov, Mogens, 16

SA Broadcasting Corporation (SABC), 26
Saif, Sami, 1–2
Saint Joseph University in Lebanon
 (IESAV), 137
Salem, Rana, 137
Salhab, Ghassan, 135

Samuel Jordan Center for Persian Studies and Culture, and Fariborz Maseeh, 83
Sanctuary, Gary, 71
Satin Rouge (*Red Satin*; dir. Raja Amari, Tunisia, 2002), 64
Saulter, Storm, 212
Saverin, Eduardo, Facebook cofounder, 82–3
Scherfig, Lone
 An Education, 1
 Italian for Beginners, 1
School of Motion Picture Medium and Live Performance in Cape Town, The, South Africa (AFDA)
 alumni achievements, as role models, 32
 awards, 32–3
 CILECT conference of 2012, 29
 curricular responses to globalization, 25
 curriculum of, 31–3
 exchange programs, 35
 inequality, 35
 learning by doing, 33–4
 learning narratives, 31, 32
 nation building, 28
 Passchier's theory of entertainment, 30, 31
 scaffolded learning, 29, 30
 success of graduates, 27
 ubuntu, philosophy of, 27
 values of, 25, 28, 33
 work-integrated approach of, 28, 33
Scotland Movie Centre, 50
Scratch (dir. Deirdre Logue, 1998)
Screen Institute Beirut (SIB), 126, 132, 135
Seade, Jesús, xiii, 18
Secrets/Anonymes, Les (*Buried Secrets*; dir. Raja Amari, Tunisia, 2009), 64
Sellam, Golda, 3, 14
 see also Cinélink
Selvadurai, Naveen, Foursquare cofounder, 83
Semat Cairo, 134, 136, 139, 147
Sembène, Ousmane, 3, 4
 see also *Moolaadé*
Shadid, Wesam Farouk, 140
Shaikh Hamad ben Khalifa, emir of Qatar, and Al Jazeera Satellite Channel, 87
Sharmin and Bijan Mossavar-Rahmani Center for Iran and Persian Gulf Studies, 83

SHASHAT Women's Cinema, NGO
 absence of a Palestinian National Film Center, Film Board, or Film Commission, 104
 "A Day in Palestine," 104
 annual women's film festival, 102
 areas of activity, 102–4
 beginning of Palestinian-Palestinian training, 111
 capacity building, 101, 102, 103
 "Crossroads," 119–20
 decentralized film libraries, 104
 "Documentary Film Day at Palestinian Universities," 114–16
 "Films for Everyone," 104
 Heinrich Böll Foundation, 120, 121
 "I am a Woman," 104, 121–3
 international trainers/training, 105, 107–11
 "Palestine Summer," 104, 120
 short film collections, 104, 118
 Stockholm Academy of Dramatic Arts, 119
 training/production program "Confession," 116–18
 "Worlds," 121
Shawi, Corine, 127, 135, 145, 147
Sheikha Mozah bint Nasser Al Missned, chair of Qatar Foundation, 84
Shu Kei, dean of Hong Kong Academy for Performing Arts (HKAPA), 19
Sider, Larry, 71
Sidewalk Café, Georgetown, Guyana, 212
Silence in a Noisy World (dir. Katrine Philp, 2008), 136
Silver Entertainment, 50
6 Documentary Films from Lebanon and Denmark (The National Film School of Denmark/IMS, 2009), 127
6 Film fra Mellemøsten (6 Films from the Middle East, DR/IMS/CKU/The National Film School of Denmark, 2006), 127
Skibsholt, Sine, 143, 144
Skovgaard-Petersen, Jakob, 136
Slock, Jean-Luc, 3
 see also Caméra-etc
Sluizer, George, 100
small nationhood, measures of, 11
small nations, 6, 11–13, 205–6, 210

Snow, C. P., "two cultures", film schools' merging of, 156
social movements on the periphery, audiovisual wing of, in Latin America, 243–47
Some Movements for Web Camera (dir. Olavi Linna), 134
Souaiby, Eli, 137
Soul 2 Soul Films Nigeria Limited, 50
Soundview Films, 50
South African Communication Association (SACOMM), recommendations of, in post-Apartheid era, 35
South African Film and Television Awards (SAFTA), and AFDA, 33
Spacek, Sissy, 63
Spider-Man 2 (dir. Sam Raimi, 2004), 160
Spielberg, Steven, 87, 88
state structures, deterioration of, in Nigeria, 49
Steen, Rasmus, 128, 132, 133, 136
Stepanyan, Tamara, 137, 143, 145
Steve Film Centre, 50
Stjernfelt, Agnete Dorph, 131
Stockholms Dramatiska Högskola (Stockholm Academy of Dramatic Arts/Dramatiska Institutet), 9
Stoneman, Rod, 3, 9, 13, 14, 19
 see also Huston School of Film and Digital Media
Straub, Jean-Marie, 68
Student Academy Awards, 32, 155
students, foreign, recruitment of, at American and European universities, 81
Studio Film Club, at the UWI, and painters Peter Doig and Che Lovelace, 212
Sud Ecriture, 64
Sueños lejanos (Distant Dreams; dir. Alejandro Legaspi, 2007), 254
Sugar Cane Alley (dir. Euzhan Palcy, 1983), 203, 214
Suissa, Daniele, as teacher at Red Sea Institute of Cinematic Arts, 88
Super 16, 12, 13
Supreme Movies, 50

Tarkovsky, Andrei, 68
Tarnation (dir. Jonathan Caouette, 2003), 217
Tawfik, Rania, 130
Teia, collective, 254
 O céu sobre os ombros (The Sky over His Shoulders), 254
telenovelas, Globo's most lucrative, featuring favelas, 248
teleSUR, 61
Ten (dir. Abbas Kiarostami, 2002), 217
Terkelsen, Malina, 136, 139, 143
theater arts programs, renaming of
 at Ambrose Alli University in Ekpoma, 46
 at University of Calabar, 46
 at University of Jos, 46
 at University of Nigeria, Nsukka, 46
 at University of Port Harcourt, 46
theory, tool box of, 67
theory and practice, refusal of split between and Paulo Freire, 221
ties, strong as compared with weak, 129
Tinpis Run (dir. Pengau Nengo, Papua New Guinea, 1991), 72, 73–4
Titanic, and chlorination of Baja California, 2
 see also James Cameron
Travelling Caribbean Film Showcase, 213, 216
Trier, Lars von, 13, 130
Trinidad and Tobago Film Company (TTFC), 210
Trinidad and Tobago Film Festival (TTFF), 210–12
Triple 'O' Films Nigeria Limited, 50
Troca de Olhares (Exchange of Gazes), series, 252
 Morrinho (Little Favela), 252–3
Tropa de Elite 1 (*The Elite Squad*; dir. José Padilha, 2007), 242, 246
Tropa de Elite 2 (2010), 242
12 Documentary films by Lebanese, Iranian and Danish Directors (The National Film School of Denmark/ IMS, 2010), 127
twinning, 126, 128, 131, 132, 133, 135, 136

Udefiagbon, as first commonly
 acknowledged Benin video drama, 45
unemployment, in Nigeria, 39, 41, 45, 47,
 48, 49, 51, 53, 54
Uteteneghiabe, Omo-Osagie, 50
UNESCO Convention on the Protection
 and Promotion of the Diversity of
 Cultural Expressions, 62
United Nations Development Fund for
 Women (UNIFEM), 100
United Nations Development Program
 (UNDP), 100
United Nations Human Development
 (UNHD) agency, 40
United Nations Industrial Development
 Organization (UNIDO), 52
United Nations Population Fund
 (UNFPA), 100
United States Agency for International
 Development (USAID), 100
Universal Films Centre, 50
universities, American, and successful
 international students, 83
University of California Los Angeles
 (UCLA), and tuition, 161
University of Cape Town, and nurturing
 of directorial voices, 27
University City, in Abu Dhabi, 85
University of the West Indies, 204–5
 building critical mass and embracing
 the digital, 217–18
 devising curricula at, 208–16
University of Southern California (USC)
 Institute for Creative Technologies
 (ICT), 160
 international students, 82
 portrait of Greta Garbo, 156
 tuition, 161
 women faculty, 156
 see also Red Sea Institute of Cinematic
 Arts and Steven Spielberg
University of York Film Schools Seminar,
 The, 13
UrbanSim, and Pentagon and University
 of Southern California, 160
Usinas Culturales / Cultural Factories, 7
Uwagboe, Omadeli, 45, 50
Uyiedo Theatre Troupe, and Aghabiomo
 Ogbewi, 45

Valck, Marijke de, and Film Festival
 Research Network (FFRN)
 film training and film festivals, 17
Van Dael, Joris, founder and director of
 Belgian Kidscam, 225, 231
Ved Havet (Aside the Sea; dir. Sine
 Skibsholt, 2011), 144
Venezuelan Film Festival, at Cave Hill,
 UWI, 216
Ver Favela, funding from Petrobras,
 247
Vianna, Hermano, 244
Victorian College of the Arts, Melbourne,
 8
Video Diary of Ricardo Lopez, The
 (dir. Sami Saif, 2000), 1–2
video film industry, in Nigeria, 39, 40, 42,
 47, 52, 53, 54
Vídeo nas Aldeias (Video in the Villages),
 249
Video Workshop, in Haderslev, 12
Vinterberg, Thomas, 130
Virgo, Clement, working from industrial
 base outside the Caribbean, 206
Vision Machine, and use of digital media
 in a therapeutic context, 228

Walcott, Derek, 203
Wale Adenuga Productions, in Nigeria,
 45, 47
wa Micheni, Mwenda, 49
We Are Going Home (dir. Jenn Reeves,
 1998), 173
Welles, Orson, 69
Wells Entertainment, 47
Wend Kuuni, 3, 69
 see also Gaston Kaboré
Wenner, Dorothee, as director of the
 Berlinale Talent Campus, 14
West Indian Federation, doomed in the
 1950s, 207
What I Saw (dir. Ethar Hassaan, 2010),
 95–6
White Dress (dir. Omaima Hamouri,
 2012), 121
Wicht, David, on training for
 entertainment, 28
Wild Field, The (dir. Hong Sen, Vietnam,
 1979), 65–7

Wollen, Peter, 68
Wong Yiu-ming, Anthony, 2
 see also Renaissance Foundation
work-integrated learning, and teaching
 film production for the market, at
 AFDA, South Africa, 28–33
World Bank, 3
World Trade Organization, 3
Writing, different types, on practice-based
 film education, 14–16
Wu Wenguang, and Caochangdi
 Station, 10
Xingu (dir. Cao Hamburger, 2011), 243

Xstream Pictures, 2
 see also Jia Zhangke

Yanogo, Serge, 3

Yglesias, Jorge, Humanities Chair at
 EICTV, on challenges of rural
 immersion program, 189
Yoruba traveling theater, 41
youth, in Benin, Nigeria, 47–9
 video film, 49–54
YouTube, 32, 60, 83, 158, 239, 252

Zanan-e Bedun-e Mardan (Women
 Without Men; dir. Shirin Neshat and
 Shoja Azari, 2009), 92
Zan Boko (dir. Gaston Kaboré, Burkina
 Faso, 1988), 69–70
Zentella, Ricardo, instructor from La
 Matatena, 229
Zentropa Film Town, 13
02 Filmes, and production of City of God
 and City of Men, 242

Printed in the United States of America